ALIENATION EFFECTS

THEATER: THEORY/TEXT/PERFORMANCE
Series Editors: David Krasner, Rebecca Schneider, and Harvey Young
Founding Editor: Enoch Brater

Recent Titles:

Alienation Effects

PERFORMANCE AND SELF-MANAGEMENT
IN YUGOSLAVIA, 1945–91

Branislav Jakovljević

ANN ARBOR

University of Michigan Press

Copyright © 2016 by the University of Michigan
All rights reserved

Published in the United States of America by the
University of Michigan Press
Manufactured in the United States of America
⊗ Printed on acid-free paper

2019 2018 2017 2016 4 3 2 1

A CIP catalog record for this book is available from the British Library.

ISBN: 978-0-472-07314-6

To Nikola and Maria

Acknowledgments

I dedicate this book to my children, Nikola and Maria. Yugoslavia will be a part of their lives more than they will ever be able to know—so much for intangible heritage. I would have not been able to write this book without the commitment and support of my wife, Jasminka. Much more than the translations from the French in this book is hers.

In *Alienation Effects*, I investigate the transformation of performance, broadly conceived, in Yugoslavia in the post–World War II period. In the period that extended from the establishment of self-management as the dominant ideological and economic model, contemporaneously with early experimental work in theater and visual arts, to the hyperinflation that spelled the end of the Yugoslav brand of labor and highly visible postmodern cultural productions, the concept of performance in Yugoslavia spanned a broad range of activities, from labor organization to conceptual art. Instead of composing a historical survey, in this book I have tried to understand different historical periods by focusing on a select number of case studies, each of them requiring a different methodology. My work on the 1950s and early 1960s was based on archival research in Serbia and the United States. This painstaking labor was made easier by the assistance of friendly staff of the Archive of Yugoslavia (Arhiv Jugoslavije), Museum of Yugoslav History (Muzej istorije Jugoslavije, especially Momo Cvijović), and the Hoover Institute library at Stanford University. I am grateful to Mary Munill from the Stanford Library office for Interlibrary Borrowing. Throughout the process, I relied on generous help of my friends from the National Library of Serbia (Narodna biblioteka Srbije): Svetlana Gavrilović, Sreten Ugričić, and Saša Ilić. In my research on the late 1960s and 1970s (and beyond) I employed both archival and ethnographic fieldwork methods. I am grateful to Slavica Vukadinović, Srđjan Veljović, and Stevan Vuković for their help in accessing archival material held in Belgrade's Student Cultural Center (Studentski kulturni centar, SKC). These documents came to life through my conversations with some of the main protagonists of the conceptual art

scene in Belgrade of the 1970s and 1980s, Slobodan "Era" Milivojević, Raša Todosijević, Zoran Popović, and Jasna Tijardović. I offer my thanks to them for sharing their time and memories with me, and for giving me a permission to use the photographs of their performances in this book. Big thanks to Mladen Stilinović and Branka Stipančić for their help in obtaining the images of Mladen's works and the permission to use them. I also want to thank Dunja Blažević, Ljubica Mrkalj, Nebojša Janković, and Žarko Papić for providing me with important information about their activities on the Belgrade art scene of the 1970s, and Goran Đorđević for letting me use images of some of his works. I also want to thank Marinko Sudac, Irwin, Belgrade Student Cultural Center (SKC), and Anne Marchand for allowing me to use the images from their collections. The image on the book covers was made during the concert of Belgrade Symphony in Train Factory "Goša" in Smederevska Palanka on the occasion of Youth Day, on May 25 1954. I made every poossible effort to find the person who made this photograph, but to no avail. The cover was designed by Belgrade-based multimedia artist group Škart. My thanks go to Đorđe Balmazović and Dragan Protić for their flexibility and for doing great work under pressure of deadllines. I also want to acknowledge the work of a new generation of artists, theoreticians, and art historians whose critical interpretation of conceptual art in Serbia and Yugoslavia was important for my own work: Milica Tomić, Branimir Stojanović, and Jelena Vesić.

My archival research and fieldwork would not have been possible without support from the Hellman Foundation and Stanford University. Just as important as financial support was the intellectual and institutional support of Harry Elam, under whose tenure as department chair of Stanford Drama/TAPS I started this book, and of Alice Rayner, who chaired the department when I finished. My special thanks to Peggy Phelan for her friendship, support, and guidance throughout this period, and beyond. I want to thank them and my other colleagues for providing a cordial and supportive work environment. They taught me that self-management is not only a principle of labor organization, but also a very delicate art of working together. It is an art of generosity and care, and is not limited to immediate interactions. In my labor on this book I benefited enormously from Amelia Jones's comments, from Mariellen Sandford's copyediting, and from the patience and understanding of my editor, LeAnn Fields. Ljubiša Matić made indexing into an art form. I am indebted to him for his attentiveness to every word and letter in the book. He was the last line of defense against typos and other omissions. I am

solely responsible for any mistakes, large and small, that made it into the published version of the book.

My work on this book started long before I even thought of writing it. It was fueled by the unraveling of the country where I was born and raised. I received my first lessons about self-management as an egalitarian practice and its distortions as an ideological discourse from my parents, Branislava and Radoš; I articulated my first critiques of Yugoslav politics in conversations with my sister Lidija. This daily exercise of critical thinking continued over the years through dialogues with my friends Perica Gunjić, Milan Rakočević, Pavle Levi, and many others. I hope that in this book captures some of the verve and passion of these shared experiences.

Contents

Introduction: Socialism and Sociality

SELF-MANAGEMENT

In *Perestroika Timeline*, the Saint Petersburg art collective Chto Delat? establishes a connection between the crisis that spelled the end of the Cold War and the one that shook world markets some twenty years later.[1] The installation consists of simple gray-scale images, with captions painted directly on a gallery wall, beginning with Leonid Brezhnev's death in 1982 and proceeding with a series of political and cultural events that mark the decade that followed, such as the 1985 appointment of Mikhail Gorbachev as the general secretary of the Soviet Communist Party; the 1986 explosion at the Chernobyl nuclear plant; the 1987 landing in Red Square of a small plane operated by the young German, Mathias Rust; the 1988 start of the withdrawal of Soviet armed forces from Afghanistan; all the way to December 1991, when the leaders of Russia, Ukraine, and Belarus signed the Belavezha Accords, putting an end to the Soviet Union. This sequence concludes with a string of statements that show postcommunist Russia in a stark light: "The Soviet Union collapsed. The national economy has been stolen from the people through 'privatization' that leads to the rise of a class of oligarchs. The population has suffered massive impoverishment. Extreme forms of nationalism and religious obscurantism have become widely popular. Civil wars and terrorism have afflicted large parts of the former Soviet Union. Economic collapse has led to a severe decline in health care, education, scientific research, and culture. Neoliberalism has triumphed throughout the world. The interests of the majority have been sacrificed to the needs of speculative transnational capital." The section of the installation entitled "What Might Have Happened" presents an alternative vision of the recent past: "The Soviet Union is transformed into a federative state based on broad autonomy for republics, districts, and cities; Workers take full control of all factories and enterprises; All political authority is transferred to factory and local councils (soviets); The west undergoes its own version of perestroika. Inspired by the processes under-

way in a renewed Soviet Union, western societies carry out a series of radical social-democratic reforms; Governments fully disarm and unite to create a fund to ensure the future of the planet; Socialist culture enjoys a rebirth worldwide" (Chto Delat? 2009–10).[2] The second and third items on this "what if" list had already occurred in Yugoslavia during the 1950s and the 1960s with the establishment of workers' self-management as the official doctrine of its political economy. *Perestroika Timeline* concludes precisely with the year in which the wars of succession after the dissolution of Yugoslavia commenced, putting an end to any hope for the survival of this kind of self-management. By the time *Perestroika Timeline* reached museums in Europe and the United States, Yugoslav self-management was buried under two decades of war and transition to capitalist economy.

With the end of the Cold War, the discourse of Yugoslav self-management moved from international policymaking forums to alternative art exhibitions and publications. Self-management, in its multiple historical and contemporary forms, was the theme of Austrian artist Oliver Ressler's video installation *Alternative Economics, Alternative Societies*. First exhibited in 2003 at ŠKUC gallery in Ljubljana, and subsequently in some twenty galleries and museums across Europe, *Alternative Economics, Alternative Societies* features videotaped statements by scholars, artists, and activists engaged in the study and practice of "alternative economics." In his rationale for the installation, the artist states that the main aim of the project is to address the gap that opened up with the "loss of a counter model for capitalism" after the collapse of "socialism in its real, existing form." According to Ressler, this "thematic installation . . . focuses on diverse concepts and models for alternative economies and societies, which all share a rejection of the capitalist system of rule."[3] *Alternative Economics, Alternative Societies* started with five videos and grew over the years to sixteen videotaped accounts on subjects that range from current practices, such as "Inclusive Democracy" (by Takis Fotopoulos) and "Caring Labor" (by Nancy Folbre), to historical precedents, such as Alain Dalotel's report on the Paris Commune and Todor Kuljić's on workers' self-management in Yugoslavia.

One such alternative economic practice is the recuperated factory movement in Argentina, which emerged in the months and years after the breakdown of Argentine banking system in December 2001. Marina A. Sitrin, the chronicler of this movement, points to political and cultural sources of the Argentine workers' movement. The most significant of them is certainly HIJOS, Hijas y Hijos por Identidad y Justicia y contra el Olvido y Silencio (Daughters and Sons for Identification and Justice and against Silence and Forgetting), which during the 1990s staged a series of public actions that

came to be known as *estrache*. In these public demonstrations with strong elements of street theater, which attracted from a few dozen to a few hundred participants, HIJOS called for public indictment and prosecution of perpetrators of political crimes that took place during the "Dirty War" (1976–83). Collectivity and equality are the main organizing principles of *estrache*. Unlike Bread and Puppet Theater, which bases its activism on principles similar to that of HIJOS, but hinges its existence on the powerful personality of its founder and leader, Peter Schumann, *estraches* never had an individual leader or organizer. Instead, the members of HIJOS insist on collective decision-making, development, organization, and execution of its public actions. While organizing these events in order to bring to public light war criminals who went unpunished, HIJOS at the same time set up a pattern of self-organization that laid-off workers embraced during the process of recuperation of closed factories and establishment of workers' collectives. As Sitrin points out, apart from autonomy and equality ("horizontalism"), *autogestion* became one of the main principles of the recuperated factory movement. Collaborative and symbiotic relationships between workers' collectives and art groups became one of the staple characteristics of the recuperated factory movement.[4]

In one way or another, all of these art initiatives—*Perestroika Timeline, Alternative Economics, Alternative Societies*, and *HIJOS*—are indicative of a "social turn" in making and exhibiting art that has taken place in Europe and the United States since the beginning of the twenty-first century. This highly participatory and performance-based form of artistic practice conceives of art and its institutions as uniquely positioned to address social issues and generate solutions to local political and economic problems. The best-known recent example of this kind of art is probably Tania Bruguera's *Immigrant Movement International*. In 2011, this Cuban American artist used funding from the New York art organization Creative Time and the Queens Museum of Art to set up her art project in a storefront office on Roosevelt Avenue in Corona, Queens, far from the hubs of the New York art world in Manhattan and Brooklyn. Bruguera's "installation" consisted of the artist and her assistants offering undocumented immigrants a range of services that were unavailable to them elsewhere, such as legal advice, computer lessons, and health classes, to name a few. This work radically challenges the artist-audience relationship: here, the artist is a facilitator of a process in which there is no clear separation between producers and receivers of art. What qualifies this as an "art project" is not the production of tangible works or discrete events (performances), but a process that rejects all trappings of anything "aesthetic" in order to make room for art as a space for

activism and education. If, as Claire Doherty puts it, in socially engaged art the artist turns "from object-maker to service provider" (2004:9), then we should recognize that one of the key aspects of the "social turn" in art during the first decade of the twenty-first century consisted in artists' reappropriation of art funding. In putting together *Immigrant Movement International*, Bruguera used grants she received to produce a "work" for an audience that would never have benefited from this money had it been used for art exhibited in a Manhattan art gallery. Pablo Helguera, one of the most prominent advocates of this new curatorial and educational practice, recognizes direct and actual, rather than symbolic, social engagement as one of the defining characteristics of what he calls "socially engaged art," or SEA. "SEA is a hybrid, multi-disciplinary activity that exists somewhere between art and non-art, and its state may be permanently unresolved. SEA depends on actual—not imagined or hypothetical—social action" (Helguera 2011:8). According to Helguera, the other defining characteristic of SEA is its anticapitalist stance: "Socially engaged art is specifically at odds with the capitalist market infrastructure of the art world: it does not fit well in the traditional collecting practices of contemporary art, and the prevailing cult of the individual artist is problematic for those whose goal is to work with others, generally in collaborative projects with democratic ideals" (4). Emphasis on communicative rather than representational action often lends these kinds of work overtones of educational and communal, rather than aesthetic, work.[5]

When it comes to historical sources of social practice in art, there is a general agreement that it hails from the politicized avant-garde between the world wars, reemerging in happenings in the 1950s and 1960s, in conceptual process art and institutional critique during the 1970s, and in relational art in the 1990s.[6] While most critics and scholars who have written about recent social art practice tend to privilege its historical precedents in Western Europe and the United States, in her influential book *Artificial Hells* Claire Bishop offers a more inclusive and balanced account of participatory and socially engaged art in Western and Eastern Europe (and beyond). Milan Knížák's actions during the 1960s and 1970s, and Moscow conceptualists' performances in the late 1970s and 1980s, which Bishop discusses in a chapter entitled, significantly, "The Social under Socialism," have their place in the history of conceptual, participatory, and performance art of the late twentieth century. Performance actions in Czechoslovakia and the Soviet Union (and here we could add Hungary and Poland) were clandestine interventions within oppressive political regimes that actively proscribed this kind of art and withdrew from it any kind of institu-

tional support. The problem here is not in chronology or geography, but in a blanket understanding of politics in the so-called postsocialist era.

Alienation Effects disturbs this clear scheme of dissident art in the former East and critical art in the former West. Perched on the Cold War geopolitical, economic, and cultural fault lines, the Socialist Federative Republic of Yugoslavia (1945–91) is an important focal point for understanding art practices of the late twentieth century, not only as an exception to the generalized divide between capitalist West and socialist East, but as a prism for discerning fine-grained structures of artists' engagement with the "social" that escape broad ideological divisions. In this book I am not concerned only with representational, or as Helguera has it "symbolic," art, but also with "actual" artistic practice (2011:8). In this analysis, art as a social product is inseparable from art as a social relation. This closeness of aesthetic practice and social organization is particularly important for the study of performance in Yugoslavia. For a brief moment in the aftermath of 1968, and within the confines of state-funded art institutions in Yugoslavia, the protagonists and supporters of conceptualism saw process art and self-management as inextricable, thus bringing in the closest possible proximity two poles of a broad semantic range of "performance": on one end, an artistic practice largely seen as "unproductive," and on the other, industrial production. However limited and short-lived, this idea of integral social art practice did not emerge in opposition to the art market or state censorship; instead, it claimed industrial democracy at home and conceptual art practices from abroad as its dual origin. In *Alienation Effects* I trace the main cultural, political, and economic currents that went into the making of this moment, and its subsequent unraveling. This arch is inseparable from the history of the second Yugoslavia.[7]

In his videotaped statement for Ressler's *Alternative Economics, Alternative Societies*, sociologist Todor Kuljić correctly distinguishes between industrial and political democracy in Yugoslavia, a split that defined (and doomed) Yugoslav self-management: "The decisions in the production plants were made independently; the workers' councils were sovereign. But, on the other hand, they were under the auspices of the ruling party. One should differentiate several issues, those where the workers' councils were sovereign, and the others, where they were dependent on the decrees from above" (Kuljić 2003:n.p.). Yugoslavia was the first state ever to introduce self-management as an official form of industrial organization and an integral part of its economic and political system; at the same time, self-management remained historically tied to a whole spectrum of political ideas associated with labor movements. As a result, attempts to define, his-

toricize, and theorize self-management in Yugoslavia and abroad, primarily in France, have been tangled and often contradictory. Consider, for example, a definition of self-management from the *Encyclopedia of Self-Management* (*Enciklopedija samoupravljanja*):[8]

> Self-management, as the main *principle* of social organization of Yugoslavia, is (*a*) a system of social relations based on social ownership of the means of production; (*b*) a mode of production in which the means of production and management are given back to the subjects of associated labor, that is, a social relation of production motivated by individual and common interests; (*c*) a social relation and a system based on man's sense of belonging to the basic values of the society, to qualified and responsible decision-making . . . ; the emergence of a new social organization in which, truth be told, not everyone can decide about everything, but which makes possible responsible decision-making under conditions of interdependency, mutual social responsibility, and solidarity, and which leads to the liberation of man. (1979:876)

This lengthy definition goes on to list the withering away of the state (item *e*), the rights of man (item *f*), and nonalignment (item *g*) as the main components and outcomes of self-management in Yugoslavia. Compare this definition of self-management to Henri Lefebvre's take on the same concept:

> The principal contradiction that *autogestion* introduces and stimulates is its own contradiction with the State. In essence, *autogestion* calls the State into question as a constraining force erected above society as a whole, capturing and demanding the rationality that is inherent to social relations (to social practice). Once aimed at ground level, in a fissure, this humble plant comes to threaten the huge state edifice. It is well known to Men of State; *autogestion* tends to reorganize the State as a function of its development, which is to say it tends to engender the State's withering away. *Autogestion* revives all the contradictions at the heart of the State, and notably the supreme contradiction, which can be expressed only in general, philosophical terms, between the reason of the State and human reason, which is to say, liberty. ([1966] 2009:147)[9]

If self-management offers a mechanism for political and economic emancipation, Yugoslav ideologues were trying to legislate that emancipa-

tion while thinkers on the French left were calling for its implementation. While often opposed, both sides claimed the same historical legacy of self-management, which goes back to Marx and Engels's earliest considerations of workers' self-organization in their writings on the Paris Commune. Another rich vein of arguments for self-management within Marxist political and economic thought comes from the early twentieth-century revolutions in Russia and Central Europe, most prominently in the writings of Vladimir Ilyich Lenin, Georg Lukács, and Antonio Gramsci. No less important were social thinkers who departed radically from the "classics" of Marxism, such as anarchist Pierre-Joseph Proudhon and utopian socialist Charles Fourier.[10] Discrepancies between genealogies of self-management in Yugoslavia and France are as significant as their broad areas of overlap: whereas in Yugoslav histories of self-management various forms of self-organization among communist partisan guerillas during World War II play a prominent role, they are, of course, rarely mentioned in histories of self-management written outside of Yugoslavia; and conversely, while ideas of nonleftist forerunners of self-management such as Anton Pannekoek are regularly acknowledged in non-Yugoslav sources, they are completely omitted from Yugoslav histories of self-management.[11] However, historical circumstances are just as important as theoretical sources for the general turn toward self-management in the mid-twentieth century. Stalinization of the USSR in the 1930s transformed the landscape of the Left in the aftermath of World War II. While initially allied with the Soviet Union, in 1948 the Communist leaders of Yugoslavia came in conflict with their senior partner. Once it became clear that the schism was irrevocable, the Yugoslav party tried to put together an alternative model of socialism, taking Marx's idea of the free association of workers as its starting premise.[12] The Communist Party of Yugoslav's top leadership took responsibility for introducing, developing, and maintaining a self-managing system of labor organization in Yugoslavia. At the same time, demands for self-management in France came from fringe political groups on the left that rejected the politics of the French Communist Party, which maintained close ties with the Soviet Union.

Significantly, both in France and in Yugoslavia, the idea of self-management was informed by experience of interwar avant-garde artistic associations, and carried forward either by former members of avant-garde groups or by their self-appointed heirs. The integration of artistic and social practice, characteristic of post–World War II continental Europe, emerged as the most viable alternative to the doctrinaire socialism that the Kremlin imposed on its acknowledged and unacknowledged zones of in-

fluence. In France, the legacy of surrealism was particularly influential among such groups as Situationist International, and for journals such as *Socialisme ou Barbarie*, as well as for individual thinkers, among them Lefebvre. Although not as easy to discern, this same legacy helped the establishment of self-management in Yugoslavia. During the 1920s and 1930s a robust surrealist group was active in Belgrade. Unlike the French surrealists who, to use André Thirion's phrase, remained "revolutionaries without revolution," many Belgrade surrealists joined the communist underground resistance, and some of them climbed to the very top of the Yugoslav communist guerilla army. After World War II, and especially in the aftermath of Yugoslavia's break with the Soviet Union, most of the former surrealists rose to high positions within the Party, state, and cultural institutions. The highest ranking among them was Koča Popović, a wartime general in the partisan army, who served as the chief of the Yugoslav General Staff from 1948 to 1953 and as foreign minister from 1953 to 1965. During this period, he paved the way for the Yugoslav foreign policy of the "third way": self-management in domestic and nonalignment in international politics.[13] In 1931, as a member of the surrealist group in Belgrade, Popović coauthored the book *An Outline for a Phenomenology of the Irrational* (*Nacrt za jednu fenomenologiju iracionalnog*) with Marko Ristić, one of the signatories of "The Second Manifesto of Surrealism," which states, famously, that "everything tends to make us believe that there exists a certain point of the mind at which life and death, the real and the imagined, past and future, the communicable and the incommunicable, high and low, cease to be perceived as contradictions" (in Breton [1930] 1969:123). Yugoslav doctrines of self-management and nonalignment seem to extend this principle to the positions held by the East and the West regarding the Cold War, to communism and capitalism, and to command and market economies.[14]

For a short period following World War II (1945–48), Yugoslavia went through a massive economic, political, and social transformation. By means of nationalization, expropriation, reorganization, and targeted investment, the entire economy was restructured from a market economy to a planned economy (that is, from a profit-based economy to a command economy). In the arts, this meant not only nationalizing museums, galleries, and schools, but also establishing artists' associations, launching guild publications, adopting new education models, and radically changing the modes of interface between art and the public. Visual art was no longer available only in galleries; public squares, buildings, factories, and all means of public transportation became the space in which to display art. The same was true for literature, which was no longer confined to books and literary journals;

the physical media for literature now included workers' papers, pamphlets, and public displays. Theater moved from the stage to factories, streets, village squares, and stadiums. This applied not only to the mode of reception, but also to art's mode of production. In order to celebrate industrialization, art was now produced in construction sites, factories, schools, and fields. In short, this redirection of the arts amounted to a wholesale importation of socialist realism. During the 1930s and 1940s, this art form evolved in the Soviet Union into an elaborate style that privileged naturalistic over formalist and abstract representation. Even more importantly, this art form was deeply integrated into an immense cultural apparatus that included art institutions, artists' associations, agencies for funding the arts, systems of material and symbolic rewards for individual artists, and routinized channels of interaction between culture and politics. This "style," then, is an intricate part of a vast segment of society integral to the functioning of its entire economy. Any consideration of socialist realism merely as a style and not as a vital part of a political economy is incomplete. Socialist realism, like opera in the baroque, was engineered from scratch with a precisely defined purpose and place within society: to supplement "intangible" segments of the economy that were lost with the transfer to a command economy, such as worker motivation, competition, and the sense of tangible results in a system of production in which (at least declaratively) personal gain was subordinated to societal well-being. In 1945, the political economy of socialist realism was implemented in Yugoslavia together with a single-party political doctrine and a command economy. Socialist realism as a "style" survived Yugoslavia's 1948 break with the USSR, but only for little more than a year. In his December 1949 address to the Slovene Academy of Arts and Sciences, Edvard Kardelj, a high Party official who eventually became the leading ideologue of Yugoslav self-management, signaled the departure from socialist realist style by criticizing the Soviet model and inviting Yugoslav scholars and artists "to be free in their creativity. Precisely because of the lack of conflicting opinions and scholarly discussion, there is a deprivation of progress in science, and there is no successful struggle against reactionary ideas and dogmatism in science" (1949:1). Although this was not a decree, the message was clear. As soon as the following year, in major art shows socialist realist paintings made room for works that experimented with abstraction.

The presence of former surrealists and other pre–World War II literary and artistic figures placed in high positions of culture, most notably Miroslav Krleža in Zagreb and Marko Ristić in Belgrade, established strong and sustained institutional support for an idea of art that was much broader

than the "official art" in the Soviet Union and countries under its influence. In Yugoslavia, this alternative idea of art never completely replaced socialist realism. Instead, the two perspectives were forced into an uneasy coexistence in which art practice was free of socialist realist aesthetic constraints, while art institutions remained organized according to principles established immediately after World War II. Beginning in the early 1950s, art in Yugoslavia followed two tracks that existed side by side: individualistic art and art that celebrated socialism, manifested, for example, in the simultaneous production of films exploring the dark side of Yugoslav society and World War II spectacles, of experimental literature and works celebrating the communist guerilla struggle, and of plays inspired by a heroic past and festivals of cutting-edge experimental theater from around the world. In the early 1960s, literary critic Sveta Lukić recognized the mechanisms of this regulated permissiveness, which he described as "socialist aestheticism." According to Lukić, Yugoslav critics and writers were already engaged in an active critique of socialist realist literature in the early 1950s, years before their colleagues in Poland and leftist writers in France and other Western European countries. The rejection of vulgar politicization of art as one of the main tenets of socialist realism led to the negation of *any* political content in literary works. As Lukić observed, "Yugoslav literary critics stressed that art has no ulterior, nonartistic functions; it does not serve interior, momentary needs and interests." As a result,

> The very neutrality of many contemporary works led me to conclude that aestheticism created works which suit out bureaucracy even though they need not like them. If we were to develop a social analysis further we would find that such art in fact expresses the essence of this kind of bureaucracy. Socialist aestheticism has thus functioned negatively as a program for a politically loyal, neutral, aestheticizing, literature which lacks a larger public. Its positive justification lies in the fact that it has produced some works of merit. ([1968] 1972:175)

As with literature, so with visual arts. Art historian Lazar Trifunović, an early advocate of Art Informel, expanded Lukić's analysis to painting, asserting that "aestheticism was 'modern' enough to appease the general complex of 'openness toward the world,' traditional enough ... to appease the new bourgeois taste nurtured by social conformism, and inert enough to fit into the myth of the happy and unique community; it had everything that was necessary to blend into the politically projected image of society"

(1990:124). The positive justification, we may add, of this approach to visual arts was that Yugoslavia was the first socialist country after World War II to get a museum of modern art, the Museum of Contemporary Art (Muzej savremene umetnosti) in Belgrade, dedicated exclusively to collecting and exhibiting twentieth-century abstract and nonrealist art.[15] While the formal properties of socialist realism disappeared from painting, literature, and other arts, socialist realism as a political economy was never completely eliminated or replaced by a different organizational and funding model. Because of that, the arts in Yugoslavia suffered from a split between their phenomenal appearance and their functional support in the same way in which Yugoslav self-management endured irreconcilable contradictions between industrial democracy and political autocracy.

Over the course of four decades, Yugoslavian leadership failed to establish a functioning political economy of self-management. In fact, Yugoslavia's entire history followed a path of incomplete, erratic, uneven, ambiguous, and ceaseless disintegration of the political economy of socialist realism. From its inception in the early 1950s, self-management was the main mechanism of Yugoslavia's transition from a "totalitarian" to a "liberal" society. One of the common methodological mistakes in scholarly works about the second Yugoslavia is to lump its economic history under the general designation of "self-management" without any regard for the changes this socioeconomic order underwent over the decades. So an outline of the main periods of Yugoslav self-management is in order, especially as this book takes its general structure from this periodization. For the sake of clarity, the history of Yugoslav self-management can be divided into three distinct periods.

The first phase (1949–63) began with the "Instructions for the Formation and Operation of Workers' Councils in State Industrial Enterprises" ("Uputstvo za osnivanje i rad radničkih saveta državnih privrednih preduzeća"), which the Yugoslav federal government issued in December 1949. By the next summer the government had already formed workers' councils in a select number of factories. In June 1950, the federal parliament adopted the Basic Law on the Management of State Economic Enterprises by Workers' Collectives (Osnovni zakon o upravljanju državnim privrednim preduzećima i višim privrednim udruženjima od strane radnih kolektiva). This initial phase of self-management, which was codified in the constitution of 1953, was marked by attempts to depart from a Soviet-model command economy, established during the period of Yugoslavia's close affiliation with the USSR (1945–48). While there were significant steps made toward decentralizing the economy, some important functions such

as investment decisions were still controlled by the federal government and its ministries. During this period Yugoslavia joined international economic markets and, beginning in 1953, enjoyed spectacular industrial growth: in 1953 the rate of industrial production went up by 111%; in 1954, by 126%; in 1955, 147%; and in 1956, 162% (Bilandžić and Tonković 1974:51). At this point, it was one of the fastest-growing economies in the world.

The second period (1963–74) was inaugurated with another new constitution, followed by massive economic reform two years later. This was preceded by a slump in growth in the second half of the 1950s, and it comes as no surprise that the authorities proclaimed the reinvigoration of the economy as the main goal of this reform. With the 1963 constitution, the last vestiges of centralized economic planning were rescinded, including the regulation of prices and income. This amounted to the introduction of market socialism, and both the good and the bad sides of a market economy were evident almost immediately. Industrial growth rose (aided, in part, by the country's reorientation from heavy to consumer industries), but so did spending and inflation. During this time Yugoslavia experienced a noticeable growth in its workforce; unemployment was remedied in the short term by further liberalization of travel and arrangements with Western European nations that regulated the export of laborers. Two important outcomes of the 1963 constitution and the subsequent 1965 economic reforms were the expansion of self-management to all spheres of work, including service industries, and the limitation of the League of Communists' influence on decision-making in factories and other business enterprises. In short, it was a period of liberalization in all spheres of economic and social life in Yugoslavia. This was particularly evident in open discussions of economic and political inequality, which had their most public expression in workers' strikes, in the student rebellion of June 1968, and in the mass national movement in Croatia in 1971–72.

The third period was 1974–89. The last sweeping organizational overhaul of Yugoslav society started with the constitutional amendments of 1971, which initiated an increase of federalism in Yugoslavia by giving more sovereign rights to the constitutive republics. It became a common point of nationalist historiography (especially in Serbia) to blame this new structure of federalism, the most important feature of which was the near-sovereign status of the autonomous regions of Kosovo and Vojvodina, for the disintegration of Yugoslavia. Ethnic strife during the 1990s occluded the fact that the constitution of 1974 introduced much deeper changes to the concept of self-management than it did to federalism. On the most basic level, the constitution changed the very status of labor by replacing self-

management with a new legal term: "associated labor" (*udruženi rad*).[16] Following this fundamental change, the basic organizational unit of labor was no longer a factory or an enterprise, but a Basic Organization of Associated Labor (Osnovna organizacija udruženog rada, or OOUR). The aim was to transform the political economy of the country: for instance, accumulation was now renamed "past labor" (*minuli rad*), and all profit was termed "income" (*dohodak*). A new delegate system was introduced into the system of political representation, which was both territory and production based. Relationships between OOURs were regulated through a complex system of contracts, a permutation of self-management that was commonly referred to as a "contractual economy." This system was codified in the Associated Labor Law (Zakon o udruženom radu), which was implemented soon after the constitution, in 1976. Even the drafters of the system of associated labor—its conceptual mastermind Edvard Kardelj among them—admitted that it had many glitches and was a work in progress. This awkward structure proved utterly incapable of withstanding the loss of Kardelj, its founder, and Josip Broz Tito, its charismatic leader (in 1979 and 1980, respectfully), a leadership vacuum that was compounded by the 1982 debt crisis. The undoing of Yugoslavia over the course of this decade was in great part tied to the implosion of the system of associated labor. In this book I argue that associated labor was a deeply conservative turn away from self-management, and that this devolution led to the bloody unraveling of the country. To put it in a more straightforward way, associated labor was a strategy for defeating integral self-management. In order to underline this ideological distinction, in the third chapter of the book I use "associated labor" to designate Yugoslav self-management in its last, decadent, phase. So while *autogestion*, self-management, and associated labor are related terms, they are by no means interchangeable.

At the center of *Alienation Effects* is the "planetary" event of 1968. In France, students and workers demanded *autogestion* as a viable alternative to capitalism; in Yugoslavia, students called for the consistent implementation of self-management, which an accumulation of hypocrisies threatened to turn into an ideological chimera. They called it *integral self-management*. In both cases, they found what they were asking for, if not in a revolutionary transformation of entire society, then in forms of collectivity that emerged spontaneously through their immanent political action. In the case of integral self-management, a collective effort is facilitated through solidarity and inspiration instead of through hierarchy and command. I found exemplary instances of integral self-management in situations I witnessed in antigovernment demonstrations that shook in Belgrade at the

outset of the Yugoslav wars of the 1990s; I saw young students picking up brooms to sweep the Hall of Heroes (Sala heroja), the largest auditorium at the School of Philology, after mass teach-ins during a fifty-day strike at Belgrade University in May and June 1992, in which faculty and students demanded President Slobodan Milošević's resignation; at one point during the same marathon strike, hundreds of protest marchers who faced off with riot police in a narrow street in front of the president's villa, instantly and with no command or coordination removed their shirts, taking the police by surprise with this sudden exposure of their vulnerability and making them reluctant to use batons on naked flesh. When I spoke of this episode to an old *soixante-huitard*, he retorted that the same strategy emerged spontaneously among protesters *back in the day*: it worked well until "somewhere in Italy" the police came up with a counterstrategy of using red-colored liquid in their water cannons: the sight of bare skin covered with "blood" made students panic and disperse. This particular instance of subversion and appropriation epitomizes the afterlife of political movements that emerged from 1968 in Yugoslavia and elsewhere, which was marked as much by co-option as it was by repression. At the same time, it left the important legacy of integral self-management that survived attempts to outlaw or codify self-management. It is a tangible manifestation of an intuition for social justice that survives until the present.

ALIENATION

If periodization of self-management reads like a legal history of Yugoslavia, it is because it was precisely that.[17] Not a single alteration to this ongoing experiment was initiated from "below," by organized workers. However, Yugoslavia's liberalization by executive order created room for vigorous ideological negotiations outside of political institutions, which were firmly in the hands of the League of Communists of Yugoslavia. In many of these debates, alienation emerged as a central issue.[18] Why alienation and not, say, freedom of speech and of political association? A short answer could be that the foundational ideological premise of the second Yugoslavia was that, in general, socialism is a more advanced sociopolitical order than capitalism, and in particular, that a single-party system is a better solution for Yugoslavia than a multiparty parliamentary democracy, which failed miserably in the interwar period and which the new leadership routinely blamed for the country's bloody demise in World War II. Still, any answer to the question about the importance of the theory of

alienation for Yugoslav self-management is incomplete if we don't take into consideration its centrality for the emancipatory politics in socialist Yugoslavia: to begin with, it refers to the emancipation of the working classes, and then by extension, to emancipation of Yugoslavia from a doctrinarian and vulgar understanding of this emancipation, ossified in the Stalinist Marxist doctrines of "diamat" (dialectical materialism) and "histmat" (historical materialism).

The first scholarly works on alienation in Yugoslavia coincided with the publication of Croatian translation of Marx's *Early Writings* in 1953. In Yugoslavia as elsewhere, the publication of *Early Writings* not only provided scholars with an insight into Marx's intellectual development and range, but also opened a whole new dimension of Marx's thought. Unlike the first generation of Marxists, who based their theoretical writings and political doctrines on Marx's mature writings on the economy, primarily *Capital*, and on Friedrich Engels's late works (such as *Anti-Dühring*), the second generation of Marxists, such as Ernst Bloch, Georg Lukács, and Antonio Gramsci, to name some, was informed by Marx's more philosophical reflections from his early works, some of which were published between the 1910s and 1930s. His critique of Hegel's notion of alienation gave them the tools to depart from the dogmatic Marxism that dominated Communist parties in the USSR and across Europe, while still remaining close to Marx.

In "Economic and Philosophical Manuscripts" of 1844, Marx takes labor as the primary model of alienation:

> The product of labour is labour embodied and made material in an object, it is the *objectification* of labour. The realization of labour is its objectification. In the sphere of political economy this realization of labour appears as a *loss of reality* for the worker, objectification as *loss of and bondage to the object*, and appropriation as *estrangement*, as alienation [*Entäusserung*]. (Marx 1975:324)

As many commentators have pointed out, *Entäusserung* is the concept that Marx takes over from Hegel, who uses it to designate externalization or objectification of certain human qualities. Along with this Hegelian term, Marx also introduces *Entfremdung* to describe that which is foreign:

> But estrangement [*Entfremdung*] manifests itself not only in the result, but also in the *act of production*, within the *activity of production* itself. How could the product of the worker's activity confront him as something alien if it were not for the fact that in the act of produc-

tion he was estranging himself from himself? After all, the product is simply the résumé of the activity, of the production. So if the product of labour is alienation, production itself must be active alienation, the alienation of activity, the activity of alienation. The estrangement of the object of labour merely summarizes the estrangement, the alienation in the activity of labour itself. (326)

In other words, labor is a figure of alienation that becomes a hallmark of all production of life under industrial capitalism: "Man, who has realized that in law, politics, etc., he leads an alienated life, leads his true human life in this alienated life as such. Self-affirmation, self-confirmation in *contradiction* with itself and with the knowledge and the nature of the object is therefore true *knowledge* and true *life*" (393). This generalization of the concept of alienation enabled the second generation of Marxists to expand it from labor and private property to other spheres of life under capitalism, from law, to politics, to commerce, to art.

Here, of course, of special interest is the work of Bertolt Brecht because of the central importance that *Verfremdung*, a concept similar, but not identical, to Marx's *Entfremdung*, has in his theater. Brecht recognized the *Verfremdungseffekt* in Shakespeare as well as in traditional Chinese theater, and to him this indicated that the strategy of making strange was inherent to theater as a medium. In *Short Organon* he wrote that whereas "the old V-effects completely remove what is being represented from the spectator's intervention, turning it into something unalterable," "the new kinds of *Verfremdung*" he started exploring in the late 1920s "were supposed to remove only from those incidents that can be influenced socially the stamp of familiarity that protects them against intervention today" ([1949] 2015:242). In Walter Benjamin's interpretation of the term, performance "uncovers [social] conditions" by "*making them strange (verfremden)*" (Benjamin 1973:18). This was one of the first attempts at a linguistic clarification of Brecht's central theoretical term. In a short article, "Alienation According to Marx and According to Brecht," published almost three decades later, Yugoslav dramaturg and theater director Hugo Klajn focused on the prefixes that Marx and Brecht attach to the word *fremden*, pointing out that *ent-* commonly designates "separation and distancing," while the prefix *ver-* "indicates, among other things, a transformation." Therefore, Klajn suggests that in his discussions of *Entfremdung* Marx emphasizes "a condition or a quality that results from an action" such as "alienation of labor or commodity," and Brecht employs *Verfremdung* to designate "a process, or the very performance of an action" such as "actor's estrangement" (Klajn

1966:n.p.). Brecht became a major force in post–World War II theater in both Western and Eastern Europe through his work with the Berliner Ensemble in East Berlin and their triumphant excursions to Paris and London. His impact on the cultural scene in Yugoslavia was indirect but no less significant. While a string of Brecht's plays were performed in theaters across Yugoslavia, starting with the 1947 production of *Señora Carrar's Rifles* (*Die Gewehre der Frau Carrar*) in Zagreb, much less visible but certainly more influential was the adoption of Brechtian ideas through the work of his prewar associate Oto Bihalji-Merin, who in the aftermath of World War II exerted a quiet but significant influence on cultural politics in Yugoslavia. After Yugoslavia's breakup with the Soviet Union, which resulted, among other things, in the dethroning of socialist realist "style," especially in painting, in the late 1940s, Bihalji-Merin was one of the backers of socialist aestheticism. On the one hand, Brecht's expansive notion of realism, with which Bihalji-Merin became acquainted in the early 1930s in Berlin, offered a valid alternative to socialist realism. On the other hand, it opened avenues of exchange between aesthetics and politics that went beyond theater proper to inform a wide range of artistic activities. This displacement of alienation from the proletarian class to culture in general was characteristic of the third generation of Marxists that in the aftermath of World War II mounted a critique of production relations that had advanced beyond the conditions of nineteenth-century industrial capitalism.

Herbert Marcuse was certainly one of the most influential theoreticians of alienation from this generation. In his writings from the 1950s he used Freudian concepts such as repression and the superego to provide a psychological underpinning for his Marxian analysis of alienation: "The reality principle asserts itself through a shrinking of the conscious ego in a significant direction: the autonomous development of the instincts is frozen, and their pattern is fixed at the childhood level" (Marcuse 1955:33). He claimed that this automatization of somatic behaviors comes directly from autorepression. The most common form of this repressive system is labor, which in the industrialized world becomes inseparable from productivity and efficiency. If, as Marcuse says, the "reality principle sustains the organism in the external world," then the "*performance principle* [is] the prevailing historical form of the *reality principle*" within the structure of industrial capitalism (35). The performance principle is an extension of the Marxian analysis of alienation beyond the crude labor relations of nineteenth-century industrial capitalism. In advanced industrial societies, the subject of intense commodification is no longer what Marx called "actual labor" but the "capacity to work," or in other words, the totality of a "laborer's

life" (Marx 1971, 36). Capitalism latches onto a wide and diverse range of "work" available to each individual. It extends beyond labor time to include periods of rest and enjoyment. The reality principle structures not only "labor power," but also libidinal energies, which it "represses" into normative forms of sexuality. In this way, Marcuse extends the notion of alienation from labor relations to all social relations an individual establishes within a capitalist society. Consequently, he argued that the path toward disalienation passes through an enlightened regression of sorts. "With the emergence of a non-repressive reality principle, with the abolition of the surplus-repression necessitated by the performance principle," the processes of the "division of labor" in "societal relations" and "the taboo on the reification of the body" in "libidinal relations" would be reoriented and loosened (1955:201). Western readers might find it surprising that in the 1960s Marcuse sought practical affirmation of his critique of industrial capitalism not in Californian counterculture but in Yugoslav self-management.

In Yugoslavia, the theory of alienation enabled nondoctrinaire philosophers to offer a Marxist critique of a society that embraced Marxism as its main ideological principle. This local variant of "humanist Marxism" close to critical theory offered the most viable critique of diamat in Yugoslavia. Veselin Golubović writes in his book *With Marx against Stalin: Yugoslav Philosophical Critique of Stalinism, 1950–1960* (*S Marxom protiv Staljina: Jugoslovenska filozofska kritika staljinizma 1950–1960*) that there were two distinct lines of critique of Stalinist Marxism that emerged in Yugoslavia in the aftermath of 1948: one line was "dogmatic and declarative," while the other was creative, humanistic, and inherently Marxist. The first never departed from the schematics of diamat, while the other found its inspiration and source of legitimization in Marx's early writings. The point of distinction between these two currents of philosophical Marxism in Yugoslavia is best reflected in their attitudes toward alienation: whereas the first denied the importance and even existence of theory of alienation in Marx's mature works (in this, it was strikingly similar to Soviet Marxists whom it formally rejected), the other used alienation as one of the foundational moments in the establishment of an elaborate and diverse brand of critical theory. Moreover, the "humanist Marxists" used the notion of alienation in their critique of Stalinism in philosophy, which they denounced as "self-alienated Marxism" (Golubović 1985:44). Throughout the 1950s, the vast majority of theoretical statements on the subject of alienation came from the circle of young philosophers and sociologists from Zagreb, who were joined by their colleagues from Belgrade and Sarajevo. They dislodged dia-

mat as the dominant form of Marxism in Yugoslavia at Bled Congress in 1960, and a few years later they established the Korčula Summer School on an island off the Croatian coast and the journal *Praxis*, published by the Society of Philosophers of Croatia and edited by a group of philosophers from Zagreb University. Very quickly, the summer school and the journal gained prominence in professional circles both in Yugoslavia and abroad. Marcuse and Lefebvre participated in the first summer school session in 1964; Marcuse and many other foreign guests kept coming back and published regularly in *Praxis*, which quickly became one of the most prestigious Marxist scholarly journals in Europe. Respect for the so-called Praxis group, a loosely organized group of mostly like-minded philosophers from across Yugoslavia, quickly spread beyond European philosophical circles. As soon as 1964, Erich Fromm organized in New York a symposium on socialist humanism, and a year later he published with Doubleday an edited volume featuring papers from the symposium (Fromm 1965). Alongside other prominent philosophers such as Herbert Marcuse, Lucien Goldmann, and Bertrand Russell, the symposium and the volume featured a strong lineup of Yugoslav Praxis philosophers: Gajo Petrović, Rudi Supek, Predrag Vranicki, Veljko Korać, Mihailo Marković, and Danilo Pejović. Another confirmation of the esteem that Yugoslav philosophers marshaled among their Western colleagues came only a couple of years later, when Paul Edwards invited Gajo Petrović to contribute an entry on alienation to the eight-volume *Encyclopedia of Philosophy*.[19]

Since the *Praxis* group was philosophically closest to the Frankfurt School, this approach was the most prominent among Yugoslav philosophers. However, this interpretation of alienation was by no means exclusive and without alternatives. During the 1960s, there were several competing concepts of alienation vying for dominance on the left. Apart from the Frankfurt School's historical interpretation of alienation, equally influential was Jean-Paul Sartre's existentialist formulation of this concept. The reception of Sartre in Yugoslavia was in great part determined by vicissitudes of his political itinerary in the early years of the Cold War: for example, while in his 1950 book *Existentialism and Decadence* (*Egzistencijalizam i dekadencija*) Rudi Supek criticizes him for his adherence to the ideas of Friedrich Nietzsche and Martin Heidegger, only a few years later Boris Ziherl in a similarly titled *On Existentialism and Other Contemporary Phenomena of Ideological Decadence* (*O egzistencijalizmu i drugim savremenim pojavama idejne dekadencije*, 1955) admonishes him for his support for the USSR in the early 1950s.[20] As both Sartre's and Yugoslavia's positions with respect to the USSR changed during the course of the decade, the French

philosopher's books were translated and his plays performed.[21] In what later became recognizable as a well-established practice of policing its own theoretical terrain, in its first issue *Praxis* published a long article on Sartre. In the beginning of his article Danilo Pejović, one of the journal's founders, offered a defense of Sartre from his orthodox Marxist critics in Yugoslavia, only to conclude with a scathing critique from the position of critical theory: "For now, he is an existentialist who wants to be a Marxist, too. Is that impossible? Isn't there Marxism and 'Marxism': the Marxism of the early Lukács, Adorno, and Marcuse, and the 'Marxism' of Stalinist and post-Stalinist sycophants across the world who don't know much, so that the less they have to say, the noisier they get." Therefore, "Sartre's philosophy of existentialism is a typically French variant of radical nihilism, in which everything appears as a self-obliteration of Nothing: I am nothing, the other is nothing" (Pejović 1964:80). In the end, what Heidegger called "nihilation" emerges as a uniquely existentialist form of alienation, which Sartre memorably captured in his play *No Exit* (*Huis Clos*): Hell is other people.

This strong reaction to Sartre on the pages of *Praxis* speaks to the increasing presence of Sartrean existentialism in Yugoslav culture, from literature to theater to visual arts. Nor is it accidental that in his condemnation of distortions of Marxism, Pejović rushed to invoke Stalinist politicians and their poltroons among scholars. While from the very beginning it was clear that the intellectual edge was on the side of "Marxist humanists" gathered around *Praxis*, that did not mean that orthodox Marxism was swept from the philosophical and political scene in Yugoslavia. In fact, even in the heyday of the Praxis group in the late 1960s and early 1970s, their brand of revisionist Marxism was prevented from spreading though philosophy departments and from entering the League of Communists' ideological interpretation of Marxism. Even as the theory of alienation entered high school textbooks, the mainstream of ideologized Marxism in Yugoslavia remained rigid in its espousal of some orthodox Leninist views, such as that of the role of the Party in the struggle against alienation. Croatian philosopher Mislav Kukoč points out that the Party and Praxis Marxism coexisted, in part, because they both espoused the program of disalienation. While it is out of question that they approached the problem of alienation from different perspectives, they shared what Kukoč called the "utopian character" of disalienation (1988:619). According to him, traces of the religious background of the idea of alienation survives in all variants of Marxism, which casts the overcoming of alienation as its historical horizon, or translated into religious terms, as the *eschaton* (1985:652). Another common thread between

the official and revisionist Marxism in Yugoslavia was the belief that Yugo-
slav self-management offers proof that the process of disalienation can be
initiated even within historical conditions of deep alienation.[22]

Far from being unique for Yugoslavia, the dissipation of the theory of
alienation started in the United States and Europe even as critical theory
was reaching its peak in the 1960s. In the United States, this process was
taking place through expansion of the idea of alienation and its transfer
from philosophy to psychology and its gradual pathologization. In France,
the theory of alienation was subjected to vigorous critique in philosophical
debates on the left during the late 1960s and 1970s. The critics of alienation
often pointed out the not only religious but plainly theological origins of
this concept.

> Paul wrote of the incarnation that Christ "was utterly crushed by
> taking on a servile image"' (Philippians 2:6–7); ékénôsén, says the
> Greek, rendered by the Vulgate as *exinanivit*, "drained away, worn
> out." It is through Luther, who translated: *"hat sich selbst geeussert"*
> ("Jesus was taken outside himself") that Hegel receives this nihilist
> tradition, and will transmit it to Marx and the politicians under the
> name of alienation. ([1974] 1993:71)

This is Jean-François Lyotard in *Libidinal Economy*, having already attacked
Louis Althusser for his critique of alienation only to radically change his
position in the years leading up to *Postmodern Condition*.[23] Lefebvre was
much more consistent, and his charge against Althusser in the immediate
aftermath of 1968 was based, among other things, on Althusser's dismissal
of alienation. To Lefebvre, this was especially "paradoxical" because in the
May events this concept fulfilled its "critical" role of "debunking" neocapi-
talism and exposing its exploitative and rigidly hierarchical nature (Lefeb-
vre 1971:379). It is not surprising that the Praxis group leveled these very
charges against Althusser, and it kept him sidelined in Yugoslavia through-
out the 1960s. His work entered Yugoslav Marxism in the aftermath of 1968
and became an important source for "Ljubljana school" of psychoanalytic
Marxism in the late 1970s. An important first step in this return of the re-
pressed was Slavoj Žižek's critique of critical theory and, by extension, of
Praxis philosophers, which was the first Marxist critique of their work that
didn't come from the positions of doctrinaire diamat. While moving in step
with the development in leftist thought in the West, this exhaustion of
"Marxist humanism" in Yugoslavia was inseparable from the era of "post-
1968" and the emergence of the discourse of postmodernity.[24]

Continuing with the critique of the theory of alienation he started in *Libidinal Economy*, in *Postmodern Condition* Lyotard uses the very same examples as Lefebvre, this time not to attack or defend Althusser on the subject of alienation, but to depart from the concept altogether. In his discussion of the "nature of the social bond," Lyotard comes up with the idea of a universal balance of "etatism," according to which in both the capitalist West and the socialist East the state emerged as a ultimate victor out of the turmoil of the 1960s. It succeeded not by using the force that was at its disposal, but through the system of co-optation of the same critical discourse (of alienation) that Lefebvre lauded a few years earlier: "Everywhere, the Critique of political economy (the subtitle of Marx's *Capital*) and its correlate, the critique of alienated society, are used in one way or another as aids in programming the system" ([1979] 2003:13).[25] The "system" Lyotard invokes comes from Talcott Parsons's idea of society as a self-regulating system, which had, according to the French philosopher, won out against the Marxist conception of a society divided in a perpetual class struggle. "The true goal of the system," writes Lyotard, "the reason why it programs itself like a computer, is the optimization of the global relationship between input and output—in other words, performativity" (11). That is to say, if the "grand narrative" of revolution has lost its "credibility" through the disappearance of the revolutionary subject, this loss can be traced in the emergence of the new grand narrative of performativity. Taking into consideration Lyotard's argument about postmodernism as a historical limit of the critique of alienation, we can say that *Alienation Effects* is an investigation of the theoretical no-man's land between performance principle and performativity.

To sum up, the general reevaluation of alienation in the French theory of the 1970s, especially in its encounters with psychoanalysis, resulted first in the removal of the negative value judgment that Marx assigned to it in his *Early Writings*. This changed view of alienation is perhaps best exemplified in one of Lyotard's last statements, his interview for the French television show *La Cinquième*, which was aired only a few days after his death in April 1998. The transcript was subsequently published in the journal *Chimères* and entitled, simply, "L'aliénation." In this braided discussion of philosophical, linguistic, and psychological aspects of alienation, Lyotard questions the narrowing of this phenomenon offered by traditional Marxism:

> This alienation, is it good? Is it bad? It can be detestable. It can drive us crazy, make us rightly alienated, broken down. How do we say it in French? "Timbré." The English say cracked: "fêlé." It can also make us passionate. We could, for example, start to write or to paint

or to direct movies, for the sole reason of trying to voice this thing that inhabits us from the beginning and that alienates us, hoping to empower (to disalienate) ourselves, all the while knowing that we will not succeed, that, in this case, this thing knows more about us than we know about ourselves. (136)

Alienation is not an affliction; not even a condition. It is constitutive of the subject, and because of that we, the modern subjects, are responsible to that which is the other and the alien:

This other lives in us . . . it is not something that exists outside of us. Maybe this other is good, maybe it is mean—we will figure this out, but nobody wants to find out. This other is very difficult to manage, maybe even impossible, but it makes us custodians of the alienated [aliénés]. It turns out that they are not alienated pure and simple, as if a different species, but that we can access the madness they are suffering from, because we suffer from the same craziness. This anomaly is not something reserved to this mean other. (137)[26]

Lyotard's choice of words—aliéné, the insane—points to a particular practitioner of alienation whose experience became fundamental to artistic investigations of the late twentieth century. But this is not mere pathologization of a Marxist term and its depoliticization. The case in point is Antonin Artaud, and his deployment of this term is more complex than Lyotard indicates. We find it in the phrase aliéné authentique of his late writings:

And what is an aliéné authentique?[27]
It is a man who preferred to become mad, in the socially accepted sense of the word, rather than to forfeit a certain superior idea of human honor. . . .
For a madman is also a man whom society did not want to hear and whom it wanted to prevent from uttering certain intolerable truths. (Artaud 1976:485)

While in Artaud's assaults on the psychiatric establishment aliéné is commonly understood in its conventional sense of "insane" or "mad," it is important to keep in mind the Marxian sense of alienation as inauthenticity. Artaud's aliéné authentique disrupts the easy logic of the orthodox readings of Marx, according to which alienation eliminates authenticity and, conversely, authenticity does away with alienation. In this passage between

languages, Artaud's phrase captures the insight that performance revealed in the late twentieth century, after the romance about art as an inherently disalienating force has been dispelled: the foreign and the strange (the alien) as authentic only insofar as it is inassimilable into social mechanisms of appropriation.

PERFORMANCE

Considering the wide dissemination and diversity of alienation discourses in the aftermath of World War II, it comes as a surprise to see how little attention—save for overlaps with Brecht scholarship—this idea has received in performance studies. It may seem self-evident that the ways in which a society conceptualizes labor are inseparable from representational uses of human bodies. However, it is far less obvious if we recall that performance studies as an academic field formulated most of its basic premises at the historical juncture of capitalism's passage from the industrial to the so-called postindustrial stage. This shift was marked by the massive reorganization of bodily behaviors, from their social arrangements, to employment and labor, to public perceptions of sexuality. If a work of art carries an ideological stamp of the society within which it was produced, so does a scholarly discipline. Whereas initially the span of the performance studies "broad spectrum" approach covered a fairly narrow distance from theater to anthropology, in the new millennium it has expanded ever so slightly to include nonaesthetic performances, primarily through Jon McKenzie's recovery of Herbert Marcuse as one of the unacknowledged predecessors of the field. As McKenzie correctly recognized, "performance" had to be a good guy in the story of late capitalism, a transformative and emancipatory force opposed to industrial society: in short, a principle of disalienation directly opposed to the repressive and numbing "reality principle" of industrial capitalism. Marcuse posits that if for Freud, Thanatos is that which lurks beyond the pleasure principle, then beyond the performance principle is a "resexualized body," which he names Eros.

If Marcuse's theorization of performance was strikingly absent from the discourse of performance studies in its formative years, that may be because this discourse took as an unspoken and uninterrogated starting point Marcuse's premise of the affective labor of Eros as a recuperative force opposed to the oppressive reality principle. Consider Richard Schechner's texts from the late 1960s, such as "In Warm Blood: 'The Bacchae,'" which he concludes by asserting that "the state cannot recover its youthful virility,"

while "the young, blond, effeminate god offers nothing but his politics of ecstasy" (1969:107); and, following up in an essay named after the political program of this divinity: "Underneath whatever repressive machinery civilization constructs to keep itself intact, a counterforce of great unifying, celebratory, sexual, and life-giving power continues to exert its overwhelming and joyful influence" (217).[28] *Alienation Effects* does not follow the "young god's" trajectory into a promised land of an extraideological "life force": precisely the opposite—it points to this assumed *outside* as a zone under most intense ideological pressure.

Following up on the "performance turn" in post–World War II art (from happenings to body art and beyond), theories of management, and technological revolution, McKenzie argues that the paradigm of performance goes beyond the limits of art and the humanistic sciences. He asserts that in the second half of the twentieth century the term "performance" was "radically reinscribed, reinstalled, and redeployed in uncanny and powerful ways." This period saw a "rapid extension of performance concepts into formalized systems of discourses and practices," which McKenzie groups into aesthetic, managerial, and technological (2001:13). He claims that this is not just a semantic issue: in this dispersal across discourses, performance departs from human behaviors to include a whole range of phenomena related to efficiency. Categories and measurements of productivity no longer pertain to individuals and groups, but to systems, technologies, and social apparatuses. A coercive relation to labor is an inherent part of the scientific management of Frederick Winslow Taylor and his followers, while "inspired" labor belongs to what McKenzie calls "performance management." The latter displaces "the rational control of workers by empowering them to improve efficiency using their own intuition, creativity, and diversity" (2001:63).[29] By shifting the status of performance from a "principle" to a "paradigm" McKenzie strips from it the negative valence that undergirds Marcuse's critique of alienation and turns it into a value-neutral category at the very center of postindustrial societies: "Performance will be to the twentieth and twenty-first centuries what discipline was to the eighteen and nineteenth, that is an onto-historical formation of power and knowledge" (18). This transfer of performance from a "principle," as a law discerned through analysis, to a "paradigm," as a foundational design, presupposes, counterintuitively, a shift from general political theories to the specificity of embodied behavior as a basis of any collectivity. In other words, it spells out the end of ideology.

Managerial production of "inspired" labor is also at the center of Luc Boltanski and Ève Chiapello's influential *The New Spirit of Capitalism*, in

which these French sociologists argue that in the 1970s, capitalism rein-
vented itself by adopting elements from critiques leveled against it during
previous decades, including demands for *autogestion*. They assign these
critiques to two broad categories: social critique, which comes from labor
movements, and which focused on "the egoism of private interests in bour-
geois society and the growing poverty of the popular classes in a society of
unprecedented wealth"; and artistic critique, originating from that broad
and ambiguous swath of capitalist society usually described as "bohemia,"
which "foregrounds the loss of meaning and, in particular, the loss of the
sense of what is beautiful and valuable, which derives from standardiza-
tion and general commodification, affecting not only everyday objects but
also artworks . . . and human beings" ([1999] 2005:38). Here, as in many
other analyses of late capitalism, 1968 figures as a watershed year in West-
ern societies' relationship to their accumulated internal contradictions.
Boltanski and Chiapello offer that, responding to massive workers' move-
ments of the 1960s in France, the "employer class" used the bait-and-switch
technique of experienced salesmen. In response to demands for equality
and autonomy, it offered the ideals of informality, creativity, networking,
and flexibility; in other words, it used experience-centered solutions of-
fered by "artistic critiques" to answer demands posed by "social critiques."
The emergence of a system of post-Taylorist business enterprise in industri-
alized societies coincides with the rise of service industries and the specific
forms of labor prevalent among them. This comes down to the very organi-
zation of the workplace: "Given that what matters most is *intangible, impal-
pable, informal*—a term that characterizes both *relations* and the *rules of the
game*, which are invented as one goes along—the most appropriate organi-
zational mechanisms are thus likewise interpersonal," observe Boltanski
and Chiapello (118). As a result, the "third spirit of capitalism" sees itself as
a kingdom of disalienation, in which there is an individual answer to every
systemic problem.[30]

If in the late 1960s performance had a double valence vis-à-vis alien-
ation as both its cause (performance principle) and its cure (politics of ec-
stasy, informality), it seems that over the ensuing three decades this bipo-
larity withered away. When it reemerged in the 1990s, performance was a
gallery practice that offered, as Nicolas Bourriaud writes, "more or less
tangible models of sociability" ([1998] 2002:25). What he calls "relational
aesthetics" is situated precisely in the fundamental difference between so-
ciety and sociability: whereas the first requires systematic, the second is
satisfied with partial solutions; the former is oriented toward development,
the latter toward growth. And the oppositions mount: in place of regula-

tion the second places informality, and in place of politics, relationships and so on. Speaking about differences between art of the 1960s and 1990s, Bourriaud sketches an image of joyful capitulation: "Social utopias and revolutionary hopes have given way to everyday micro-utopias and imitative strategies, [and] any stance that is 'directly' critical of the society is futile, if based on the illusion of a marginality that is nowadays impossible, not to say regressive" (31).[31] It seems as if, over the arc of the twentieth century, the hope for the performance of disalienation has undergone an infinite fragmentation: from the general defeat of capitalist exploitation, to the possibility of disalienated individuals in a society of alienation, to isolated instants of disalienation in an otherwise alienated life. This brings us back to socially engaged art from the beginning of this introduction.

In Yugoslavia, the social and conceptual frame of performance was constituted in a historical, cultural, political, and ideological context that differed in many ways from those in the United States and Western Europe, and had its own complex, layered, and ever-changing structure. That does not mean that it was an endemic model with no applicability beyond its own narrow historical and geographical boundaries. Although in many ways alternative art in 1970s Yugoslavia resembles the social turn of the 2000s (and its predecessors), it significantly differs from them precisely because the latter is an exception to the general climate of the society and its attitudes toward art in the post-1989 era (especially in the United States, but also in the UK and continental Europe). Self-management as the main principle of performance in the broad sense in Yugoslavia becomes an irreplaceable methodological tool for discerning the distinction between works in different social contexts. Formal properties of artwork offer no guarantee of their ideological content: on the contrary, they can be directly opposed to it. In *Alienation Effects* I tried to attend to these distinctions, which are not always discernible at first sight.

The first survey exhibit of conceptual and performance art in Yugoslavia, *New Art Practice, 1966–1978* (*Nova umjetnička praksa 1966–1978*), which art historian Marijan Susovski organized in the Contemporary Art Gallery (Galerija suvremene umjetnosti) in Zagreb, recognized this engagement with social environment as a common thread of young artists and groups across the country. In his introduction to the exhibition catalog (which at the same time served as the first exhaustive anthology of survey articles and artists' statements of this kind in Yugoslavia) Susovski insisted that it was not just the engagement with new media, but precisely the leftist orientation and "critical art production" that distinguished the work of this "generation of artists who were . . . born, raised, and began their artistic practice under

new social conditions" of socialist self-management (Susovski 1978:3). Following this exhibit, "new art practice" became a common denominator for the alternative art that started emerging in youth cultural centers in the late 1960s, and, catalyzed by the youth movement of 1968, adopted more radical and socially engaged form in the early 1970s. Unlike other instances of "global conceptualism" that gained prominence in the wake of 1968, in the case of Yugoslavia "new art practice" represented not only a new approach to art making, but also a new form of organization within state-supported art institutions. I am here referring specifically to conceptual art produced in Belgrade's Student Cultural Center (Studenski kulturni centar, or SKC) and at their annual art festivals, April Meeting (Aprilski Susreti) and October (Oktobar), as well as at other similar institutions throughout Yugoslavia, such as the Student Center (Studentski centar, SC) in Zagreb, Student Cultural Center (Študentski kulturni centar, ŠKUC) in Ljubljana, and Youth Tribune (Tribina mladih) in Novi Sad. In Belgrade, conceptual art practice reached its most radical form in *Oktobar 75*, an artistic "action" that directly addressed the status of labor and art in Yugoslavia by renouncing the conventional practice of exhibiting "artworks" (even if they are conceptual and/or ephemeral) and replacing them with highly politicized discourse: a series of artists' statements on the politics of artistic practice in Yugoslavia. As it were, the phrase that became prominent some three decades later appears in comments that the curator of this art event, Dunja Blažević, made in the aftermath of *Oktobar 75*. According to her, the goal of this action was to "establish a more objective standard in relation to the valorization of art as a sphere of *social work*" (1976:n.p.; emphasis added). Conceptual artists, art critics, and curators did not conjure up the idea of "social work" (*društveni rad*) out of thin air, but borrowed it directly from the theoretical arsenal of socialist self-management.

In *Alienation Effects* I engage performance that occurred under a specific form of political economy that proclaimed an ambition to overcome the division between productive and unproductive, industrial and aesthetic labor. This political economy is inseparable from a performance culture that is contemporaneous with the one all too familiar in the West, but at the same time significantly different from it. Unlike scientific and performance management, self-management was not only a concrete set of organizational principles of industrial and nonindustrial labor, but also a vehicle for the political, ideological, and even aesthetic representation of labor. Under self-management, performance is not a free-floating paradigm, but a practice that ties together a variety of human actions that are always specific and never free of ideology. In this book I am arguing for a multiplicity of performance

histories and the specificity that comes with it. Since the end of the Cold War, the "opening" of Eastern Europe has brought a wholesale approach to its recent past, especially when it comes to avant-garde and experimental art. These revisionist histories have pushed Yugoslav post–World War II art into the Eastern European "camp" without giving any consideration to its position vis-à-vis its own social, political, and cultural setting.[32] I am not saying that performance and other art forms are overdetermined by their political and social context; however, abstracting them from this milieu brings a certain leveling of the field that only serves art industries and their profits. This equalization is based on formalist analysis and its obsession with periodization and lines of influence. Performance is particularly vulnerable to the shortcomings of this kind of approach. In a work that is primarily concerned with performance, specificity means, first and foremost, the emancipation of performance from its status as an aesthetic object or aesthetic "fact." What "fact" does to conventional history, form does to performance history: it brings self-evidence to historical analysis, which then proceeds through analogies. In order to be seen and described, performance needs to break free from this imperative of form and similarity.[33]

This is by no means an attempt to reanimate performance and restore it to its original condition, which is to say, to "liberate" it from the ossification by the art industry. In short, the goal of *Alienation Effects* is not to disalienate performance. This brings me back to the initial statement in this section about the status of alienation in performance studies and Brecht scholarship. Even at the points of intersection between them, for all the talk about *Verfremdungseffekt* (V-effekt, A-effect), scholars' attention remains fixed on *verfremden*, while the effect remains a self-explanatory add-on. That leaves utterly unclear the role of effects in relation to performance. It seems that *Verfremdung* and *effect* speak differently about performance. One can "make strange" an object or an action consisting of things and bodies, while "effects" are detached from them and belong to a different species. This is, in fact, how Gilles Deleuze speaks of effects: if bodies with their physical properties (actions, passions, etc.) are engaged in causal relationships, they cause an entirely different species of things. "These *effects* are not bodies, but, properly speaking, 'incorporeal' events. They are not physical qualities and properties, but rather logical or dialectical attributes. They are not things or facts, but events" ([1969] 1990:4). Both sense and nonsense belong to the order of these incorporeal entities:

> Sense is always an *effect*. It is not an effect merely in the causal sense; it is also an effect in the sense of the "optical effect" or a "sound ef-

fect," or, even better, a surface effect, a position effect, and a language effect. Such an effect is not at all an appearance or an illusion. It is a product that spreads out over, or extends itself the length of the surface; it is strictly co-present to, and coextensive with, its own cause, and determines this cause as an imminent cause, inseparable from its effects, pure *nihil* or *x*, outside of the effects themselves. (70)

Deleuze adds that these kinds of effects "have usually been designated by a proper or a singular name" such as "Kelvin effect" and "Seebeck effect" in science, or in medicine diseases named after doctors who first described the set of symptoms (70). The proper name Brecht designates singles out one effect of alienation and certainly doesn't encompass a great variety of *effects* that emerged in performance practices in the course of the late twentieth century. It seems that we have to settle for alienation effects without the proper name attached to it, while keeping in mind that we are talking about a range of effects that are, to use Deleuze's locution, "copresent" and "coextensive" with their own causes. Insofar as they "determine them as imminent," they know these causes in a way that is inherent and unique to the process of causation. In that sense, self-management knows alienation in a way that no other social order does. Starting from Marxist alienation, it reveals its multiplicity; in its encounter with psychoanalysis, it shows its constitutive nature for subject formation and removes subject formation from value judgment. In short, taking effects into account does not lead to restoration of performances or their interpretation, but to their eventalization.

This book is not a survey of performance in Yugoslavia, but an evental analysis of several significant intersections of different kinds of performances. While it is my basic assumption that the second Yugoslavia was a common cultural space, I am focusing on several urban centers that became fertile ground for experimental art and performance, primarily Belgrade, Zagreb, and Ljubljana. And even here, my goal is not an exhaustive inventory of performance and the conceptual art scenes from which it emerged. For example, while I talk about the great Art Informel artist from Zagreb Ivo Gattin, I don't follow his line of influence in Belgrade (Mića Popović and his circle) or that of the equally great sculptor Olga Jevrić; similarly, I dwell on the very beginning of alternative theater in Yugoslavia by looking at the first production of *Waiting for Godot* in Belgrade, but I don't look at other independent theater groups such as KPGT in Belgrade or Kugla glumište in Zagreb.[34] I investigate festivals of new art organized in Belgrade in the 1970s such as April Meeting and Oktobar but not other festivals in Belgrade (BITEF) and elsewhere (Eurokaz in Zagreb, Yugoslav

Documenta in Sarajevo). Nor do I want to present the artists I am talking about as previously unknown and "repressed" artists from the socialist East: there is a solid bibliography in English on virtually all performance and conceptual artists I am talking about. The practice of publishing catalogs bilingually (local language and English) started in Yugoslavia as early as the catalog for *New Art Practice* and continued with monographs on artists I am discussing in this book, such as Raša Todosijević, Era Milivojević, Marina Abramović, Mladen Stilinović, and Irwin. In addition, artists and art historians from Yugoslavia collaborated regularly with their peers from the West and published regularly abroad; some of them, such as Jasna Tijardović, Zoran Popović, and Goran Đorđević, are in this book. Others, such as Braco Dimitrijević, Nena Dimitrijević, Vlasta Delimar, Sanja Iveković, Bálint Szombathy, Gergelj Urkom, Neša Paripović, Tomaž Šalamun, David Nez, Janez Janša, and many others I do not discuss in detail (or not at all) simply in order to avoid listing and enumeration at the expense of analysis.

In its general design, this book follows a decade-by-decade periodization of self-management in Yugoslavia: here the 1950s are marked by departures from the Soviet model of the economy and of art, which resulted in a push toward a socialist market economy and integral self-management in the 1960s. The 1970s were marked by a definitive breach between ideological discourse and labor performance, and in the 1980s macroeconomic performance marginalized and "deregulated" labor, which eventually led to obliteration of the worker as a political subject. What is important here is not to identify exact historical boundaries between periods and in doing so reinforce them, but to recognize their *instability*: a period is defined not only by the calendar and objects that happen to be produced within a certain time segment, but also through institutions that come to support forms of artistic production for which they were not initially intended (socialist realism in providing institutional structure would support socialist aestheticism; socialist aestheticism would back conceptual art). This provisional periodization comes from an approach to the history of the second Yugoslavia that is geological, not chronological, which enables one to recognize the synchronization of different strata contained within each of its "periods."[35]

Even though live art is the main focus of *Alienation Effects*, because of the specific social organization of Yugoslavia, it plays an important part in the country's political economy, and accordingly it is inseparable from other segments of society. So the first chapter, "Bodywriting" covers not only the period of a planned economy, but the difficult transition from command to market socialism, and the permutations of the planned economy that were

incorporated into self-management. Chapter 2, "Syntactical Performances," focuses on the emergence of plural visions of self-management in the public sphere. The final chapter, "Disalienation Defects," examines the predicament of Yugoslav self-management in the late 1970s and 1980s, which set up its long and bloody dénouement in the 1990s. While recognizing the need for a much broader critical reassessment of the legacy of the so-called postmodernisms of the 1980s, I use this opportunity to look at postmodernism's role in the Yugoslav crisis. Each of these historical strata called for a different methodology. In the first chapter, in which I analyze relatively distant historical events, I have relied exclusively on archival material. In the second, concerned with more recent history, I combined archival research with interviews with participants and witnesses of performances I am discussing. And in the final chapter I often relied on memories of my own experiences. I organized each chapter around two kinds of performances, which can be described as small and large scale. In the first chapter, the microperformance is a clandestine 1954 performance of *Waiting for Godot*, which I take as a model of proto-performance art in the former Yugoslavia. It was staged only once, and for a small audience of not more than forty spectators. I juxtapose it with the mass celebrations of Youth Day that strove to mobilize the entire population. In the second chapter, the performance of large magnitude is the student revolt at Belgrade University in June 1968. This watershed moment of Yugoslav self-management in the late 1960s had many manifestations, and the uprising at Belgrade University was just one of them, perhaps the most visible. One of the outcomes of this crisis was a spate of performance art pieces that were staged in Belgrade's Student Cultural Center in the aftermath of "June."[36] In the third chapter, "microperformances" consist of gestures that, intentionally or not, often went unnoticed in the greater public sphere, which becomes increasingly dominated by a macroeconomics that left no space or time for reflection and critique. In the final analysis, all of these permutations of performance—on both grand and minute scales—chart the crisis of the political subject that marked all stages of Yugoslavia's turbulent history.

I wrote this book in Silicon Valley, the new capital of abstract labor. It is my hope *Alienation Effects* will put at least a small *effet*, as French soccer players say when they kick the ball with a spin, on the enormous intellectual effort that is happening around me. It is also my hope that *this* story about the demise of Yugoslavia is not just a cautionary tale, and that it can invite reconsiderations of alienation, performance, and self-management even in the least likely of places.

PERFORMANCE STATE

On the front page of its weekend issue for February 28–March 1, 1987, the Sarajevo daily *Oslobođenje* published in big, bold letters the headline "The Serpent Egg of New Collectivism." An additional line above the headline conveyed the editors' dismay—"Is even this possible!"—and the blurb below explained what the hubbub was all about: "The creation of Ljubljana's NK, approved as the official poster for Youth Relay, is a copy of a Nazi poster" (Idrizović 1987:1). Thus broke one of the greatest in the series of scandals that shook Yugoslavia in its waning years. The article continued on the fifth page of the journal, and in it the author, Nagorka Idrizović, explained that the poster was a replica of Richard Klein's Nazi propaganda image used in 1936 Olympic Games and published in A. J. P. Taylor's book *From Sarajevo to Potsdam* (1966). In the rest of the article, the author spared no vitriol against its authors, the group New Collectivism, which was a part of the alternative art association Neue Slowenische Kunst, active in Yugoslavia's northern republic of Slovenia since 1984.[1] The incredulity of "Is even this possible!" addressed as much the audacity of the artists as it did the lack of vigilance on the part of the selection committee that approved the poster for the largest state-sponsored spectacle in Yugoslavia. To make the embarrassment even worse, the incriminated poster had been published on the front pages of Yugoslav dailies (including *Oslobođenje*) two days earlier, on Thursday, February 26, following the session of the Federal Committee for the Celebration of Youth Day, held the previous day. According to news reports, arguments in this long and to all accounts uncomfortable meeting did not even touch on the poster based on Nazi propaganda, but on another poster for the local celebration in Slovenia. The representative of Yugoslav armed forces, Colonel Radivoj Cvijanović, objected that the poster, which featured several unrelated elements including the ruins of a Hellenic temple, had only local Slovene and European, while eschewing Yugoslav and socialist, symbols (Tomović 1987:1).[2] The authors

were asked to revise the "local" poster, while no one objected to the poster that was aimed for use around the country. Once the scandal broke, the critics attacked New Collectivism for identifying the Yugoslav brand of socialism with Nazism. In their defense, New Collectivism claimed that they were using the legitimate postmodern technique of retro-avant-gardism. Commenting on the scandal, Roman Uranjek, a member of New Collectivism, remarked that "social-realistic Nazi art or any other ideological art is all the same" (qtd. in Leposavić 2005:174). The implication is that they all fall within a broad category of totalitarian art.

In making this statement, Uranjek was simply following a well-established tradition in the scholarship on European mass cultures of the early twentieth century. By the late 1980s, it had almost become a scholarly instinct to compare, identify, and find common aesthetic and organizational strategies between the mass festivities organized by movements on opposite sides of the ideological spectrum. For example, in his work on the *Thingspiel*, a mass theater form favored by the Nazis between 1933 and 1937, Hennig Eichberg calls for the examination of the "unacknowledged predecessors" of Thingspiel in communist mass theater events of the 1920s, as well as for a comparative study of the national-socialist and leftist festival plays of the Weimar Republic (Eichberg 1977:137, 138). Personal aesthetic affinities that attracted artists from one ideological extreme to works representative of another extreme, such as those of the Italians Gaetano Ciocca and Telesio Interlandi, supporters and advocates of Mussolini's fascism who admired the mass appeal of Bolshevik culture, could lead even a sensitive scholar like Jeffrey Schnapp to call attention to the commonalities in experiments with mass theater not only within the Left and Right in the Weimar Republic, or between the Third Reich and fascist Italy, but also between these right-wing regimes and the Soviet Union (Schnapp 1994:83). These comparisons are prompted not just by structural and formal similarities, but by the pronounced agonistic nature of both rightist and leftist mass spectacles.

Youth Day had its origins in the first mass celebration established in the socialist Yugoslavia. As early as April 1945, while the final push for the liberation of the northwestern parts of the country from the Nazi invaders was still in progress, the Central Committee of the Antifascist Youth of Yugoslavia (Centralni komitet Antifašističke omladine Jugoslavije) asked its local organizations to join a nationwide relay run as a way of celebrating Marshall Tito's birthday.[3] A memo sent to all cells of the Antifascist Youth of Yugoslavia announced that "as Comrade Tito's fifty-third birthday is approaching," this organization's "Department of Sports and Physical Culture

will organize mass youth relay races across Yugoslavia. Young runners will carry nicely crafted batons and in them written birthday cards to our Marshall, and in that way they will bring to Belgrade the good wishes of the people who will greet them along the way" (in Stanimirović 1981:27). Tito's birthday celebration was a track-and-field relay race. In fact, the sources of this form of celebration suggest that New Collectivism's poster was more spot-on than the young designers might have imagined. According to a participant in the first relay race, Ljubica Stanimirović, the Antifascist Youth Organization in the central Serbian town of Kragujevac, which organized the first Tito's Relay, found its inspiration for the *štafeta* in "revived memories of that day in 1936 when at dusk the torch from Mount Olympus arrived in Kragujevac . . . on its path to the Munich Olympics.[4] For many years since then, generations of young pupils have run through streets and courtyards, practicing the handing of the baton" (1981:22). The race almost immediately took on the name Tito's Relay Race, or *Titova štafeta*, which, in fact, pointed back to the etymological roots of *štafeta* in the Italian word *staffetta* and the French *estaffette*, designating the courier or the one bringing news (Kastratović-Ristić 2008:23). Because this event involved masses of people, in Yugoslavia the word *štafeta* quickly came to symbolize not only the baton relay, but also the elaborate system of symbolic displays, sports events, and celebrations that accompanied it. Tito's Relay Race quickly outgrew the form of a linear run suggested by its name (and its origin in track and field) and evolved into a vast network of races. A number of schools, factories, and local municipalities organized their own *štafetas*, which joined together into regional *štafetas*, and regional *štafetas* merged to form *štafetas* of the republics. In addition, a number of countrywide organizations had their own *štafetas*: from the association of the communist partisan veterans of World War II, to associations of cyclists, mountaineers, radio amateurs, and firefighters, to name a few. Last but not least, the Yugoslav People's Army had several *štafetas*, since each of its branches had its own. In the end, the map of the relay runs and celebrations that accompanied the passage of runners through villages, schools, towns, army barracks, factories, impassable mountaintops, and riverbeds resembled a capillary system that joined the entire country into an interconnected organism.

During the first two decades of the *štafeta* tradition, Tito received thousands of batons from all parts of the country. As the ethnologist Ivan Čolović points out, the meaning of this network of relay running was not only in the direct, hand-to-hand communication between the masses of citizens and the country's leader, but also the confirmation of his legitimacy as the undisputed ruler (in Leposavić 2005:141). This kind of legitimi-

zation was necessary in the immediate post–World War II period, when the former communist guerilla's grip on power was still weak. As time passed, the meaning of this mass performance changed to accommodate the country's ideological transformations.

Some 12,500 runners participated in the first relay race in liberated Yugoslavia. The countrywide trail ended in a mass meeting in Slavija, one of the main Belgrade city squares, from which Tito himself was absent. He was in Zagreb, so the final leg of the baton's journey was made in an airplane. By the following year, there was a protocol in place, according to which the arrival of Tito's Baton (*Titova štafeta*) in the capital of Yugoslavia was celebrated in one of the main city squares, usually the Square of the Republic, after which it was handed to the president in a special ceremony arranged at his residence in the White Palace (*Beli dvor*). From the inception of this tradition, which was by far the largest mass celebration in post–World War II Yugoslavia, devotion to Tito was measured by the number of bodies and the distance traveled: in 1950, 93,000 km and over a million runners; in 1951, 128,000 km and 1.5 million runners. The largest relay run was organized in 1952, when some 1,555,000 runners covered over 130,000 km. In the early 1960s, the format of the relay was changed, and the multitude of small local batons was replaced by the single Youth Baton. As Čolović observed, putting an end to the vast capillary system that had connected the entire country through local races coincided with the emergence of another, more efficient and ubiquitous network, that of television (145). The daily televised updates on the progress of the Youth Baton culminated in a live broadcast of the final mass performance. Still, this didn't reduce the symbolic significance of a performance of this magnitude, which each year, for a few weeks, turned Yugoslavia into a veritable performance state.

In 1953, the year the new constitution set the legal foundations of Yugoslav self-management, the sports society "Partizan" organized a performance of en masse street exercises on the occasion of the arrival of Tito's Baton in Belgrade. Beginning that year, the huge stadium performance became a regular practice, with not only the central mass celebration, but also many local "salutes" to Tito's Baton organized along its long route throughout Yugoslavia. In 1956, for the first time, the arrival of Tito's Baton in Belgrade was celebrated with a mass spectacle held in the stadium of the Yugoslav People's Army. On that occasion, Tito suggested that instead of celebrating his birthday, May 25 should be declared the official Youth Day. He symbolically handed the baton back to the youth, and they responded the following year by starting the relay run from his birthplace, the village of Kumrovec in Croatia. With this symbolic exchange, time—that is to say,

history—began to seep into the geopolitics of the body that was the Youth Relay: every year, the starting point of the run was chosen for its symbolic place in the history of the Yugoslav revolution or for its relevance to the politics of the day. In other words, the *štafeta* became the means not only of celebration, but also of commemoration and education. It not only organized the diverse cultural and ethnic spaces of Yugoslavia into one homogenous body, but also symbolically inscribed history in its geographical space, and pointed the direction toward the future.

Great care was taken so that each year the relay race would begin from a different republic, and from a starting point that held a significant symbolic meaning. So, for example, in 1963, the *štafeta* departed from the central Bosnian town of Jajce to commemorate the twentieth anniversary of the Second National Antifascist Liberation Council of Yugoslavia (Antifašističko veće narodnog oslobođenja Jugoslavije, AVNOJ), in which delegates from all parts of the country laid the foundation for the socialist and federal Yugoslavia. The following year, it started from Skopje, the capital of the Republic of Macedonia, a gesture expressing the nation's solidarity with the city reeling from a devastating earthquake the previous year. Among other things, the Youth Relay, as it had been called since 1957, was a celebration of labor. It usually started in mid- to late April, so that the ritual of running coincided with May 1, International Labor Day, which was one of the major state holidays in Yugoslavia. The two holidays merged into a prolonged ceremony that had the festival of labor as one of its main components. It culminated on or right before 25 May in a number of activities that ranged from sports events (the final match of the soccer cup, or Tito's Cup, as it was called, was held at that time, as well as of other sports competitions) to cultural and educational activities. In 1968, the Youth Festival of Labor was for the first time organized in the city of Zrenjanin in the northern Serbian province of Vojvodina. That same year, the Youth Relay had begun its long journey from the camp of Voluntary Youth Work Brigades at Đerdap, the construction site of a dam on the river Danube.

A great economic reform had been initiated in 1965, and that was the first year on record since World War II without any major, or "central" as they were called, youth work actions. Over the following two years, none of the major construction sites around the country used any voluntary labor. But after that, they started coming back, having been adjusted to the new socialist market economy. One of the best examples of this changed nature of Youth Work Actions was New Belgrade, which was suspended soon after it was initiated in 1948. In 1968, on its twentieth anniversary, the tradition was revived in "Youth Work Action New Belgrade '68," albeit on completely

different principles than youth work actions from the period of reconstruction and industrialization. Momčilo Stefanović, the chronicler of this youth work action, writes that in "New Belgrade '68," the tradition of volunteer labor was adapted to economic reforms, and as a result, for the first time ever a youth work action was set up using the principles of an enterprise in socialist market economy. He explains that the Youth Work Brigade won the contract for untrained labor that was offered by the communal direction for the development of New Belgrade. The enterprise "New Belgrade '68" was charging 10 dinars per hour of labor, which was 2.5 dinars below what for-profit construction companies were charging (Stefanović 1969:56). If the purpose of socialist realism as an aesthetic system was to support and improve labor efficiency through its aestheticization, then by joining self-management and market socialism, volunteer labor in Yugoslavia also entered the sphere of socialist aestheticism. This, in turn, called for the new aestheticization of labor. In order to understand this new aestheticization of labor, we need to look at the one that preceded it.

CHOREOGRAPHY OF LABOR

"Socialist society restores the face to a human being," a face that is a "mirror and an incarnation of inner thoughts and feelings." A shock worker's eyes "glow with mature resolution mixed with childish enthusiasm." His voice rings:

Labor sings from men's eyes, from their faces.
Like a mighty river sings emancipated labor.
Like a meadow, forest, garden with birdsong
With song of labor our city sings.

Workers' backs are "tanned with the sun" and "hands reach for a shovel or pickax or any other tool." In their bare legs "muscles swell with tension." Steel mill workers, "naked from the waist up, with tight muscles, bony and steely solid, tirelessly move their strong arms" to feed ore into a blast furnace. Seen in a silhouette against the scorching spectacle of melting steel, their bodies are "sweaty and smeared with soot," but they are "indefatigably bright and joyous."

From this textual montage of fragments taken from literary and journalistic texts published in Yugoslavia during the first few years after World War II, a composite image of a strong laboring body emerges.[5] It is never

alone. Individual bodies come together to form a labor brigade: "bony Mijo Jozić, powerful Jevrem Lukić, resilient Muslija Alispahić, tireless Stanko Lazić" (Burina 1949:3). In this collective labor, each body overcomes its own limitations and joins together to form a vast toiling configuration: a body joins another body; hand joins hand, until, as the poet Desanka Maksimović put it, "Hundreds of thousands / of young hands . . . cut a road into a mountain's chest" (1947:14). Through all of this digging, drilling, breaking, pushing, and lifting, steely and earthy bodies humanize the landscape and turn it into a vast organism. The tracks of the Šamac-Sarajevo railroad, which 60,000 youths built from April to November 1947, are "two steel veins that reach the horizon" (Đonović 1948:96). In his report from the same construction site, Marin Franičević also uses the metaphor of the bloodstream to anthropomorphize the industrial countryside, describing the railroad as an "important artery in our five-year plan" (1947:576). He emphasizes that what goes on at work sites across the country is not just the development of industry, but also the fashioning of the "new man, who already has been sketched in during the years of the war for liberation, and who is taking shape, developing, and growing everywhere, especially on railroad construction sites" (1947:576).

Public sculpture was the most appropriate medium for displaying the colossal features of this "new man." One of the earliest examples of new art dealing with these contemporary themes was Boris Kalin's *The Hostage* (*Talac*) from 1945. The worker in chains is heavyset. His limbs are strong, made for heavy lifting; his shoulders are broad and his neck thick. The worker's massive feet are firmly planted on the ground, and they provide a solid basis for upward movement: the body stands strong and tall, and it rises from and uplifts the land that war had reduced to rubble. In 1945, Yugoslav authorities submitted a report to the International Reparation Commission in Paris finding that in World War II the country suffered direct material damages valued at $9.1 billion, which was 1.4 times the damages reported by Great Britain and 7.2 times those incurred by the United States (Dobrivojević 2010:104). Even more devastating was the human loss: according to some official reports, over a million Yugoslavs died in World War II; only the Soviet Union and Poland suffered more human casualties. And all of that in a country that was underdeveloped to begin with: according to data for 1939, only 45% of the country's production came from industry, while the rest came from agriculture; in 1940, as much as 86% of money spent on imports was for industrial goods (Majdanac 1981:21).

The officials of the Communist Party of Yugoslavia (Komunistička partija Jugoslavije) saw the country's vast construction sites and newly built or

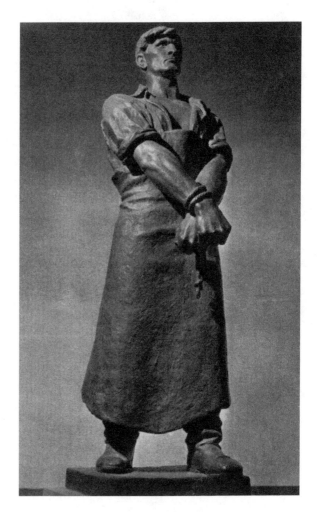

Fig. 1. Boris Kalin:
The Hostage. Bronze,
1945.

repaired factories as a crucible where a whole new class would be forged,
a new political subject without which the socialist state could not survive.
As in many other things, here the CPY followed the Soviet example. Like
Russia, Yugoslavia was a distinctly agrarian state before the revolution;
and unlike in the first socialist state, in Yugoslavia the revolution coincided
with the war for liberation from the Nazi invaders and the puppet regimes
they established on Yugoslav soil.[6] In post–World War II Yugoslavia, as in
postrevolutionary Russia, the Party was engaged not only in rebuilding the
economy, but also in "creating the 'proletarian' subject" as the new domi-
nant class (Dobrenko 2007:150). According to data for 1921 to 1931, peas-

ants accounted for 80% of the Yugoslav population, and only 9% were em-
ployed in industry. In Serbia alone, which was less industrially developed
than Slovenia and parts of Croatia, yet more so than Bosnia-Herzegovina,
Macedonia, and Montenegro, workers employed in handicraft trades out-
numbered industrial workers by more than 3% (41.8% to 38.2%) (Majdanac
1981:16). Evgeny Dobrenko points out that in the Soviet Union, the "nomi-
nation" of the new political subject was at once a political, industrial, orga-
nizational, and discursive operation. Here, arts played a key role. Speaking
of Fedor Gladkov and other leading authors from the Soviet industrializa-
tion period in the 1930s, Soviet critic Alexandr Ianov explained that writers
and party leaders

> were obliged to, in no time at all, fundamentally rework amorphous
> human material into a purposeful structured social body. . . . Over
> the course of the First Five-Year Plan, the numbers of the working
> class grew annually by 21 percent. This meant that in less than one
> five-year period yet another working class arose alongside the old
> one, a new working class equal to the old ones in number! (in Dob-
> renko 2007:166)

Based on the Soviet economic model and prepared with the aid of So-
viet experts, the industrialization of Yugoslavia (the stage that followed
reconstruction in the multiphased development of the economy) was the
central feature of the First Five-Year Plan. The implementation of the plan
itself was prepared in a series of legislative moves, such as the Law on the
Federal Economic Plan and State Planning Bodies (May 1946), the Law on
State Enterprises (July 1946), and the Law on Nationalization (December
1946), which turned all privately owned industries and corporations over
to the state. In addition to nationalizing all businesses and industry, the
government centralized the banking system and began regulating prices at
the end of 1946. The Yugoslav First Five-Year Plan, popularly known as
"Petoljetka," was presented at the Federal People's Assembly (Narodna
skupština) on April 24, 1947, and passed four days later (April 28), for the
period from (retroactively) January 1, 1947, to January 1, 1951. The Law on
the Federal Economic Plan and State Planning Bodies cleared the way for
the establishment of the Federal Planning Commission, which collected
data from all communes and factories about their production capacities
and needs, and used this information to determine production goals or
"norms." The main norms of the first Petoljetka were announced in the in-
troductory section of the text of the Plan Law: "liquidation of economic and

technological backwardness; reinforcement of economic and defensive powers of the nation; further reinforcement and development of the socialist sector of national economy; improvement of workers' well-being in all branches of the economy" (Zakon 1947:6). Although it addressed in minute detail all branches of the economy, the plan privileged heavy (or extensive) industries and investments in underdeveloped regions. So, according to projections set by the plan, the relation between heavy industry and the consumer goods industry, which in 1939 stood at 43:57, by the end of the Five-Year Plan was supposed to be reversed to 57:43. Further, according to the plan, by 1951 the GDP was supposed to reach 193% of what it was in 1939 (Majdanac 1981:39).[7] In another demonstration of the new centralized economy, the government put the Federal Planning Commission in charge of extensive parts of industry, mines, and infrastructure, and the republican and communal planning bodies in charge of consumer goods[8] and other industries that were deemed less vital for the overall development of the economy. One of the biggest impediments to the implementation of this ambitious plan was the lack of labor power. The answer to this problem was a voluntary youth workforce. In all facets of its execution, the plan depended on it. According to some estimates, during the First Five-Year Plan, one million Yugoslav youths worked on some seventy construction sites, contributing approximately 60 million workdays of free labor (Selinić 2007:56).

The Brčko-Banovići railroad was the first massive youth labor action (Omladinska radna akcija), in which 60,000 young men and women built ninety kilometers of tracks from May 1 to November 7, 1946; this was followed in 1947 by the above-mentioned Šamac-Sarajevo railroad. That same year work began on the Brotherhood and Unity highway that was to run from Zagreb to Belgrade. The first laborers arrived at the New Belgrade site in the marshlands on the left bank of the river Sava near Belgrade. By 1948, roughly 49,800 voluntary youth workers were laboring on the construction sites of the new Yugoslav Parliament Building, a hotel nearby, residential buildings, and student dorms (Selinić 2005:89). In short, a whole new city was rising on the sandy expanses across the river from the old Belgrade city center.

As the mission and even the organization of mass labor changed with the shift from reconstruction to industrialization, so did its representations in art. The idea of socialist labor struggling against and overcoming nature, established in Soviet literature and art,[9] was taken over during the period of industrialization by Yugoslav writers and painters in their depiction of railroad and highway construction sites. The socialist city called for a new,

semibiblical theme of the new city as the realization of emancipated labor. In the "Morning" (Jutro) section of his poetic cycle Socialist City (Socijalistički grad) Dragutin Zdunić rhapsodizes,

> Look, a sunlit city stands,
> Clean boulevards and the rustle of many branches,
> Avenues full of flowers lead far away,
> Mighty facades, light wings' noise,
> Shimmering of the sun's dust all around
> Bonds life and lifts it into heights.
> And the poet writes that in apartments of this city of light,
> The room is clean, immeasurably white,
> Like our robes and our bodies.
> There is not a speck, only sun's strings
> Seep through the windows.
>
> (Zdunić 1947:806)

In this ethereal city, bodies are no longer sweaty and soiled, and jaws are not cringing with exertion. Instead, "In thoughts and hearts above the entire city / Song accompanies our hours of work and rest." This labor is elevated from drudgery to dance, and promoted from punishment to pleasure by technology and industry. Here are the opening lines of the section "Factories":

> Bright halls with glass ceilings,
> Factories are as luminous as day. . . .
> Under domes hums a gentle song,
> And you hardly hear a movement, easy buzz.
> That is a machine purring its easy song.
>
> (807)

Whereas in Zdunić's vision of the socialist city labor has been transferred over to machines—a move perfectly in tune with the utopia of the classics of Marxism—in City in Hands (Grad na rukama) Slobodan Marković places physical labor at its very foundation:

> There is no greater happiness than becoming the city's foundation,
> Your youth being embedded in its first laughter.
> I foresee: spacious spring over palaces
> And my eye as it swims with it.

> If I close my eyes in that whitest of days,
> Perhaps I will again swing on a scaffolding,
> In that blue, dear, heavenly bed
> And my sleeves will be all white again
> From lime and sand dearer than pearls,
> Because the city is not just a row of long roofs.
> The city is the faith of my proud republic,
> Branch full of fruit, sprouted from trenches!
>
> (Marković 1949:3)

This emphasis on concrete physical labor literally grounds this city and establishes a clear path toward the realization of a futurist vision. When it comes to visual arts, this reconciliation between the ground and the heights reached by modern buildings, and between the present and the future, was accomplished with unmatched effectiveness in Boža Ilić's painting *Sondage of the Terrain in New Belgrade* (*Sondiranje terena na Novom Beogradu*).[10]

Ilić's painting was shown in December 1948 at the seventh exhibition of ULUS,[11] only months after voluntary work brigades arrived in New Belgrade.[12] Yugoslav art critics instantly proclaimed this painting a major breakthrough of the new, socially conscious art. It was not only this painting's obvious timeliness and topicality that set it apart from other works exhibited at that time, but more than anything else its representation of labor. A full-page color reproduction of Ilić's painting was published on the first page of the first issue of *Umetnost*, the journal ULUS founded in 1949. It was followed by a long article entitled "Ideological Content Gives Wings to Talents" ("Idejnost daje krila talentima") by Jovan Popović, one of the leading advocates of socialist realism in Serbia and Yugoslavia. Without ever explicitly mentioning Ilić and his painting, Popović writes of a need for specificity and ideological clarity in painterly portrayals of scenes from the "battlefields" of reconstruction and industrialization. He complains that too often the authors of these works are content to just highlight factories and machines, even though these structures are ideologically neutral and have the same form and shape in both socialist and capitalist societies. "The most important" components of the Yugoslav postwar economy "are precisely the relationships of workers to industry"; however, complained Popović, "What is usually shown are roughly sketched figures doing primitive work, in helpless poses, with eternal shovels and buckets" (1949:9). Popović's disapproval of "hunched and faceless figures" identifies digging as the paradigmatic gesture of labor in countless paintings and drawings. Voluntary workers were mobilized to perform unskilled work that boiled

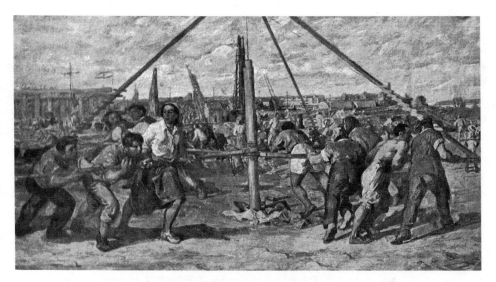

Fig. 2. Boža Ilić: *Sondage of the Terrain in New Belgrade*. Oil on canvas, 1949. Courtesy of Narodni Muzej, Belgrade.

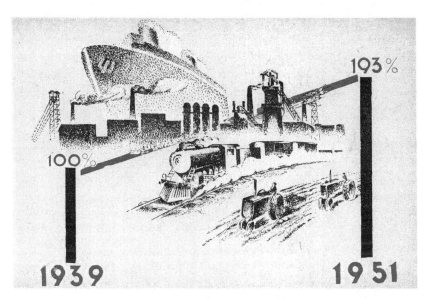

Fig. 3. Five-Year Plan of the Federative People's Republic of Yugoslavia's Development: Projection of the GDP. From the pamphlet The Five Year Plan of the Development of People's Economy in FNRJ from 1947–191. (*Petogodišnji plan*) *razvitka narodne privrede FNRJ u godinama 1947–1951.*

down to a very limited number of operations: striking (with a pickax or hammer), shoveling, and pushing (wagons or wheelbarrows). The performance of these operations demanded gestures that pointed downward, toward the ground, or at best thrusting forward. Even the word *udarnik*, the most coveted title among the ranks of socialist workers (paid or voluntary), referenced a gesture pointing downward: *udarnik* comes from the verb *udariti*, to strike or hit.[13] This wrestling with the earth forced workers away from the heroic poses of labor heroes and toward hunched bodily postures that suggested subordination and suffering.[14] The vector of labor in artistic representations contrasted sharply with diagrammatic schema of the Five-Year Plan, which always pointed upward.

Both in the Soviet Union and in Yugoslavia, replacing the market economy with a planned economy resulted in a shift from the idea of economy as a "science of unintended consequences of human action" to a "science of allocative efficiency" (Rutland 1985:31).[15] The central planning agency was charged with the task of replacing the unpredictability, haphazardness, and injustice of a capitalist market with predictability, rationality, and justice of the grand plan. Here, the *plan* appears almost in its etymological sense: as a blueprint, drawing, a diagram of a new structure, which in this case is not just a building, but the industry and agriculture of a vast economy. Further, in the case of the Five-Year Plan, this regulation of space becomes intrinsically tied with the ordering of time. The plan is also an intention, a proposal, or a set or tasks and prescriptions for the accomplishment of a certain number of goals. Finally, it is important to stress again that in Yugoslavia the first Five-Year Plan had the power of law: any failure to meet the goals was routinely seen as a subversive act.

All of this amounted to a vast scripturalization of the entire economy. The plan prescribed extremely detailed production targets for all industrial branches and the commodities they produced. As Albert Waterston observed in his survey of the Yugoslav first Five-Year Plan, an industrial branch such as the glass industry was divided into sections for "ordinary glass, optical glass, safety glass for autos, fireproof glass, glass containers for medical use, and glass for electric bulbs," each with its own production goals; and further, "the number of telegrams to be sent and the number of telephone calls to be placed was estimated, as were the number of restaurants and number of meals they would serve" (Waterston 1962:10). The diagram is the visual form that brings together all phases of the plan: from its preparation, to setting up the production norms, to its propagation and implementation. Because of that, the diagram is not just a technique for illustrating and visualizing the plan, but the very means of scriptualizing

economic (and every other) performance. In other words, the diagram does not *represent*, it *acts*. John Bender and Michael Marrinan align the diagram functionally with "working objects," which are not "raw nature" or "concepts," "much less conjectures or theories; they are materials from which concepts are formed and to which they are applied" (Bender and Marrinan 2010:33). The unmatched accomplishment of Ilić's painting was not in its depiction, but in the diagrammatization of labor.

The same issue of *Umetnost* that opened with Ilić's *Sondage of the Terrain in New Belgrade* closed with a full-page color reproduction of another instant masterpiece of Yugoslav socialist realism, Đorđe Andrejević Kun's *Witnesses of Horror (Svedoci užasa*, 1948).[16] The placement of these two paintings in the inaugural issue of the journal published by the association of Serbian painters signals a change of generations and of themes in postwar Serbian art. If critics recognized Kun as an artist who set the standard for the visual representation of the People's Liberation Struggle (Narodno-oslibodilačka borba, or NOB) as the first major theme of Yugoslav socialist realism, then Ilić was hailed as a painter who set the paradigm for the visual representation of the second major theme, the country's reconstruction and industrialization. In the first major newspaper article on *Sondage of the Terrain in New Belgrade*, Oto Bihalji-Merin called attention to Ilić's solutions to the problem of representing "work enthusiasm" in painting.[17] Bihalji-Merin writes that Ilić depicts the "rhythm and happiness of collective creation in building our socialist fatherland," while "all figures in the painting are plausibly and truthfully linked in a process of labor" (1949:6). Grgo Gamulin, another prominent advocate of socialist realism, objected, saying that Ilić did not pay enough attention to the detailed depiction of workers' faces. "Despite, or because of that," writes Gamulin, the bodies receive ample emphasis: "Big figures in the foreground are animated by real action taken from contemporary life, and brightly illuminated by daylight." All of this brings forward "individual characteristics that mirror the new humanism of our age" (1949:835). In his programmatic introductory text to the first issue of *Umetnost*, Popović finds the depiction of labor crucial for new socialist painting: "Our man is working, he is working hard, both in big collectives and alone. But what is he doing, and how, what is the meaning of his work, what does he feel, what is he getting from this conscious labor with which he is transforming the nature and himself?" (1949:9). They all seem to be in agreement that *Sondage of the Terrain in New Belgrade* finally offered a solution to the elusive problem of the pictorial depiction of organized labor.

As in other paintings and drawings of construction sites during this

period, workers in *Sondage of the Terrain in New Belgrade* are engaged with the ground, therefore with the very base of all future building. However, in choosing to depict a soil probe, an operation that precedes all other procedures involved in constructing a building, including digging the foundation, Ilić transposed a ground-oriented action into vertical direction. The figure of a young woman in the foreground strictly parallels the drill's axis, and finally offers an image of a worker who does not stoop to penetrate the earth. Here, socialist realist composition finally finds a formula for dignified digging. Further, the pyramidal shape of the probe that dominates the entire composition is also an arrow that points upward. This is the labor that strives upward, and as such it resonates both with the height and the brightness that dominate the poetry of socialist cities and with the ascending arrows in diagrams representing the Five-Year Plan. *Sondage of the Terrain in New Belgrade* is not only a representation of labor, but insofar as it includes a diagram of economic growth, it is an image that performs, or a working object. With his diagrammatic painting, Ilić offered a solution to one of the main problems of socialist realism: the efficacy of the image.

At almost 4.5 by 2.5 meters, this painting is monumental in both its subject and its physical size. The sheer proportions place it in the same category as sculptural works of that period. Here, in a diagrammatic composition, Ilić uses the painting's theme to solve problems of stasis and two-dimensionality inherent in the medium of painting. In choosing to depict the action of pushing a large sondage drill instead of a wagon, he departs from linear movement and replaces it with rotation. This movement gives him an opportunity to present each body working in unison with others, without sacrificing individual traits. Further, because of the circular itinerary, the human body is presented from all sides: the sum of individual motion merges into one moving body. In this way, Ilić's painting can be seen not only as a formal success in overcoming the limitations of the medium by offering a three-dimensional sculptural view of the body in a two-dimensional painting, but, more importantly for critics and patrons of the day, it offers an image of harmonious collective effort. And even beyond that, it provides the "static" and "spatial" medium of panting with a strong temporal dimension. While socialist history has a clear point of fulfillment, a secular parousia of sorts, its calendar is organized cyclically into five-year periods. The vertical axis of the sondage apparatus divides the picture plane in two halves. In each of them, there is a group of three plus two youth laborers, symbolizing the two Five-Year Plans.

Sondage of the Terrain in New Belgrade furnishes not just an image, but an entire choreography of labor that is monumental, dynamic, and charged

with symbolism. Accordingly, it provides an unacknowledged ideal for practical staging of particular mass exercises in Youth Day performances in the years to come. Critics, including Bihalji-Merin, recognized in it the realization of socialist realism's basic tenets. On the one hand, it conforms to the so-called theory of reflection, which Soviet critic Georgi Plekhanov explained with the simple premise that "objective" reality precedes any subjectivity, so that the material reality comes as the first condition of truth. However, it is the task of art not only to reflect the material reality, or objects and nature, but also the social reality that actively transforms nature and produces objects. In his *Unaddressed Letters* Plekhanov states explicitly his firm belief in the existence of a "close causal relationship between art of a people and its economy" (1957:52). This points to labor as another pillar of socialist realism, which Maksim Gorky formulated at the First Congress of Soviet Writers: "For the basic hero of our works we must choose labor, i.e., a person organized by the labor process, who for us is armed with all the might of contemporary technology, a person who in turn makes labor easier and more productive, elevating it to a degree of art" (in Dobrenko 2007:161).

Efficient and impeccable as it is, this labor is not just an extension of performance done by machines. Far from being dehumanized as in capitalism, the experience of labor in a socialist society is informed by high political awareness. In reports from construction sites and factories during the first years of the plan, labor is described not only as collective and organized, but also as frenetic. Workers appear as if possessed in their efforts to meet and surpass goals set by the plan. Literary texts and economic reports are dotted with references to the zeal and energy of working masses. For example, a report from the first year of the plan in Yugoslavia speaks of the workers themselves being surprised with what they were able to accomplish once they were taken over by "shock worker enthusiasm and inspiration" (Filipović 1947:3). However, this is not a St. Vitus dance of labor. This passion for work is kept in check by the high ethical standards of socialist workers. As Antonije Marinković points out in his report from coal mines, published in a literary journal, "In our country, for every workingman, labor became a matter of respect and honor, elevated to the status of a cult. That is one of the most important characteristics of our construction sites. Attitude toward labor became the most important factor in the assessment of every workingman" (1949:1). This integration of efficient organization and zeal for labor leaves room for nothing else. In its schema of labor, monetary remuneration becomes incidental to the results of labor.

In planned economies, socialist competition replaces the race for profits

that drives capitalist market economies. This kind of rivalry does not pit one company against another, worker against his neighbor on the production line, as in capitalism, but entire factories, brigades, and individual workers against all kinds of obstacles: from difficulties posed by nature, to scarcity, to moral vices such as alcoholism. In the Soviet Union, socialist competition emerged during the First Five-Year Plan as an expansion and systematization of the idea of shock work (Siegelbaum 1988:40). Both of these aspects of socialist competition are equally important: "systematization" suggests that surpassing norms and setting records for productivity was impossible with just the sheer physical strength and zeal of the workers, but also required the careful organization of labor. "Expansion" refers to the popularization of shock work and its growth from elite units and individuals to the proletarian masses; and further, it pertains to vast mechanisms for the propagation of socialist values, such as *ideinost'* (ideological content) and *udarnichestvo* (shock work), epitomized in the figure of the hero of socialist work. The first such hero was Alexey Stakhanov, who, in a competition organized by a local Party group at the Central Irmino coal mine (Donbas region in Ukraine), on August 23, 1935, excavated in one shift over 102 tons of coal (Siegelbaum 1988:70). Widely popularized throughout the Soviet Union, Stakhanov's accomplishments gave rise to a shock work movement named after him, Stakhanovism.

By instituting socialist competition as the driving force of the nation's economy, Yugoslav planners emulated the Soviet model. As in the Soviet Union, unions were in charge of organizing competitions, and journalists and writers were assigned the task of describing and immortalizing the triumphs of Stakhanovites and fashioning them into heroes of labor. While *Sondage of the Terrain in New Belgrade* fulfills the tasks of socialist realist art, the political and social context within which it was produced sets it apart from similar works from the Soviet Union. Ilić's painting was produced, exhibited, and celebrated in a charged atmosphere of an escalating conflict between Yugoslavia and the USSR. In some ways, it is positioned at the very center of the watershed political event that in many ways determined Yugoslavia's position during the Cold War. On the one hand, Ilić completed and exhibited the painting as the rift between the two socialist regimes was growing beyond repair. On the other hand, the painting was almost immediately mobilized on this new ideological front. The history of its appearances in Yugoslav window-shop publications provides a telling illustration.

Starting in 1945, Oto Bihalji-Merin edited the journal *Jugoslavija SSSR:*

Časopis društva za kulturnu saradnju Jugoslavije sa SSSR Yugoslavia USSR: (The Journal of the Society for Cultural Cooperation between Yugoslavia and USSR), which served as one of the main channels for import of socialist realism into Yugoslavia, and presentation of Yugoslav accomplishments in this realm to the Soviets. With its large format, glossy cover pages, and ample illustrations (some of them in color), it stood out from among other periodicals published just after World War II period in Yugoslavia. A full-page color reproduction of Ilić's painting *In Bosnian Mountains (Po Bosanskim planinama)* was published in the February–March 1948 issue of *Jugoslavija-SSSR*. Bihalji-Merin might have been more than just a champion of Ilić's work: in June of that year, right about the time when Ilić started working on his monumental painting, *Jugoslavija-SSSR* published a photograph from construction sites in New Belgrade that very much resembles *Sondage of the Terrain in New Belgrade*. It is hard to imagine that the critic and the painter did not share their knowledge of the sondage motif, and it remains unclear who "discovered" it first. Be that as it may, a full-page black-and-white reproduction of *Sondage of the Terrain in New Belgrade* was published in May 1949 issue of this magazine. That was its penultimate issue. The same year, Bihalji-Merin started another similar venture, *Jugoslavija: ilustrovani časopis (Yugoslavia: An Illustrated Magazine)*, even more luxurious than *Jugoslavija SSSR*, and published in Serbo-Croatian, English, and German. A full-page color reproduction of Ilić's painting appeared in the first issue of this magazine, published in the fall of 1949 (p. 87). It was the only painting that was featured in Bihalji-Merin's magazines that presented Yugoslavia to the East and the West, respectively. This publication history expands the motif of *turning* in Ilić's painting to include Yugoslav foreign policy.

In the first two years after the liberation, Yugoslav Communists saw themselves as the most faithful followers of the Soviet model of socialist society. Among other things, the country went further than any other state in the Soviet zone of influence in nationalizing the economy and setting up and implementing its Five-Year Plan. Tito's name was routinely invoked next to Stalin's, as in Antonije Marinković's poem "Facing the Beauty of Our Construction Sites" ("Pred lepotom naših radilišta"):

Only pines and gray rocks are with me in Brač island desert
All alone in the hills, if only there was someone to walk with me.
And while I was yearning for hoe's cling or bird's song
I read the letters "Tito-Stalin" on a roadside cliff

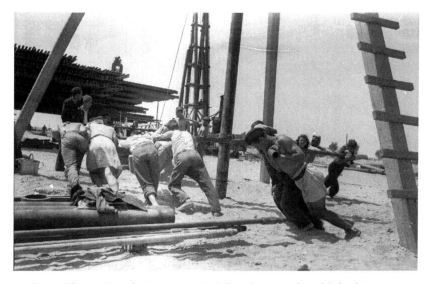

Fig. 4. The caption that accompanied the photograph published in
Jugoslavija-SSSR 32 (June 1948): 8 read: "Young builders bring the new
spirit to every workplace on the construction site." Photograph cour-
tesy Tanjug.

And instantly I became brighter and stronger; sad loneliness was
 gone.
Two good, strong comrades were walking along with me.
(Marinković 1949:4)

In January 1948, the Foreign Relations Department of the USSR's All Union
Communist Party (Vsesoyuznaya Kommunisticheskaya Partiya, or VKP)[18]
issued a report "On the Effects of Decisions Made at the Conference of
Nine Communist Parties about Strengthening the Forces of Democracy and
Socialism in Yugoslavia" ("O vlianii reshenia soveschania predstavitelei
deviati kompartii na ukreplenie sil' demokratii i sotsializma v Iugoslavii")
in which it praised the Communist Party of Yugoslavia for its domestic and
international successes; yet some fifty days later, the same department is-
sued another report under the telling title "On the Anti-Marxist Attitudes
of Communist Party of Yugoslavia Leaders in Internal and Foreign Poli-
cies" ("Ob anti-marksistskikh ustanovkakh rukovoditelei kompartii Iugo-
slavii v vopsroakh vneshnei i vnutrennei politiki," March 18, 1948) that
reflected a complete turnaround in the Soviet attitude toward Yugoslavia
and its leadership (Živanov 1999:24).[19] This was followed in June of that

year by the famous Cominform Resolution, which proclaimed that Yugoslavia had abandoned its Marxist orientation and accused the leaders of Communist Party of Yugoslavia of being Western spies.

The conflict with the Soviet Union was characterized by a traumatic split. Far from being metaphorical, this trauma was played out both on the corporate body through the violent separation of "Cominformists" from the rest of the social body, and on the physical bodies of top Yugoslav leaders.[20] In the early stages of the conflict, the Yugoslav leadership tried to present this falling out as a misunderstanding, but after it became clear that the rift was irreversible, they tried to out-Soviet the Soviets by resorting to Communist orthodoxy in every aspect of social and political life in the country.[21] This included the use of political violence, even to the extent of establishing a prison colony for supporters of the Cominform Resolution on the Goli Otok island in the Adriatic Sea.[22] Confrontation with the USSR had disastrous consequences for the economy: on the one hand, ample Soviet assistance was built into many projections of the First Five-Year Plan; on the other hand, in response to a military threat from the Soviet Union and its allies, Yugoslav authorities shifted the emphasis of civil industries to arms production.

All of this led to massive setbacks in meeting goals set by the plan, which was eventually delayed by one year. In his exposé at the Federal Assembly budget hearings on the Five-Year Plan, held December 26–30, 1948, the president of Yugoslavia, Josip Broz "Tito," offered an explanation for the rift with the Soviet Union and its allies that suited the occasion: according to him, the Soviet Union wanted to maintain Yugoslavia's dependence on the USSR for industrial products, and thus objected to its rapid industrialization. Tito argued that this demonstrated its true imperialist nature (Broz 1949:7). Interestingly, investments in the "social standard" were the very first items in Tito's budget report for 1949. Included at the top of his list were 25% increases for education and culture (5). The chart submitted by Boris Kidrič, the head of the Federal Planning Commission, also prioritized the nonproductive sector, with investments in education and culture topped only by investments in capital industries (Kidrič 1949:102). A few weeks later, the literary journal *Književne novine* published on its cover page Bojan Štih's article "Writers—to the Battlefield of Their Themes" ("Pisci—Na poprište tematike"), in which he urged writers and artists to leave the isolation of their working rooms and studios and turn to laboring men and women as their main subject and source of inspiration: "That is why the writer's path is now, more than ever, leading to people in factories, mines, big construction sites, to all of those places where the main theme of

our literature is being shaped, developed, and woven together: socialist development as its main theme and story, its very source" (Štih 1949:1).

This was no time for subtleties. In the very next paragraph, Štih adds: "The magnitude of this theme in its political and economic aspects was demonstrated in the Federal Assembly's budget hearings at the end of last year." If early in the postwar period Yugoslavia imported socialist realism as a ready-made representational theory and practice, it was only as the confrontation with the Soviet Union was approaching its peak that it came to fully dominate culture. Relegation of considerable funds for culture and education in the 1949 budget and the prompt response from "cultural workers" in fully adopting socialist realism is just one example of its full integration into Yugoslavia's political economy. Here, Dobrenko's call for a methodological distinction between a "political economy of Socialist Realism" and "Socialist Realism itself as a political economy" is crucial (2007:19). Socialist realism is not a style, nor a method of painting and writing, nor even an ideological statement about art's social purpose. Instead, it is fully integrated into the planned economy and one of its key elements. This integration is accomplished not only through its stylistic features and ideological statements, but also through the organization of creative labor in artists' and writers' guilds, the activities of these organizations for the purpose of relaying and promoting political decisions and ideas, and the dissemination of works and their reception to lay and professional audiences. In short, socialist realism demands efficacy from all representational forms. In this, it attempts to fold together productive and nonproductive poles of the performance continuum.

Ilić's *Sondage of the Terrain in New Belgrade* was not perceived as just a representation of the performance of labor, but instead as its inherent part. It was born out of the fervor of socialist competition. By 1949 Yugoslav workers were no longer fighting only the elements, the difficult terrain, old habits, or established production norms, but also the very progenitors of socialist competition. In September 1949, as anti-Titoist propaganda from the Soviet Union and its ally states was entering its most vicious phase, Yugoslav newspapers were filled with articles reporting on feverish contests spreading across the nation like a wildfire. New Belgrade was still the center of attention. Bihalji-Merin's article on Ilić's painting was surrounded by reports of record-breaking efforts by workers, and a few days later, the same daily featured on its front page a comparative list illustrating the superiority of Yugoslav shock workers over Soviet Stakhanovites, and inaugurated its own hero-miner, Alija Sirotanović. The celebration of these record-breaking results was at the same time the proclamation of a quanti-

tative transformation of socialist labor: in Yugoslavia under the siege con-
ditions, the nascent self-management turned socialist competition into a
festival of labor! There could be no higher proof that, unlike in the USSR,
revolution was alive and still going strong in Yugoslavia.[23]

ET IN ILLYRIA EGO . . .

The Party always had to stay one step ahead of its constituency. As news of
record-breaking production was pouring into the editorial offices of Yugo-
slav mass media, the CPY's Politburo was in search of a new model of so-
cialism that would be distinct from Stalin's but still retain the main features
of a socialist political order. In May 1949 the Federal Assembly passed the
Law on People's Committees (Zakon o narodnim odborima), which re-
duced some of the limitations that were imposed on local governments.[24]
In September, Party and union leaders issued "Instructions for the Forma-
tion and Operation of Workers' Councils in State Industrial Enterprises"
("Uputstvo za osnivanje i rad radničkih saveta državnih privrednih
preduzeća"). By the end of the year, federal authorities ordered a small
number of enterprises across the country to elect workers' councils. This
was done without much pomp.[25] By the time the Basic Law on the Manage-
ment of State Economic Enterprises by Workers' Collectives (Osnovni za-
kon o upravljanju državnim privrednim preduzećima i višim privrednim
udruženjima od strane radnih kolektiva) was passed on June 27, 1950, there
were already hundreds of enterprises that had workers' councils in place.
In the first countrywide elections of workers' councils, 975,000 workers
from 6,319 enterprises elected 155,000 members to workers' councils,
which, as one historian of self-management points out, meant that every
sixth worker participated in management (Majdanac 1981:90). This, how-
ever, did not mean that self-management was a fully established practice.
It was rather a first step in the gradual transition from statist to self-
managing socialism.

There are several important aspects to this diffusion of management
and its amalgamation with labor. First is the CPY's need to disidentify with
the Stalinist model for the organization of a socialist state. This imperative
for self-determination was reflected in both the historical and the theoreti-
cal framing of self-management by the CPY. On the one hand, from the
very beginning, Yugoslav authors insisted that self-management was a re-
sult of the Yugoslav working-class struggle for emancipation. It was pre-
sented as a continuation of a trend that started with the founding of the

CPY in the immediate aftermath of World War I, its clandestine activity in interwar Yugoslavia, its leadership in the antifascist struggle during World War II, and finally, its drive for reconstruction and industrialization in the postwar years. All of that notwithstanding, Yugoslav historiography of self-management maintained that, despite all of its shortcomings, the statist and centralist period between the end of the war and the implementation of self-management was necessary for the development of socialism in Yugoslavia. According to this schema, in Yugoslavia, workers' councils emerged from an interaction between Party leadership and spontaneous movements formed within enterprises. Even the choice of the first factory to establish a workers' council is packed with symbolism: its name, Prvoborac, which in Yugoslav languages refers to a guerrilla fighter who joined the resistance in the early days of antifascist struggle, underlines the claim that the earliest forms of socialist self-organization were already established in partisan-controlled territories during the war.[26] Further, the president of the first workers' council, Ante Gabelić, was presented as shining example of the thesis that self-management was a natural extension of shock workers' ethics.[27] In this sense, self-management is both a departure from and a continuation of the populist practices of Soviet leaders, who often elevated common workers above engineers and other technocrats.[28]

The mythology of shock work posits labor not only as a productive activity and mode of organization, but also as a way of knowing. In the early stages of self-management's introduction in Yugoslavia, its propagators emphasized this native empiricism and its aura of authenticity. Conceptually, self-management was portrayed as a "more developed model of socialism that would be closer to Marx's visions" (Vranicki 1975:456). Returning to the basics of Marxist thought was an essential aspect of Yugoslav self-management's imperative to distance itself from Stalinism as a distortion of authentic Marxism. Eric Terzuolo has observed that this negation of Stalinism influenced the choice of works upon which the theoreticians of self-management based their analyses. He sees the emphasis CPY leaders (who included the architects of Yugoslavia's self-management) placed on Lenin's *State and Revolution* as a gesture against Stalin's "psychological fixation" on another important work by Lenin, *What Is to Be Done?* (Terzuolo 1982:210). The choice of sources from classic Marxist literature significantly informed the CPY's framing of the very idea of socialism. Yugoslav party leaders, including the main theoreticians of self-management, read Lenin's call, not only for the "breaking up of old bureaucratic apparatus," but also for taking "measures" against the "transformation of workers and employees into bureaucrats," as a prophetic warning against Stalinist

deviations (Lenin 1932:92). In the same text, Lenin cites Marx's example of the Paris Commune's successful efforts to prevent the bureaucratization of workers (97). Not surprisingly, Yugoslav ideologues nominated Marx's *The Civil War in France*, together with *State and Revolution*, as the most valuable theoretical precursors of Yugoslav self-management (Terzuolo 1982:211). This strong identification with Marx's book on the Paris Commune bespeaks not only the search for historical precedents of self-management in the first socialist revolution, but also the state of siege under which Yugoslav self-management was established.[29]

The second aspect of self-management's move toward labor, just as important as its separation from the Soviet Union and other countries of the socialist bloc, was the process of decentralizing the internal organization of the country. The Basic Law of 1950 introduced sweeping changes that amounted to dismantling the command economy in Yugoslavia. Early that year, along with the first experiments with workers' councils, came a massive reorganization of the economy, which transferred a number of factories and entire industrial branches that were supervised directly by federal institutions to republics (and further, those overseen by republics to communes). This amounted to a significant reduction of rigid compartmentalization of the economy into federal, republican, and local (Majdanac 1981:89). Thus began the process of reducing decision-making powers of federal institutions and their vast bureaucracies: Albert Waterston notes that whereas in 1948 federal ministries had 43,500 employees, by 1955 their number was reduced to 8,000 (1962:28). The First Five-Year Plan was at first delayed and then replaced by the less ambitious Key Investment Program. As the government transferred supervision from the federation to republics and local authorities, the Federal Planning Commission was first reduced in size and then disbanded. By 1952, Yugoslavia had totally abandoned the Soviet model of a command economy and replaced the central plan with "social planning," codified in the Law on Planned Management of the Economy (Zakon o planskom upravljanju privredom). According to this law, the state determined only the general parameters of the economy, and all planning was left to the enterprises themselves. In an effort to distance itself from state power structures, in its Sixth Congress, held in November 1952, the Communist Party of Yugoslavia changed its name to the League of Communists of Yugoslavia or LCY (Savez komunista Jugoslavije).[30] The following year, the Federal Planning Commission officially ceased to exist after its name was changed to the Chief Administration for Planning and its staff reduced from seven hundred to around fifty (Waterston 1962:31).

These organizational changes were accompanied by a transformed structure of ownership. Even though the launching of self-management was marked by ceremonial events—such as the symbolic passing of Jesenice Steelworks' keys to its workers—the newly instituted social ownership of the means of production remained one of the most contested aspects of Yugoslav self-management. For Kardelj, who was the architect of this concept, there was no dilemma: since any ownership relationship is an expression of social relations, socially owned property in Yugoslavia is a "system of institutionalized interpersonal rights and obligations of workers and all other citizens, and not a relation of individuals or collectives toward things or as an ownership monopoly over men" (Kardelj 1977:19). This doesn't even begin to address the problems that emerged, such as the conditions for starting up new firms or accountability for existing ones. Slovene economist Aleksander Bajt explains that ownership over the means of production breaks down into two relatively independent categories: economic and legal ownership. Starting from the principle that economic ownership over property is based on who has control over the goods that property yields, Bajt establishes that in Yugoslavia the means of production belong to workers. He defines self-managing social ownership as that kind of ownership in which "the subject of decision-making about the use of the means of production is identical to the subject of decision-making regarding the products of these means" (Bajt 1988:153). Workers participate in their enterprises not by investing capital, but by investing their labor. Further, they participate in the ownership of this investment and its product through decisions they make. Therefore, self-managing social ownership is inseparable from decision-making. As soon as the process of transforming state into social ownership of the means of production started in the late 1950s, scholars close to the Party line presented it as a powerful disalienation mechanism. For example, in an article published in 1961, sociologist Dragomir Drašković argues for self-management as the "first intentional and organized step toward disalienation." While acknowledging that social ownership does not "abolish alienation" automatically, he insists that it "opens up a new phase in which industrial workers manage the means of production." Therefore, "the state has begun to wither away, and its economic functions . . . are increasingly transferred to production workers." This "initiates the process of economic and political disalienation, which in the current communal system becomes an all-encompassing process of the liberation of labor and creation of a total man" (Drašković 1961:295).[31] This "total man" is no more a man of iron, but a man in a white coat.

After 1950, there was a radical change in the iconography of work in

Yugoslavia. The preferred setting is no longer the outdoors, but factory halls and conference rooms. Workers' bodies are no longer tense and muscular, engaged in record-breaking efforts, but relaxed, cleanly dressed, gathered around machines or conference tables, making decisions about their firms. In short, they are not so much laborers as managers. But this is not all. Bajt explains that legal ownership in Yugoslavia was structured in such a way that the collective was not a full legal owner of the means of production. Legal ownership of social property was regulated through contracts, and in this regulation the state still played a large role.[32] He calls this kind of property "state social ownership." Questions of economic ownership and legal ownership revolve around the question of subject: whereas in the former the subject is always a specific worker, in the latter it is an abstract entity (firm, state); the former does not necessarily translate into the latter, and vice versa.

This opens up one of the least-explored questions of Yugoslav self-management: that of subjectivity—the third aspect of labor's new role in the nation's economy. The paucity of theoretical investigations of this question is all the more daunting since it is precisely on this point that self-management represents the most decisive break with the Stalinist model of socialism. Like their Soviet precursors, Yugoslav authorities used industrialization not only to emancipate, but also to create, a revolutionary subject. From 1945 to 1949, the number of workers in Yugoslavia almost quintupled: in 1945, there were 461,000; the number for 1946 rose to 721,000 (an additional 280,000), and it never stopped climbing: 1947—1,167,000; 1948—1,517,000; and in 1949, on the eve of the transformation to self-management, there were almost 2 million workers in Yugoslavia (Bilandžić and Tonković 1974:19). And this is precisely where the rift within Yugoslav socialist realism (as a political economy) takes place. Dobrenko argues that "ridding labor of all economic content can be considered one of the most significant accomplishments of Stalinism," adding that this operation took place on the level of discourse, that is, of socialist realism: "Ultimately, the effectiveness of the Soviet economy was directly proportional to its beauty" (2007:164). In Yugoslavia, the introduction of self-management was explained as the recognition of material interest as the driving force of workers, and simultaneously as a refutation of socialist realism's aesthetic principles. Whereas Yugoslav authors refrained from going further than stating that under conditions of étatist socialism, the state functioned as a capitalist, which "reduced the producer to the level of the means of production," economist Susan Woodward was much more straightforward in asserting that "budgetary autonomy" represents the "core idea of 'self-management'"

(1995:167). It is asserted at all levels: from the federal institutions (which were "withering away" with each new reform), to republics, to communes, and finally to each individual, who was seen first and foremost as an economic subject guided by her interests and desires. In accord with this economicist interpretation of society, in the early 1950s Yugoslav authorities were already starting to phase out voluntary labor. Considering its low productivity and high expenditures (quotas had to be met regardless of cost!), beginning in 1951, voluntary labor brigades were employed only on local projects (Woodward 1995:149).

Perhaps it should be noted that Jacques Lacan received one of his first mentions (if not the very first) in socialist Yugoslavia in the same year Ilić produced his famous painting, and that this reference was made within the context of art criticism. In 1948, the literary journal *Republika* published an article by the notable Soviet art critic Vladimir Semyonovich Kemenov. In his condescending take on Western art, Kemenov, a proponent of socialist realism, references Maurice Nadeau's discussion of Lacan. He expresses his contempt for psychoanalysis by placing Lacan's profession in ironic quotation marks. In this translation into Croatian of a Russian translation of a French source, Lacan's name becomes "Locan." So Lacan here appears under two layers of ideological discursive sedimentation, as "'psychiatrist' Locan" (Kemenov 1948:309). This paralexis is particularly telling if we take into consideration the import of Lacan's notion of the imaginary for analysis of ideological apparatuses. *Sondage of the Terrain in New Belgrade* very accurately corresponds to two metaphors Jacques Lacan uses in his discussion of the imaginary in *Freud's Papers on Technique*. A successful joining of geology and optics plays a great part in the efficacy of this image: it depicts the action of drilling into different geological strata of the earth, while at the same time projecting the image of an idealized world that is based on this work. The structure of projection is, for Lacan, the very condition of the imaginary, the first layer that emerges in the constitution of the psychic subject in the mirror phase. "For there to be an optics, for each given point in real space, there must be one and one corresponding point in another space, which is the imaginary space" ([1973] 1978:76). What optics does for space, geology does for time, for the projection is both spatial and temporal. And it is in a 1954 lecture that Lacan first introduces the experiment (imaginary, of course) with the real vase and imaginary bouquet projected into it through a system of mirrors.[33] He insists that for a projection to be successful, the beholder, that is the subject, has to occupy a very specific position in relation to this optical apparatus:

For there to be an illusion, for there to be a world constituted, in front of the eye looking, in which the imaginary can include the real and, by the same token, fashion it, in which the real also can include and, by the same token, locate the imaginary, one condition must be fulfilled—as I have said, the eye has to be in a specific position, it must be inside the cone.

If it is outside this cone, it will no longer see what is imaginary, for the simple reason that nothing from the cone of emission will happen to strike it. It will see things in their real state, entirely naked, that is to say, inside the mechanism, a sad, empty pot, or some lonesome flowers, depending on the case. ([1975] 1988:80)

It is the job of the symbolic to make sure that the eye/I is positioned in one and one only position that makes it see the desired projection. By now it is clear that, if the plan can be identified with the imaginary, within a command economy socialist realism secures the one and only position that the subject can take in order to get things right. Even the slightest change in the projection apparatus reveals the true state of this political economy—so much so that it can be taken, and it usually is, as the very cause of its failure. In Yugoslavia, the adjustment of the "projection apparatus" from socialist realism to socialist aestheticism was dictated by the change in the political economy of the country.

At first, Western governments viewed Yugoslavia's conflict with the USSR with suspicion, but as time passed and the split appeared irrevocable, they showed increasing support for their unexpected ally. By the end of 1948, with the postponement of its trade treaty with the USSR, Yugoslavia had already signed bilateral treaties with a number of Western states, including Great Britain, Italy, Belgium, and France. By the following summer, a major turn arrived with the U.S. administration's decision to relax export-licensing controls on Yugoslavia, which opened the way for its full membership in the International Monetary Fund and made it eligible for aid programs for war-ravaged European countries. As Susan Woodward points out, by the end of 1950 "two thirds of the Yugoslav current-account deficit was covered by U.S. loans" (1995:145). Opening of economic channels went hand in hand with cultural exchange. By 1950, Yugoslav artists were already going on study tours to the United States and France. International exhibits followed: the same year (1950) an exhibit of French early modernism was organized in Belgrade in which for the first time after World War II the works of Eugène Delacroix, Henri Rousseau, and Gustave

Courbet were on display, followed two years later by a major exhibit of French twentieth-century painting (from the contemporary classics Henri Matisse, Fernand Léger, Georges Braque, and Pablo Picasso, to the early Informel paintings of Hans Hartung and Victor Vasarely's geometrical abstraction). By 1956 modern American art from the Collection of MOMA roared into town, showcasing the work of Arshile Gorky, Willem de Kooning, Robert Motherwell, Franz Kline, Clyfford Still, and, of course, Jackson Pollock.

International trade agreements opened the door for export of Yugoslav products, mostly raw minerals. However, that was not the only thing Yugoslavia had to offer: as Marie-Geneviève Dezès writes, by the beginning of 1951 a new word had entered the language of French political discourse: *autogestion*, a "translation of a word used in Yugoslavia to describe a socialist experience of a new kind" based on "collective decision-making from the bottom up, social control over the means of production, democratic planning, federal decentralization and deconcentration on political, economic, and cultural levels" (Dezès 2003:29). Not everyone was so enthusiastic about Yugoslav ideological exports. As early as 1950, on the pages of *Socialisme ou Barbarie*, Cornelius Castoriadis spoke about the conflict between Stalin and Tito as a "typically interbureaucractic struggle over the division of the proceeds of exploitation" and of Titoism as the "highest expression of the struggle of local bureaucracies against the central bureaucracy" (1988a:190). It is not surprising that in his writings from the 1950s he doesn't even mention Yugoslavia in his discussions of the spontaneous forms of workers' self-management that emerged during the popular uprisings against Soviet bureaucracy in East Berlin in 1953 and in Poland and Hungary in 1956 (see Castoriadis 1988b:57–89). Improbably as it may seem, in the course of the 1950s Yugoslav self-management provided enough justification for both of these mutually exclusive assessments.

Since the introduction of the first features of self-management in 1950, economic reforms had significantly altered Yugoslavia's socialist economy. The planning system was divested of rigid norms and the need for complex coordination between different segments of the economy. Instead, it was transformed into a more flexible set of expectations and predictions. Rejecting the vulgar Soviet notion of the planned economy, Kardelj, one of the main ideologues of Yugoslav self-management, saw the plan as an "instrument for the perpetual reproduction of socialist socioeconomic relations, for the reproduction of self-management on a higher plane of socialist development based on the relations of ownership" (Kardelj 1979:69). Importantly, in Kardelj's vision, the source of planning in self-management was

no longer a central planning bureau, but the worker as the "autonomous creative subject of planning" (67). In the everyday workings of the Yugoslav economy, this declarative empowerment of the worker translated into a relative autonomy of individual enterprises. While the state still could intervene in the decisions of individual firms, it was expected that the market, not the central planning body, would regulate the economy. According to this simple formula, workers as owners of the means of production and of their own income would increase productivity and make wise choices out of their own self-interest. Instead of fulfilling and overreaching the goals set in advance by the Five-Year Plan, profit became the new standard of successful performance. This purely market emphasis on revenue called for a renegotiation of the status of labor and of ownership in Yugoslav enterprises. While the land was owned by the state, the means of production (buildings, machines, etc.) were under legal ownership of workers who "associated" their labor to form an enterprise. The special feature of the Yugoslav enterprise was the workers' council, which, among other things, made decisions about hiring and firing, as well as about the use of profits. After covering all costs, such as contributions to the state (interest on fixed capital, land rent, and taxes), the enterprise could either invest its profits into further development of technology or use it to increase wages. Even though the latter was curbed by a steeply progressive profit taxation, the economic reason for this liberalization of wages, even at the risk of inflation caused by the (relative) liberalization of prices that accompanied it, was the stimulation of productivity. It was expected that the workers would perform better if they could make decisions about their own rewards.

In the September 1958 issue of *American Economic Review*, young Stanford economist Benjamin Ward published the article "The Firm in Illyria: Market Syndicalism." Ward based his hypothetical economic model of "market syndicalism" on the ongoing Yugoslav experiment with so-called market socialism. Ward's "market syndicalism" was not just an economic utopia, but a possible next step in Yugoslav economic reforms. He came to this model by removing two components from Yugoslav "market socialism": in "Illyria," unlike in Yugoslavia, there was no minimum wage, and the state had no right to intervene in the decision-making of the enterprise (Ward 1958:570). Ward speculated that, if driven by purely economic reasoning, the "Illyrian rule" would be that the "wages per worker" are "maximized if the competitive firm chooses the output at which marginal revenue-per-worker equals marginal cost-per-worker" (572). In other words, in the same way in which a purely market capitalist model encourages "profit-maximizing behavior," market syndicalism encourages

"wage-maximizing behavior" (572). The "Illyrian equilibrium" is disturbed when the number of workers is decreased or increased: in the case of the former, the overall output declines and with it the overall income, and in the case of the latter the wages decline since profit sharing applies to more workers. Ward's elaborate calculations exposed the vulnerability and near unsustainability of this model. He pointed out that in the Yugoslav model of market socialism, despite the nominal power of workers' councils, the "policy decisions are made by the director without much reference to wage-maximizing desires of the workers." And when it came to directors (managers), Ward admitted that "it is likely that other motives" play a part in their decision-making (584). It is precisely this additional component, this extraeconomic force—the "other motives"—that played the crucial role in maintaining the "Yugoslav equilibrium." On the one hand, it was the increasing influx of outside capital. On the other, it was an elaborate system of extraeconomic forces that substituted for the operations of central institutions of a capitalist economy, such as the stock exchange. This nondiscursive environment that did not belong exclusively to the sphere of politics or to the sphere of economy was of crucial importance for the functioning of society. "Something additional to worker self-interest might well be necessary in the Illyrian environment to ensure entry equivalent to that under capitalism," wrote Ward (583). *Something additional* to the efficiency based on input-output ratios was necessary not only for "entry" (start and expansion) of enterprises, but for their very functioning and survival. McKenzie argues that in "Performance Management, feedback is used to measure, analyze, and adjust an entire system's performance in relation to its component systems and to its environment" (2001:70). He proposes that the study of aesthetic performances offers a model that is helpful for understanding the input and output relation. "Feedback is a specific performance that can affect the direction of overall performance," and as such, it is a "performance about performance," or a "self-referential metamodel of the Performance Management paradigm" (90). Tangible but obscure in the everyday functioning of society in Yugoslavia, this "additional element" was displayed only periodically and always in a spectacular fashion.

If we move back from Ward's hypothetical and metaphorical "Illyria" to its source in theater and literature, the first thing we come across is precisely that additional element. In Shakespeare's *Twelfth Night*, Sir Andrew declares his delight in "masques and revels." Asked how good he is in these performances, he responds: "As any man in Illyria, whatsoever he be, under the degree of my betters" (Shakespeare 1997:1773). As its title suggests, *Twelfth Night* was performed on the final night of Christmas festivities, most likely

at the court of Queen Elizabeth. *Twelfth Night*, as one witness described it, "mingled comedy, with pieces of music and dances."[34] In the play, the "Illyrian equilibrium" is disturbed by a possibility of inauspicious marriages, and it is finally restored through an intricate series of disguises, tricks, and illusions. Stephen Orgel has written that the masque, that allegory of power performed in European seventeenth-century courts, is philosophically both Platonic and Machiavellian: "Platonic because it presents images of the good to which participants aspire and may ascend; Machiavellian because its idealizations are designed to justify the power they celebrate" (1975:40). Masque not only glorifies the power by putting it on display, as Orgel observed, but, unlike satire, it "educates by praising" and takes part in the operations of power through its very ephemeral quality (41). It shows that at the moment of the inception of modernity, unproductive consumption already figured as an indispensable element of symbolic exchange.[35] This kind of inclusive celebration, in which actors and spectators merge and intermingle, demonstrates that aesthetic performance is that additional element necessary for the functioning of certain kinds of social order. Here, the aesthetic performance is not a model of a larger social drama. It does not hold a meta-status. Instead, dissociated from its metaphoricity, it functions as a constitutive element of the political economy.

SOCIALIST BAROQUE

Although ideologically paradoxical, the link that New Collectivism made between the Nazi Olympics and the public ritual in a socialist state is anything but surprising. The sources of large-scale secular rituals in continental Europe nation-states are often traced back to Jean-Jacques Rousseau's notion of the festival and the subsequent adoption of this idea by the Romantic movements across Europe. While Rousseau's notion of a spontaneous celebration was based on the existing festivities in Swiss rural communities, it quickly became absorbed by well-organized mass movements. It provided important justification for mass festivals in the aftermath of the French Revolution, and further in the first decades of the nineteenth century.[36] One of the most influential mass sports movements in the early nineteenth century was the German *Turnverein*, which Friedrich Ludwig Jahn established in 1811. Guided by the slogan "love for the fatherland through gymnastics," the Turnverein movement promoted the unification of Germany, its emancipation, as it were, from the cultural domination of France, and the purification of the bodies and souls of young Germans

(Nolte 2002:8). In 1817 Jahn had organized the first mass Turnverein festival at Wartburg Castle: a three-day-long procession of nationalist speeches, demonstrations of gymnastics skills, and the burning of non-German books (Mosse 1975:77).

Jahn's Turnverein was just one of the mass manifestations that, throughout the mid-nineteenth century, accompanied and sustained attempts to unify German lands. After the failure of the 1848 revolution, the hope for national unity found its expression in a wave of mass festivals organized in 1859 on the occasion of the one-hundredth anniversary of Schiller's birth. Between the mass spectacle of Jahn's gymnasts at Wartburg Castle and the so-called Schiller-feiern of 1859, a number of the features of mass ceremonies were established: the open-air setting, regularity, massiveness, emotional appeal, blurring of the separation between performers and spectators, use of costumes, the rhythmic structure of performances, torch processions, and a flag display, to name just some of them. However, more important than any of these formal properties was the motive of the participants' collective struggle for national unification. This conventional structure and clarity of motivation fueled the trend of mass festivals during the 1860s, which suddenly subsided after the 1871 unification of Germany and the formation of the Second Reich. George L. Mosse writes that Sedanstag, an annual festival that commemorated the 1870 German victory over France at Sedan, and the first annual festival that the "Second German empire created for its own glorification," was ultimately a failure "because it had been organized from above in a conservative manner, had stressed discipline, and gradually excluded popular participation" (1975:91). All of these features would eventually return to reenergize mass ceremonies in the aftermath of World War I.

The movement for the unification of Germany was by no means the only national Romantic movement in Europe during the nineteenth century. Miroslav Tyrš and Jindřich Fügner modeled their Sokol movement on Jahn's Turnverein. In Sokol organizations, national romanticism acquired a somewhat different outline: instead of unification, they promoted the liberation of Czechs from the Habsburg monarchy; and instead of Germany they celebrated the spirit of pan-Slavism. Sokols became famous for their mass spectacles, dubbed *slets* (from the Czech word *slet*, meaning the gathering of birds), the first of which was organized in Prague in 1882 and which gradually spread throughout parts of Central Europe populated by Slavs, including the lands of the South Slavs. The idea of Yugoslavism was, at least in part, fueled by the pan-Slavic sentiments that Sokols espoused and promoted.[37] During their visit to Belgrade, the Sokol organizations

from Bohemia, Slovakia, Slovenia, and Croatia discussed the formation of the state of the South Slavs,[38] and at the Pan-Slavic Sokol Slet, held in Prague in 1912, the Serbian Sokols from Austro-Hungary performed the exercise "Liberation and Unification" (Brozović 1934:118). After the formation of the Kingdom of Serbs, Croats, and Slovenes in 1918, King Alexander used the Sokol idea as a tool in his project to forge an integrated Yugoslav nation. On the occasion of the First Yugoslav All-Sokol Slet, held in Belgrade in June 1930, King Alexander asked the Sokol groups to, "from cradle to grave, . . . serve Yugoslavia and the Yugoslav idea" (in Brozović 1930:306). After the assassination of King Alexander in 1934, the Sokols continued their mission and, for example, performed their exercises and organized procession and sports competitions on September 6, 1936, on the occasion of the birthday celebration of King Alexander's son, King Peter II (Kastratović-Ristić 2008:24). Obviously, as was the case with the state festivals of the Second Reich, this bourgeoisified and instrumentalized romanticism did not suffice for the creation of the common Yugoslav identity.[39]

If, through the legacy of the Yugoslav interwar monarchy, centralism and unitarism were considered among the main enemies of federative and socialist Yugoslavia, how are we then to understand manifestations of "love for the fatherland through gymnastics" that took place every year on May 25? Like King Alexander before him, President Tito presented himself not only as the unifier and savior of the state, but also as its personification. The key difference is not only in the vast ideological distance between the two rulers, but also in the idea of Yugoslavism they promoted. Whereas the integral Yugoslavism of King Alexander was based on the idea of the ethnic coherence of Yugoslav peoples, the socialist and federalist Yugoslavism championed by Josip Broz Tito and Edvard Kardelj was based on the idea of the free association of Yugoslav peoples based on their own national interests. This Yugoslavism was dialectical as well. Starting from the premises of the Marxist theory of state, it was seen as a Hegelian *Aufhebung* of the nation, that is, its simultaneous overcoming and its preservation. One of the speakers at the Sixth Congress of the Yugoslav Socialist Alliance of Workers (1966) eloquently used the word *natkriljivanje*, which means both surpassing and preserving, when he spoke of Yugoslavia as the result of the "common interest of its peoples and nationalities" (in Marković 2001:29). Of course, the ideologues maintained that this state, perfect as it was, was still subject to the laws of dialectical materialism, according to which the state is the manifestation of class struggle, and as such will "wither away" together with the "withering away" of the class system.[40] This idea was completely for-

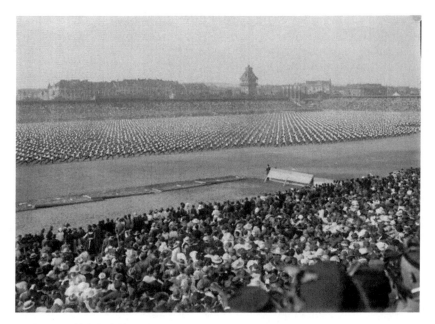

Fig. 5. All-Sokol Slet, Prague, 1920.

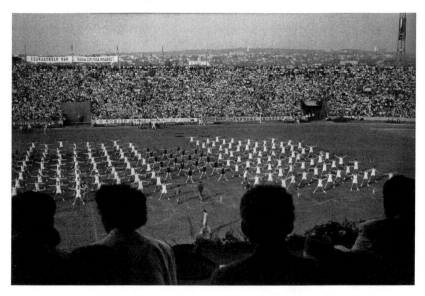

Fig. 6. Youth Day celebration, Belgrade, 1958. Photograph courtesy of Muzej istorije Jugoslavije.

eign to the Romantic cultural model that is centered on the nation and national culture. Where does that leave the Youth Day *slet*, that form of collective performance so deeply rooted in romanticism?

Performances of large magnitude that emerged from nineteenth-century romanticism were always closely bound with larger political movements. With their specific goals, mass emotional appeal, and rhetoric of uphill political battle, these festivals clearly exhibited all of the strong characteristics of liminality in performance. The disruptive power of mass political movements was capable of sweeping into their currents performances that were neither addressing the masses nor explicitly propagandistic in nature.

In performance studies and beyond, in the study of culture in general, the mass festival is commonly considered one of the central examples in the argument about the subversive potential of performance. So, continuing the line of the argument he began in his 1969 *The Ritual Process*, in his writing from the 1980s on celebrations and festivals, Victor Turner claims that the deeper meaning of these performances is to be found in their function as "an independent critique of the society that brought them into being, and hence a possible front of alternative ideas, values, motivations, and designs (rough sketches rather!) for living" (1982:28).[41] With the end of the Cold War, the "liminal norm" entered the study of Soviet mass celebrations. For example, in her otherwise very valuable book *Life Has Become More Joyous, Comrades: Celebrations in the Time of Stalin*, Karen Petrone makes a sustained effort to demonstrate that "while parades celebrated the disciplined conformity of the individual to the collective, they were also sites of individual and non-conformist behavior that challenged Soviet discipline" (2000:45).[42] These kinds of claims collapse formal and structural similarities between performances that belong to completely different discursive regimes, to such an extent as to alter their very meaning and purpose. In short, the "liminal norm" brings under the same rubric all performances of large magnitude and obscures significant differences that exist between them. If the postrevolutionary mass spectacles in the early Soviet Union, such as *The Storming of the Winter Palace* (1920), were still able, through reenactment, to inspire some of the subversive and revolutionary energy of the historical event, they would not have turned into the purely normative performances we see by the mid-1930s. In order to understand these performances of pure normativity, we have to reach not only beyond the "liminal norm" of the mid-twentieth-century academia, but also beyond the Romantic movements of the previous century. Consider the following report from a mass celebration:

> In the night of the 5th to the 6th August, a hundred thousand par-
> ticipants in costumes and masks were dancing . . . they were en-
> chanted by the torch processions of the carnival heroes, by . . . the
> fountains which resembled burning asters, by the nightly sky bright-
> ened by the play of the projectors, by the fireworks and the rockets,
> and they went down the river . . . in boats decorated with pennants.
>
> Forty orchestras played for them, and the visitors to the park en-
> joyed themselves in fair ground booths, in the circus, the theatre, at
> concerts . . . they were dreaming in the garden of reverie or on the
> bridge of Sighs; on the Avenue of Fortune they tried to have a look
> into the future. . . . The crowd was full of life, they felt free and un-
> restrained. (Sartorti 1990:42)

This is not a description from Venice or Rome circa 1680, but a report on a
Moscow carnival in the summer of 1937.[43] By the mid-1930s, there was noth-
ing left of the fervor that characterized the early postrevolutionary festivals.
As Soviet civil religion evolved, new special days were added to the stan-
dard calendar that in the 1920s had featured holidays such as May Day,
October Revolution Day, and Red Army Day. These included Air Force
Day, beginning in 1933, on the third Sunday in August; All-Union Railroad
Worker Day, 1936, on the first Sunday in August; Navy Day, 1939, on the
last Sunday in July; and All-Union Physical Culturist Day, 1939, on the sec-
ond Saturday in August. These holidays, crowded in the middle of the short
Russian summer, were celebrated with elaborate festivities and parades.

In her excellent study "Stalinism and Carnival," Rosalinde Sartorti ar-
gues that, whereas the early postrevolutionary festivals were closely associ-
ated with the carnival tradition that came from the peasant culture and were
marked by excess and spontaneity, the parade, which becomes the domi-
nant form of public celebration in the 1930s, is a festive manifestation of
military and industrial culture (46). Apart from the solidification of Stalin's
position as the head of the state, the formalization and hierarchization of
Soviet parades in the early 1930s also reflected the introduction of the First
Five-Year Plan in 1928 and the "general holiday fatigue" of the mid-1920s
(58). Stalinist purges and periods of starvation caused by forced collectiviza-
tion of agriculture were followed by festivals of opulence and order. Unlike
postrevolutionary festivals that depended on the masses of amateurs, these
affairs demanded a high level of professionalism. Sartorti cites the example
of the 1935 May Day celebration, when five thousand professional artists
from Moscow theaters took the roles of historical and literary personalities
(65). Two summers later, Gorky Park became the staging place for the carni-

val described earlier. Even though they were strictly ordered and regimented, these spectacles required the population's willing participation. They were realizations of the ideal of total participation that was pursued in vain by the early twentieth-century mass political movements. The number of participants in May Day parades grew from 750,000 in 1929 to 1.5 million in 1933. A traveler from aboard wrote on his visit to Moscow: "It is the world's most unique parade—the one parade in which (barring a few thousand in the review-stands) there are no spectators. Everybody marches. A parade for parade's sake, without audience or wise-cracks from the sidewalks or the faintest suggestion of self-consciousness" (Lyons 1935:212). These performances of greatest magnitude are materializations of the principle of teaching by praise established in baroque festivals.

Sure enough, there are a number of formal similarities between socialist and baroque festivals. For one, in their relatively free combination of various spectacular elements, from marches to dances to theater performances, they are pronouncedly eclectic. Second, even with this variety of performances, parade dominates both forms. These are festivals of mobility: baroque cavalcades, processions, and ceremonial entries are paralleled by the marches, motorcades, air shows, and regattas that were prominently featured in Stalinist festivals.[44] Third, both baroque and socialist festivals are displays of ostentation, which is formally marked by the fireworks displays. Finally, these mass displays of visibility are always oriented outward. It is not only uniformity they seek, but, as Giovanni Careri points out, style:

> By combining techniques and crossing boundaries in the *feste*, Baroque decoration displayed its full capacity to signify and its full power to transform all who participated, according to the principles of its "style," a word that should here be understood as a "pathos"— that is, a force that seizes subjects from the outside, gives them a form that they in turn internalize, and allows them to feel similarity in the common action. (2003:216)

This mobilization and unification through rational and utilitarian means of design and willing participation strictly corresponds to the aestheticization of labor and the incorporation of intangibles such as *style* into the political economy. However, even a cursory comparison of these fetes and the mass gymnastics of the early twentieth century reveals significant differences between the socialist spectacles and baroque festivals.

Indeed, it may seem that even one glance at the Belgrade Youth Day of

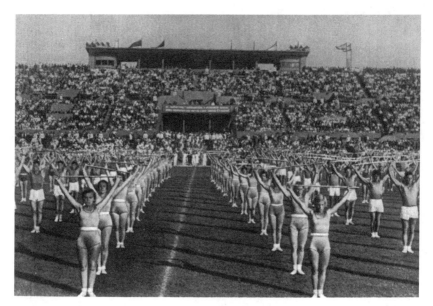

Fig. 7. All-Union Physical Culturist Day, Moscow, 1939.

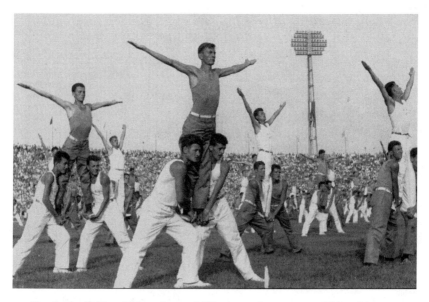

Fig. 8. Youth Day, Belgrade, 1958. Photograph courtesy of Muzej isto-
rije Jugoslavije.

the 1960s automatically leads us back to Moscow's All-Union Physical Cul-
turist Day from the 1930s, and further back to the Nazi rallies earlier in the
decade, then on to the Sokol *slets* from the 1880s, and all the way back to
Turnverein, which is so close, historically and culturally, to German ro-
manticism. This lineage provides a logical answer to Isaiah Berlin's poi-
gnant question about the sources of the "world-wide growth of national-
ism, enthronement of the will of individuals or classes, and the rejection of
reason and order as being prison-houses of the spirit" that suddenly came
to dominate the "last third of the twentieth century" (1998:558). And surely
enough, if we extend the gaze forward from organized masses in the Red
Square and the Stadium of the Yugoslav National Army to the mayhem on
the Caucasus and in Bosnia, it becomes hard to refute the idea that the lat-
ter is a natural continuation of the Romantic tradition and its "resistance to
rationalism," its belief in a "perfect society compounded of a synthesis of
all the correct solutions to all the central problems of human life," and its
doctrines that "morality is moulded by the will and that ends are created,
not discovered" (580). According to this schema, the period of socialism
(with its enforced order exemplified in disciplined mass performances)
amounts to no more than a brief and enforced suspension of this deep and
murky undercurrent. Surely this is the easiest way to naturalize and nor-
malize the catastrophe of Yugoslavia. But things are a bit more compli-
cated, especially if we take into consideration that what is brushed off as a
"brief suspension" could be in fact a historical complex with its own estab-
lished structure that is much more substantial than a thin crust covering
the deep abyss of irrationality.

The phrase "historical complex" comes from Spanish literary critic José
Antonio Maravall, who devised this and other terms (such as "historical
situation") to describe the baroque as a more complex and far-reaching
phenomenon than a historical period or an artistic style. In his book *Culture
of the Baroque: Analysis of a Historical Structure*, he outlines in great detail a
number of the baroque's properties that bear striking similarities to the
culture of the Soviet Union and of Socialist Federative Republic of Yugosla-
via. First, Maravall sees baroque societies primarily as postrevolutionary:
for him, the baroque is not a continuation of the Renaissance, but its ques-
tioning and, ultimately, its liquidation (Maravall [1975] 1986: 134). As in the
seventeenth-century baroque state, one of the main tasks of the postrevolu-
tionary state in the twentieth century is to keep in check the revolutionary
energy that brought it into being. That is why—and this is the second
trait—baroque societies, like socialist ones, are in permanent crisis. Mara-
vall goes as far as defining the culture of the baroque as a systematization

of a series of responses to a prolonged social crisis (22). Similarly, the entire history of socialist Yugoslavia can be seen as an endless series of crises: political crisis in 1948, economic crisis in 1962, social crisis in 1968, constitutional crisis in 1974 . . . But doesn't this apply to all socialist states, especially socialist economies, with their perpetual need for reform and readjustment? Why the Soviet Union and Yugoslavia? Third: What brings together the seventeenth-century baroque society and these two twentieth-century societies is that they establish states that are not based on the principle of ethnicity. While in the baroque state the mass constitutes, as Maravall puts it, a "proto-nation," in Yugoslavia it becomes a postnation of sorts. Fourth, and this is a more general point that is applicable to all modern societies and not only to these two socialist ones, Maravall presents the baroque as the first mass society in the modern sense of the word: the mass society in the sense of guided society. And not only that, but this mass society is guided in a uniquely modern way: through a wide proliferation and consumption of cultural objects and by the emerging military and bureaucratic order.

The continuous organization of mass activities in the former Yugoslavia suggests that this society followed the baroque model according to which the state abandons the simple principle of ruling by presence in order to adopt the dynamic model of ruling though participation. This culture of "active obedience" (74) is accomplished through a delicate balance of violence and pleasure. When it comes to the baroque, the violence is manifested in the emergence of standing armies and the pleasure in the equally emergent concept of culture. The latter consists of an "entire complex of social, artistic, and ideological expedients that were cultivated specifically to maintain authority psychologically over the wills of those who might, as it was feared, be led to take up an opposing position" (46). That is why Maravall considers "guiding" or "management" as one of the key characteristics of the baroque society. Finally, all of these pressures and forms of resistance combine into uniquely baroque dynamics of conservatism and progressivism. According to Maravall, for all of its fascination with the ideas of constant change, movement, velocity, and circulation, the baroque never brings into question the "permanent nucleus of identity" lodged at its center (179). A baroque monarchy allows modification only insofar as it does not endanger the main properties of the state, as stability, security, unity, and substantiality of its purpose (193). This state ascribes to novelty a status completely different from the one it had during the revolutionary period. Maravall writes that after the Renaissance experience, the baroque

could not completely extinguish the idea of change. "The baroque pro-
claimed, cultivated, and exalted novelty":

> [These] declarations in favor of the new were no less fervent than
> those of the sixteenth century, but to the extent that they were per-
> mitted they were be limited to poetic game playing, literary outland-
> ishness, and *trick effects machinated on stage*, which evoked wonder in
> and suspended the depressed psyche of the seventeenth-century
> urban inhabitant. Nothing of novelty, let me repeat, so far as of the
> sociopolitical order was concerned; but, on the other hand, there was
> an outspoken utilization of the new in the secondary, external as-
> pects (and, with the respect to the order of power, nontransferable
> ones) that allowed for a curious interplay: the appearance of a dar-
> ing novelty that enveloped the creation of the outside concealed a
> doctrine—here the word ideology would not be out of hand—that
> was inflexibly anti-innovation, conservative. (Maravall [1975]
> 1986:227; emphasis added)

All of that twisting and twirling in stadiums and city squares; all those
bodies running and jumping, groups blending and dividing, intermingling
and separating; all that long-distance running, giving and taking of ba-
tons—it could all be categorized, very generally, as "novelty." This is pre-
cisely the quality that the organizers of Youth Day were perpetually in
search of for their mass spectacles. This deeply baroque society celebrated
itself by using the techniques of romanticism, or, for that matter, of Western
pop culture, or any other cultural style that could convey the impression of
novelty without endangering what society had designated as its "perma-
nent nucleus of identity." Obviously, other socialist states in post-World
War II Europe and around the world exhibited similar baroque properties.
However, whereas in most of these places the "baroque complex" was in-
scribed on top of the nation-state, in the USSR and Yugoslavia it was inte-
gral to the idea of the supranational state. That does not mean that the two
federations shared the same "permanent nucleus of identity." The best way
to understand the specific nature of the Yugoslav baroque is to look more
closely at a specific mass performance.

Between 1945 and 1987, there were two important structural changes to
the staging of Youth Day. First, in 1955, the mass celebration was relocated
from Belgrade's main city square to the Yugoslav People's Army Stadium.
The following year, the transformation of the spectacle was completed

when Tito turned his birthday festivities into a celebration of Yugoslav youth. This had direct consequences for the nature of this mass performance. The stadium spectacle became not only a display of sports prowess for the guest of honor, but also a demonstration by and for Yugoslav youth to spotlight their accomplishments in labor, science, and other areas. Beginning in 1957, Tito always received the Youth Baton at the stadium, becoming an active participant in the spectacle.[45] The creators of these mass performances acknowledged the achievements of youth by making the end of their race, the Youth Baton handover, the culminating point of the entire ceremony. The second change came in 1965, when the performance was moved from afternoon (4:00 p.m.) to evening (8:00 p.m.) hours, which gave the Youth Day organizers more opportunities to use lighting effects and fireworks. From that point on, they persistently strove to introduce innovations into this well-established program. For example, in planning the 1971 Youth Day, they concluded that the overall concept of the stadium celebration had been so greatly and thoroughly improved and enhanced that they had arrived at the "point where we have to decide: should we keep the existing character of the performance (mass gymnastics with artistic elements) or search for new ways of and new solutions under existing conditions." After articulating so clearly this perfectly baroque condition of the precarious balance between novelty and tradition, the choice was obvious: the only way to reinforce the tradition would be to increase innovation. "If we decide that the performance needs to become even more of a spectacle that is unrepeatable and unique in our country, then we have to try to have more creative input from creators of the spectacle" (Archive of Yugoslavia, stack II, folder 20, 1971).[46] By the following year they had selected a proposal by a group of experienced librettists (Momčilo Baljak, Slobodan Božić, Miroslav Nastasijević, Pero Zubac), entitled *This Time Will Be Remembered by Us: Together in Youth, Together in Work, Together in the Future* (*Ovo vreme se pamti po nama: zajedno u mladosti, zajedno u radu, zajedno u budućnosti*). Calling for 9,500 participants, it was the most massive Youth Day performance ever.

In their introductory remarks, the authors of the script noted that the entire event should celebrate the creativity and feelings of the youth, and strive to "promote the legacies of the thirty-year-long socialist development: self-management, freedom, and brotherhood and unity" (Archive of Yugoslavia, stack II, folder 21 1972:1). The authors suggested that the "youth experience [these ideas] not as abstractions, but as a reality that they have to fight for and guard" (1972:1). Following on the tradition of the Youth Day celebrations, they added that the performance should also com-

memorate two important dates: the thirtieth anniversary of both the Allied Socialist Youth of Yugoslavia (Savez socijalističke omladine Jugoslavije) and the first volunteer youth work action. This tribute to the past and to revolutionary traditions was juxtaposed with a spectacular device that was never previously seen in Youth Day celebrations: the "living screen" in which participants, with the aid of multicolored ribbons, formed images and messages across an entire side of the stadium. This tribute to the general ideological tenets of the society represents the first level and overarching premise of the Youth Day celebration.

The main program, which traditionally consisted of several sections, each allegorizing one of the main themes of that year's festivity, forms a second level of the celebration. The most visible and spectacular part of the Youth Day festival, this level represented its main ideological charge, and it was often erroneously seen by the critics of Yugoslav socialism as something akin to this society's "permanent nucleus of identity." In 1972, the spectacle opened with the exercise "Because Two and Two are One." The unity expressed in this title refers not only to Yugoslav youth, but also to the youth and President Tito together. The opening number is dominated by a symbolic representation of the anniversary so obvious that it was not even mentioned in the introductory remarks: Tito's eightieth birthday. Upon entering, a group of four hundred girls formed eight "buds" on the stadium's green turf. On the "living screen," performers spelled out the message: "Thank you for the war. Thank you for peace."[47] Recent scholarship by Bojana Cvijić and Ana Vujanović suggests the "textual" acquires significance as "social choreography" only through embodiment (2015:58). So, while this message greeted Tito when he entered the stadium, his arrival set it in motion. The buds exploded into full bloom and the girls were joined by five hundred dancers who performed folk dances.

Throughout the evening, each section was designed to balance the conventional ideological message with innovative staging and performance practices. So, in the second section, love as the source of revolution was celebrated in a full-blown rock concert. The third segment focused on physical culture with feigned basketball and volleyball matches flanking a large-scale mass gymnastics exercise. At one point, the gymnasts formed a geometric pattern that covered the entire field. It split diagonally, and a large group of girls carrying long, blue pieces of cloth rushed into this "opening" to form a river.

The river spilled out across the field. Members of the Voluntary Youth Work Brigades, in their uniforms and armed with their tools, entered from the western and eastern sides of the stadium to battle the torrent. After the

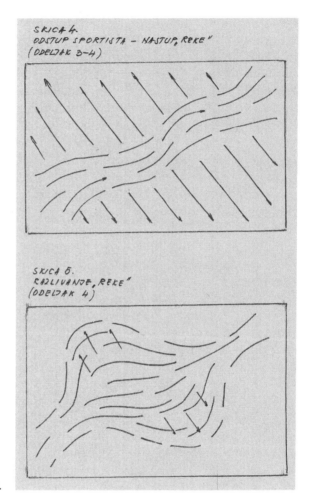

Fig. 9. Diagram of the "river" entering the field, and then flooding. Pencil on paper. Courtesy of the Arhiv Jugoslavije.

river was pushed back into its bed, the whole group broke into a "free, joyous, youthful dance accompanied by modern musical rhythms" (Archive of Yugoslavia 1972:6). This dramatic scene was followed by more conventional performances that celebrated labor and the army. Then a strong and "masculine" (7) exercise by army members gave way to a disheveled procession of "pioneers," young children dressed as butterflies, sheep, and flowers. "The finale of the performance is based on the elements of the carnival, in which children are joined by all other performers" (10). Gradually, all participants entered the soccer field and formed a rich ornament in

Fig. 10. Diagram of the taming of the flooding river. Pencil on paper. Courtesy of the Arhiv Jugoslavije.

the shape of a flower with eight red hearts for petals, symbolizing Tito's eight decades. While the "living screen" spelled out the message "We love you," a young worker emerged from the center of the flower carrying the Youth Baton. Thus began the final, ecstatic stretch of the relay run that had carried the baton across the country. In its baroque flowering, this image is a far cry from the strict geometrical order of socialist realist All-Union Physical Culturist Day in 1939 Moscow. It would be a mistake to search for the content of the elusive "permanent nucleus of identity" of Yugoslav society in this rhetoric of allegorical images, exaggerated messages, stiff humor, physical prowess, and ecstatic jubilation. We need to look further. So far, we have looked at the spectacular aspects of Youth Day celebration, while paying little attention to its organizational structure.

The Youth Day celebration was fully funded directly by the federal government of Yugoslavia (Federal Executive Council, or Savezno izvršno veće). It also relied heavily on help from participating republics and cities, and on the voluntary labor donated by thousands of young men and women. The Yugoslav People's Army, which participated every year, had its own sources of funding. In 1972, the budget for the Youth Day celebration was 3.3 million Yugoslav dinars, and in 1975 it exceeded 5 million.[48] The annual stadium spectacle was an important source of income for all kinds of professional performance makers, from choreographers, to set designers, to composers, to theater directors, to professional actors. Youth Day Organizing Committee hired thousands of skilled and unskilled laborers, from professional musical score copyists, to laborers who loaded and unloaded truckloads of materials

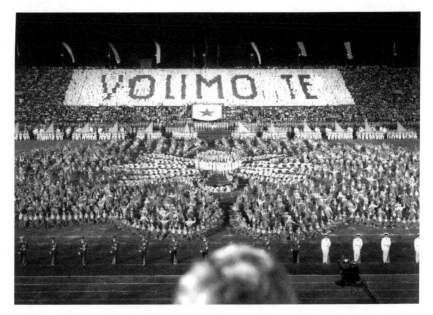

Fig. 11. "We love you": The final image of the 1972 Youth Day stadium spectacle. Photograph courtesy of Muzej istorije Jugoslavije.

for the construction of colossal sets, to electricians, to cooks. It purchased thousands of small props and costumes directly from factories. It transported thousands of participants from all parts of the country to Belgrade; and while they were there for the final stretch of rehearsals for the grand spectacle, it provided lodging and food.

In 1967, for example, the organizing committee made 129 contracts with individuals, including the composer who rearranged the overture of *The Barber of Seville* for stadium performance, choreographers who rehearsed amateur dancers, the crew that provided technical support, security guards, and one Ivko Milojević, who wrote the birthday message to Tito in calligraphy on special parchment (Archive of Yugoslavia 114/I 1967). The committee wrote requests to the National Ministry of Defense asking for the means of transportation; to music schools asking them to release their students for the rehearsals of a huge orchestra of accordions; to Radio Belgrade for recording time in studios; to a small privately owned enterprise called Morava that would manufacture the official stamp of that year's Youth Day; to companies in the lighting industry for eight hundred special handheld torchlights; to the Elektrometal company for the import of eight hun-

dred small bulbs from Pagani Company in Milan, Italy; to Elektrometal, again, asking for the waiver of the tax on the bulbs . . . As these orders, contracts, and agreements streamed out of the office of the organizing committee, the requests for the tickets for the Youth Day stadium spectacle poured in: 90 for the League of Communists of Yugoslavia, 63 for the Federal Executive Council, 142 for the Ministry of Foreign Affairs, 86 for the foreign correspondents, 40 for the youth magazine *Kekec*, 180 for the Bureau for the International Exchange of Youth and Students (80 for two groups from USSR, and 100 for the employees), 2 for *National Geographic* reporters James P. Blair and Edward Lenahaun, 3,000 for the Central Committee of the Youth League of Serbia, 8 for a firm named Azbest Produkt, which brought its business partners from Czechoslovakia . . .

What happened each year on the evening of May 25 at the Yugoslav People's Army Stadium was the summation of a swarm of capillary performances, only a small part of which were of the aesthetic kind. On that night, the stadium was not only the stage for an oversized ideological exhibit, but also a political arena, a business forum, and a publicity fair. Ultimately, the Socialist Federal Republic of Yugoslavia did not just display some more or less successfully conceived allegories of state ideology, but first and foremost exhibited how flawlessly and impeccably it functioned. The Youth Day celebration emerged at the same time as the economic model of Yugoslav self-management, and it evolved together with this economic structure. Its main purpose was to put this system on display by giving it an observable form. All of that doesn't mean that Youth Day spectacle was a performance of pure visibility. Like the Yugoslav society, it consisted of several distinct and complexly intertwined layers. There were at least three economies at work in Youth Day festivities, each corresponding to one layer of the spectacle: first, the symbolic economy, manifested in the inscription of major anniversaries and events in the very structure of the event; then, a vast mimetic economy manifested in the choreography of symmetries, uniformities, groups, and mass movements; finally, an economy of transactions between corporate bodies—that is, an economy of market distinction—that provided support for the first two, highly visible economies. Every year, the mass of bodies organized in vast geometrical figures that seemed to move, expand, contract, morph, blend, and explode into thousands of individual particles, was an operative allegory of Yugoslav self-management. In post-revolutionary societies, baroque as a "historical complex" emerges as a strategy for quenching the revolutionary élan and for the alienation of mechanisms of radical change that the political revolution sets in motion. Through its layered structure on the formal

level and capillary connectedness with the country's political economy on the ideological level, Youth Day was the performance that most successfully encapsulated the permanent nucleus of Yugoslav society's identity. In fact, because of the dynamics and complexity of this nucleus, performance was better suited than any other art to give it a legible form.

Interestingly, when it comes to the logistics of this performance, only a very small part of it was dictated directly by the League of Communists of Yugoslavia. Unlike the Soviet festivals, the purpose of this normative political spectacle was not to aggrandize the Party and its leadership. In fact, both Tito and the League of Communists stayed at arm's length from it. Until the last moment, when the time came to claim tickets for the spectacle, the Party was only marginally engaged in the preparations of the performance. What this spectacle put on display was not the Party hierarchy, but precisely the "additional element" that Ward recognized in his article on Illyrian market syndicalism. This additional element was the "market" part of market socialism. And it showed that this market was not a true market with a stock exchange, bonds, and stocks, but instead an intricate network of businesses and industries, local Party organizations, and, more than anything else, sociopolitical organizations such as the League of Socialist Youth, the Yugoslav Socialist Alliance of Workers, and hundreds of smaller organizations and associations that mobilized the entire population, not only Party members. In fact, the entire Youth Day celebration was the epitome of sociopolitical organization. In that sense, the stadium performance demonstrated the workings of the sociopolitical organizations as a currency of the Yugoslav socialist market. That currency really didn't flow freely but was instead regulated and programmed. However, unlike in the Soviet Union, this plan didn't call for a vast scripturalization. Instead, it relied on carefully calibrated diagrams. In that sense, the taming-of-the-river scene staged on May 25, 1972, was a perfect metaphor for this diagrammaticity. Aesthetically, this image came from the repertoire that runs back to the very point of separation from socialist realism, marked by Ilić's *Sondage of the Terrain in New Belgrade*. The rich symbolic content of the Youth Day mass performance also included a display of the layered nature of Yugoslav culture: one of its layers certainly consisted of incorporation of aesthetics into the political economy, a model that survived from socialist realism and was recognizable in its intent, reach, and deep funding structure; another was a mode of organization that tried to depart from planned economy; the third one was an aesthetic doctrine that was completely divorced from and opposed to socialist realism as a representational "style."

SOCIALIST AESTHETICISM

The baroque complex disrupts the notion of the "period" in a strict sense of the word. In it, each stratum is semipermeable and synchronized with other layers. A good example of this perpetual negotiation between different layers is the critique of Stalinism in Yugoslavia. On the political level, this critique became official to the point of becoming a rationale for oppression soon after the breakup with the USSR in 1948. While many alleged supporters of Stalin were incarcerated in the camps on Goli Otok and elsewhere, the leadership was pushing economic reforms that lead toward a gradual opening toward the West. At the same time, the diamat approach to Marxism survived in professional philosophy, and even after it was severely criticized, it was never completely banished. The publication of Marx's *Early Writings* in 1953 indicated the emergence of a new stream within Yugoslav Marxism that was intellectually and politically in step with the (re)emerging critical theory in the West, especially in Germany.[49] Simultaneously with the publication of this important volume, a group of young philosophers from Zagreb University started publishing on subjects that were until then rarely mentioned, such as the critique of ideology and alienation.

The inaugural scholarly article on the subject of alienation in Yugoslavia was Rudi Supek's "Importance of the Theory of Alienation for Socialist Humanism" ("Značaj teorije otuđenja za socijalistički humanizam"), published in Sarajevo scholarly journal *Pregled* early in 1953. Here, Supek is still limiting his discussion to religious alienation as a fundamental form of alienation of consciousness. The same year, however, Supek's colleague from Zagreb University Milan Kangrga published in the Zagreb-based journal *Pogledi* his article "Problems of Ideology" ("Problemi ideologije"), in which he didn't hesitate to add ideology to Marx's list of areas of alienation:

> Since consciousness and understanding are social phenomena, talking about ideology means talking about man's alienation, that is, about those social relations and conditions of life that make possible, condition, and produce this alienated, distorted, deformed, and split ideological consciousness, because ideology is alienation of man on the level of his consciousness and understanding. (Kangrga 1953:782)

Having established ideology as an area of alienation, Kangrga unambiguously indicates that this applies to all ideological formations, including the one that is dominant in Yugoslavia. He calls for an analysis that

would demonstrate where, how, and when social, political, scientific, artistic, ethical, etc. positions become mystifying, intolerant, monopolistic, exclusionary, therefore ideological precisely in the moment when they don the robe of sanctity, unmistakability, progressiveness, justice, democracy. (792)

This was an open challenge to doctrinaire Marxism imported from the Soviet Union, which was left untouched after the split of 1948. Their intellectual superiority and political urgency notwithstanding, the "Marxist humanists," as this group often self-identified, didn't dislodge the "diamat" brand of Marxism from the ideological mainstream in Yugoslavia. While ostensibly critical of the USSR, the Yugoslav ideologues' incredulity toward young Marx betrayed their deep and unbroken ties with Soviet Marxism. Following the publication of the RussiaWn translation of Marx's early works in 1956, Soviet Marxist scholars' response to the challenge of alienation was that of denial and rejection. On the one hand, scholars such as E. P. Kandel argued that the concept of alienation belonged to Marx's "immature" writings. He finds the proof of this immaturity in its near disappearance in Marx's later major works such as *Capital* and *The Communist Manifesto*. True to the methodology of historical materialism, Kandel argued that "the highest stage [of any phenomenon] permits us to understand its earlier stage" (in Yanowitch 1967:37). Therefore, in the light of the theoretical concepts of Marx's "highest stage," such as commodity production and proletarian revolution, the notion of alienation becomes theoretically insignificant. On the other hand, a number of scholars argued that the socialist revolution and the abolishment of private property effectively eliminates alienation from the relations of production, so that it is inapplicable and theoretically uninteresting for Soviet Marxism. Instead, it becomes the staple of Western "revisionist Marxism." Critical anthologies published in the USSR such as *Against Contemporary Revisionism* (*Protiv sovremennogo revizionizma*, 1958) feature chapters dedicated to "new Marxist" thinkers outside of USSR (Ernst Bloch, Georg Lukács, Leszek Kołakowski, Henri Lefebvre—and the Communist Party of Yugoslavia!), who are submitted to merciless critique from the positions of diamat.[50] The fact that very often gets overlooked, especially from the Western and postsocialist perspective, was that the Yugoslavian authorities found an important source of legitimization precisely in these criticisms coming from the East: by setting themselves up against the authoritarian forms of socialism practiced in the USSR and other Eastern bloc states (Bulgaria, Albania, Czechoslovakia of the 1970s, and Romania of the 1980s), they

appeared revisionist and liberal even when they resorted to repression, as in the aftermath of 1968.

Veselin Golubović points out in his history of Yugoslav revisionist philosophy of the 1950s that the philosophical critique of Stalinism after 1948 splits into two distinct periods: the first one, from 1950 to 1953, was marked by the emergence of critical discourse of ideology and alienation in articles such as Kangrga's "Problems of Ideology." This period was followed by a lull in the mid-1950s, which ended in the closing years of the decade. The second period culminated with the annual congress of Yugoslav Philosophical Association (Jugoslovensko udruženje za filozofiju) in which the young revisionist Marxists established their intellectual superiority over their older colleagues, who still to a great degree followed formulaic Soviet-style Marxism (Golubović 1985:48). The interval between the two peaks in the critique of philosophical Stalinism was not a period of calm dominance of one philosophical or ideological system. Far from that: it was the time of sharp clashes that were a direct outcome of the liberalization of public discourse that followed the rejection of Stalinism. On the philosophical terrain, these debates were sparked by the arrival of existentialism, which challenged both Marxist diamat in philosophy and socialist realism in culture. It coincided with the first serious ideological rift within Yugoslav leadership, which opened up with the publication of the high Party official Milovan Đilas's critique of the emerging upper classes in Yugoslavia.

Translation and publication of Jean-Paul Sartre's literary works in Yugoslavia in the wake of the rejection of socialist realism can be seen as a cautious search for alternative literary techniques. His two lesser dramatic works *The Respectful Prostitute* (*La putain respectueuse*) and *The Unburied Dead* (*Morts sans sépulture*) were published in 1951 and his more prominent novella *Nausea* (*La nausée*) in 1952. These works went hand in hand with the publication of Albert Camus's major novels *The Stranger* (*L'étranger*) and *The Plague* (*La peste*) in 1951 and 1952, respectively. These initial publications were accompanied, on one hand, by the quick acceptance of existentialist literary techniques by young authors such as Radomir Konstantinović in Serbia and Edvard Kocbek in Slovenia, and on the other, by harsh criticisms of Sartre's philosophy. In 1950, Rudi Supek, who would go on to become one of the leading voices of "humanist Marxism," published the book *Existentialism and Decadence*, and the following year the Croatian philosopher of the pre–World War II generation Marijan Tkalčić published a long essay titled "Existentialism (Kierkegaard-Heidegger-Sartre)" ("Egzistencijalizam (Kierkegaard- Heidegger-Sartre)"). Whereas the latter dis-

cusses Sartre's philosophy within the larger context of existentialism, and the former expands the range of "decadents" to encompass Romantic literature and surrealism, a polemic—one of the first in post–World War II Yugoslavia—that sprang up in 1953 focused exclusively on Sartre. In the third issue of the literary journal *Nova misao* Boris Ziherl, one of the most prominent representatives of diamat Marxism in Yugoslavia, published the essay "Egzistencijalizam i njegovi društveni koreni" ("Existentialism and Its Social Roots") in which he offered a sharp critique of Sartre's philosophy. Literary critic Voja Rehar mounted a defense of Sartre, which was published together with Ziherl's response in the sixth issue of *Nova misao*.[51] Ziherl's stated purpose was to demonstrate incompatibility between Sartre's existentialism and Marxism and, moreover, to question the French philosopher's turn toward Marxism and expose him as an "anti-Marxist" (Ziherl [1953] 1955:60). One of the cornerstones of Ziherl's criticism was Sartre's theory of alienation, which he laid out in his reflections on the Other in his major philosophical work, *Being and Nothingness*, and the drama *No Exit*. Summarizing Sartre's theory of the Other as that which is a "medium that I undeniably need in order to overcome and realize myself," Ziherl argues that Sartre takes this life-and-death struggle between the self and the other ("either I will overpower him or he will overpower me") as the starting point for his "interpretation for all social relationships" from "class struggle" to "ethnic relations" (24). Ziherl's most pointed criticism of Sartre concerns this irreconcilable opposition between the self and the other, and concerns as well some of the central tenets of his philosophy, such as freedom, choice, and, above all, a subject's "thrownness" into the world and his indetermination. Ziherl takes Sartre's reliance on the subject's "autonomy of will" as the central proof of his inability to depart from bourgeois unfreedom. "Contrary to Sartre, we think that socialism's victory will be all the more certain if *men become more free*, that is to say if they come to a deeper understanding of the objective tendencies of the society's development, if they have more possibilities and the will to resolutely transform socialist tendencies into socialist reality" (64). Ziherl's dismissal of Sartre didn't diminish his impact on Yugoslav culture of the 1950s. In fact, the critique of diamat by other means seemed to deepen during the lull of the mid-decade. This departure from socialist realism resulted not only in an opening of the scope and methodology in traditional arts— literature, visual arts, and theater—but in an opening of space for new arts, including performance. Severing of cultural ties with the USSR meant at the same time an opening toward the cultural and artistic currents in Western Europe.

Existentialist concerns not only informed literary and philosophical debates, but deeply affected attempts to rethink European culture in the aftermath of the Holocaust. In 1953, the same year as Ziherl-Rehar polemic, the eight annual Rencontres internationales de Genève conference, held in Geneva, Switzerland, from the second to the twelfth of September, adopted a strikingly Sartrean theme: "The Anguish of the Present and the Obligations of the Mind" ("L'angoisse du temps présent et les devoirs de l'esprit").[52] In Sartre's early philosophy, especially that of *Being and Nothingness*, the concept of anguish (*l'angoisse*) is directly related to will and negation, and therefore to alienation. As he puts it succinctly, "Anguish is precisely my consciousness of being my own future, in the mode of not-being. . . . If nothing compels me to save my life, nothing prevents me from precipitating myself into the abyss" (Sartre [1943] 1956:32). While the keynote speakers attempted to take the idea of anguish outside of this immediate frame of reference and examine it from perspectives of psychology, religion, politics, ethics, and philosophy, the Sartrean tension between anguish and horror informed conference discussions of keynote presentations and accompanying artistic programs. Consider the following statement by Polish émigré writer Czesław Miłosz:

> I am personally very upset by the audience's reaction to this play. I understand that a concentration camp is a very amusing place, of course, and little laughs coming from the audience are absolutely appropriate; but to consider such a play to be something ingenious, well done, as it was said by people who did not understand that one should not laugh while watching such a play, that repulses me. (in Saussure et al. 1954:235)[53]

This was Miłosz's response to the performance of *En attendant Godot* on September 6, 1953, which he offered during a public scholarly debate over Beckett's play (in all likelihood the first ever) that took place during the conference.[54] What Miłosz saw was Roger Blin's second run of Beckett's play, which was, after it premiered in Paris in January the same year, on its first tour through France, Switzerland, Germany, and Italy.[55] Théâtre de Babylone's performance of *En attendant Godot* was one of the artistic events that accompanied the conference. Miłosz spoke up in the Second Closed Discussion held on September 7, 1953, on the theme "Ethics and Aesthetics." His comments provide a rare glimpse at an initial response to Beckett's play, before numerous scholarly exegeses were written and published:

In *Godot*, there are two guys waiting for God; but God does not appear. And, for entertainment, to pass their time, we have images of enslavement and torture, of men by men. This is not a tragedy, but its exact opposite. There is nothing tragic in this play, because tragedy is when human will that wants to accomplish something meets an unyielding destiny. In this play, the characters are determined by the laws that they obey. All of them are gangsters; those two guys waiting don't do anything. They are absolutely passive; they are waiting for something unrealizable that will never happen. Godot will never come. Pozzo, the torturer, is subject to a strict determinism, but the same can be said about the one that is tortured. They are connected and there is no will; there is just submission. (in Saussure et al. 1954:236)

In the third year of his Parisian exile, and on the verge of his international breakout, which came with the 1953 publication of his books *The Captive Mind* and *The Seizure of Power*, Miłosz's reaction was clearly that of a writer from a socialist country:

But, this criticism: I will certainly be able to formulate it in Warsaw, in front of the Writers' Union of Poland, about the Western plays that deal with pure aesthetics. This lack of will, this lack of revolt against destiny is reminiscent of a kind of decadence, which is also present in the reaction of the audience that considers that such a play can be ingenious. On the other hand, we can say that such an art—the sadism of desperation—does not prepare for the advent of a new metaphysics. There is a certain metaphysical fluctuation at the edge of mystery. But, I do not see that; on the contrary, it is an art that employs appearances, metaphysical appearances that lead to pure desperation, where there is no possibility of transcendence. The next stage will never happen. For example, we will not see a mass movement bring happiness to the world. It is a profoundly antimetaphysical play. (236)[56]

Issues from this closed discussion apparently lingered into the second half of the conference. For instance, two days later, in the discussion of Italian philosopher Guido Calogero's paper "L'angoisse et la vie morale" ("Anxiety and Moral Life"), in which he spoke about the virtues of Socratic irony in the face of mortal fear, Georges Bataille raised the question of the alter-

natives to philosophical rationality. Suggesting that "the mysterious and the sacred are mutually engaged," he went on to ask:

> Doesn't the sacred overlap with poetry? And at the same time doesn't it overlap with tragedy? For men in general, there is a precious kingdom that is very essential to them: the kingdom of poetry, of the sacred, of tragedy; but it is, at the same time, the kingdom of fear, of anxiety, of that thing which Mr. Calogero says we are at odds with: death. This is finally the essential question: Does Mr. Calogero believe that irony can go beyond its object in certain cases? Does it go beyond God? His irony—Socrates's—does it go beyond death? Applied to the present situation, would irony go beyond death? (in Saussure et al. 1954:295)

When Calogero hesitates to apply his ideas to the "present situation" and goes back to Socrates's attitude toward his own death, Bataille persists. OK, he says, I agree with you, Mr. Calogero, but don't you realize that this pertains to something more than the history of ethics? "We should, at least, find out if the reasonable man is at times overwhelmed or not, and if, once he is overwhelmed, he stops being rational" (296). Calogero dodges the question once again, and poet Dušan Matić takes over, pushing further Bataille's question of understanding and ethical relation:

> What happens after? Does ethical action end when the act of understanding the others (or the other) is finished? Is that not the same as Tolstoy's: to understand is to forgive? I think that the action continues, the ethics continues. . . . I will take a classical example: I can understand and I have understood what Hitler is, but does the dialogue with him continue? Is there always a possibility for dialogue? If not, what should be done?" (297)

This insistence on "after" and "beyond" may be an indicator of similar intellectual affinities shared by Bataille, an on-again, off-again advocate and critic of surrealism, and Matić, a poet and former member of the surrealist group in Belgrade. Bataille, who had recently published *The Accursed Share*, had an obvious interest in the conference topic.[57] In the conclusion of the first volume of his magnum opus, he questioned the Marshall Plan as a possible point of convergence between a general and a restricted economy. Namely, in this vast project of financing the rebuilding of war-ravaged Eu-

rope, capitalism, that epitome of the restricted economy which is concerned with profit and accumulation, seemed to have come close to succumbing to the general economy, which asked for unproductive consumption and expenditure. "It was necessary to deliver goods without payment: It was necessary to *give away* the product of labor" (Bataille 1991:175). However, in the very next step of his argument, Bataille warns that along with this distribution of aid comes the distribution of credit (178). Yugoslavia was on the receiving end. After initially refusing in July 1947 to join the membership of the European Recovery Program (the official title of the Marshall Plan), a year later, in the immediate aftermath of the break with the USSR and its Eastern European allies, Yugoslavia was the first socialist country to join the program. That was just the first step in a series of agreements that deepened Yugoslavia's economic ties with the West. And indeed, soon the nonreturnable aid ("goods without payment") turned into loans ("distribution of credit"). Matić's participation in Recontres internationales de Genève as the only representative from a socialist state came in the wake of the Yugoslav constitution of 1953, which abolished Soviet-like economic policies and codified socialist self-management as the legitimate constitutional order of the land.

In his notes from the conference, Matić wrote that the greatest impression on him was not made by any of the keynote speakers or discussants, but by two artistic events that did not belong to the main conference program: the concert by the Swiss conductor Ernest Ansermet, and Samuel Beckett's play *Waiting for Godot*, performed by "some Parisian troupe" (Matić 1961:235). He described the latter as a "kind of contemporary European *Lower Depths*. Only without the old man Luke" (235).[58] In fact, he was so impressed by Beckett's play that during his stop in Paris he got hold of the theater journal *L'avant-scène*, which featured the script of *En attendant Godot* accompanied by two photographs from Blin's production. Upon his return to Belgrade he gave the journal to Vasilije Popović, a recent graduate of the first class in theater directing at the Belgrade School of Drama, who at that time worked as an assistant director at the Belgrade Drama Theater.[59] Popović had the play translated and proposed to stage it at his home institution. The repertoire of the Belgrade Drama Theater, alongside with some other public events of that time, such as Mića Popović's solo show of his nonrealist paintings (1950) and the *Exhibition of Contemporary French Art* (1952), indicated that Yugoslav culture was following its economy in its westward turn.[60] Starting with the 1951 production of Arthur Miller's *Death of a Salesman*, this theater turned away from the repertoire of classic dramatic literature and (socialist) realist plays to include a series of contempo-

rary works from the United States, France, and England (by Arthur Miller, Tennessee Williams, John Osborne, Jean-Paul Sartre, Jean Anouilh, and others).[61] The theater's artistic director, Predrag Dinulović, who staged the breakthrough production of *Death of a Salesman*, was not enthusiastic about Beckett's play, but he did not reject it either. Instead, he authorized rehearsals with a cast of young actors, which were scheduled to take place during the "dead time" in the theater's daily plan of rehearsals and performances. According to Popović, his arrangement with the artistic director was to bring the play up on its feet, at which point the final decision about its inclusion in the repertoire would be made (Popović 1978:21).

Rehearsals of *Waiting for Godot* in the spring of 1954 coincided with the biggest political crisis in Yugoslavia since its break with the Soviet Union. This time the crisis was internal, and it was caused by Milovan Đilas, the president of the Federal Assembly of Yugoslavia, who from November 1953 to January 1954 published a series of articles in the Communist Party's daily, *Borba*, in which he pointed to a number of quickly mounting contradictions within the new socialist society.[62] Đilas's downfall was gradual: from his trial and condemnation at the Third Plenum of the Central Committee of the League of Communists of Yugoslavia in January 1954, to the stripping of his party functions, to his expulsion from the Federal Parliament, and finally, to his renunciation of membership in the LCY later that year. The proximity and interdependence of political and cultural controversies in Yugoslavia of that time was epitomized in Ziherl's book *On Existentialism*, published a year later (1955), which brought together his polemics against Sartre's existentialism and arguments against Đilas he originally published in *Borba* in the first half of 1954. As political tensions mounted, the word spread among Belgrade theatrical and artistic circles about a new and unusual play rehearsed by a group of young actors at the Belgrade Drama Theater. In April the artistic director informed Vasilije Popović and the cast of *Waiting for Godot* that their production was not going to be included in the theater's repertory. Instead, they were allowed to hold one final dress rehearsal that would be open only for members of Belgrade Drama Theater's workers' council. Since it was never officially included in the theater's repertory, *Waiting for Godot* was not formally banned. Caught in institutional limbo, the production was simply shut down. The "Godot affair" offered the first glimpse at the mechanism of the ideological control of culture that evolved in Yugoslavia in years to come. This was not an instance of the kind of self-censorship that Miklós Haraszti suggests in his book *The Velvet Prison*, a sophisticated form of censorship that by the 1980s replaced the repressive role of the censor with the "discipline of the em-

ployee" in socialist countries (1987:72).[63] Instead, this was an example of the efficiency of self-management in workers' collectives that was expanded in 1953, a year before the "Godot affair," from factories to the "non-producing" sector to include schools, hospitals, and institutions of culture (Pašić 1978:37). Following an initiative that arrived from no one knows where, not only the security staff, but all employees, from stage hands to custodians, stood on guard at the theater's entrances.[64] Still, a few people slipped in and managed to see the dress rehearsal. These surreptitious audience members, among whom were some prominent theater critics and young intellectuals, spread the word about the terminated production. The interest in the censored play led to the production at Staro sajmište a few months later. To Vasilije Popović, the audience-less performance of *Waiting for Godot* at the Belgrade Drama Theater was a clear demonstration of the power of an unwitnessed event. In the aftermath of the dress rehearsal, he wrote, "Not existing as a performance, [*Godot*] lived on even though it was not played." And: "It was effectively performed even though it was not onstage—that is the point!" (1978:31).

Popović and his associates saw this performance as proof of the necessity for an experimental venue that would work outside of "administrative theater," as they referred to state-supported theaters. Encouraged by enthusiastic reactions to the performance of *Waiting for Godot* at Staro sajmište, they began to search for a space where they could stage other experimental plays. The director and the cast of *Godot* were joined by new allies, including the emerging literary critic Borislav Mihajlović-Mihiz and the film director Radoš Novaković, who became the theater group's managing producer. In his recollections about the "Godot affair," Popović noted that the producer of this barely existing new theater had a candid belief that its audience would consist primarily of Belgrade "bourgeoisie" and "snobs" (Ugrinov 1990:185).[65] After several attempts to find vacant spaces in downtown Belgrade that could be converted into a small theater, Popović and Novaković discovered an unused conference room on the ground level of the building that housed *Borba*, the Party's newspaper, and obtained permission to use it for theatrical performances. They found a certain symbolism in the fact that the "avant-garde scene, the first of that kind" in postwar Yugoslavia, would be housed in the "Party's fortress" (1990:187).

If in 1954 *Waiting for Godot* was seen as going too far in the direction of a new aesthetic and ideological liberalization, two years later, it seemed on the mark with the economic one. If in 1954 the new model of socialist self-management was used as a convenient mechanism for an impersonal

transmission of political decisions, then in 1956, when *Waiting for Godot* was remounted in the *Borba* building, a sudden new development of self-management in culture placed the production in a context far more awkward and alien than the old-fashioned totalitarian state. In 1956 a new set of laws and regulations were adopted that introduced the status of the "free artist" for the first time in the history of socialist Yugoslavia (Jokić and Pavićević 1969:23). These regulations came as a result of an elaboration of self-management's basic principles that asked for legal protection of labor as the cornerstone of self-management, and came as a result of the dynamic advancements in the film industry that drew actors, directors, stage designers, and other theater professionals away from their regular employment in theaters. In this new realignment, the avant-garde artists looking to establish an autonomous theater group found themselves under the same rubric as the members of *estrada*, light entertainment for the masses.

Soon after they found the space in the *Borba* building, the group was joined by the young theater director Mira Trailović, who secured substantial financial backing for the new theater from Belgrade municipal authorities.[66] The new theater was named Atelje 212 (Studio 212), after the number of seats in the auditorium. Popović writes that the opening night of *Waiting for Godot* in the new space, which took place on December 17, 1956, was sold out, and that even those who censored it two years earlier showed up to congratulate the actors on their persistence. Champagne was opened during the intermission to celebrate the "victory over the administration," as if, commented Popović, "it was not the administration itself that made this theater possible" (1971:232). He wrote that, even though the theater was small and improvised—without proscenium, lobby, or green room—the opening ceremony resembled those routinely done in the National Theater on the main city square: "They forced me to accept that which disgusted me: the old threadbare theater against which I rebelled" (235). In the very next production he started rehearsing, he observed a change among the group members: "The sacrifice and the sacrificial act, the necessity of which was so clear to us in the beginning, and which we took as a sine qua non of our work, was now disturbed; as if we were no longer capable of self-renunciation, that most supreme form of freedom; as if the time of certain selfishness would ensue, of the need for personal promotion and accomplishment" (244). The "theater of spiritual need" was drowned by its own success. The search for an autonomous avant-garde theater, for theater that was a "perpetual freshness in the world," was tainted by a "slow corrosion," at first imperceptible, but advancing with the certainty of clock-

work (245). A year after the opening of *Waiting for Godot* and the inaugura-
tion of Atelje 212, Popović made his exit from the theater and turned to
writing, adopting the nom de plume Pavle Ugrinov.[67]

The arch of the "Godot affair," in which an experimental theater pro-
duction was first rejected, then cautiously permitted to become quickly and
fully integrated into institutionalized culture, clearly illustrates the state of
Yugoslav culture in the mid- and late 1950s. Yugoslav authorities firmly
rejected the stylistic premises of socialist realism. Cultural establishment
was quick to marginalize and ridicule its representatives. Vacated space
was filled with modernist abstraction in visual art, the so-called theater of
the absurd, and psychologism in literature.[68] However, socialist realism is
more than a style, and its dethroning in Yugoslavia was incomplete at best.
It left intact the institutional structure of artists' and writers' associations
established during the period 1945–50, which were dominated by members
of the League of Communists. This combination of the new style and old
structure opened a gap in socialist realism as a political economy, which
was left without art forms that could address the widest audience in a di-
rect and unambiguous way. Summarizing this situation, literary critic
Sveta Lukić suggested that, beginning in 1950, the most prominent issue in
Yugoslav culture was its polemic against socialist realism. The result was
that "for the first time ever" there was a socialist culture that was directly
opposed to socialist realism and at the same time "internal and immanent"
in relation to the socialist project (1983:68). He made this argument in a
conversation that took place in the editorial offices of the Polish literary
journal *Kultura*, where Polish critics presented their visiting Yugoslav col-
leagues with a set of questions about the development of Yugoslav litera-
ture after the World War II.[69] In this conversation, as well as in other articles
he published before and after this visit to Poland, Lukić outlined the theo-
retical contours of this new socialist culture that first emerged in Yugosla-
via, and subsequently came to dominate some other Eastern European
countries, such as Poland and Hungary. In an article he published in the
daily *Politika* before his trip to Poland, Lukić wrote that "in contrast to So-
viet dogmatism, in which the bureaucracy orders the artists to do certain
things in a certain way, in our country the society—via politicians and
ideologues—negotiates with artists and advises them not to do certain
things" (67). He added that this cultural policy was gradually formulated
between 1950 and 1955. Needless to say, even without mentioning the "Go-
dot affair" or intending to do so, Lukić describes precisely the mechanism
of censorship that removed *Waiting for Godot* from the stage of the Belgrade
Drama Theater, and matches perfectly the timing of the reversal of its for-

tune (from suppression in 1954 to success in 1956). Second, he maintained that, when it comes to realism, "socialist realism in many of its aspects is not realism at all, but functionalism and pragmatism under the guise of realism" (Lukić 1975:230). Whereas in the Soviet Union realism had been accepted as the official style, in Yugoslavia it was replaced by abstraction in visual arts and a variety of stylistic departures from realism. According to Lukić, in the early 1950s, Yugoslav artists, critics, and art policymakers dismantled the "vulgar sociologism, moralism, speculative rationalism, and excessive politicization" characteristic of socialist realism, and instead endorsed an "aesthetic character and status of the arts" (68). Hence, he termed the resulting cultural politics and the official style *socialist aestheticism*.[70]

In his articles on socialist aestheticism (or socialist modernism, another term that critics use interchangeably), Lukić points out that the movement's "positive side" is its recognition of the work of art as a "relatively autonomous system, . . . organized according to its own rules" and therefore "immanently justified" (68). At the same time, he didn't see it as an "escape from reality." In fact, it created in "Yugoslavia a general condition" that was "richer and more supporting" for creativity (235). The fact that socialist aestheticism was relieved of an obligation to support the official politics did not mean that it was inherently opposed to that politics. Being that it represented a tacit agreement between artists and ideologues, it always led to a compromise. Thus, "Aestheticism dulls the edges, rounds things up, and suffocates a more specific and deeper departure" (69). Lukić suggested that, if placed in the Hegelian schema of dialectics, socialist aestheticism would represent the first, abstract negation of socialist realism. Accordingly, "It contains many traits of the previous phase," which is reflected in the works that are "ambivalent, ideologically and politically conformist, and neutral in relation to its epoch" (241). Like "realism" in socialist realism, abstraction in socialist aestheticism is a form of functionalism. And, in the final analysis, what social realism was for the command economy, socialist aestheticism was for market socialism.

The lacuna left in the political economy of socialist realism by the removal of a realistic representational style was difficult to bridge. It was almost impossible to use middle-of-the-road modernist abstraction as a transposition, commentary on, or even a mere illustration of self-managing labor. One of the rare instances when an explicit and even programmatic attempt was made at bringing together self-management as an ideology with socialist aestheticism was the fifteenth issue of Bihalji-Merin's magazine *Jugoslavija: ilustrovani časopis* (*Yugoslavia: An Illustrated Magazine*). While it always featured fairly straightforward and nicely packaged pitches

for national treasures, industries, and tourist offerings from the Yugoslav republics, issue number 15, published on the occasion of Yugoslavia's participation in the 1958 Universal and International Exhibition in Brussels, stands out as one of most ambitious attempts to replace socialist realism with its modernist counterpart.[71] Judging from this luxuriously produced magazine, what Yugoslavia had to sell at the Universal Exhibition was . . . itself. Most articles in the magazine dealt with the sociopolitical organization of the country, while illustrations ranging from medieval frescos, funerary art, and sculpture to the most recent painting, photography, industrial design, and architecture were arranged in such a way as to convey the sense of continuation between past and present and a unity between different aspects of contemporary culture. Hence the title of this special issue: "Tracks and the Present." In his selections for the "present," Bihalji-Merin made some bold choices, such as the inclusion of paintings by Ivan Picelj and Aleksandar Srnec, members of Croatian group EXAT 51, who in February 1953 held the first exhibition of abstract art in post–World War II Yugoslavia.[72] EXAT 51 was a Zagreb-based group of painters and architects, founded just months after Kardelj's speech in which he encouraged the "confrontation of opinions." In its manifesto, the first of its kind in socialist Yugoslavia, EXAT 51 legitimized its existence by asserting that it "considers its own foundation and activity as a practical positive result of the development of" the very principle Kardelj advocated: "confrontation of opinions" (EXAT 51 1969:39). "EXAT" is a portmanteau word made of "experimental" and "atelier," and true to this commitment to experimentation and art as labor ("atelier" as studio or workshop), painters and architects gathered under its banner proclaimed as their "main task" directing "visual activity toward a synthesis of all visual arts" and, second, "giving an experimental character to this effort" (39). In the work of Picelj and Aleksandar Srnec (also featured in this issue of *Jugoslavija*), this experimentation is manifested in works that were remarkably in step with European geometric abstraction of that period (Denegri 1969:38). On the pages of *Jugoslavija*, Bihalji-Merin juxtaposes Picelj's paintings with photographs of Yugoslav industry and Đorđe Radenković's text on self-management. Here, Picelj's geometric abstractions from the EXAT and post-EXAT period serve to contrast and complement scenes from industrial life: a blast furnace at Jesenice iron works, a workers' council meeting at the Rade Končar factory, and products from the glassworks in Skopje—all to illustrate Radenković's glorification of self-management.

Far more sophisticated than his socialist realist predecessors, Radenković, in this text addressed primarily to foreign audiences, strik-

ingly presents "social self-government" in performance management terms (remember this is 1958!). On the one hand, he argues that this form of organization is a palliative against two "major dangers" of modern industrial societies: mechanization ("the threat that worker . . . may lose all joy in labour, pride in labour, sense of labour") and excessive managerial bureaucratization (Radenković 1958:90). On the other hand, he puts forward the idea that this is a form of social, and not only industrial, organization, which brings "direct efficacy" to democracy (94). "Social self-government" is the "blending of socialism and democracy" in which the latter "ceases to be a periodical game of numbers and performances on the parliamentary stage" and instead "enters the whole life of man, just as he enters it 'through the front door'" (97). It is here that the harmonizing force of self-management meets the artistic synthesis envisioned by EXAT 51. As with socialist realism, this unifying vision was achieved only discursively, on the pages of Bihalji-Merin's *Jugoslavija*, where Picelj's works were co-opted by the socialist modernist mainstream. Outside of this brief discursive departure, EXAT's comprehensive ideas for social(ist) design were pushed into the background to make room for the less demanding (and less self-managing) and more conciliatory artists and works that Lukić associated with socialist aestheticism.

A nonconfrontational and watered-down idea of abstraction found its multiple purposes within the political economy of self-management. The Youth Day stadium spectacle offered the most comprehensive image of Yugoslav socialist aestheticism that could be surveyed in single glance. From popular music, to themes ranging from war and revolution to the sentimentalism of children and the militarism of the army, it used everything it could to achieve the desired emotional effect. Unlike Soviet spectacles, it never stopped short of abstraction. The river rushing into the stadium, spilling over its banks, being pushed back by the angular formations of young workers: this kind of formal arrangement is paradigmatic of socialist aestheticist painting. If, in its machinelike progression and certainty, the socialist realist mass spectacle strove to emulate the unfolding of the planned economy, then the slightly relaxed, modern, and semiabstract mass performances of Youth Day revealed the intricacy of the socialist market economy. If the former, with its important task of labor motivation, was an integral part of the Soviet political economy, the latter demonstrated that Yugoslavia had its distinct and viable political economy. Whereas socialist realism, both as an artistic style and as a political economy, insists on organicity, socialist aestheticism is perfectly suited to the layered structure of the baroque complex. The baroque social fabric is sedimentary, nonho-

mogeneous, and full of cracks and openings. It constitutes, in the parlance of Gilles Deleuze and Félix Guattari, a "holey space" that "communicates with smooth space and striated space" (Deleuze [1980] 1987:415). While they find a visual paradigm of this space in Sergei Eisenstein's film *The Strike*, it is no less present in the works of Samuel Beckett. In order to understand what happened in the cracks of socialist aestheticism, we have to go back to the clandestine performance of *Waiting for Godot* that followed its ban at Belgrade Drama theater and preceded its triumphant return as the inaugural production of Atelje 212.

LABOR'S OTHER

If we don't count the closed rehearsal in Belgrade Drama Theater, the first staging of *Waiting for Godot* in Yugoslavia, and by all accounts in a socialist country, took place in the summer of 1954 in Belgrade.[73] It was a one-off performance staged in the studio of the painter Mića Popović, located in the complex of buildings called Staro sajmište (Old Exhibition Grounds) situated on the left bank of the river Sava facing downtown Belgrade.[74] The cast consisted of young actors from the Belgrade Drama Theater (Beogradsko dramsko pozorište), where they rehearsed Beckett's play throughout that spring. The roles of Vladimir and Estragon were played, respectively, by Ljuba Tadić and Bata Paskaljević, and those of Pozzo and Lucky by Rade Marković and Mića Tomić.[75] The hosts of the event, painters Mića Popović[76] and Vera Božičković-Popović belonged to a generation of young up-and-coming painters that transformed the Yugoslav art scene in the early 1950s. Their studio was located in a building that formerly housed the Italian pavilion of Belgrade's Staro sajmište. In figure 12, the Italian pavilion is the small building in the upper left corner of the complex, almost completely hidden by the square white building, which housed one of the Yugoslav pavilions.

Originally, Sajmište was a complex of ten exhibition halls built in the summer of 1937. Until the Nazi invasion, it hosted international exhibits of goods and industrial products. In the fall of 1941, this complex was turned into the concentration camp the Nazi occupying forces named Judenlager Semlin (Jewish Camp Zemun).[77] Sajmište was conveniently placed north of the river Sava, on land that, following the breakup of the Kingdom of Yugoslavia, was annexed by the newly formed Croatian state governed by a Nazi puppet regime. Even though designed as a place for the display and trade of goods, the panoptic architecture of the entire complex, with its

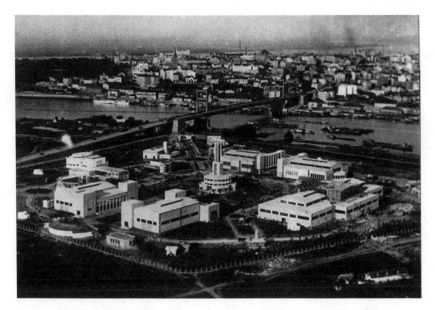

Fig. 12. A panorama of Sajmište upon its completion in 1937.

concentrically grouped buildings and central tower, made for an easy conversion into a concentration camp. All Nazi authorities had to do was build additional barbed wire fences and add guard towers at the corners of the vast yard. By May 1942, seven thousand Jewish men, women, and children had been exterminated in a truck converted into an ambulatory gas chamber, or simply died of hunger and illness (Koljanin 1992:61). Having completed "the final solution" in this newly occupied part of Europe, Nazi authorities changed the name of the camp to Anhaltelager Semlin (Distribution Camp Zemun), essentially a slave labor camp for prisoners of war and civilian hostages, mostly Serbs, from Bosnia, Croatia, and Serbia proper, who were sent on to work in other camps throughout the Third Reich. During the period from 1942 to 1944, almost thirty-two thousand passed through Distribution Camp Zemun, and eleven thousand died there (Koljanin 1992:397). The camp was damaged in the Allies' bombing raids on Belgrade in the spring of 1944, and by July it was abandoned. It suffered further damage during the military operations for the liberation of Belgrade in October 1944.

After the war, the entire complex remained abandoned until 1948, when Yugoslav leaders decided to launch the construction of New Belgrade. Rubble was cleared and pavilions were turned into the headquarters of the

Voluntary Youth Work Action New Belgrade.[78] Once this Youth Work Action was dicontinued, the pavilions at Staro sajmište were once again obsolete. In 1952 they were leased to the Association of Artists of Serbia (ULUS), which let young artists use empty buildings as their studios. For a short period of time in the 1950s, the former extermination camp housed a community of avant-garde painters, writers, and theater practitioners. Vasilije Popović had a room in the (formerly) Romanian pavilion. In reminiscences he wrote years later, he compared Staro sajmište to a huge "celestial wheel" with the central axis and parts dispersed around it (Ugrinov 1990:11). The wheel had been broken; the buildings were dilapidated and unkempt, surrounded in the summer by abundant vegetation. And while from this jumble of crumbling walls and invading plants occasionally emerged fragments of a building's former splendor (the banner mounts at the entrance of the Italian pavilion, the round windows of the Swiss pavilion, and the blue ceramic tiles that framed the entrance to the Romanian pavilion), the more recent past of this place bled silently into the present.

The spiral staircase in Mića Popović and Vera Božičković-Popović's ground-floor apartment led from the living room to their studio, which was large by postwar Belgrade standards. Mića Popović remembers that it measured almost fifteen by seven meters (in Popović 1978:30). On the day of the *Waiting for Godot* performance, the painter and the director cleared the studio and brought in chairs they had borrowed from neighbors. They drew a chalk line across the width of the room, dividing it into two parts of unequal size: the larger section for the audience, and the smaller one for the stage (1978:30). A large ceiling lamp illuminated the performance area. Vasilije Popović worked the lights by simply turning the wall switch on and off to indicate the break between acts (Ugrinov 1990:173). In the Italian pavilion, the play found itself in what Peggy Phelan calls "the scandal of ethical blindness" that was "the catastrophe of the Holocaust" (2004:1281). Seeing without looking, it achieved clarity that needed no stage metaphors. It was as if, once placed on the broken celestial wheel, the play was freed of all symbolism, and the tangibility of the here and now that Beckett suggested through numerous metatheatrical devices finally and fully emerged. There was no curtain to conceal the stage and no coulisses to cover the bare walls of the former death camp.[79]

Mario Maskareli, a young painter who lived in the neighborhood, made *Godot*'s famous tree from objects he found at the site: a broom handle topped with a whirl of corroded wire (Popović 1978:28). Actors played in costumes that were borrowed from the costume depot of Belgrade Drama Theater.[80] The hosts worried that the floor might yield under the pressure

of more than forty bodies crammed into the studio (Ugrinov 1990:172). The weight was not only in the bodies of the spectators and performers, but around them as well. There was very little room for stage action in the tiny performance area. And there was scant energy. Instead of memories of the mise-en-scène, what stayed with actors was the general atmosphere of the stifling enclosure and the heavy air.

> LJUBA TADIĆ: The edge of the proscenium was marked by a chalk line. That was the limit of how far we could go. Then they hung the big lamp—do you remember the lamp?—and the lampshade so that the light would focus on us. We realized that there were not going to be any reflectors in there.
> Then the audience came in. Those spectators, I remember all of them. . . .
> RADE MARKOVIĆ: Many sat on the floor.
> LJUBA TADIĆ: They sat on the floor and on chairs. There was a big table on the right, and they sat on it as well. . . . And then the performance began. As soon as it began, the storm came from the Sava. There was lightning.
> BATA PASKALJEVIĆ: Terrible weather. The storm.
> LJUBA TADIĆ: The glass in the windows fogged.
> BATA PASKALJEVIĆ: Terrible pressure.
> LJUBA TADIĆ: Pressure and heat. We were drenched with sweat, all wet, as if we were pulling an oxcart. . . .
> BATA PASKALJEVIĆ: Our words were drowning in sweat; they came soaked out from our mouths. (in Popović 1978:28)

These reminiscences of performing in *Waiting for Godot* don't contain even a hint of recollections about the individual actors' gestures or ensemble work. It is as if the actors are describing forced labor instead of a theatrical performance. This atmosphere, as heavy and dense as Jupiter's, turns the stage into a locale buried under the wreckage of the past, of the memories, buildings, and objects all around them. The director says very little about his staging of the play. If he seems to have remembered everything but his own directing, it is probably because that which is unforeseeable, that which obeys no direction, theatrical or otherwise, took over the performance. Vasilije Popović:

> When the first thunder rocked the heavens exactly during one of the long pauses in the play and temporarily shut down the light, we had

an almost physical sense that we were outside, in the midst of the storm and tempest, on that marshy land on which Beckett placed the action of his play, and at the same time miraculously protected from it. And then, just before Pozzo and Lucky's entrance, the skies opened, with powerful lightning nearby, so that the words from the stage were no longer audible, at least to those of us who were in the back. Finally, at the point of nightfall in the play, the light in the studio went completely out (most likely, a transformer nearby was hit by lightning), so that the end of the first act was played literally in total darkness, illuminated only by lightning (instead of moonlight, as specified in the script). We continued the performance with candles, which were placed along the edge of the stage. (Ugrinov 1990:174)

Instead of being installed into the site (its history, its physicality up to the point and including the poor electrical wiring and the apocalyptic storm), the performance absorbed it. Performers were crushed under its weight.

LJUBA TADIĆ: Now, what happened during the performance, to me it's as if it was a memory of a delirium; the same way that in *Godot* everything is somehow delirious. We, I remember, got down on the floor—you know the scene "the collapse of humanity" when we all lay down on the floor—it is then that I felt none of us could stand up. That's how tired we were, so that we hardly could bring the show to its end. (in Popović 1978:28)

Only moments later, still crawling on all fours, Gogo points up to the sky: "Look at the little cloud." Vladimir has the strength only to lift his gaze: "Where?" Estragon: "There. In the zenith," to which Didi retorts: "What is there so wonderful about it?" (Beckett [1952] 1954:54). Nothing wonderful indeed, for it indicates that the two of them, along with their neighbors Pozzo and Lucky, are at the nadir. The four of them—in the words of Robbe-Grillet, a "seething, groaning heap" of bodies—are pressed against the earth with no strength left to raise an arm, much less to stand on their own feet (1965:111). Like Stanislavsky much before him, Beckett used diagrams in his preparation for stage productions. Stanislavsky's diagrams are either a notation of characters' movements onstage or, in the case of static scenes, an outline of the stage composition. In Beckett's diagrams it is impossible to find composition sketches of the kind Stanislavsky made for the dialogues between Sorin and Treplev in *The Seagull*. In comparison, Becket's diagrams

Fig. 13. Samuel Beckett, *Waiting for Godot*, act 2. Pencil on paper. Copyright The Estate of Samuel Beckett. Permission to reproduce the image Cruciform "Heap" by kind permission of the Estate of Samuel Beckett c/o Rosica Colin Limited, London.

are rigidly geometrical. Spare and functional, they always indicate the lines of movement. In sketches he made for static scenes, Beckett goes no further than marking the actors' onstage positions. The vocabulary of his diagrammatic notation is also very frugal: it is limited to arrows, points, numbers, and characters' initials (see McMillan and Knowlson 1993). At one point, this narrow lexicon of signs combines to make a formidable image. In one of Beckett's notebooks from the period in which he was preparing to direct *Waiting for Godot* at the Schiller Theater in Berlin (the so-called Green Notebook) there is a diagram of the "heap" scene (fig. 13).

In their comments on Beckett's diagrams, Dougald McMillan and Martha Fehsenfeld point out that this particular image is located in the section of the "Green Notebook" entitled "Wartestelle" ("Points of Waiting"). They are, as they explain, "tableaux," "poses" or the "tangible instances of waiting" (McMillan and Fehsenfeld 1988:117). There are four of these instances in Beckett's plan for *Godot*, and they are all grouped in the second act. The heap is the penultimate such instance, and McMillan and Fehsenfeld suggest that it indicates the positions of four characters: Lucky's body is prostrate at a right angle across Pozzo's in a cross-like fashion. "Estragon occupies the lower stage right quadrant of the cross and is facing stage right, Vladimir is in the lower stage left quadrant and faces stage left" (1988:118). Visually, these four diagrammatical bodies combine to form a new, composite body that is slowly rising from the floor—no longer Pozzo and

Lucky, Gogo and Didi; no longer human, but a human-like geometric form consisting of lines, circles, and letters. Commenting—in an entirely different context yet clearly comparable to the one I am discussing here—on Victor Turner's suggestion that "in the 'breakdown' the individual is 'reduced or ground down in order to be fashioned anew,'" Saidiya Hartman observes that this "breakdown also illuminates the dilemma of pleasure and possession since the body broken by dance insinuates its other, its double, the body broken by the regimen of labor" (1997:78).[81] It is precisely here, in this instance, that the stage composition called *Waiting for Godot* reaches not only the point of perfect stillness, but also its rock bottom.

On that stormy night in the former extermination camp, the diagram of the heaped-up bodies was inscribed upon another diagram, the only one that survived from this particular production of *Waiting for Godot*. This diagram is the straight chalk line on the studio floor. For how long did it stay there? Did the chalk dissolve in drops of sweat from actors' bodies? Was it smeared as the body-heap rose from the floor? The chalk line establishes an impenetrable boundary between this body-pile and the observing bodies crowded in the section of the studio designated as the auditorium. This faint and murky line adopts the significance and efficiency of separation (*Trennung*) that both Brecht and Benjamin talked about. Benjamin expands on Brecht's *Vrefremdungseffekt*-producing separation of theatrical production's elements into an external separation structured by "the abyss which separates the actors from the audience like the dead from the living, the abyss whose silence heightens the sublime in drama and whose resonance heightens the intoxication of opera" (Benjamin [1966] 1973:1). The ultimate result of social separation is psychic alienation induced by a violence that is as immense as it is invisible. Here again emerges the figure of incommunicable currents that run past each other.

In the winter of 1941/42, Hilda Dojč, an inmate at Judenlager Semlin, wrote to her friend outside the camp:

> At the barbed wire fence all philosophy ends, and a reality—a reality that you who are outside can't even imagine because you'd howl with pain—emerges in its fullness. That reality is unsurpassable, our misery enormous; all clichés about the strength of one's spirit break down in front of tears from hunger and cold, and every hope that liberation is near disappears in the face of a monotonous perspective of a passive existence that does not resemble life in any way. That's not even the irony of life. It is its deepest tragedy. (in Koljanin 1992:85)

Hilda Dojč's letter marks the beginning of a human being's degradation that ended in a state that inmates in camps located far to the northwest of Belgrade called *Muselmann*. In his influential book *The Empty Fortress: Infantile Autism and the Birth of the Self*, Bruno Bettelheim explains that "the connotation" of calling certain inmates *Musselmänner* "was that they had resigned themselves to death unresisting, if this was the will of the SS (or of Allah). To the other prisoners, but also to the SS, this seemed totally alien, 'Eastern' acceptance of death, as opposed to the 'normal' one of fighting and scheming to survive" (Bettelheim 1967:65)[82] Here alienation is not only a cultural misnomer, but a psychic condition of separation from the world that Bettelheim recognizes as one of the central properties of autism: "A highly personal extension of the body, a merging of the body and external things, stands at the beginning of an important recognition: that this world, though not ours, is ours to try to change as we wish, is to that degree here to be made our own. Only when we feel we can do that does the world seem not alien" (136). Exhausted with life but not yet dead, *Muselmänner* endured the afterlife between the end of work and biological death. Keenly aware of the history of Staro sajmište,[83] the director of this clandestine production of *Waiting for Godot* observed that the language itself reveals a deep undercurrent in the seemingly discontinuous history of this site: what before the war was a place to display and trade goods (*roba*), during the war became the place to incarcerate slave labor (*robovi*) (Ugrinov 1990:13, 53). It is precisely at this point that Marxian analysis of alienated labor meets theories of psychic alienation that emerged from the experience of the Holocaust. At the moment of performance, this place was still under the sign of labor, but unlike any other that inhabited it in its short and momentous history: the voluntary and unproductive labor of art.

The transformation, even for an evening, of an artist's studio into a public space in which a production—that is, a form of labor—was on display has a far-reaching significance in the context of Yugoslavia in the early 1950s. The notion of the studio as a place of solitude goes back to the Renaissance: a *studiolo*, or a *cabinet de curieux*, was often built as a windowless chamber with walls lined with cupboards containing objects that symbolized the order of the universe, and arranged around the central space of inspection occupied by the prince-scholar. However, contrary to the Romantic myth of artistic production coming from the exertion of a solitary genius, numerous examples of artists' working environments from the Renaissance to the nineteenth century offer evidence of a studio as the space of collective effort and the site of multiple exchanges. Rembrandt's and Raphael's studios were populated by a number of artists and artisans. In

these settings that combined elements of a studio, a workshop, and a shop, there emerged a specific division of labor, with apprentices, assistants, and specialists performing their precisely defined parts in the production of the work of art. Anthony Hughes compares the relation between the head of the studio and this intricate system of collaborators to a musical perfor-mance, and the studio to a collective performance space (1990:38). The con-cept of the artist's studio in mid-twentieth-century Europe and America was the product of a radical overturn of the notion of the studio as a work-shop that came with the emergence of modernist art. The tension estab-lished during this period between the rebellious artist working in the isola-tion of his studio and the academic sociality of mainstream art still resonated in and around the studio of Mića Popović and Vera Božičković-Popović. What Caroline A. Jones described as an "opposition" between "the ideology of the brushstroke" and the "academic notion of *fini*"—where the latter stands for "careful work" and "social responsibility"—clearly un-derlined the split in Yugoslavia in the early 1950s between the generation of emerging painters and established artists still trying to shed the stylistic residue of socialist realism (Jones 1996:9). Painters such as Mića Popović in Belgrade and Edo Murtić in Zagreb were trying to get away from the pre-scriptive style of socialist realism by using the paintbrush as an instrument for reflection. Here the insertion of live performance into the artists' studio does not represent a replacement of the brush with a body, but an exten-sion and continuation of the search for a gesture that is radically different from socialist realist posturing.

Speaking of the abstract expressionist studio in this same period, Jones points out that it was perceived as an arena where the brushstroke was seen in radical opposition to ordinary labor. The "manly, athletic work en-coded in the spontaneous brushstroke is not housework; nor, in some sense, is it 'labor'—that category of human effort required for survival or wage. It is gratuitous, expressive, personal" (1996:10). And further, she ref-erences an observation that Meyer Schapiro made in 1957 about "the great importance of the mark, the stroke, the brush, the drip, the quality of the substance of the paint itself, and the surface of the canvas as a texture and field of operation—all signs of the artist's active presence. . . . All these qualities of painting may be regarded as a means of affirming the individ-ual in opposition to the contrary qualities of the ordinary experience of working and doing" (11). In the Yugoslav context, this amounted to the artists' rejection of the representation of laboring bodies in search of a ges-ture that spoke of the autonomy of their work. In the catalog for his 1950 exhibition, one of the first public art shows that established a significant

departure from socialist realism, Mića Popović stated his position that "one can't ask painting to narrate the same way literature does" (in Denegri 1993:92). While this kind of statement sounds remarkably close to Clement Greenberg's formalism, it was aimed directly against the prescriptive doctrine of socialist realism and its privileging of the representation of labor over artist's gestures that make representation possible: "What is good in art is that which is experienced, warm, made with a lot of love, and in a word, honest" (39).

This statement from a painter working in Staro sajmište betrays his belief in the same kind of personal idiosyncrasy as that of the defiantly individualistic abstract expressionist painters. Here, however, individualism is pitted against the notion of *fini* as a finish that glosses over, so as to conceal, actual (social) reality. However small and marginalized, the performance of *Waiting of Godot* in a place of labor—coercive, voluntary, artistic—represents a shift from the representation of working bodies to a fragile and temporary moment of reflection, by means of an aesthetic performance, on art's multiple Others (labor, imprisonment, commerce). The doors of a studio/workshop/factory were opened wide for an audience to take an "honest" look at the labor performed there. The picture they encountered was all but pretty, and it matched what they were likely to find in any other workplace. While socialist realist artists were striving to find and depict gestures that would encourage, induce, and perpetuate the cult of labor, the workers, freshly recruited from voluntary youth work brigades, performed their work in conditions that were openly discussed only in closed Party circles. Reports from Party and factory inspections on the construction sites in New Belgrade reveal that workers lived in rooms that were "dirty, squalid, without chests, tables, chairs, with knobs ripped from doors," and in which the "air was intolerable" (Selinić 2007:83).[84] Food was no better: the workers' eatery at the Federal Parliament construction site was known to run short of bread supplies, had lousy meals, was dirty and unsanitary, and had "bread, boots, clothes, socks and kitchen towels all stored in one place" (84). Artists housed in former concentration camp buildings lived on the city's margins, shoulder to shoulder with these workers. Their position was removed from "inside the cone," the one and only position that produced a coherent and polished (*fini*) image of the world.

There is one and only one point at the tip of the cone that gives a coherent image precisely because it corresponds to another point that is opposed to it: the subject of representation. The separation, or the barrier, upon which the image is constituted, enables the subject to see and to be seen: "In the scopic field," writes Lacan, "the gaze is outside, I am looked at, that is

to say, I am a picture" ([1973] 1978:106). The value of painting, of trompe-l'oeil, is precisely in its distinctness from other images, in its display of its own representational nature. Modern painting discovers its primary value in this noncorrespondence with its subject. The painter does not reflect, but *fails*, "reality." What Jones overlooks in her discussion of the "ideology of the brushstroke" is this failure. The correspondence between the blot and *fini* is never direct, never perfect. It is precisely this failure, the wresting of the paint away from the control of the virtuoso painter, that Lacan calls attention to in his remark on expressionist painting.[85] The drop from the paintbrush that falls accidentally on the canvas, like the drop of sweat in the steamy studio that falls on the chalk trace to make a stain, is "the first act in the lying down of a gaze. A sovereign act, no doubt, since it passes into something that is materialized and which, from this sovereignty, will render obsolete, excluded, inoperant, whatever, coming from elsewhere, will be presented before this product" (114). This "rain of the brush" is the constitutive failure of the image. It is the Other around which the subject coheres—its initial slippage and alienation. The bodies heaped on the studio floor, likewise obsolete, inoperant, coming from elsewhere, constituted the Other of labor that is necessary, operative, and familiar. Insofar as their gestures were the *Other of labor*, they can be said to mark the emergence of performance in Yugoslavia. This sovereign gesture of art on a studio floor can be said to constitute the beginning of performance art in an onto-historical sense.

If we take Jean Dubuffet's 1944 and 1946 Parisian exhibitions and those of Jean Fautrier and Wols from 1945 as the first manifestations of Art Informel in postwar Europe, and the 1951 exhibitions *Véhémences Confrontées* and *Signifiants de l'Informel*, together with the publication of Michel Tapié's book *Un Art autre* (1952) as the onset of the period of the movement's dominance in European art, then Yugoslavia was lagging behind. The earliest gestures toward Art Informel in Zagreb and Belgrade can be dated back to 1956, and its more decisive assertion on the art scene came in 1960, suggesting that the emergence of Informel in Yugoslavia was yet another instance of this peripheral culture's reluctant acceptance of an art movement already established in major European centers.[86] This kind of reading of Informel's advent in Yugoslavia and its significance for local culture turns a blind eye to (at least) two larger points. First is the inherent historicity of the new painterly tendencies in postwar Europe, which included tachism, lyrical abstraction, *nuagisme, paysagisme abstrait*, action painting, and others, summarily referred to as *informel*. Michel Ragon suggests that European postwar abstract painting consisted of at least two waves, which were

determined by the age of the painters and by their native cultures (1971:81). One of those waves was the period of increased internationalization that came in the wake of the Twenty-Ninth Venetian Biennale (1958), which indisputably established Art Informel as the leading (even though not formally organized) movement in European painting. Needless to say, this recognition of Informel was also the beginning of its crisis, which led Italian art critic Renato Barilli to speculate about "hot" and "cold" Informel: whereas Informel painting belongs to the former, including the works of Dubuffet, Wols, Hans Hartung, and Antoni Tàpies, in the latter, this approach to abstraction evolves into other radical art practices such as "poor art" (*arte povera*), body art, video, and performance (in Denegri 1980:128). Second, in each of its local manifestations, Informel can be seen simultaneously as part of a larger European movement *and* as a development within its own culture (129). Instead of a center-periphery trajectory in the proliferation of new artistic styles, typical for Europe in the eighteenth and nineteenth centuries, Informel did not leave Paris as a fully formed style to be transplanted to local art scenes, but instead evolved as it entered different cultures.

Acceptance of Informel in Central and Eastern Europe was uneven, to say the least, and was directly related to different political situations from one country to the next. Whereas excessive sovietization of Yugoslavia during the period between 1945 and 1948 simply wiped away its interwar avant-garde heritage, in Czechoslovakia and Poland, where at that time the influence of Soviet cultural policies was much milder, there was a resurgence of interest in interwar surrealism. Art historian Piotr Piotrowski emphasizes that this rekindling of the avant-garde tradition, together with influences from the West, played a pivotal role in emergence of Informel in Poland in 1956, when Tadeusz Kantor exhibited his first canvases done in this style, as well as in Czechoslovakia two years later (Piotrowski 2009:72). Whereas Kantor's early Informel, as well as that of other Polish artists such as Jerzy Kujawski and Alfred Lenica and Czechs Josef Istler and Jiri Balcar, was marked by a marked gesturality, Yugoslav Informel was characterized by artists' radical experimentation with materials used in the process in painting. This destructive attitude toward the canvas was championed by Ivo Gattin, the pioneer of Informel from Zagreb. He started from standard Informel procedures, which included incorporation of nonpainterly materials such as broken glass and sand into his paintings. Once he produced his first Informel canvases (1956), he moved rapidly from paintbrush to industrial torch blower. By melting the surface of the painting he initiated processes in the materials applied on canvas that were no longer subject to

his control. Gradually, this relation to the canvas transforms the very format of the painting, turning it from a flat square into a shapeless volume of melted and burned material. In the article "New Material" ("Novi material") published the following year, which remained his sole theoretical publication, Gattin called attention to the impact of industrially produced materials on modern art. Unlike in the Renaissance workshop, in the modern studio "factories dictate the visual and the qualitative evolution of the material, while for the painter the material becomes a terra incognita." This attitude toward material has become so common, continues Gattin, that "for many contemporary paintings we can assert, without exaggeration, that the factory is their cocreator" (Gattin 1957:11). Gattin held "materiality of the material" as important as "drawing, color, and tone" because "it carries the direct vibration of painter's nerve" over to the canvas (11). Paradoxically, while he emphasized materials' role in conveying authorial "vibration," by replacing the materiality of the brush with the immateriality of the flame, Gattin removed himself from a direct contact with the canvas. Here the "rain" of the brush was liberated from the artist's touch and left to spontaneous interactions of material and heat. In this text as well as in his numerous paintings, Gattin seemed to suggest that radical art practice had to choose between two forms of an artist's passivity: vis-à-vis industry or vis-à-vis material itself. He opted for the latter.

Gattin's work from the late 1950s was a turning point in Yugoslav post–World War II art: for the first time, the process took precedence over the art object, which becomes stripped of any utilitarian value. The painting is no longer an aesthetic object, but a residue of artistic performance. Unlike most Informel artists in Croatia, Yugoslavia, and beyond, Gattin was unswerving in his commitment to his radical approach to painting. In 1962 he made his last "burned" canvases, and in 1963 he moved to Milan, Italy. While most art historians took this as his "exit" from active art practice, Branka Stipančić calls attention to small-format drawings he made from 1963 to 1967. In one of them, produced in 1964, he combines drawing with written text. Like some other modernist artists before him, facing the impasse of his radical artistic practice, Gattin turns to writing.[87] In this drawing/poem/manifesto, he demonstrates an awareness that departure from conventional format (square canvas) and technique (brush, paint), takes him away from painting as such, and into the realm of live action: "To go outside the margins is / the necessity of my action," and further:

All this is
a *happening* that has determined

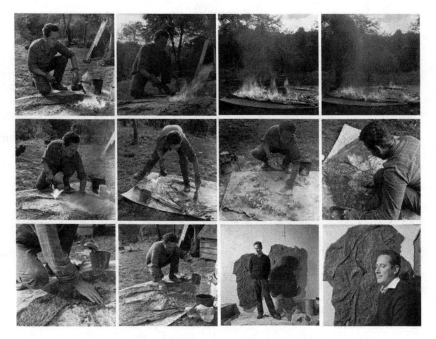

Fig. 14. Ivo Gattin: *Process*, 1962. Photograph by Nenad Gattin. Courtesy of Marinko Sudac Collection.

the form, color,
material, and image of my
"painting."

(in Stipančić 1992:24)[88]

And like some other radical modernist artists, Gattin made an exit from his art and entered a period of silence, which in his case lasted for an entire decade.[89] He returned to painting in 1977, but his departure from art, like Popović's from theater, marks the limit of radical artistic practice in Yugoslavia of the 1950s.

Several Yugoslav artists, Mića Popović among them, followed Gattin in using flame and acids to "attack" the canvas and initiate chemical processes in which the artist's hand was no longer involved. Since through this process paintings acquired a layered, almost geological quality, critics observed that the artists were abandoning "composition" in favor of "structure" (Denegri 1980:131). Still focused on art object, rather than on art process, they called this aggressive branch of Informel "structural." While seen

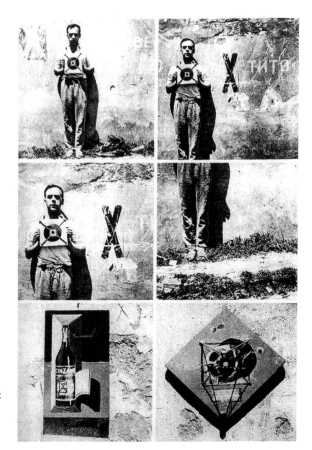

Fig. 15. Leonid Šejka: *Declaration*, April 1958. Photographer unknown.

as representative of, to use Barilli's formulation, "hot" Informel, Gattin's actions are actively anticipating "cold" Informel. In Zagreb, the group Gorgona (1959–66), which was described by some critics as "radical" or "conceptual" Informel, abandoned the art object and experimented with "Gorgonesque ideas," "Gorgonesque actions," and "Gorgonesque behavior" (Dimitrijević 2002:68). In Belgrade, the group Mediala, founded in 1957, engaged in a seemingly paradoxical pursuit of the ideals of Renaissance painting and neo-Dadaist strategies for the destruction of the art object, which made them, as the art historian Miško Šuvaković observed, at the same time retrograde and proto-postmodernist (1993:66). Even before Mediala was formed, as early as 1955, one of its founders, Leonid Šejka, staged actions that were part of his overall artistic project, which also included painting, writing, and film.

The series of photographs in figure 15 includes shots made during one

of Šejka's proto-performance art pieces. He performed these actions for limited audiences (sometimes of only one), and away from public spaces. They complemented his writing and paintings, and represented an integral part of his personal cosmology. According to this cosmology, the world consists of the City, the Garbage Dump, and the Castle. The City is the realm of collectivity, work, rationality, and order. "Since the City has its own causality, the action can't exist outside of that causality, independently from it. Every action is integrated into the movement of the whole mechanism. Every movement is part of the general machine called the City" (Šejka 1982:14). In order to perform an autonomous action, an individual has to search for the Garbage Dump. This is not a place of exile. While physically overlapping with the city, it is its verso, its negation, its imprint. The Garbage Dump is the place of uselessness, nonproductivity, insignificance, formlessness, and passivity. The Garbage Dump does not allow even the use of the word "worker" (58). This prohibition signifies, on the one hand, the nonproductive nature of the Garbage Dump, and on the other, its sacredness and exclusion from the circulation to which it is subjected in the City. The graffiti "Tito" inscribed in Cyrillic letters on the wall behind the performer is the name of the archetypical worker. At the same time, it is a trace of the vast machinistic performance that organizes the City into huge arrangements of bodies. Scratched onto the stucco wall of the Garbage Dump, these letters are liberated in the same way in which an empty bottle, once freed of its purpose, becomes an object. In his narrative about the one who searches for the Garbage Dump in the fissures of the City, Šejka writes, "He was hoping that if the objects without use become what they really are, he will also be able to say: 'I am'" (57). This poststructural performance represents a staging of "the rain of the brush" after the reign of the brush had ended.

In 1939, Soviet citizens spelled out with their bodies the acronym of the Soviet state. The characters CCCP (USSR) march across Red Square. Almost forty five years later, Yugoslav youth put their bodies together to form Tito's name.

In his Fluxus-inspired 1970 publication *Mixed Media*, Bora Ćosić named this form of mass performance "bodywriting" (*telopis*), and used it as one in a series of examples (alongside with Andy Warhol's films, Dalí's paranoic-critical method, Allan Kaprow's happenings, and the Slovene art collective OHO) of a much wider phenomenon of pan-aestheticism (Ćosić 1970:7). In his book *Sodom and Gomorrah: An Attempt at Comparative Phenomenology*, he related bodywriting not only to mass gymnastics, but also to the tradition of music hall performances of the early twentieth century. Here he recognized the "ancient homunculus ideal," according to which a "seemingly inani-

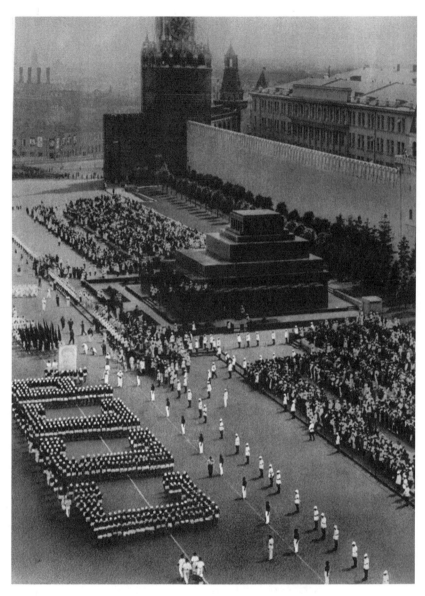

Fig. 16. All-Union Physical Culturist Day, Moscow, 1939.

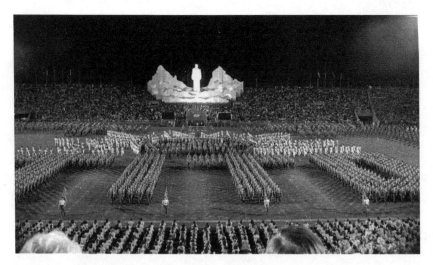

Fig. 17. Youth Day, Belgrade, 1983. Photograph courtesy Tanjug.

mate object, image, or a pattern" comes to life on its own "since it already consists of undeniably living elements, that is to say beings" (Ćosić 1963:111).[90] How do we then read and understand these living, pulsating patterns? Are they performances or texts? Discourses or nondiscursive formations? Without any doubt, they bring together, in an unconventional and surprising way, two poles of Wilhelm Worringer's *Abstraction and Empathy*. *Telopis*, bodywriting, is at once an abstract pattern and a living, organic form. It both happens and, to use Worringer's locution, is redeemed from the course of happening (1997:21). It is both read and experienced. It brings together text and performance, letters and diagrammatic lines. Or more precisely, it forces bodies and letters into diagrammatic formations.

And further, what is the distance between the graffiti "ТИТО" engraved in stucco behind Šejka's back and the same name written in bodies on the stadium's green, or from drained *Godot* actors on a studio floor to enraptured laborers on a construction site, or from Gattin's conflagrations to heroic statues on city squares? Infinite, it seems, and none. The garbage dump, the former concentration camp, and the painter's backyard are artistic undercommons, but they are not dissident spaces. I want to see them as those unlegislated regions of baroque states, tears and gaps in their fabric of power, that Élisée Reclus and other nineteenth-century anarchists left to the social imaginings of equality and freedom.

TWO | Syntactical Performances

BEYOND THE PERFORMANCE PRINCIPLE

In the immediate aftermath of the May–June 1968 uprisings around the world, posters with the slogan "Marx Mao Marcuse" began appearing on the streets of Rome. While in Italy (and elsewhere in Europe) student protests were spawning radical political groups, Herbert Marcuse offered his vision of a new society to an audience gathered on the other side of the Adriatic.[1] In a talk entitled "The Realm of Freedom and the Realm of Necessity: A Reconsideration," which he gave on the small island of Korčula off the coast of Croatia, he called for the "transformation of work itself," which would come not only through a revolutionary change in production relations but through the "emergence and education of *a new type of man*" with the ultimate goal of creating a whole new humanity (Marcuse 1969a:24; emphasis added). It was this kind of vision, beginning with the publication of his book *Eros and Civilization* (1955) and culminating with his response to the wave of student demonstrations in 1968, that made Marcuse, in the early 1970s, one of the most prominent representatives of the Frankfurt School of critical theory.

Marcuse's presence in Yugoslavia during that summer, when his name resounded on American campuses and on the street battlegrounds of major European cities, was hardly a surprise. He had been associated with the Korčula Summer School since its first session in the summer of 1964. Internationally recognized leftist philosophers such as Henri Lefebvre, Ernst Bloch, Lucien Goldmann, and Eugen Fink had landed the summer school its worldwide recognition. Organized by the same group of Zagreb philosophers who edited the journal *Praxis* during its decade-long lifespan (1964–74), the Korčula Summer School became an annual showcase for the so-called Praxis philosophy, which, along with the Frankfurt Institute for Social Research (the Frankfurt School), ranked as one of the most prominent centers of critical and unorthodox Marxism in Europe.[2] Although most of its scholarly output was published in *Praxis*, the journal was not

merely the publication arm of the school. The papers selected from each summer filled only one of four annual issues of *Praxis*, and many of the most provocative and original articles published in the journal were not presented at Korčula. Milan Kangrga, the founder and the main organizer of the school, has suggested that some of the most stimulating ideas during the school's sessions were not brought up in plenaries, but in small discussion groups and informal conversations in beachside restaurants (2001:229). Each summer, the weeklong gathering had a different topic, and in August 1968, in recognition of Marx's 150th anniversary, it was "Marx and Revolution."[3] That summer the school drew some five hundred participants from Eastern and Western Europe and America, which set the school's record for attendance.

International developments notwithstanding, Marcuse's visit to Korčula during the summer of 1968 also had a lot to do with the internal dynamics of Yugoslav Marxism and its development over the previous decade. The group of young philosophers and sociologists behind the journal *Praxis* and the Korčula Summer School emerged in the early 1950s, and by the end of the decade they commanded considerable prestige in their academic fields. In the process, they developed a brand of Marxism as a properly philosophical undertaking that rejected the doctrinaire Marxism developed in the USSR of the 1930s and 1940s and insisted on bringing Marx's ideas in dialogue with other currents in modern philosophy, from Martin Heidegger's brand of phenomenology (Gajo Petrović, Vanja Sutlić), to Hegelian dialectics (Milan Kangrga), to twentieth-century reformist Marxists (Predrag Vranicki). This group of young Marxists first asserted its superiority over "diamat" in an annual congress of the Yugoslav Philosophical Association (Jugoslovensko udruženje za filozofiju) held on November 10–11, 1960, in the Slovene resort of Bled. The theme of this watershed conference was the theory of reflection, one of the central theoretical concepts of Soviet-style Marxism. Its Yugoslav adherents, used to Georgi Plekhanov's and Todor Pavlov's laconic premise about human conscience as a subjective reflection of objective reality, found impossible to swallow unorthodox claims, such as Milan Kangrga's argument that for Marx there is no such thing as "objective" and innate nature. In his close reading of *German Ideology*, Kangrga suggested that Marx is not talking about "nature in itself" but about "nature that is produced according to man's measure, about nature as alienation (*Entäusserung*) of human production." He concluded that for Marx, nature is but an "objectified human production (labor), a product and result of human productive activity, his own creation that takes place within the medium of historicity" (1960:37). In the general

discussion, instead of offering a counterargument to Kangrga and friends, the exponents of diamat lapsed into complaints about the influence that philosophical "trendies" had on the Philosophical Association's board.

In post-1948 Yugoslavia, pushing through a certain agenda in a philosophy conference was not a purely scholarly affair. Yugoslavia's political leaders promoted the country as a reformist beacon among socialist countries, and their own actions as both political and theoretical contributions to resurgent Marxism. Many of Yugoslavia's top politicians started their careers in international Marxist circles of the 1920s and 1930s, in which the idea of a politician-philosopher was a matter of distinction from the utilitarian politicos of the day. Bertolt Brecht summed up this idea in his 1931 text "Theory of Pedagogies": "Bourgeois philosophers draw a major distinction between those who are active and those who are contemplative. Those who think do not draw this distinction. If one draws this distinction, then one leaves politics to those who are active and philosophy to those who are contemplative, whereas in reality, politicians have to be philosophers and philosophers have to be politicians" (Brecht 2003:89).[4] An intense encounter between a politician and philosophers took place in the conference "Marx and the Present" ("Marks i savremenost"), held June 1–4, 1964, in the northern Serbian city of Novi Sad, in which Veljko Vlahović, one of the highest-ranking politicians in the country, presented the paper "Remarks on Certain Approaches to the Theory of Alienation" ("Neka zapažanja u tretiranju teorije otuđenja").[5] Notably, he gave his paper back-to-back with "Socialism and Alienation: Theses" ("Socijalizam i alijenacija: teze") by Predrag Vranicki, one of the leading members of "humanist Marxist" group from Zagreb University. Whereas the former spoke in generalizations about "forces of alienation" and "struggle for disalienation," the latter argued very directly about Stalinism as a specific form of political alienation in socialist societies. In a carefully structured series of short theses, Vranicki first pointed to "double consciousness" and "homo duplex" as a common form of psychological alienation in socialist countries. From there, he went on to list some of the main traits of the "myth of Stalin" as a pervasive form of self-alienation to which socialism is vulnerable: from "personality cult," to "bureaucratism," to the necessity of the "separation of party and state" (Vranicki 1964:485). All who would listen understood very well that Vranicki was talking about the lingering features of Stalinism in Yugoslavia and about the necessity of further liberalization of Yugoslav society.

In the general discussion, Gajo Petrović offered a detailed critique of Vlahović's paper. He organized his comments in eighteen points, ranging from relatively benign ones, such as Vlahović's loose handling of analogies,

to serious methodological mistakes in his treatment of alienation as either economic or ethical category, to his utter incomprehension of Marx's "ontological understanding of man" (Petrović 1964b:567). In short, he treated the paper by the member of the Central Committee of the League of Communists of Yugoslavia like a college senior's term paper. While acknowledging Vlahović's high rank in the political hierarchy of the country and applauding his willingness to give his ideas a trial in front of an audience of professional philosophers, in his meticulous analysis Petrović didn't come near one of the most poignant moments in the politician-philosopher's talk. Nested between critiques of "theories of nonsense" in Western Europe and racism in the American South was Vlahović's direct address to his audience: "Our state is, in fact, a state that negates the state, and such a state deserves some respect" (Vlahović 1964:478). Philosophers in the audience knew all too well that this was the state itself addressing them from the lectern. This was an astonishing instance of self-referentiality. The state, personified in one of its top politicians, was saying: I deny myself theoretically, but in order to do that I have to magnify myself politically. And that meant this: by approving my philosophical self-disavowal, you are also endorsing my political elevation. In his response to Petrović's comments, Vlahović said as much: "To me, anyway, this is not the first time to collaborate with philosophers and other scholars. There are comrades present in this room who worked with me on the League of Communists Program. We had over twenty meetings. Among other things, we reviewed some issues related to alienation while working on the chapter on bureaucratism" (592). The philosophers in the audience knew whom he was talking about. His collaborators came to his aid, refuting Petrović's critique. But even those who didn't participate in the tailoring of Party documents were in some agreement with the state.

Self-management was the minimum of consensus between the state and its critics, that is to say, between politicians and philosophers. Vranicki, in the paper I cited above: "With the workingman's self-management begins the process of elimination of hired labor, which is the very alienated relationship in which the man is a mere means of production" (486). However: "Considering the complexity of internal and international situation and influences in its early phase of development, not all forms of self-management, which are basically disalienated, are absolute in their own right" (484). Two years later, Petrović concluded a talk on alienation he gave at the University of Notre Dame in South Bend, Indiana, by circling back to this same idea: "Economic disalienation requires the elimination of state ownership and its transformation into a truly social ownership, and

that can be accomplished only through reorganization of the entire social life on the basis of self-management of production workers." And that is not all. Disalienation necessitates overcoming all forms of labor, including the intellectual labor of philosophers: "Philosophy should stop being a narrow and specialized branch of thought. It should evolve as a man's critical reflection on himself and the world in which he lives, as self-reflection which runs through all aspects of his life and serves as a synchronizing force for all his activities. As a category that implies the negation of philosophy, the category of disalienation is not only philosophical, but also meta-philosophical" (Petrović [1966] 1969:71). The politician and philosophers shared the same theoretical premise of overcoming the state and philosophy through socialization of management and of critical discourse. As a minimum of social agreement, self-management was not only the common goal, but also a medium of communication between the state and its critics.[6] Part of the reason Marcuse and other reformist Marxists kept coming to Korčula was that in Yugoslavia their ideas were not confined to street protests, but had at least some chance of filtering up to the highest levels of institutional politics. The theory of alienation was one avenue of this traffic between critical theory and state politics.

The "new type of man" Marcuse spoke about on the island of Korčula in August 1968 was a disalienated man. In the late 1960s, Marcuse's critique of industrial capitalism seemed to offer a natural continuation of the Marxist theory of alienation. He signaled the Marxian basis of his theory in the title of his talk at Korčula, which referenced the celebrated phrase from *Capital*. In his update of Marx's classical economic theory, Marcuse suggested that the "realm of necessity" invades the "realm of freedom" by replacing production with consumption. Starting with the explosion of the production of consumer goods in the early 1950s, the theory of the production of needs was gaining prominence among Western Marxists, and by the late 1960s it was already a well-known story. The "French May" and other developments in and around 1968 gave Marcuse ample evidence of the emergence of an oppositional movement that seemed to turn the two realms from a simple duality to a dialectical process:

> The growing productivity of labour tends to transform the work process into a technical process in which the human agent of production plays increasingly the role of a supervisor, inventor and experimenter. This trend is inherent in, and is the very expression of the rising productivity of labour. It is the extension of the realm of freedom, or the realm of possible freedom to the realm of necessity.

The work process itself, the socially necessary work, becomes, in its rationality, subject to the free play of the mind, of imagination, the free play with the pleasurable possibilities of things and nature. (1969:23)

Marcuse's conceptualization of labor as the political and therapeutic locus of liberation comes from his parallel reading of Freud and Marx in his landmark works *Eros and Civilization* (1955) and *One-Dimensional Man* (1964). In the former, he posits work as inherently opposed to the "pleasure principle." According to Marcuse, work is that aspect of human existence which engages directly in the natural economy of "scarcity" in a "world too poor for satisfaction of human needs." It follows, then, that "for the duration of work, which occupies practically the entire existence of the mature individual, pleasure is 'suspended' and pain prevails" (1955:35). What distinguishes advanced capitalism is that the organization of work matches the "specific *organization* of scarcity," which is no longer aimed at mere survival but toward meeting certain goals set by the society itself. This denaturalization of "scarcity" transforms the realm of work into the "performance principle" as the "prevailing historical form of reality principle" (35). According to Marcuse, the performance principle represents the very essence of alienated labor. The "modern individual" is reduced to an "instrument of alienated performance," save for a few hours of leisure that offer a possibility of experiencing pleasure and happiness. Because of this work of repression, even "his erotic performance is brought in line with his societal performance" (Marcuse 1955: 47). Jon McKenzie recognized that Marcuse theorizes performance as a "mode of social domination which corresponds to the apparatus of modern technology" (2001:160). If, as McKenzie argues, performance studies barely acknowledged Marcuse's notion of performance, it may be because the formative years of this discipline coincided with the swing in the opposite direction. In the late 1960s, the general perception was that the realm of freedom expands into the realm of necessity, or to put it differently, that aesthetic performance comes to inform and transform industrial performance. What aesthetic performance seemed, at the time, capable of offering was, paradoxically, the promise of removing mediation from person-to-person relationships, and with it a path to authenticity in all realms of human existence, including labor. But what was this unalienated, authentic labor?

Starting in the 1950s, Yugoslav humanist Marxists identified this kind of labor not only with self-management, but with an expanded notion of human activity they recognized as *praxis*. In his editorial for the first issue

of the eponymous journal, published in 1964, philosopher Gajo Petrović explained that the editors' choice of the "Greek variant of the word does not mean that we understand this category in the sense it had somewhere in Greek philosophy. We did that in order to make a clear distinction in relation to the pragmatic and vulgar-Marxist understanding of practice and to indicate that we are interested in the authentic Marx" (1964a:4). Indeed, authenticity and humanism were perhaps two leading categories in the Praxis school's elaboration of its philosophical and social goals. Unlike representatives of "diamat" who insisted on the scientificity of Marx's thought, this group insisted on its openness and contemporaneity. They demonstrated this breadth of Marx by engaging in wide variety of its interpretations, from psychoanalytic to phenomenological. Several group members were particularly interested in the latter, as evidenced by Branko Bošnjak's article "The Name and Concept of Praxis" ("Ime i pojam Praxis"), published in the same issue of the journal. While offering a brief historical survey of praxis from Plato to Hegel, Bošnjak emphasized praxis as "the essence of human existence" (1964:7). Praxis philosophers discussed "existence" both in Heideggerian and in Marxian terms: the former helped them address the ontological status of Being, which they grounded in a thoroughly historical and materialist notion of "total man" (13).[7] From this investigation of Marx in light of contemporary philosophical and extraphilosophical issues emerges the notion of praxis as a new humanism: "The task is to humanize everything that exists. That is the dimension of praxis in philosophical considerations" (19). An important aspect of this "humanization" was overcoming alienation. Petrović would go on to write that, "according to this interpretation, praxis is a specifically human form of existence that decisively sets man apart from all other beings. It is a free and creative activity through which man fashions and shapes himself and his human world; a historical action led by a call from the future" (1986:303). The performance principle defines the form that alienation takes in industrial societies, and performance for dialecticians is what Yugoslav humanist Marxists presented as an alternative to the idea of praxis.

Responding to Marcuse's lecture at Korčula, Ernst Bloch focused precisely on the notions of alienation and possibility that are central to "The Realm of Freedom and the Realm of Necessity: A Reconsideration." Departing in his own fashion from the vulgar reading of Marx's notion of man as a certain kind of primordial human, Bloch posed the question of the "self from which man is alienated" and answered in the same breath that it is the "unknown man, the *homo ignotus* in us" who seeks to discover the new. And it is precisely this *new* that socialism strives to affirm: "The possible is

what is only partially conditioned; one more conditioning factor is needed for it to be realized, and that subjective factor is action, which is the transition from theory to practice" (1969b:595).[8] In his response, after delving into the question of the revolutionary subject, Marcuse turned to the question of the possibility of departing from alienated labor, or, to use the terminology of *Eros and Civilization*, from the performance principle.[9] For Marcuse, as for many other Marxists gathered at Korčula that summer, this possibility was offered by self-management. On many occasions during that week on the Adriatic coast, the notion of *autogestion* as formulated during the French May and the doctrine of self-management as formulated by Yugoslav ideologues were seen as comparable or complementary, and in any case close enough to point in a direction beyond the performance principle. Marcuse emphasized that in order to accomplish this surpassing, self-management had "to be more than a mere change in the form of administration." He professed his agreement with the idea, suggested repeatedly during the conference, that "self-government is a way of life," and then asked, what kind of life?[10] "The way of life in which people no longer satisfy the repressive, aggressive needs and aspirations of a class society . . . ; self-government in the enterprises, in the factories, in the shops, can be a liberating mode of control only if a liberating change in the controlling groups themselves has occurred." And further, with a hint of criticism for the Yugoslav official doctrine of self-management:

> We cannot hope for the miracle that such a change would come in the process of self-government after its establishment. Once the process of self-government has started without a change in the subjective conditions, we may get only the same only bigger and better. That may be already a great progress, one should not minimize it, but it is certainly not the beginning of a socialist society as a qualitatively different form of life. (1969b:329)

This veiled criticism was insufficient. Reports from Korčula reveal that students participating in the summer school were disappointed by the absence of a plan for concrete political action that would ensure the continuation of the student movement that seemed to emerge in the aftermath of the student demonstrations that had erupted at Belgrade University only a few weeks prior.[11] In the early 1960s, there were already two distinct discourses of self-management in Yugoslavia—that of politicians and that of philosophers—that tolerated each other. They were in a continuous process of repositioning. The student unrest in June 1968 radicalized this dif-

ference. It exposed the gap between the theory and practice of self-management in Yugoslavia and demonstrated that it was unsustainable.

CRACKED BAROQUE

The student uprising at Belgrade University started on June 2 and lasted until June 9. In some respects, it resembled similar student demonstrations that were shaking universities around the world, from Poland to Japan. What is significant for 1968 as a planetary phenomenon was that each participating event was singular in the way in which it emerged, its meaning, and its legacy. For example, French sociologist Edgar Morin compared the complex, rhythmic development of protests in Paris and across France from May 3 to 30 to the first act of a French neoclassical drama, and the long aftermath that took place in June to the second act (Morin 1975:42). This structure came, he argued, from a deep rupture within the "sociological event" that produced a theatrical pairing of the random or accidental with the innate, hidden, and unfathomable aspects of the crisis (33). What distinguishes the student strike at Belgrade University in June 1968 from the majority of other student protests around the world is that moments of theater—not theatricality, but theater as such—proved to be necessary for the synchronization of the random and deep levels of the crisis. Almost in an Aristotelian fashion, the beginning, the high point, and the end of the process were marked by performances, each of them displaying different forms of theatricality.

The first piece of theater happened on June 2, 1968. That evening, the dress rehearsal of a variety show, *Caravan of Friendship* (*Karavan prijateljstva*), sponsored by the large-circulation daily *Evening News* (*Večernje novosti*), was scheduled to take place in an adult education center at the outskirts of New Belgrade.[12] Staged by Croatian theater and television director Anton Marti, *Caravan of Friendship* was a typical example of live popular entertainment in Yugoslavia during the 1950s and 1960s, featuring singers, dancers, and comedy acts. The caravan was typically a monthlong tour that culminated with a spectacle in Belgrade. At each stop along the way, the caravan participants performed in shows that were conceived as contests in which audience members voted for their favorite singers in two basic categories, pop and folk music. *Caravan of Friendship* drew its ideological legitimization from the idea of brotherhood and unity: it emulated the Youth Relay Race not only in its "run" through all republics and autonomous regions, but also in its insistence on visiting factories.

In 1968, the caravan's first public performance was scheduled for June 3 in the small eastern Serbian town of Kučevo. From there, it would roar through eighteen cities in Serbia, Macedonia, Montenegro, Croatia, and Bosnia and Herzegovina. That year more than ever, *Caravan of Friendship* served as the epitome of the Yugoslav economy's ability to reconcile business with socialism. Along with promoting its general sponsor, the *Evening News*, in 1968 *Caravan of Friendship* advertised the state-owned Industriaimport, the main importer for the French carmaker Simca (Société Industrielle de Mécanique et Carrosserie Automobile) in Yugoslavia. Consequently, the contestants and their entourage were driven around the country in Simca cars and buses. The capstone of this traveling spectacle was to take place in Belgrade with a performance by the two singers who had won the most contests during the tour (Đorđe Marjanović in the category of pop and Safet Isović in the category of folk songs), plus a special appearance by the American television actor Roy Thinnes, who played one of the leading roles on ABC's soap opera *The Long, Hot Summer*.[13] The final rehearsal on June 2 was supposed to take place in front of an audience of participants in Volunteer Youth Work Action New Belgrade '68. Even that decision fit the new mantra of a profit-driven culture. Although they saw themselves as carriers of the legacy of the heroic postwar socialist reconstruction, the organizers of this modern brand of youth work actions adjusted to the burgeoning economic and ideological environment. In the summer of 1968, they were all about business: the organizers of the youth work action were proud of the fact that they outbid other competitors in an open contest to get the contract for developing the infrastructure in New Belgrade.

In its press statement explaining what set off the June 2 clash that initiated the week of student protests, the headquarters of the Youth Work Action "New Belgrade '68" declared that the security forces of the adult education center prevented the students from entering the building because they were following instructions they had received from the variety show producers, who "insisted this performance should be closed to the general public because it was scheduled to play for paying audience in downtown Belgrade" ("Od mirnih demonstracija . . ." 1968:6).[14] The tension that sparked the explosion at the dress rehearsal of the *Caravan*'s 1968 tour came from the volatile charge created by two different cultures in close proximity: the mainstream culture of Yugoslav popular entertainment and an emerging alternative politics that had its strongest support among students.

The large complex of student dormitories, popularly known as Student City (Studentski grad), was located across the street from the hall in which the variety show was to take place. It was another hazy early summer eve-

ning in New Belgrade, similar to the night when *Waiting for Godot* was performed fourteen years earlier. Early June is the finals period at Belgrade University, and the dorms were packed with students reading for their exams. Late in the afternoon there was a power outage, and many students left their rooms. A large group gathered in front of the education center, trying to get to the variety show. At one point, a long file of brigadiers from Volunteer Youth Work Action New Belgrade '68 showed up and marched into the building. Some students tried to force their way in, and security guards intervened. When the scuffle between the students and security guards did not let up, a forty-man-strong unit of riot police showed up. The scuffle turned into a fight: alarmed by the news about the police intervention, many students came out from the dorms and joined their friends in front of the concert hall. The police got their own reinforcements. A fire truck was brought to the scene, and the police used a water cannon to push the students back toward the dorm. Many students were injured. There was a rumor that one of them died (Hodžić et al. 1971:56). By midnight, there were around three thousand students in the plaza facing the dormitories. The crowd pushed back the police and, at one point, seized the fire truck. At first, the speakers used it as a podium. Then, around midnight, the group decided to march to Belgrade city center in order to make their grievances public. The police blocked their path at a railway underpass, which was located a couple of hundred yards from a complex of newly built government buildings. Some of the students tried to negotiate with the police, but the large group of students waiting for the negotiators launched rocks at the police. Then, at one point, a gunshot was heard. Riled students set the truck on fire and pushed it toward the police cordon. This led to another violent clash, after which the group of student protesters disbanded and retreated to their dormitories. There gatherings continued throughout the night. The students were bewildered by the excessive actions of the police. Why did they show up in such numbers? And why were they so violent?[15]

The events following the June 2 skirmishes with the police were, in part, an upshot of grassroots student self-organization at Belgrade University. In the spring of 1968, the university newspaper, *Student*, published a series of articles, editorials, and documents that spoke of a deep social crisis in Yugoslavia. It all began with another seemingly insignificant incident. In its April 23 issue, *Student* published a sharp exchange between a group of students from the Department of Sociology at the School of Philosophy and the leadership of the Student Federation, the state-sponsored association of students at Belgrade University. Earlier that month, the group of students

initiated the signing of a petition in support of student protests in Poland, which the University Committee, the governing body of the Student Federation, denounced in a published statement. The conflict between these two student bodies—one official and recognized as the most powerful sociopolitical organization at Belgrade University, and the other a spontaneously organized group—touched the very core of the doctrine of Yugoslav self-management. In their open letter, the sociology students questioned the legitimacy of the University Committee that condemned the 1,520 students who signed the petition: "Who gives to the University Committee or to any other body in this free-thinking country the right to disavow and condemn anyone's personal opinion?" And they went on to point to the paradox of the University Committee's renouncing "the action that was initiated by the members of the Student Federation . . . if we take into consideration that the main principle of our socialism is SELF-MANAGEMENT, which means decision-making from below" (*Student* 1968:1). They concluded the letter by questioning the very purpose of the Student Federation as a legitimate sociopolitical organization.

In this conflict, the ad hoc group from the Department of Sociology gained certain visibility and at least some concessions from university officials. On May 11, the University Committee supported the initiative of the students from Sociology to organize a peaceful protest in front of the West German embassy against that country's threats of militarization and in support of its student movement. A few days later, *Student* published telegrams of support that the University Board sent to the nonparliamentary opposition in West Germany and to the Union of Students at the Sorbonne. Then, in its next issue, on May 21, only four days before the Youth Day celebration, *Student* published a front-page editorial that spoke directly to the deep social crisis in Yugoslav society. The anonymous editorial opened in an almost threatening manner: "What are students up to? Are they working on anything else except on their exams? How do they feel?" (1968:1).[16] Responding to its own questions, the article spoke of the "tension" among students, which could easily turn into an "open conflict." The editorial energetically dismissed the notion that this discontent was just an attempt to imitate student uprisings at universities across Western Europe and America, and pointed to the increasing social inequalities and injustices pervasive in Yugoslav society, including rising unemployment, corrupt institutions, and the lack of criteria for managers' and politicians' personal responsibility as its source (1). The editorial suggested that the "tension" was not limited to the School of Philosophy, and pointed out examples of public gatherings at the schools of Agriculture and Law, where students

voiced their dissatisfaction with their material conditions. In conclusion, the editorial claimed that student requests submitted to the administration regularly ended up rejected, regardless of the merit of the request, and were "approved only if the students threaten with demonstrations" (1).

The *Student* editorial was not only a disclosure of the hypocrisy of socialist bureaucracy, but also a bold reminder of the bloody conflict between students and police that had taken place only a year and a half prior in the streets around the School of Philosophy, located in downtown Belgrade. In December 1966, the Student League organized a protest against the war in Vietnam. After the meeting, which took place in a large lecture hall, a group of students wanted to deliver a protest letter to the American Center Library, which was located around the corner from the School of Philosophy. They were intercepted by riot police, who fired tear gas and used water cannons and cavalry. The police beat students in the streets, and even chased after them in university buildings. The students saw the beatings, arrests, and arbitrary court sentences for what they were: flagrant offenses against the human rights of Yugoslav citizens. The invasion of university buildings by the police was, in their eyes, an equally disturbing infraction of the autonomy of the university. The references to the potential conflict in the *Student* editorial of May 21, 1968, suggested that the confrontation between students on the one side and a brutal police force and incompetent and corrupt justice system on the other was far from over.

Spontaneous gatherings at Student City continued throughout the sleepless night between June 2 and 3, following the "first battle at the overpass," as the night clash with the police came to be known among students. One significant development of this night was the open mistrust that students expressed toward the Student City branch of the Student Federation. The rebels accused its officials of shutting down the PA system in the dorms, which in the initial stages of the conflict with the police served as the only means of communication in the vast complex of dormitories. In place of the ousted Student Federation officials, the students formed their own action committee, the first of its kind during the protest. It issued a call for another protest gathering the following day (June 3). In the meantime, the University Committee held an early morning emergency meeting in downtown Belgrade. Many participants from the previous night's protest march joined the meeting and informed the members of the University Committee about the police brutality against students in Student City and at the overpass. It was at this meeting that the first suggestion of a university-wide strike was brought up. Like many students who lived in dorms and private housing scattered throughout Belgrade, the members of

the University Committee went over to Student City to join the protest that was to begin at 8:00 a.m. Several speakers suggested organizing another protest march to the building of the Federal Parliament in downtown Belgrade, where students could present their grievances to the country's political leaders. Before 10:00 a.m., some four thousand students marched in an orderly column along the same route they had taken the previous night. The photographs show that many of them chose to dress in their best clothes. This was an important occasion for these young men and women, many of whom came from the impoverished countryside and subsisted on small government stipends. In their ceremonial approach to this public display of their discontent, they more closely resembled the civil rights marchers in Selma, Alabama, than the urban guerillas in Paris and Bonn.

Two workers driving a small truck joined the column at the front. Standing on its flatbed and leaning against the cab, young men and women waved Yugoslav national flags and the flags of the League of Communists. The students also displayed large portraits of President Tito and Che Guevara. On crude improvised posters they wrote slogans that ranged from expressions of their commitment to Yugoslav socialism ("Tito-Party"), to specific grievances ("I was beaten up"), to their calls for broad social changes ("Students-Workers," "Down with the red bourgeoisie," "Do we have a Constitution?"). Shortly after 10:00 a.m. they arrived again at the overpass. And yet again, strong police forces blocked their passage. This time around, a number of high-ranking politicians stood behind the police lines. A student delegation was allowed to get through the tight police line to negotiate with the politicians. The students' bottom-line request was to hold a protest meeting in front of one of the governmental institutions, preferably in downtown Belgrade, or at least in front of the new government buildings that were only a few hundred yards away from the overpass. The politicians insisted that the marchers retreat to Student City and hold any mass gatherings there. The negotiations lasted for almost two hours, while the protesters and the police waited in the scorching sun. Then, shortly after noon, there was a skirmish on the right wing of the front line. In an instant, it turned into a massive police assault. Afterward, students who were in the first lines claimed that they clearly heard the order: "Charge" (Arsić and Marković 1984:81). The violence from the previous night was happening again, this time on a much larger scale. According to witnesses' accounts, the policemen wielded their batons arbitrarily and brutally beat up the demonstrators, regardless of their behavior. They attacked students who were not fighting back or resisting, and even those who were trying to run away. The following witness account is from a spe-

cial issue of *Student* published on June 4, the day after the incident; the issue was promptly banned at the request of the public persecutor:

> Policemen charged with their batons raised above their heads. And they started beating. With all their strength. Dull thuds all around. Screams! Cries! A girl from the School of Philology shudders under the shower of strikes. Radomir Andrić, also a student from the School of Philology, protects his head with a red flag; five policemen throw him to the ground and beat him up with their batons and shoes. Fracas! At one point I see the following:
>
> A policeman throws a tear gas bomb.
> A police captain yells that students can get to downtown Belgrade only over his dead body.
> Screams. Beatings; batons that hit on legs, heads, backs. (in Arsić and Marković 1984:83)[17]

Policemen assaulted blindly any civilian in their path, so that even Miloš Minić, the president of the Serbian parliament, received a blow to the head when he tried to stop them. In the end, in the two clashes between students and the police forces on June 2–3, 169 people were injured (134 students, twenty-one policemen, nine brigadiers, and five civilians), and out of them twelve were hospitalized (Hodžić et al. 1971:60). With these instances of mass violence, Belgrade joined the global 1968.

After the second "battle at the overpass," the protesters again retreated to Student City, and just a couple of hours later the action committee, the student working group, and the editorial board of *Student* issued the "Declaration" (*Proglas*) in which they condemned police brutality and biased reporting of the mainstream media. At the same time, a list of demands was culled from the section of the "Declaration" that addressed the social situation in Yugoslavia. This list of demands was formulated around four main points. The sociologist Nebojša Popov, who was a witness and participant in the June uprising at Belgrade University, and who subsequently did extensive research on these events, divided the student demands into "specific" and "general" (1983:38). The former included release of students taken into custody, prosecution of police officials responsible for the brutality, consideration of students' grievances by the highest state bodies, and dismissal of journalists and editors who reported falsely on the student movement (Hodžić et al. 1971:62). In their general demands, the students asked for: "consistent application of the principles of pay in proportion to

the work done"; "energetic action against amassing wealth in a nonsocialist way"; equality in education, so that the "social structure of the students reflects the social structure" of the general population; and, finally, the "abolition of all privileges that exist in our country" (61). That same afternoon there were gatherings at various parts of Belgrade University in which lists of students' demands were disseminated.

In the aftermath of the clash at the overpass, the authorities also held their own meetings and made decisions, too. They instructed the police to surround the university buildings where students held their meetings. Apparently, this time they were not asked to use violence to disperse the gatherings. At the same time, only students and faculty were permitted to enter the buildings. The same evening, the students decided to go on strike until their demands were met. They responded to the police blockade by setting up their own security guards at the entrances of the university buildings they occupied. The standoff had begun.

By late afternoon on June 3, the School of Philosophy became the focal point of the strike. It was located in the section of downtown Belgrade that most closely resembles a campus. Several schools and administrative buildings stood in close proximity: the Rectorate (university administration offices) housed in Kapetan Mišino Zdanje building; the schools of Philosophy, Philology, and Mathematics; and two art schools, the Academy of Fine Arts and the Academy of Theater and Film. A few of these buildings (Kapetan Mišino Zdanje, the School of Mathematics, and the School of Philosophy) faced a small city square, appropriately named Student Square. In an attempt to break the information wall that state media erected around them, the striking students addressed the citizens from balconies facing the Student Square. They also pasted posters on the walls with slogans such as "Don't believe the press!" "Workers, we are with you," and "Enough corruption." On the balcony of the School of Philosophy, alongside the national flags and the flags of the Communist League, they had hung a bloody shirt as evidence of the police brutality.

At first, curious Belgraders began to gather in the small park at the center of the Student Square. By evening, the crowd had grown larger and began to push toward the university buildings that were separated from the park by Vasina Street. The traffic was interrupted, and more people from city buses and trolleys joined the gathering. According to some witness accounts, by early evening there were some five thousand people in front of the School of Philosophy. The ordinary citizens listened attentively to the orators who addressed them from the balcony, without the aid of loudspeakers. They grabbed the fliers with the "Declaration" and the lists

of demands that students threw at them from the windows. At one point, the students seemed at the brink of accomplishing one of their most valued goals: establishing a meaningful connection with the workers.

Citizens gathered on the Student Square kept calling for the workers to speak up, until, encouraged by the chants, a young man in a cheap suit climbed on one of the trolleys trapped by the crowd. He identified himself as a worker, and in a brief speech informed the crowd that in his factory the workers were told that students wanted to destroy their machines, the only source of their income. "Now I know who is telling the truth, and I choose to stay with them, even if I get fired from work. I promise that tomorrow my comrades will find out what happened today" (in Pavlović 1990:47). The security forces made sure this didn't happen. By Tuesday morning (June 4), factories at Belgrade's outskirts had organized their own worker guard units to turn away student delegations. Those rare messengers who entered factories were allowed to meet only with managers, who were Party members already briefed on the situation and instructed to reject any offer of collaboration that might come from students. All of these measures were accompanied by a campaign in the media that was eager to discredit the striking students as supporters of Milovan Đilas, Aleksandar Ranković, the Comintern, or mysterious foreign powers trying take advantage of the situation.[18]

PERFORMING SELF-MANAGEMENT

The most significant outcome of the first phase of student demonstrations was the emergence of action committees, which were in charge of day-to-day and hour-to-hour decision-making during the university strike. The first one was established in Student City on the morning of June 3, when protesters elected some twenty of their peers to make collective decisions (Hodžić et al. 1971:59). During the days that followed, action committees sprang up in schools across Belgrade University. They turned out to be the most significant form of self-organization during the strike and its greatest legacy—a Belgrade '68 version of the workers' councils of the 1919 Hungarian revolution. While the self-management reforms of 1963 and 1965 shifted the decision-making power to employees, thus enabling the idea of the worker as the political subject, real decisions were made within well-guarded institutions of the League of Communists of Yugoslavia. For the first time in the short history of Yugoslav self-management, there was an alternative to the official doctrine that did not come from an opposing ideo-

logical camp, but that actually asked for more rigorous and straightforward implementation of the principles of self-management. This time, the criticism of the Yugoslav ideological state apparatus did not come from the positions of "real" socialism or Western liberalism—both easily dismissed by Yugoslav ideologues—but from the position of sincere and direct proponents of self-management. It was this idea, not fashionable rebelliousness, that emerged as a true, shared value among Belgrade students and their peers at the Sorbonne and other universities across Europe and beyond.

Everywhere they sprouted, action committees became an exemplary articulation of what was then called *action-critique*. As Henri Lefebvre explained in his writings on 1968, action-critique poses in "new terms . . . the question of acting 'subjects,' and of objects and projects" (1969:31). Seen in this way, action-critique was the conceptual and operational center of what French students called "generalized" and their colleagues in Belgrade "integral" self-management. Lefebvre described it as "the social practice and the theory of this practice" that "implies the establishment at the base of a complex network of active bodies." And further: "The many interests of the base must be present, and not merely 'represented' or handed over to the delegates who became divorced from the base" (86).[19] Maurice Blanchot, a member of one action committee in the *Quartier latin*, described it as a "communism on the other side of communism":

> Communism cannot be an heir. We must be convinced of this: it is not even the heir of itself and is always called upon to allow the loss, at least momentarily, yet radically, of the legacy of centuries, however venerable this legacy must be. The theoretical hiatus is absolute; the rupture, in fact, is decisive. Between the liberal capitalist world, our world, and the present of the communist exigency (present without presence), there is only the dash [*trait d'union*] of a disaster, an astral change. (2010:93)

In his early sixties at the time, Blanchot joined the Student-Writer Action Committee at the Sorbonne and immersed himself in the work of editing and writing for this group. In the midst of this feverish activity, Belgrade journalist Ilija Bojović approached him for an interview.[20] Blanchot responded by writing the "Letter to a Representative of Yugoslav Radio-Television," which he concluded as if continuing his reflection on communism: "In a few days, an entire modern society fell into dissolution; the great Law was shattered; the great Theory collapsed; the Transgression was accomplished; and by whom? By a plurality of forces escaping all the frames

of contestation, coming literally from nowhere, unlocalized and unlocaliz-able. This is what I believe is decisive" (84). The letter is dated June 6, 1968. That was exactly the midpoint of the student demonstrations in Belgrade. Two days earlier, the movement had entered an imperceptible zone of di-saster; it had already died without any of its participants noticing.

The turning point in the student protest was June 4, and the end of that day was marked by the second piece of theater. It was time for the authori-ties to get to work, and they did. As early as the night of June 3, Serbian prime minister Đurica Jojkić met with representatives of the students' ac-tion committee, and they formed a joint action group charged with identi-fying individuals responsible for the violent events of June 2 and 3.[21] On the following day, a number of governing bodies and sociopolitical organi-zations held emergency meetings. Even though they differed in their levels of condemnation or support for the student movement, the statements is-sued by these groups clearly demonstrated an attempt on the part of the institutions to absorb the initial shock and to take the situation into their own hands through partial appropriation of the student movement. While, on the one hand, the Belgrade City Committee of the League of Commu-nists and the Belgrade City Assembly sharply criticized the demonstra-tions, the institutions on the level of the republic and federation were more lenient. One of the highest Yugoslav governing bodies, the Executive Com-mittee of the Yugoslav Central Committee, concluded that some of the stu-dents' demands, specifically those concerning their material and living conditions, were acceptable and the Committee expressed a willingness to meet with the students. By Tuesday, June 3, the action committee had al-ready drafted the "Political Action Program of Belgrade Students," which, even though it repeated the key demands of the "Declaration" and "Stu-dent Demands," displayed clear signs of compromise between the sponta-neously organized action committee and official sociopolitical organiza-tions active at the university, such as the Student Federation and the Yugoslav Youth Federation.[22] Capitalizing on this indication of potential compromise, the Presidium and the Executive Committee of the League of Communists of Serbia issued a communiqué in which they promised to meet the student demands the committee deemed acceptable. At the same time, the Yugoslav Youth Federation and the Presidium of Yugoslav Stu-dents issued their own statements in which they expressed full support for the striking students. This slew of memos, some that agreed and others that contradicted one another, began the slow grinding of the student move-ment to its eventual halt.

Students barricaded in university buildings stood firm in their decision

to continue with their strike until all of their demands were met. In a display of their ideological purity, they decided to rename Belgrade University "Red University Karl Marx." They did the most they could, without breaking the ban on public demonstrations and clashing, yet again, with the police. By the end of the day, the standoff began to take its toll on the protesters. Although meetings were held perpetually at almost all schools and departments, the School of Philosophy remained the center of activity. The large inner yard of Kapetan Mišino Zdanje became the site of an ongoing gathering that, for students and faculty, came to resemble their vision of an ideal democracy. This agora, or "Convent" as they called it, had a small podium equipped with microphones and speakers that were powered by a generator, necessary after the authorities cut the power and telephone lines in the building on the very first day of protests. A series of speakers took the podium to make speeches and announcements. Even though Dragoljub Mićunović, then an assistant professor at the School of Philosophy, quickly became the unofficial emcee of the Convent, Belgrade University did not have its own Daniel Cohn-Bendit or Rudi Dutschke to rally behind.

The iconic oration of Belgrade June was not given by any of the student leaders or their professors. Instead, it was a monologue from Georg Büchner's 1835 play *Danton's Death*. On the evening of June 4, as the strike reached the end of its first full day and students faced increasing pressure from politicians and the media, the actor Stevo Žigon delivered Robespierre's speech to the mass of anxious students gathered in the inner yard of the School of Philosophy. "Let there be no compromise, no armistice with those who were only set on robbing the people, who hoped to rob them unpunished, for whom the Republic was speculation and the Revolution was a trade," roared Žigon, driving the crowd into frenzy (Büchner 1977:29). Živojin Pavlović recorded in his diary a detailed description of this performance:[23]

Each sentence is greeted with a roaring upheaval. The crowd, electrified with enthusiasm, goes into spasms over words as if stepping on hot coals. Theater and life, actor and audience, cease to be what they are. To my astonishment, they become one. The splendor of the moment—this extraordinary mystery in which the howls and wild tremors of the mass muddle the actor's mind, so that he forgets theatrical tricks and, abandoning himself to intoxicating drunkenness, tears from his chest not words but his own flesh, and the eruption of spellbinding recitation drives the masses mad with the coincidence

of Robespierre's late eighteenth-century and contemporary truths—
that snake hiss of the dynamite stick comes to the threshold of the
impossible: Žigon ceases to be Žigon, and students, students. . . . In
front of them is no longer Žigon, not even the fictive Robespierre. In
this hypnotic moment, in front of the mass is its LEADER, the one that
students lack in reality. The one for whom they yearn. For they
know, they feel, they sense with their whole being, that without
him—without the daring, the wise, and the extraordinary one—the
action will fail. That without him the "movement" will not develop
into a revolution. (1990:67)

And it didn't. It couldn't. It went as far as it could without becoming a true
revolution. The moment Žigon stepped in front of his dazed audience, the
movement had already peaked and begun to decline imperceptibly. And in
fact, it was precisely the downward turn of the movement that made pos-
sible this sublime moment of theater. Despite the fire, despite the truth that
exploded from every word of Büchner/Robespierre/Žigon, the crowd knew
that in front of them stood an actor and not a revolutionary leader. They
were free to give the speaker their unconditional support precisely because
he was not real and the situation was not real. It is not that they were play-
ing at making a revolution. Quite the contrary: the students were acutely
aware of the stakes involved in their political position, and many of them
paid dearly for their actions that June. The sublimity of this moment was
made possible by its futility, by the impossibility of following up on the
revolutionary call. Something happened then and there, without the stu-
dents' knowledge or intention, that would transform the meaning, direc-
tion, and force of their movement. Pavlović notes that from that night on
students asked for more performances. And the actors obliged. "Instead of
bullets, the regime is spraying these naughty children with confetti" (75).
The carnivalesque atmosphere created among students the illusion that
they had found their hero and were united in their approval. It lasted only
throughout the week.
 So, to recap the first three days of Belgrade June '68: an attempt on the
part of students to see a mindless variety show escalates into a bloody bat-
tle with the police, which then turns into a standoff in which protesters
force the authorities to change their strategy, but in the process end up
changed themselves. The very notion that a minor and random incident
can spiral into a state crisis is reminiscent of Romanticist narratives such as
Heinrich von Kleist's *Michael Kohlhaas*. Like the protagonist of Kleist's no-
vella, Belgrade's wronged and offended students turn from innocents into

fighters. In this kind of sudden and improbable transformations, Deleuze and Guattari see the flow and the becoming, the vortex and the problematic as the main properties of nomadic space, which is, according to them, the opposite of the state. They argue that nomadism "is of another species, another nature, another origin than the State apparatus" (1987:352). The former cannot be reduced to the latter. "Coming from elsewhere," nomadic thought is outside of the state's "sovereignty and prior to its laws" (352). The incessant and irreversible becomings, such as Penthesilea's becoming-animal and Kohlhaas's becoming-outlaw, are initiated and driven by feelings "uprooted from the interiority of the 'subject,'" which, once exteriorized, become affects (356). In this particular case, a state accustomed to discursive overproduction is set back by an explosion of action critique. All of a sudden, self-management as an ideological currency is torn asunder by the *practice* of self-management. Detached from the state, it becomes a nomadic practice—precisely because this kind of estrangement of that which it thought it had already mastered prompted the Yugoslav state to rename the nomadism of protesting students by proclaiming their action a mere fad and an imitation of the fashion of rebellion that had been meandering across the West, from one university to another. Something entirely different was in play in Belgrade's June: through their stubborn gesture of repeatedly demanding what had been promised to them, protesters shattered the surface of official self-management in Yugoslavia. Their marches from the periphery of the city to its center were blows on the baroque ceiling of Yugoslav society, which cracked on the second attempt. And, to stay with Deleuze and Guattari, these blows tore "open the firmament itself, to let in a bit of free and windy chaos and to frame in a sudden light a vision that appears through the rent" (1994:204). After the second attempt (June 4), the repair of the crack begins with great urgency. The state has learned that this kind of breach cannot be closed by force, and it deploys a different strategy. Instead of water cannons, the state launches fireworks; instead of batons, adulation: "Then come the crowd of imitators who repair the umbrella with something vaguely resembling the vision, and the crowd of commentators who patch over the rent with opinions: communication" (204). All too appropriately, whereas a becoming with unpredictable consequences was set off by a mindless bit of stage entertainment aimed at easy profit, it was slowed to a halt by entertainment that covered over the "incommunicable novelty" of that very becoming.

The impasse the Belgrade students faced was the same that kept reappearing in all historical instances of the spontaneous emergence of self-management: the Paris Commune, Petrograd in October, civil war in Spain,

Yugoslavia's split with the USSR.[24] In all of these cases, self-management emerged under conditions of immense pressure. Every time, it was a manifestation of energy that was uncontainable and without precedent, an "incommunicable novelty." Any attempt to institutionalize this unrehearsed action threatened to calcify and constrain its vital force. The question of self-management is entangled in a paradox of iterable spontaneity. In this manner, it approaches one of the core problems of theater. Following up on the tradition that commenced with Marx, Lefebvre spoke of revolution as a dialectical overcoming—surpassing and preserving—of the aesthetic. He opens "The Style of the Commune," the preface to his *Declaration of the Commune, March 26 1871* (*La proclamation de la commune, 26 mars 1871*) with an ambiguous assertion about the nature of this revolution: "The Paris Commune? It was for one thing an immense, epic festival [*fête*], a festival that the people of Paris, essence and symbol of the French people and the people in general, gave both to itself and to the world" ([1965] 2003:188). He goes on to argue that "from the outset, the Festival contained the drama; the drama taking on its primordial meaning: a real and collective festival, a festival lived by the people and for the people" (189). True to its etymology, this drama is a true action that liberates labor and turns it into work, as in a work of art: "The people acclaimed the symbols of disalienated and disalienating labour, the fall of oppressive power, the end of alienation," and they "acclaimed the world of work, that is to say, work as world and creator of worlds" (189). This rhapsody of the Commune foreshadows Lefebvre's theorizing of council communism, published the following year: "Only through *autogestion* can the members of a free association take control over their own life, in such a way that it becomes their work [*oeuvre*]. This is also called appropriation, de-alienation" ([1966] 2009:150). But not so fast: failing to launch an eternal festival, the Commune drama turned into a tragedy. "We know that Tragedy and Drama are bloody festivals, during which defeat, sacrifice and the death of the superhuman hero who has defied destiny are performed"; and, "Those who have fought to the cry of *Liberty or Death* prefer death to capitulation and the certainty of servitude. They are still fighting, desperately, insanely with boundless courage; afterwards they light with their own hands the pyre on which they want to be consumed and disappear. The tragedy ends in a blaze and disaster worthy of itself" (189).[25]

Even as it happens, the revolutionary festival moves beyond itself, overcoming its own possibility and spelling out its own disaster. This noble *beyond* (beyond life, beyond the pleasure principle) of the Commune turns the event into a trivial belatedness of the spectacle in a desperate search for

self-gratification, support, encouragement. Party confetti instead of the fu-
neral pyre. How to maintain revolutionary élan? How to carry on, day in,
day out, with inspired work instead of mind-numbing labor? It is a small
wonder that proponents of *autogestion* felt drawn to the work of Denis
Diderot, who in *The Paradox of Acting* and other works on theater argued,
famously, that the intensity of live performance came from a firm control
on representation by actors onstage.[26] In his book on Diderot, published
toward the end of his orthodox Marxist period, Lefebvre wondered if when
a "genuine creator is spontaneous and natural, does he imitate nature?" In
response to his own question, he asserts: "No, he transforms it" (1949:272).
A decade and a half later, Jean Duvignaud, the greatest proponent of *auto-
gestion* among French theater scholars, addressed Diderot's dilemma of
spontaneity versus artifice by asserting that technique is not at all in the
business of impersonation, but of revelation: "Technique uncovers the na-
ture that teaches us that very technique" (1965:356). Beyond theater, the
Diderot dilemma pertains to a politics without the party and political ac-
tion without a template and legacy. *A communism without heirs.*

Blanchot was talking about the paradox of action critique when he
wrote to an insistent Ilija Bojović that "May" precludes writing. The event
is the other of writing, outside of it:

> Writing, the demand of writing (not only the writing that was al-
> ways put at the service of the spoken word or ideological thinking
> but, on the contrary, writing gently liberated by its own force as if it
> gave itself over to the questioning that it alone conceals), gradually
> frees all other possibilities, an anonymous way of being in relation
> and communicating (which puts everything into question, first of all
> ideas concerning God, the Self, Truth, and then the Book and the
> Work themselves), so that this writing considered in its enigmatic
> austerity should not have its finality in the Book, somehow a mark
> of the end, but writing that one could envisage outside of discourse,
> outside of language. (2010:97)

This is not to say that this action is beyond expression, a sublimity of sorts:
it establishes a different kind of writing that goes beyond discourse and
leaves it behind. It negates and subsumes at the same time. Not the writing
of traces, but its inverse, *the writing of absences; of openings and cuts.* The cut
in Yugoslavia was deep and clear: the very existence of a self-organized
and self-managed community was the most profound critique of the state-
proclaimed and ceremonial, and therefore spectacular, society of self-

management. In another text from the days of the barricades, Blanchot spoke of nationalism as the polar opposite of communism, so that socialist patriotism is no better than any other: even "speaking of the fatherland of the revolution" means "to subject oneself to the Father, to the law of the Father" (92). The imperceptible disaster of the Belgrade unrest that started with the Büchner/Robespierre/Žigon oration reached its formal conclusion with an interpellation that came directly from the place of the Father.

While being entertained and flattered, the students also became pacified. In his report about Belgrade June, which he filed weeks later, at the end of the summer, a member of the American Universities Field Staff, Dennison Rusinow, noted that "by Friday, June 7, at a diplomatic cocktail party, a resident Western observer was overheard telling a Yugoslav official, half seriously, that he thought the French, West German, Polish, and American governments should be sending delegations to Belgrade to learn how to handle student problems" (Rusinow 1968b:2). At the end of the week, there was a sudden change in the public attitude toward the barricaded students. The press, which was relatively tolerant throughout the week, suddenly returned to the kind of condemnation that marked the reporting on the clashes of June 2 and 3. There were rumors that army units were at the outskirts of Belgrade, ready to enter the city and restore peace and order. There was also increasing impatience for a public reaction from Tito, who remained silent throughout the week.

Then, on June 9, the seventh day of the strike, Tito addressed the nation in a televised speech. He took both the students and their opponents by surprise, admitting that the state and party leadership made mistakes along the way. Tito asserted that from the very beginning he agreed "with most of the students' demands," and, in an incredible turn, symbolically put himself at the helm of the student movement: "The revolt that took place partially resulted from the students' realization that I often asked questions that have not been addressed. This time I promise to them that I will do my best to see that they are addressed, and students should help me to accomplish that." He surpassed his own performative interpellation by uttering words that until then were never heard coming from the mouth of the socialist head of state: "Furthermore, if I prove incapable of solving these problems I don't deserve to hold this office." He concluded his speech in a fatherly manner, brimming with confidence: "In conclusion, I am addressing students once again: it is time to go back to your studies, because it is the time of exams, with which I wish you a lot of success. It would be a shame if you wasted any more time" (in Hodžić et al. 1971:340). This was the third and final performance of Belgrade June. Rusinow, who was one of

the very few observers who wasn't either disgusted or elated by Tito's tele-vised speech, described it as "masterly performance." Tito had carefully memorized the cautiously crafted speech. At the same time, he delivered it in an informal way, which reminded Rusinow of the "fireside chat tradi-tion," peppered with mistakes in syntax and grammar that by then were the trademark of the oratorical performances of Yugoslavia's president, whose mother tongue was Slovene, and for whom Serbo-Croatian re-mained a foreign language until the end of his life (Rusinow 1968b:16). Many students read Tito's speech as their victory, even though not one of their demands was met. The strike ended the same evening, in some places with jubilation.

By August, the political pressure in Yugoslavia, Western Europe, and around the world was mounting, and there was little that the participants of the Korčula Summer School could do to counter the wave of violence. The school was under constant threat of losing its public funding and, hav-ing had the session canceled two years earlier (1966), in 1968 it was hanging on by a thread. On August 21, in the midst of that summer's session, the Warsaw Pact troops invaded Czechoslovakia, and the participants of the summer school found themselves in a surprising situation: instead of pro-testing the reprisals of Tito's regime against Yugoslav students, they sent him a telegram pleading with him to use his "international standing" to "help the interests of socialist Czechoslovakia and its independence" (*Praxis* 1969:310).[27] This tactical move on the part of the philosophers was at the same time the beginning of the end of the Praxis school.

EXPANDED MEDIA / CONSTRICTED POLITICS

Deceptively simple, Raša Todosijević's performance *Decision as Art* (*Odluka kao umetnost*) consists of a series of actions organized around ideas of com-plementarity and exhaustion. As his partner, Marinela Koželj, sits impas-sively on a chair placed upstage right, the artist, stripped to the waist, first applies white paint to four small ficus plants positioned along the front edge of the stage. He covers his naked torso with salt, and then picks a live carp from a tank and places it on the floor. As the fish wriggles about stage, he begins swallowing large quantities of water. The artist and the fish suf-fer in unison: the carp slowly suffocates on dry land, and Todosijević gulps water until he throws up, and then drinks again. This "game" goes on until the carp expires. The performer paints one of his ears white, and then faces the audience, holding a small battery-operated flashlight in his extended

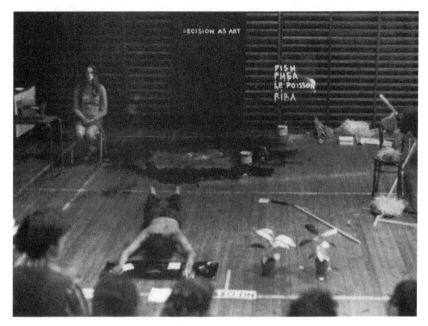

Fig. 18. Raša Todosijević: *Decision as Art*. Richard Demarco Gallery, Edinburgh, 1972. Photograph courtesy of the artist.

right arm. He holds it until the battery dies or until he can no longer hold up his arm.[28]

Photographs of this action show a banner with the inscription "Decision As Art" hanging on the rear wall, directly behind the artist, with "salt" and "fish" written in Serbian, English, and French to the stage right and left (respectively) of the banner. Todosijević was among the most reflective artists in the group that worked at Belgrade's Student Cultural Center (Studentski kulturni centar, or SKC) in the early 1970s. A visual artist by training, he was also distinguished by his curatorial projects and critical and theoretical writings. In an article entitled "Performance" ("Performans," 1981), he wrote that whereas in performance art an artist "establishes an address explicated in the first person," in theater the artist's (actor's) "subject, his true self, his beliefs about the world's meaning, in the moment of performance recede into the background" (60).[29] According to Todosijević, it is this focus on subjectivity that distinguishes performance art from traditional performance genres. At the same time, Todosijević's attention on the subject highlights the relevance of his work and the work of his friends from the SKC to the ideological transformation of self-management in post-1968 Yugoslavia.[30]

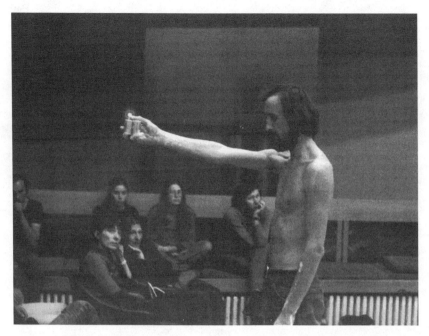

Fig. 19. Raša Todosijević: *Decision as Art, Information II*. SKC, Belgrade, 1973. Photograph courtesy of the artist.

The ideological discourse of socialist self-management frames the notion of the subject in ways different from classical political theory (needless to say, it completely ignores the psychoanalytic theories of subject formation). Étienne Balibar asserts that, historically, the emergence of the modern subject coincides with the era of monarchical absolutism, which, he writes, "seems to give a complete and coherent form to a power that is founded upon itself, and that is founded as being without limits" (1991:40). This power is both political and juridical, and as numerous commentators have suggested, it is manifested in the act of sovereign decision. Balibar locates the shift from the adjective to the substantive, from *subjectum* to *subjectus*, from royal subject to "citizen-subject," in the 1789 Declaration of the Rights of Man and the Citizen. This document and the revolution that made it possible bring with them a radically new concept of "sovereign equality" where decision is no longer tied with exception but with regularity. In a postrevolutionary society, unlike in an absolutist monarchy, freedom is understood as a public right, not a private experience, and is based not on obedience but on equality: "Real equality must be all or, if one prefers, every practice, every condition must be measured by it, for an excep-

tion destroys it" (46). If, as Balibar suggests, the citizen is the subject who has risen, and if (still following Balibar) the "citizen-subject" of the republic replaces the obedient subject of an absolutist monarchy, then the idea of self-management represents both a political and an economic realization of the Declaration of Rights. A self-managing subject is the citizen fully emancipated from any kind of subjugation.

In its short performance history, *Decision as Art* arched from a monarchic to a self-managing sociopolitical order, which can be said to constitute two opposite poles of modern subjectivity. As we are going to see, if in the former the exceptionality of decision-making turns it into an art form, then in the latter the radical democratization of decision-making strives to abolish art. Todosijević first performed *Decision as Art* in August 1973 at the Richard Demarco Gallery in Edinburgh as part of a collective exhibit by seven young artists from Yugoslavia.[31] Then, a few months later, he performed it again at the exhibit *Informacije II* (*Information II*) held at the Student Cultural Center in Belgrade. Although the British monarchy is a far cry from eighteenth-century absolutism, its ideological, political, and theological background brings to Todosijević's first performance of *Decision as Art* an inflection of a princely and decisively antidemocratic *art of decision*. Reiterated in Yugoslav postrevolutionary society, the same performance brings forward a whole new set of issues. Richard Demarco was a private gallery specializing in presenting alternative art from continental Europe, while the SKC was a public institution; whereas the former was commercial, the latter was not; and while the former was fully integrated within the network of art institutions, the latter was an expression and continuation of the communal spirit of Belgrade's June '68.

The establishment of the Student Cultural Center was part and parcel of the sweeping institutional reforms implemented at Belgrade University in the wake of student demonstrations.[32] Following up on the promises made in response to the "immediate demands" for the improvement of student living conditions, in 1969 all student dormitories scattered throughout Belgrade were integrated into a single organization named Studentski centar (Student Center) (Kljakić 1981:1). That same year, the ownership of a building overlooking Ulica Maršala Tita (Marshal Tito Street), one of the main city thoroughfares, was transferred to the newly established Student Cultural Center.[33] The building, erected in 1887, served until 1941 as the Officer's Club of the Serbian and then (after 1918) the Yugoslav royal armed forces. After the liberation it was turned into the Secret Police Club. Following the 1966 demise of the powerful head of the secret police, Aleksandar Ranković, and the mass reorganization of Yugoslav intelligence service, the

building fell into disrepair. Between 1969, when it was officially handed over to the newly formed student cultural institution, and its opening in 1971, the building—which houses a large dance hall, two galleries, a movie theater, a spacious lobby, and a series of offices—was thoroughly renovated and appointed with new equipment and furnishings, most of which were imported from the West.[34] In the eyes of many students and activists, the Student Cultural Center was one of very few tangible gains made by Belgrade students in their June 1968 uprising. Dunja Blažević, who was the artistic director of the SKC's gallery (1971–75) and then the center's director (1975–79), insists that this institution captured and carried into the 1970s the emancipatory political and artistic ideals of 1968, and points out that the SKC's first director was Petar Ignjatović, one of the prominent student leaders from the uprising (Blažević 2011; see also Becker 2006:393). Yet this and other similar institutions were but a small exception to the sharp turn, on the part of the state, away from the liberalism of the 1960s.

Silent crackdowns on the student movement started as early as the summer of 1968. In the immediate aftermath of the protest, while the enthusiasm among students for collective action was still running high, the authorities wisely limited their actions to measures that were of high political importance and very low public visibility. If what students accomplished in June was an effective repurposing of sociopolitical organizations from mere tools of the Party's political power to genuinely autonomous political bodies, then it is not surprising that in the first weeks after the cessation of the protest the officials saw the channeling of the political power back into the mainstream sociopolitical organizations as their most urgent task (Rusinow 1968b:5). By the beginning of the fall semester of 1968, the action committees and other spontaneous attempts at student organization were prohibited. In addition, gatherings and any other manifestations to mark the first anniversary of student rebellion were thwarted (Popov 1983:188). The crackdown continued the following year with pressure from the officials on student printed media, particularly on the weekly *Student* and the journals *Vidici* and *Susret*. Campaigns against the editorial boards of student publications were initiated by the state-sponsored media, and intensified toward the end of 1969. Belgrade's City Committee of the League of Communists issued scathing criticisms of the editors of these publications, which were followed by heated public debates about the autonomy of student press.[35] Toward the end of January 1970, the Parliament of the Republic of Serbia issued a statement condemning student publications, and the University Committee of the League of Communists at Belgrade University made public its conclusion that the "new orientation of

[*Student*] requires a new editorial board" (in Popov 1990:189). With the dismissal of the editors of *Student* and *Vidici* in the early months of 1970, and the discontinuation of *Susret* some six months earlier, the free student press, which represented one of the main legacies of June 1968, was effectively dismantled. Viewed in retrospect, the magnitude of the loss often leaves out of the picture small gains made by the student movement. In 1970, as the social and political organizations on the local level (city, republic) who were the publishers of *Student* and *Vidici* were cracking down on their editorial boards, the federal student organization, the Student Association of Yugoslavia, also located in Belgrade, started the journal *Ideje* (*Ideas*), which quickly became the intellectual alternative both to the mainstream philosophical and literary journals and to journals dedicated to critical Marxism such as *Praxis* in Zagreb and *Filosofija* and *Gledišta* in Belgrade. While *Ideje* continued with the publication of articles that examined the legacy of 1968 both in Yugoslavia and abroad, it also brought into critical discourse in Yugoslavia a tone that was absent from other scholarly journals, most prominently the writings that came from or were inspired by French structuralism.[36]

Artists that came of age in the late 1960s and had their political baptism by fire in the events of June 1968 took advantage of the new art institutions that supported their practice, which was marked by departure from traditional artistic techniques and engagement with new media and modes of discourse. Ješa Denegri, an influential art critic and staunch supporter of the new art who in 1971 cocurated with Biljana Tomić the first exhibition of conceptual art in Belgrade,[37] described the young artists' attitudes as "artistic nomadism" (2007:89). By this he meant their lack of commitment to a single medium and openness toward experimentation that led many away from conventional art techniques and toward conceptual art, film, photography, and performance and body art. However, insofar as the young artists associated with the SKC adopted the idea of self-management critically and tried to enact it in ways different from that prescribed by the Party, this "nomadism" also proved to be a continuation of the politics of June '68. Among other characteristics of Yugoslav post-1968 art, Denegri included its urbanity and detachment from traditional national cultures as well as a pronounced desire to keep pace with the latest artistic practices in global art centers such as New York, London, and Paris.[38] According to Denegri, what distinguished Yugoslav conceptual and performance artists from their contemporaries abroad was their tendency to work and exhibit in more or less formal groups. This was not a new development: as we have

seen, in the 1950s the group Gorgona was already active in Zagreb and Mediala in Belgrade, and the first significant steps toward conceptual art were made in the mid- and late 1960s by the group OHO, which was based in Ljubljana but exhibited and published regularly in Zagreb and Belgrade.[39] Interestingly, in the aftermath of the June uprising, the first conceptual art groups in Serbia were formed not in Belgrade but in the northern province of Vojvodina: first, in 1969, the group Bosch+Bosch in Subotica,[40] then in 1970 KÔD,[41] and a year later (∃,[42] both in Novi Sad. The most famous of these groups was the informal Group of Six: Marina Abramović, Slobodan "Era" Milivojević, Neša Paripović, Zoran Popović, Raša Todosijević, and Gergelj Urkom.[43] While exhibiting collectively, the members of these groups subscribed to no artistic program and maintained a high degree of individual distinction. Gergelj Urkom made the following statement about the Group of Six:

> It is wrong to think of the six of us as a group working on a joint programme. But the common thread that evidently exists between us points to the fact that we are not just six people with completely diverse interests. One could say it was not so much our attitude towards art that brought us together as it was the closeness of our views, which came from similar attitudes towards life. During joint exhibitions and discussions over the past few years we developed a distinct approach to art. Through mutual efforts we managed to establish a common ground, thanks to the fact that the opinions of each of us were important to the others. (in Becker 2006:394)[44]

Todosijević went even further by asserting that the group members' work on performance came from their interest in selfhood and ego, which was, as they recognized early on, best communicated through the medium of the body.[45] Denegri characterizes this approach to the body and to artistic creation as "authorial *speech in the first person*," where "speech" is, more often than not, nondiscursive: the "speech of behavior, of the body, of gestures and signs, but never forms and self-sufficient art objects" (Denegri 1983:7). Needless to say, this departure from the object toward the bodily or mental processes was described in numerous texts published in the 1960s, such as Lucy Lippard and John Chandler's *Art International* article "The Dematerialization of Art" (1968), which Denegri regularly invoked in his art criticism of the early 1970s. However, far more important than merely acknowledging that Yugoslav artists and critics were aware of the

latest artistic practices and theoretical concepts is to recognize how these practices and concepts evolved within specific artistic and social conditions in Yugoslavia.

Starting in 1972, the Student Cultural Center hosted two annual art events that were of vital importance for visual, performance, and conceptual art in Yugoslavia. The first one, entitled Aprilski susreti (April Meeting) took place each spring, and the second one in the fall.[46] The formal occasion for the spring event was April 4, "Student Day" at Belgrade University, while the fall event engaged with the contemporary art scene in Belgrade in a more explicit and openly critical manner. Named simply Oktobar (October), it was conceived as an alternative to Oktobarski salon (October Salon), which was for decades the main showcase for mainstream Yugoslav art in Belgrade. Young artists, art historians, and critics considered the October Salon indistinguishable from socialist aestheticism. Since the same group curated both events, April Meeting had the same artistic and conceptual agenda as October, only this time the critical edge was aimed at the Yugoslav culture of celebration and commemoration, which was, as we have seen, one of the hotbeds of socialist aestheticism. It needs to be mentioned that the establishment of Belgrade's alternative and conceptual art scene in the Student Cultural Center had its "prehistory" in Gallery 212 (Galerija 212), which Biljana Tomić organized within the Belgrade International Theater Festival (BITEF). In September 1968, only months after the student protest, the Slovene group OHO performed its happening at Gallery 212, and they performed again the following year. In 1971, Gallery 212 featured a roster of artists and critics who will mark the conceptual and performance art scene in Yugoslavia of the 1970s: Marina Abramović, Neša Paripović, Slobodan "Era" Milivojević, Raša Todosijević, Nena i Slobodan Dimitrijević, Ješa Denegri, Irina Subotić, Marko Pogačnik, Zvonko Maković, and Tomaž Šalamun, to name some.

In the bulletin issued during the first April Meeting in 1972, the organizers made a disclaimer in which they pointed out that it was their intention to depart from the "existing form of April festivities, from spectacle, revelry and Avala outings, and to give the manifestations related to April 4 a character that is oriented toward work and research" (Bilten 1972:1).[47] They went on to say that the April Meeting would "in fact, represent just an intensification of specific research activities that have been going on for some time" at the Student Cultural Center (1). The general theme of April Meeting in 1972 was "Interrogation of New Spaces and Media," and the following year the theme was narrowed to "Expanded Media." The choice of this theme harkens back to the discourse of "expansion" and intermediality in arts, cham-

pioned by Fluxus throughout the 1960s.[48] Whereas this slogan was retained in the first two April Meetings, the theme of the third one in 1974, phrased in the form of question, "Expanded Media or New Arts?" indicated an attempt at a critical departure from clichés about experimental art.

The organizers of April Meeting took a certain pride in the fact that, being poorly funded by the Belgrade Student Union, they could not and did not offer honoraria to the festival participants.[49] Fiercely egalitarian, they provided the same production conditions to the invited foreign artists and to the emerging artists who won their place in the program through an open call for submissions in the field of expanded media. The call stipulated that all proposals should be anonymous, that they could be authored either by a group or by an individual, and that they had to be realized within the building of the Student Cultural Center or its immediate environs. Proposals were accepted for projects in "visual, audio, mobile, mimetic, textual, film, or other" media. Importantly, in the open call it was emphasized that the goal was to support the "realization of ideas and research efforts of young artists and, at the same time, to facilitate theoretical and public discussions on all contemporary developments" (Bilten 1972:5). This kind of conceptualization made April Meeting a unique platform for the exchange of ideas between young Yugoslav artists and some of the most significant representatives of new artistic practices from Western Europe and the United States. While Belgrade was no stranger to large showcases of artistic production from around the world, it was due to its openness and commitment to critical and open discussion that the Student Cultural Center, unlike some much better-funded international art festivals, sparked vigorous local artistic production.

The first April Meeting opened on April 4, 1972, with a performance by Slobodan "Era" Milivojević, and continued the following day with the exhibition by the competition winners, among whom were some of the future leading Yugoslav conceptual and performance artists, including Raša Todosijević (Belgrade) and Goran Trbuljak (Zagreb).[50] On the third day of the festival the Italian-French artist Gina Pane, one of the pioneers of body art in Europe, performed her two-hour piece Life-Death-Dream. The weeklong program of visual art, performance, conceptual art, theater, and music concluded on April 11 with the Open Discussion on Expanded Media, attended by festival guests and some of the leading artists, film and theater directors, writers, and art historians from Belgrade and beyond.[51] The first April Meeting featured some programs that stood out at the time, such as the "Video Performance," the first-ever presentation of this new medium in Yugoslavia, with projections of videotapes by renowned artists from the

1960s such as Allan Kaprow and Dennis Oppenheim; and two perfor-
mances by the Italian theater Centro Universitario Teatrale from Parma,
Italy, which were extremely well received by audience and critics. How-
ever, performances by Era Milivojević and Gina Pane merit a detailed dis-
cussion. Not only do Pane and Milivojević epitomize a unique encounter
between the early performance art produced in Western Europe and Yugo-
slavia, but even more importantly, an analysis of their work helps clarify
some of the political and ideological issues that seem to remain obscure if
looked at from any perspective other than that of performance.

THE MAGICIAN AS SURGEON

Not surprisingly for the egalitarian spirit of April Meeting, the postperfor-
mance discussion of Gina Pane's action turned into a sharp debate, the ex-
cerpts of which were published in the *April Meeting Bulletin* on Friday,
April 7. Slavko Timotijević, the young art historian who eventually became
the curator of the SKC's gallery, observed that Pane established a new ar-
tistic language and at the same time became its principal medium (*Bilten*
1972:6).[52] Then he added that if the main goal of Pane's "unpleasant ac-
tions" such as "self-beating and vomiting" was to establish an "experience"
that the performer shared with the audience, it was doubtful that this kind
of communication was ever fully established (6). Agreeing with Timotijević,
Milica Kraus, also an art historian, observed: "Pane establishes a contact
with the audience after the performance, when the audience is no longer an
audience. It is easy to establish contacts over a glass of wine. Her provoca-
tions are produced for the upper classes of a bourgeois audience. They
leave me untouched" (6). A dissenting opinion came from Jasna Tijardović
(another young art historian), who called attention to the inherent connec-
tion between the medium of Pane's work and the audience's response.

> Gina was convincing. I trust her expression precisely because it was
> provocative. . . . Those who were present were approaching the ac-
> tion as if everything was clear to them. It turns out that it is much
> easier [for an observer] to focus in front of a painting than in front of
> such an action. Gina is herself the protagonist of her action, and she
> takes ownership of the kind of art she offers because the very nature
> of her research is difficult to accept. Reception along the lines such
> as those of "traditional" and "nontraditional" are irrelevant here. (7)

Remaining deaf to Tijardović's subtle connection between Pane's perfor-
mance and the April Meeting's mission of positioning art as a research
practice and not a production of aesthetic objects, Kraus insisted: "She uses
new forms of expression, but is in fact traditional, and that's why she leaves
us unaffected" (7).

Outside of Yugoslavia, the first piece of documentation from Gina
Pane's April Meeting performance was published only days later, in the
April–May 1972 issue of the Paris-based journal *arTitudes*, which was one
of the early critical platforms for body art in Europe. The photograph of
Pane performing *Life-Death-Dream* in the main hall of the SKC was featured
on the cover of the journal, with scant information about April Meeting and
Pane's performance included on page 17. The front-page photograph
showed Pane kneeling in front of the piece of blank paper placed on the
floor in front of her, covering her eyes with her hands. Behind her is a large
panel covered with words that few of the French readers of *arTitudes* could
understand.

The full text on the panel reads:

LIFE	DEATH	DREAM
DREAM	LIFE	DEATH
DEATH	DREAM	LIFE

LIFE — THAT'S — THE — OTHERS
DREAM IS A SOCIOLOGICAL PHENOMENON
DEATH: IT IS NECESSARY TO ACCEPT ONE'S OWN DEATH IN ORDER TO
OVERCOME IT. (*Bilten* 1972:13)

In the version of the panel inscription that was published in the bulletin,
the last two sentences of the statement were placed in the inverse order.
The text in the bulletin also contains an additional sentence: "To be aware
of oneself through constant self-analysis: that's the shortest path to discov-
ery of the motivations of our essence and the place occupied by social au-
tomatisms" (13). The themes of life, death, and the mechanization of con-
temporary society were characteristic of Pane's early performance work.

Life-Death-Dream came only one year after Pane's first actions performed
in public. These actions were preceded by installations created in response
to social and political issues of the day. In Pane's work from the late 1960s
and early 1970s, the Vietnam War figured as a symptom of the problems
plaguing modern Western societies, and in that regard she was not an ex-
ception among her generation of artists in Western Europe and the United
States. However, in its intensity and trajectory, her response stood out from
most of the engaged art of the period.

arTitudes

rédacteur en chef : françois pluchart mensuel ● numéro 6 ● avril/mai 1972 ● 5 F

Cézanne, on s'en fout !

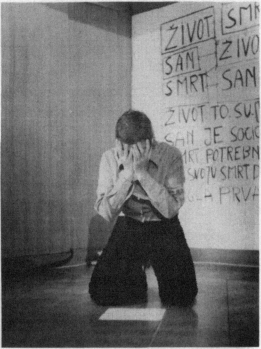

Action de Gina Pane, le 6 avril à Belgrade (information page 17).

Lorsque l'art atteint à une intensité telle que celle qu'on lui connaît aujourd'hui, l'art le plus académique, celui qui prétend incarner une tradition de beauté ouverte par Cézanne, relève la tête. C'est ce qui s'est produit naturellement et par opposition aux travaux de Manzoni et, plus tard, Beuys, Acconci, Journiac ou Gina Pane. Le plus étonnant est que cet art passéiste et réactionnaire trouve des théoriciens besogneux pour le défendre et l'opposer à la véritable création qui, dans leur langage, devient une pratique du « n'importe quoi ». Il y a plus que de la malhonnêteté dans cette attitude : une imposture à l'égard des courants novateurs de la pensée et une lâcheté devant la nécessité qui est faite à chacun d'assumer son époque.

Faire aujourd'hui remonter à Cézanne l'origine d'un art déclaré moderne relève d'une supercherie et d'une falsification de l'histoire. Il est vrai que le piège est si remarquablement tendu, l'affaire si bien montée, la notion si généralement admise qu'il faut faire au départ un grand effort d'analyse de la situation pour ne pas être victime d'une théorie dont le but inavoué est de masquer la création authentique, d'atteindre la culture et d'étouffer les formes novatrices de la pensée, celles qui s'appuient sur les réalités des données sociales et dont la finalité est précisément de dénoncer les tares de la société présente en vue d'instaurer une société plus humaine et plus juste.

(Suite page 8)

Fig. 20. The cover page of *arTitudes* 6 (April–May 1972). Photograph courtesy of Anne Marchand.

Critics and art historians who write about Pane's work from this period point to 1968 as the pivotal moment in the early career of this academically trained painter.[53] From conceptual and land art that she produced in 1968–69, Pane turned to overtly political gallery-based installations: *Fishing Plunged into Mourning* (*La Pêche endeuillée*, 1970), a grid of wooden blocks connected with charred thick rope and arranged on the gallery floor, was a comment on the civilian victims of American peacetime deployment of nuclear arms; and *Rice* (*Le Riz no. 1*, 1971), rows of skinny trunks evoking rice stems planted into soil on the gallery floor, was, as Michel Baudson writes, "indicative of the tension she felt in the face of the serious conflict: the war in Vietnam and its death wish placed in parallel to, and thus opposed to, the vital energy of an age-old nourishing force" (1998:61). Her first action involving self-injury, *Unanaesthetized Climb* (*Escalade non Anesthésiée*, 1971), was performed in her studio without an audience and in careful collaboration with the photographer Françoise Masson. It was also done in reference to the Vietnam War and, as evident from the title, its escalation: she climbed barefoot up a ladder-like structure with steps lined with sharp metal teeth. Pane performed her first public action that same year in a gallery in Bordeaux. *Homage to a Drugged Youth* (*Hommage à un Jeune Drogué*) was a social commentary addressing the themes of pain and nourishment: before she engaged in the conversation with the audience, Pane washed her hands in scalding hot chocolate (see Troche 2002:66). Pane would return to these motifs repeatedly in actions she performed in the early 1970s, including the one at April Meeting.

If we take into consideration the extreme care with which Pane approached the preparation, execution, and documentation of her live works, it is significant that her next two actions were performed in semiseclusion, away from the public art scene in France. *Nourishment/TV News/Fire* (*Nourriture/Actualités T.V./Feu*) took place outside of the gallery and museum setting, in the Parisian home of art collectors Mr. and Mrs. Frégnac, and *Life-Death-Dream* was performed in Belgrade, away from the Paris art world.[54] Both actions had a tripartite title and both were aimed at establishing a direct relationship with the audience. *Nourishment/TV News/Fire* focused on what Pane considered three predominant aspects of modern life: money, food, and television. At the outset of the action, the audience members were asked to deposit 2% of their monthly income in a safe positioned at the entrance to the space where the action took place. In the course of the first hour of the performance Pane consumed 600 grams of raw minced meat (at first she buried her face in the plate to munch the meat, but eventually had to force feed herself by using her hands to make small balls of meat, which

she stuffed into her mouth). In the second hour, she was seated on the floor and watched the news through a glaring lightbulb that was positioned right in front of her eyes. She explained that by doing this she was trying to make the audience aware of what they were watching on TV (the Vietnam War, unemployment) by removing the everyday action of following the television news feed from its usual setting, "in armchair and slippers" (Pane 1973:22). The performance concluded with her stepping barefoot on flames coming from alcohol-soaked sand until she could no longer withstand the pain.

In her oft-quoted statement from a 1979 *Flash Art* interview, Pane spoke of the wound as a means of communication: "My real problem is in constructing a language through this wound which became sign" (Kontova 1979:36). The ambition here is not to posit a field of nondiscursivity as a zone beyond language, but precisely the opposite: to introduce the body — its flesh, its fluids, its gestures — as well as objects, actions, colors, sounds, and smells into the discursive field. In *Life-Death-Dream*, Pane was trying to overcome the language barrier with her Yugoslav audience by incorporating written text into her performance to an extent she has never done elsewhere. In the first part of the action, she wrote on the white panel her words in Serbian, a language she did not know. This was followed by an attempt at direct communication with the audience. The photographic documentation shows Pane trying to grab hands of the spectators seated in the front row. Finally, in the third part of this action, she performed a series of aggressive acts toward her own body. The art critic Ješa Denegri wrote: "By irritating the capillary endings in her own skin she tried to provoke bleeding from her nose and mouth; she courted the possibility of losing her stability and falling by walking, with her eyes closed, on an imagined line; and she brought herself to the very edge of consciousness by powerfully applying pressure with her fingers on her neck arteries" (2003:25). In some of the photographs from this action, we see her vomiting on a piece of paper or lying prostrate on the floor, seemingly unconscious.[55]

The permutation of the words LIFE — DEATH — DREAM suggests that any part of the action could stand for any one of these states. In addition, the sequential use of discursive language, direct touch, and self-injury suggests that for Pane these three forms of communication are interchangeable.[56] As a text among other texts, the words written on the panel invited the spectators to engage in reading, and then move from written to spoken language, and further on, to the language of sounds, gestures, and movements. The very vigor with which Kraus and Timotijević argued that Pane's

action "failed to engage" them and left them "unmoved" confirms, paradoxically, their participation in the visceral reading of live action that Pane was hoping to elicit from her audience. In the *April Meeting Bulletin*, the "script" of *Life-Death-Dream* was accompanied by the following statement by Pane:

> Communication with the audience begins with me gesturing with my body, arms and legs. By looking, the audience not only establishes with me visual or mental contact, but begins to experience my movements viscerally. It is similar to the relationship between athletes and the audience, in which spectators share with the athlete her effort, victory, or failure. (in *Bilten* 1972:13)

As it turns out, in a body art performance, unlike in a sports contest, this "sharing" does not amount to a direct and unambiguous identification. In her Belgrade action, the audience only partially and hesitantly accepted her invitation to interact with the artist and "share" in her action. Another piece of documentation confirms the mixed reception of *Life-Death-Dream* by the audience in Belgrade's Student Cultural Center. The photograph (fig. 21) captures the moment of Pane's direct contact with an audience member.

As Sophie Delpeux pointed out in her article "Le 'familier-inconnu' de Gina Pane," insofar as Pane "strove in her actions to *touch* the audience, this photograph encapsulates her entire artistic practice" (Delpeux 2004:114). While noting that Pane took as her goal in this action to arrange an "experience of physical communication with the audience," the ambivalence of the outcome is evident in this piece of documentation: as Pane grasped the hands of a smiling audience member, the suspicion on the faces of spectators in rows behind him revealed their doubts about the purpose and even in the possibility of such a gesture (114). Pane was aware of this ambivalent reception of her actions. The following year, in her interview for *Art and Artists,* she complained of the audience's tendency to become "increasingly hostile" to her work (Pane 1973:23). Instead of retreating, she responded with even more aggressive actions.

In May 1972, upon her return from Belgrade, Pane staged in Paris one of her landmark works, *Warm Milk* (*Le lait chaud*). In the course of this action, she at one point turned her back to the audience and started making incisions with a razor blade on her back. Following the next segment of performance, in which she played with a tennis ball, Pane turned to the audience and, kneeling on the floor, brought the razor close to her face:

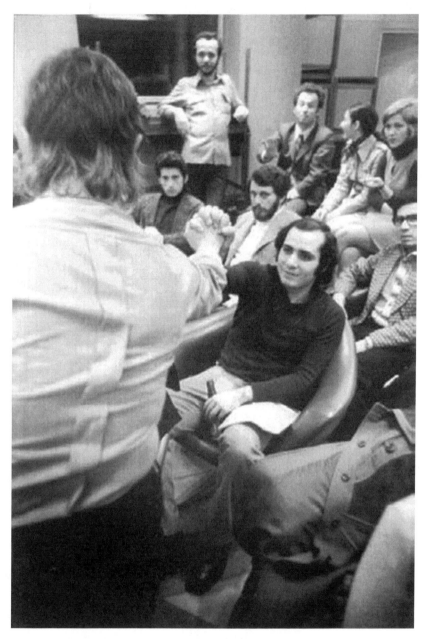

Fig. 21. Gina Pane, LIFE—DEATH—DREAM. April Meeting, SKC, Belgrade 1972. Photograph courtesy of Anne Marchand.

The tension was explosive and broke when I cut my face on either cheek. They yelled "No, no, not the face, no!" So I touched an essential problem—the aestheticism in every person. The face is taboo, it's the core of human aesthetics, the only place that retains a narcissistic power. Before the two facial slits, my action was understood as masochistic, but when I attacked my face, the attitude changed. (Pane 1973:23)

The shock of Pane's body art does not come from the spectacle of self-inflicted pain, but from the radical recasting of the traditional position of the painter, which Walter Benjamin in his parable about the surgeon and the magician defined in terms of distance:

How does the camera operator compare with the painter? In answer to this, it will be helpful to consider the concept of the operator as it is familiar to us from surgery. The surgeon represents the polar opposite of the magician. The attitude of the magician, who *heals a sick person* by a laying-on of hands, differs from that of the surgeon, who makes an intervention in the patient. The magician maintains *the natural distance* between himself and the person treated; more precisely, he reduces it slightly by laying on his hands, but increases it greatly by his authority. The surgeon does exactly the reverse; he greatly diminishes the distance from the patient by penetrating the patient's body, and increases it only slightly by the caution with which his hand moves among his organs. In short: unlike the magician (traces of whom are still found in the medical practitioner), the surgeon abstains at the decisive moment from confronting his patient person to person; instead, he penetrates the patient by operating. (Benjamin 2003:263; emphasis added)

Taking a razor to her skin, Pane recasts the painter as the surgeon. Instead of operating on the other (a patient, or a sequence of images), she makes incision into her own face, and in doing so turns herself into a patient and a representational object. The audience responds by actively resisting this change of roles that upsets the basic parameters of an aesthetic relation. What is, then, the content of this shift?

There are two sets of juxtapositions in Benjamin's parable. The more obvious one is the pairing of the painter and the operator, mirrored in the magician and the surgeon. This pair, in turn, points to the healing and spatial relation between subject and object. The magician/painter heals by

maintaining the distance; the surgeon/operator heals by overcoming it. At the time of writing the essay that contains this dazzling parable, Benjamin was investigating two aspects of distance: the first one was that of the aura, which he defined as "the unique apparition of a distance [of an object], however near it may be" (255); the other was that of artistic procedure of making strange, which he found in its purest form in Brecht's *Verfremdungseffekt*.

Throughout the 1930s Brecht gradually elaborated on his idea of the V-effekt, or alienation effect as it was later rendered in English, a technique inherent to theater and other arts (literature, painting) that has been obliterated by bourgeois theater through its insistence on realist illusionism. The fundamental feature of this device is making strange. As he explained in his 1936 article "*Verfremdung* Effects in Chinese Acting," in resorting to this device, "the artist's object is to appear strange and even surprising to the audience. He achieves this by looking strangely at himself and his performance. As a result everything put forward by him has the touch of the amazing. Everyday things are thereby raised above the level of the self-evident" (Brecht 2015:152). Benjamin understood this "effort" toward defamiliarization in terms of distance. In the first version of his essay "What is Epic Theatre?" he observed that, unlike bourgeois, epic theater "incessantly derives a lively and productive consciousness from the fact that it is theater. This consciousness enables it to treat elements of reality as though it were setting up an experiment, with the 'conditions' at the end of the experiment, not at the beginning. Thus they are not brought closer to the spectator but distanced from him" (Benjamin 1973:4). And here is the (social) experiment in all of its crudeness: a stranger enters the scene in the middle of a family row. "The more far-reaching the devastation of our social order (the more these devastations undermine ourselves and our capacity to remain aware of them) the more marked must be the distance between the stranger and the events portrayed" (5). The device of strangeness reestablishes the auratic relationship, but on a different terms. It is no longer the wonder of magic that is elicited in the spectator, but wonder over the proportions of ethical, political, and economic monstrosities that capitalism automatizes and normalizes into routines of everyday life. The difference between the alien and the strange is precisely in this reestablishment of distance. Benjamin writes that in epic theater, "the first point at issue is to *uncover*" the social conditions, and then goes on to explain: "One could just as well say: to make them strange (*verfremden*)" (1973:18). If in the 1930s radical art tried to reassert the aesthetic relation of separation in order to make "the devastation of the social order" observable, in the 1970s it demonstrated the necessity of that distance through its extreme abolition.

The operators of this radical elimination of distance became known as body artists. Their gesture was risky not only because of the pain and radical negation of the object, that is commodity, that it involved, but because of its vulnerability to misreading. The most fundamental misreading saw their work as art of action. As Pane explained, for the spectators of *Warm Milk*, the magic is gone so that suddenly the tension of the wound sets in. But it is not an isolated cut that poses this radical threat in her performance. Even though the wound represented the most shocking "sign" in Pane's performance, it was by no means the only or even the most privileged element in her actions. The cut as a "sign" that affected the audience on a visceral and most immediate level was part of a much broader texture that constituted her live works. François Pluchart wrote that Pane spoke of working not with "symbols" but with "modules." For example, she considered fire one of the "modules" in *Nourishment/TV News/Fire*, the other being the artist's body (1972:10). The action modules were neither symbols nor props, but syntactical units of live performance. This *performance syntax* brings together the discursive and the corporeal, the evocative and the literal, in order to establish a spatial and temporal sequence of heterogeneous units that generate meaning, addressing simultaneously conceptual, emotional, and sensory faculties of the beholder. The deployment of this kind of performance syntax that emerges from the expansion of visual language hitherto limited to painting and sculpture and its careful manipulation was not specific to Pane, and in fact it marks the work of a number of post-1968 performance artists on both sides of the Atlantic, such as Valie Export, Joan Jonas, Hannah Wilke, Raša Todosijević, and Era Milivojević, to name some. This syntactical performance can be seen as a continuation of practice that originated in 1968 political action, which Blanchot memorably described as "writing outside of discourse, outside of language" (2010:97). In these performances, the nondiscursive borders discourse but does not fully belong to it. While refusing verbalization, these actions retain syntactical properties of language broadly construed. In doing so, the body and the language overlap structurally: the case in point is not that the body has its own "language," but that it lends a specific grammar to the live representation in which it partakes. It resembles the epic theater's relationship to its "story," which, as Benjamin observed, "is like that of a ballet teacher to his pupil; his first task is to loosen her joints as far as they will go" (1973:16). In body art, the body is not only an object, but also a structuring device. The "joints" of this "story" are so elastic that it no longer resembles a conventional narrative, and its parts so striking that they overshadow the whole to which they belong. Importantly, all of the artists who produced syntactical per-

formances were trained painters, and they inherited from their education a notion of painterly language. However, that understanding of language as an expressive capacity of the medium came together with a radical rejection of the means of expression that were traditionally considered proper to the medium. In this kind of performance, practices, relationships, and structures are just as important as materials, if not more so.

Here, the nondiscursive is not anterior to discourse. It does not belong to an assumed prediscursive or "preverbal" domain.[57] It does not precede or produce discourse. Instead, its place is next to it—around discourse, not in addition to it. The nondiscursive belongs to the affective and the situational. And it is vigorously and deeply temporal. As such, it is precisely that which evades discourse and remains tenaciously outside of it. Instead of signifying, it establishes symbolic, or to use Pluchart's locution, "modular" chains. These sequences always have a body as their point of origin, and always remain oriented in relation to it. These pulsational and affective chains expand from the body to include objects, sounds, volumes, images, and smells, and in the process acquire a complex and rigorously presentational structure. The articulation of the structure is not conventional, and it does not lend itself to any predetermined reading. In that sense, it is the writing of cuts (and in Pane's case, physical cuts can become explicit instances of this signification) that resists habitual communication. It is not the writing of traces, but of slits and openings. Here the economy of signs is significantly distorted toward their materiality, while at the same time retaining their sequential nature. Hence the presentational nature of syntactical performance: in order to constitute itself as such, it needs a detached reader/beholder, not a participant/collaborator.[58] Dynamics between distance and nearness are fundamental not only to the internal logic of the performance, but also to the way in which it addresses its spectators.

There are two moments of engagement with the audience that throw light on the "narcissistic power" to which Pane alluded in her discussion of *Warm Milk*. On the one hand, there is a strong audience reaction to her attempt to make an incision on her face, or in other words, to rupture the psychic separation between the self and the other; on the other, there is the gesture of seemingly spontaneous contact with a spectator during the performance of *Life-Death-Dream*. In the photograph from her SKC performance, we see her grasping the spectator's palm with her open hand. This is not a handshake. Both Pane and the audience member hold their hands high, touching each other with their palms and interweaving their fingers: a gesture suggesting a certain mirroring and overcoming of the mirror at the same time. Pane indicated her particular understanding of the power-

ful and ubiquitous symbolism of the mirror in her 1975 action *Soft Matte Discourse* (*Discours mou et mat*). Dominant "modules" in the final section of this action, performed at De Appel gallery in Amsterdam, were two mirrors positioned on the floor, with a mouth drawn on one, and the word "ALIENATION" inscribed on the other. The most striking syntactical element of this action was Pane's smashing of the mirrors with her bare hands, to which she turned twice in the course of the performance. First, she broke the two mirrors, then moved on to the next segment, which, as in *Warm Milk*, involved playing with a tennis ball, this time much more labored and less playful. Exhausted from this game, she crawled back to the mirrors and shattered them into small pieces, cutting her hands in the process.[59]

Breaking the mirror and grabbing the spectator's hand were both aimed at overcoming "social automatisms," as Pane explained in the *April Meeting Bulletin*. Through these radical gestures the artist strove to overpower these internalized aspects of the performance principle. In Pane's work, there is a strict parallelism between overcoming alienation and overcoming distance. In that sense, subverting alienation and uncovering distance can be said to represent the single most important political claims of her syntactical actions. And in this program of dealienating perfomance, self-wounding became the most striking liberatory gesture. Speaking of *Unanaesthetized Climb*, Pane asserted that by climbing the spiked steps of the ladder-like structure barefoot, she "wanted to emphasize the fact that the artist's—as well as man's—relationships are perverted in the rush to achieve a goal, in the frenzy to get ahead. There is no mutual respect or trust. Therefore every gesture is inhuman and people's sensibilities are automatically anesthetized; they're no longer aware of the effects of their actions" (Pane 1973:22). Jennifer Blessing observed that Pane's "stated attempt to transcend alienation in her performance of suffering" closely resembles, but cannot be identified with, the "goal of the disturbed skin-cutter to feel something other than terrifying isolation" (2002:26).[60] In *Soft Matte Discourse*, the gesture of smashing the mirror was aimed at penetrating through both discursive language (the drawing of the mouth) and the alienating self-isolation (the inscription "ALIENATION"). Aimed against alienation that permeates an "anaesthetized society," Pane's actions often involved suffering as both symbolic and political intervention. As François Pluchart pointed out, her body actions aimed "at emphasizing, to denounce them and correct them, certain determinisms, according to which every day is identical to the preceding one and which throw the man toward a fate of self-mutilation and destruction" (1984:129). Both the mouth she drew on the mirror and the inscription "ALIENATION" were marks of uniformity and reiteration. The

violent act of smashing the mirror into smithereens has to be read as an act of escape from its isolating repetitiveness.

If, as Rosalind Krauss has argued, much of the experimental art of the 1970s was indexical in nature, then Pane's actions represent one of the most radical examples of this indexicality. In her "Notes on the Index: Part 1," Krauss explained indexes as the types of signs that, unlike symbols, establish their meaning "along the axis of a physical relationship to their referents." They are the "marks or traces of a particular cause, and that cause is the thing to which they refer, the object they signify" (1986:198). Insofar as Pane spoke of her self-inflicted wounds as the "problem of language" and, therefore, of signification, they belong to Krauss's category of indexes. Unlike other "indexical" (body) artists such as Acconci, Pane made a clear distinction between the "cause" of indexical art and the "object" it "signifies": the latter is certainly the body of the artist, while the former, as Pane herself indicated on numerous occasions, is the alienation prevalent in postindustrial societies. It is not at all accidental that in Pane's work mirroring became both the means of representation and its subject. This, in turn, corresponds to the distinction Krauss made between reflection and reflexivity. On the one hand, through physical touch with the audience in *Life-Death-Dream*, Pane engaged in an act of mirroring, which Krauss characterized in her article "Video: The Aesthetics of Narcissism" both as a "move toward an external symmetry" and as a "vanquishing of separateness" (1978:53). On the other, reflexivity—which Krauss described as a "strategy to achieve a radical asymmetry" and as a "fracture in two categorically different entities that can elucidate one another insofar as their separateness is maintained"—became prominent in Pane's body art pieces in which aggression toward the audience is sublimated into self-wounding. The tension between reflection as the realm of alienation and reflexivity as the means of overcoming alienation informed much of Pane's action work of the 1970s. The arena within which the drama of the separation between these two tendencies took place was that of subject formation. And that is the context within which the juxtaposition of Pane's and Milivojević's April Meeting performances becomes significant.

THE SURGEON AS STITCHER

In his two-volume book *Verfremdungen*, which already in its title references Brecht, Ernst Bloch sets up two most prominent post–World War II concepts of alienation, Marxian *entfremden* and Brechtian *verfremden*, as a state-

ment of a problem and an answer. He proposes that, whereas the first term, *entfremden*, contains the Hegelian sense of "the externalization of Idea into Nature" to which Feuerbach adds "a clearly negative connotation" of "man's alienation from his very self," the second term, *verfremden*, designates "estrangement" or "displacement" that makes the thing no longer "wholly self-evident" (Bloch 1970:121).[61] He concludes that the "roundabout way of estrangement is . . . the shortest route away from alienation and to self-confrontation" (125). In his article Bloch sets the two meanings of estrangement in a dialectical relation, and then adds an interpretation that departs from straightforward Marxist theory. A similar procedure is recognizable in Hugo Klajn's article "Alienation according to Marx and according to Brecht," which was published at almost exactly the same time as Bloch's. Before he turned to theater and drama in post–World War II Yugoslavia, Klajn earned a medical degree at the University of Vienna, where he trained with Sigmund Freud to receive a specialization in psychoanalysis. So it seems he couldn't help himself: "Brecht's device of alienation responds Marx's condition of alienation as some kind of homeopathic healing, according to the principle of *similia similibus*, as healing with the same thing that causes the ailment" (1966:n.p.). Bloch concludes his discussion of *Entfremdung/Verfremdung* by invoking the paradigmatic psychoanalytic situation of mirroring: "The real function of estrangement is—and must be—the provision of a shocking and distancing mirror above the only too familiar reality; the purpose of the mirroring is to arouse both amazement and concern" (125). This intertwining of Marxist and psychoanalytic notions of alienation was not lost on Jacques Lacan, who, in the seminar coterminous with the two texts I just quoted, complained about the pervasiveness of discourses of alienation at the time of his lecturing in the early 1960s.[62] "One has to admit that there is a lot of this alienation about nowadays. Whatever one does, one is always a bit more alienated, whether in economics, politics, psycho-pathology, aesthetics, and so on" (Lacan [1973] 1978:210). But then, he warned, that is not the kind of alienation he had in mind when he spoke about subject formation.

The recognition on the part of Krauss and other art historians of the strong narcissistic strain within the new art of the 1970s went hand in hand with their turn to Lacanian psychoanalysis in search of an understanding of the relationship between subjectivity and representation. And it seems that a number of performance artists' use of mirroring in their investigations of the authorial subject position in relation to the work of art pointed to Lacan's concept of the mirror stage (Valie Export's 1967–68 *Abstract Film No. 1*, Joan Jonas's 1969–70 *Mirror Pieces*, Acconci's 1973 *Air Time*, Pane's

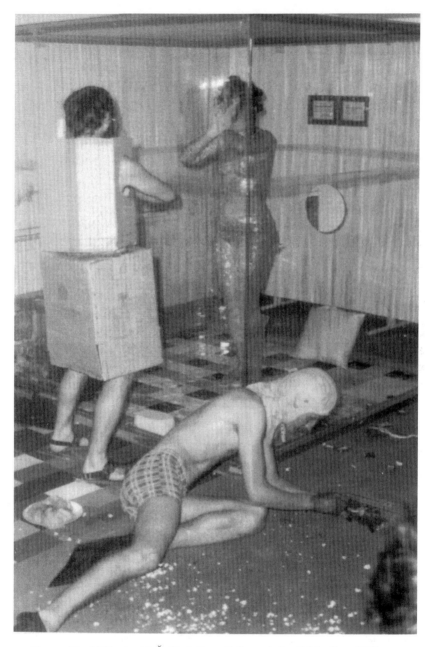

Fig. 22. Era Milivojević: *Ž1M: A Dress Rehearsal*. April Meeting, SKC, Belgrade, 1972. Photograph courtesy of the artist.

1975 *Soft Matte Discourse*, Dan Graham's 1976 *Public Space / Two Audiences*, and Marina Abramović and Ulay's 1977 *Balance Proof*, to name but a few). In Era Milivojević's performance *Ž1M: A Dress Rehearsal* phenomena of mirror and mirroring are not as prominent as in the pieces listed here. If they are occluded and relegated to the background, it is because this piece comes at the end of a long series in which precisely these phenomena were given a central position.

Ž1M: A Dress Rehearsal started at 9:00 p.m., immediately following the first April Meeting's opening ceremony, and it was staged in the hallway in front of the gallery at the Student Cultural Center. Apart from Milivojević, two other young painters, Milan Marinković "Cile" and Ljubica Mrkalj participated in the performance. A glass cube that measured 2 × 2 × 2 meters dominated the performance space. The cardboard box that Milivojević wore on his body echoed this geometrical structure. He and Marinković, who wore swimming trunks, aviator-like headgear, and swimming fins on his feet, were located outside the glass box. Ljubica Mrkalj, her body wrapped in translucent tape, was confined inside the glass enclosure, which was adorned on its rear wall with a round mirror and two death notices.[63] Inside the glass cube, there was a TV set with its screen turned toward the wall. Most of the action took place around the glass box, taking the audience's attention away from the mirror. In the course of the action, Marinković covered the glass walls with drawings and scribblings done in thick white paint, which additionally obscured the view of the interior of the glass box. If we consider *Ž1M: A Dress Rehearsal* within the context of Milivojević's performances that immediately preceded and followed it, it becomes clear that the entire structure of this performance is informed by the phenomena of mirroring.

There are several elements in *Ž1M: The Dress Rehearsal*, such as the mirror and the translucent tape covering Mrkalj's body, that represent points of continuity between this work and Milivojević's "art sessions" that immediately preceded it.[64] His early conceptual work suggests that he was not only a pioneer among his generation of Belgrade artists in moving decidedly away from easel painting to installations and public performances, but also that he was among the first to engage directly the question of the subject position. Among Milivojević's other works from this early period, a series of installations and actions that involved wrapping, taping, and covering objects with translucent packing tape stands out. The first in the series was the wrapping of a replica of Michelangelo's statue *Dying Slave* (c. 1969). In a brief comment on this public action, which took place on the

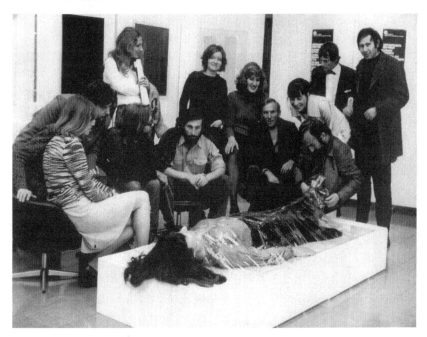

Fig. 23. Era Milivojević: *Taping the Artist*. SKC, Belgrade, 1971.
Marina Abramović on the table and, among others, Gergelj Urkom,
Raša Todosijević, Neša Paripović, Biljana Tomić, and Ješa Denegri in
the background. Photograph courtesy of the artist.

busy staircase of the Belgrade Academy of Fine Arts, Milivojević said that
the thick layer of tape encasing the statue becomes a mold for a sculpture
that is a duplicate of another sculpture, therefore, a "copy of a copy"
(2001:17). That the taping up of objects was an intervention in the process
of reflection and identification became clear soon thereafter, when in the
fall of 1971, on the occasion of the opening of the first October event at the
Student Cultural Center, he covered with tape all mirrors he could find in
this recently renovated building, including the large mirror panels in the
lobby area.

If tape-wrapping the replica of a classical statue can be seen as a cri-
tique of institutional and educational processes in the arts, then taping up
surfaces that occupy a highly charged place within the psychoanalytic
theory of subject formation could be interpreted as an indication of the
artist's concern with the social and psychic positioning of the subject in
Yugoslav society. Milivojević's work with mirrors coincided with similar
works done by conceptual artists outside of Yugoslavia, and was at the
same time radically different from them. Unlike, for example, Joan Jo-

nas's *Mirror Check* (1970), in which the artist stood naked in front of the audience and investigated her body parts with a mirror that gave her a detailed and fragmented view of her own body, Milivojević opted to shut down the mirror reflection rather than being absorbed in it.[65] Through this disruption of the process of self-recognition, the artist obscured rather than scrutinized the content of the mirror. The attention that Milivojević directed to this reflective surface resulted in the removal of the image from this optical device that figured prominently in the history of painting from Diego Velázquez to Michelangelo Pistoletto. While the tape made the mirror matte, it also protected its surface. This is a gesture that stands in sharp contrast to Pane's aggression toward the mirrors in *Soft Matt Discourse*. In the final analysis, covering the mirror with clear tape can be seen as a paradoxical effort to capture and fix that which is not there to begin with: the mirage produced on the thin silvery film that covers one side of the glass. Of course, Milivojević's taping actions and installations can and should be read in relation to Lacan's theorization of the mirror stage. Therefore, we can say that in Milivojević's hermeneutics of the mirror, the investigation of primary symbolization never came at the expense of primary socialization.[66] Namely, in a performance in which he for the first time made use of participants other than himself, Milivojević staged the action of taping up, this time not a surface reflecting the image, but another human being. It was Marina Abramović— significantly, the only female member of the informal Group of Six artists who became closely associated with the post-1968 conceptual and performance art scene at Belgrade's Student Cultural Center.

The first three Milivojević taping actions can be seen as exercises in the symbolic adaptation and permutation of its most prominent material element, transparent tape. Whereas in the action of wrapping up of a statue it became a mold, therefore an instrument for reproducing shapes and images, in the second action it was used to obscure and remove *any* image from the mirror surface; finally, in the third, the tape acted as the surface covering the subject—this time it was quite literally a living human being. The taping up of the human body can be seen as a literalization of the symbolic attempt in the previous action to fix and arrest the image. And it is in this action that the Lacanian undertones of this entire series began to emerge clearly. In Milivojević's actions, the displacement of the "object" of taping from a vertical to a horizontal position underlines, on the one hand, the spatial relation between the subject and representation, and on the other, the nature of the tape as the "barrier" that determines and organizes this relationship. Here, the passage from mirror to Marina was decisive.

Formally, it marked the shift from installations to actions; structurally, from the single artist's creation to a collaborative work of art; finally, on the symbolical level, it replaced representation (statue, mirror image) with the female body. And that changed the significance of the dividing line, or the bar/barrier; or in this case, the translucent casing made of tape.

In the course of his investigation of the letter, Lacan presented the algorithm S/s as the very "locus of the unconscious," at the center of which, needless to say, is the line of demarcation that separates the upper and lower region of the sign. In his reading of this simple mathematical formula, Lacan takes into account its departure from the linearity of writing toward the hieroglyphic properties of its spatial organization. According to this reading, the signifier not only designates the signified, but stands "over" it. In working out the "algorithm," as in an interpretation of a dream, nothing can be deemed insignificant. The line $(-)$ that in mathematics designates division, in Lacan's reading becomes the "bar" that separates two levels of signification. He describes it as the "barrier resisting signification" positioned at the very center of a drama of signification based on the "primordial position of the signifier and the signified as distinct orders" ([1966] 2002:498). The bar is not just a line separating the signifier from the signified, but the boundary of the symbolic order. That which is below the threshold of the symbolic order always escapes the grasp of the signifier, and of representation. In the progression of Milivojevic's actions, positioning the Other (human body, not a statue; woman, not a man) in the place of the signified radically destabilized this "central locus."

To some degree, the neatness with which Lacanian analysis corresponds to certain works, from visual art to literature and film, can be an occasion for skepticism. It seems almost *too* inevitable that an artist who investigates the mirror as the privileged site of representation would place a woman in the place of the other and of the signified, both of which are marked by lack. Indeed, in Jacques-Alain Miller's conceptualization of the subject's relation to the process of signification, lack occupies the primary role. He portrayed this relation with the figure of "suture," asserting that "it names the relation of the subject to the chain of its discourse." The subject figures in this chain "as the element which is lacking, in the form of a stand-in. For, while there lacking, it is not purely and simply absent. Suture, by extension—the general relation of lack to the structure of which it is an element, inasmuch as it implies the position of a taking-the-place-of" ([1966] 1978:26). Not surprisingly, Miller's psychoanalytic concept of suture entered film theory much sooner and more thoroughly than theoretical investigations of theater and performance. The analogy between film as a se-

quence of images and Miller's discourse as a "signifying chain" is, of course, too close to be productive. This, in turn, could lead to an association of Milivojević's adhesive tapes with the film reels and his action of taping as literal "suturing" or stitching of the subject to her position in space. But this leaves unanswered a number of questions related to suturing in relation to performance.

In one of the earliest uses of the theory of suture in film, Jean-Pierre Oudart focuses on the role of absence in phantasmatic projection as the main property of spectatorial investment in cinematic representation. Here the emphasis shifts from chain (linearity, succession, etc.) to questions of space and volume. So Oudart posits that "every filmic field is echoed by an absent field, the place of a character who is put there by the viewer's imaginary," which he names "the Absent One" ([1969] 1978: 36). The process of suturing amounts to the transposition of the spectator into the "filmic space" from which s/he is barred. In cinema, the "chain of sutured discourse" is not "articulated" by a sequence of shots, but by a spatial relation in which "the same portion of the space" is "represented at least twice, in the filmic field and in the imaginary field" (39). In itself, this "field" is articulated by cinematic "framing which plays an essential role, since any evocation of the imaginary field relies upon it: that is the filmic field and the fourth side: the field of Absence and the field of the Imaginary" (39). In other words, the cinematic "field" is strictly limited by the conditions of the medium, and the "space" that it produces is generated by the illusion of perspectival depth. As Stephen Heath asserts in his gloss on Oudart's theory of suture, in cinema "the Absent One" takes the place of the theatrical "fourth wall" (1978:57). The theatrical fourth wall not only survives in cinema but becomes the central element of its spatial production because it facilitates the relationship of mirroring: "The ideal chain consists . . . of a duplicating representation, which demands that each of the elements composing its space and presenting its actors be separated and duplicated." (39). Hence Oudart argues that the "profound relationship linking the cinema to the theatre" comes from "the place of metaphorical representation, at once spatial and dramatic, of the relations of the subject to the signifier" (38). However, what Oudart believes to be the shared property of film and theater is precisely the source of limitation of his theory of cinematic suture in relation to live performance. Here "dramatic," that is to say, narrative, produces a certain kind of "space"; he concludes that the "metaphorical representation" is spatial *because* it is dramatic. "Thus," writes Oudart, "what we are here calling the suture is primarily the representation of that which, under the same heading, is now used to designate 'the relationship

of the subject to the chain of its discourse'" (38). This holds only for narra-
tive cinema and narrative performance. Once it strips itself of narrativity,
performance "articulates" its discourse by nondiscursive means. Instead of
as a chain, the "discourse" of performance is organized as a living space. In
other words, instead of being sequential and imaginary, it is pulsational
and real. This is not to say that suturing is inoperative in performance, but
that the structure of lack is organized in an entirely different way.

The crucial difference between live performance and narrative cinema
is that the latter's "space" is always evocative and illusionary. Strictly
speaking, the filmic "field" is a volume outlined by the extension of the
edges of the frame to include the spectator. The glass cube in Milivojević's
Ž1M comes across not only as an extension of the illusionistic space of the
mirror, but also as a literalization of the volume implied in the cinematic
"field." The transparent vessel that in his previous actions held the other is
now made of glass. Unlike in the action of taping up mirrors, this glassed-
in space of representation is no longer a surface but a volume. Further-
more, as in the action of taping up Marina Abramović, the translucent en-
closure envelops the female body. This time Ljubica Mrkalj, unlike
Abramović, was not fixed on the pedestal. As if suggesting that *Ž1M* picked
up where his previous taping action left off, Milivojević had Mrkalj starting
from a position similar to that of Abramović: wrapped in tape and lying
down in a horizontal position. However, in the course of the performance,
the subject begins to move. She eventually stands up and begins perform-
ing her own actions.[67] At one point, Milivojević applied a stripe of tape
across the middle of the glass box, but that could no longer prevent the
"signified" from adopting the agency of her own. Of course, it turns out
that this agency is illusory. Mrkalj performed actions assigned to women
by the patriarchal society: still wrapped in tape, she pulled curlers from her
hair, put on plastic gloves, and cleaned the glass from within (Mrkalj 2011).
In the end, the image was turned inside out: if the glass cube resembled an
aquarium, then the snorkeling outfit of Milan Marinković indicated that
what was perceived as "outside" was submerged underwater, so that in
relation to it the cube constituted an outside. Likewise, it was not only
Mrkalj who was inside the box, but even more so Milivojević: clad in card-
board boxes, his body adopted the geometrical form of the space that
"holds" representation.

It is precisely through this drama of the loss of the self that Milivojević's
performances differed from indexical works that marked the artistic pro-
duction of the early 1970s. Even though in this period his performances
featured costumes and elaborate stage actions, he and other members of

the informal group at the SKC insisted on distinguishing their performances from the tradition of happenings, which was by then well known in Belgrade and Yugoslavia.[68] In his article "Performance," Todosijević writes that in performance "an artist attempts to express himself though several simple gestures, giving up on the eclecticism and excess that we have encountered in happenings. The artist's body becomes the center of actions, and any additional props, eccentric or banal details, costumes, and everything else are there just to direct audience's attention" (Todosijević 1983:57). And further: "Today, [live] works are not counting on audience participation as happenings did; they are much simpler, and focused more on the artist's person, so there is no room for improvisation and accidents" (60). This kind of live art is not inclusive and collaborative, but distinctly presentational and frontal. This insistence on distance and separation, as it were, of one subject from another, can be seen as a direct response to the threat of assimilation into larger collective, which was too often in the course of the twentieth century offered as a way out of the alienation and isolation of an individual. The danger hidden in this solution was that dealienation all too easily turns into desubjectivization.

If we return to *Ž1M: The Dress Rehearsal*, we will find that the radical transposition of the mirror from flat surface to volume threatening to engulf the entire space can be seen in relation to the section of Lacan's essay on the mirror stage that has rarely been mentioned in Lacanian readings of performance. The case in point is a seemingly random digression, characteristic for Lacan, which follows his discussion of the formative role of the image (form, gestalt) in the development of an individual. Speaking of the mimetic aspects of the formation of the self, he brings up the article "Mimicry and Legendary Psychasthenia" in which Roger Caillois argues that certain aspects of mimesis may lead to self-obliteration.[69] As Lacan put it, here the "morphological mimicry" becomes part and parcel of the "derealizing effect of an obsession with space" ([1966] 2002:5). What is he referring to?

Continuing the work he began with his 1934 essay "The Praying Mantis: From Biology to Psychoanalysis," in which he tried to establish a bridge between surrealism and science, Caillois in his article "Mimicry and Legendary Psychastenia," published in 1935 in Georges Bataille's journal *Minotaure*, argued that certain instances of mimicry in nature, especially among insects, cannot be explained by Darwinian arguments about survival-driven adaptation to the environment. Citing such examples as the leaf-like insect *Phylliidae*, which engages in cannibalism precisely because it too successfully mimics leaves (its main foodstuff), Caillois tried to provide enough basis for a drive that is opposed to the pleasure principle

and parallel to the death drive, a drive he calls *instinct d'abandon* (instinct of letting go) ([1935] 2003:102).[70] Caillois explained this instinct as a "veritable *lure of space*" and a "disorder of spatial perception" (99). To use Lacanian language, this would be the case of an overidentification with the image and, in fact, so much so that the image overwhelms the subject's sense of reality. Caillois described this disorder as a radical decentering of the self: "Matters become critical with represented space because the living creature, the organism, is no longer located at the origin of the coordinate system but is simply one point among many" (99). This is, of course, a striking case of the decentering of the Cartesian subject. Caillois likened the radical cases of animal mimicry, such as the "truly frightening" ability of a decapitated praying mantis to feign "rigor mortis in the face of danger" (79), to the phenomenon that Pierre Janet, French psychologist and Freud's opponent, observed in schizophrenic patients as a "form of mental depression" characterized by the "lessening of those functions which enable one to act upon reality and perceive the real" and named it *psychastenia* (in Caillois 2003:67).[71] Following up on Janet, Caillois wrote that, overtaken by the *instinct d'abandon*, the subject "tries to see *himself, from* some other point in space. He feels that he is turning into space himself—*dark space into which things cannot be put.* He is similar; not similar to anything in particular, but simply *similar.*" In short, he concludes that all of this can "bring into light one single process: *depersonalization through assimilation into space*" (10). There is a certain kind of representation in which the "field" and "space" are not metaphorical but literal, and which strive to assimilate the viewer into a certain symbolic order not through spectatorial projection, but through expansion of this "field" to include the social sphere in its totality. Here the case in point is mass spectacle, which often, as was the case in Yugoslavia, aspires to engulf the entire state.

If there is one aspect of Milivojević's performance that is more thought provoking than the exploration of the spatiality of the mirror, it is its title: *Ž1M* is an abbreviation of the slogan "Živeo 1. maj," that is, "Long live May 1." This strong reference to the international day of labor determines the nature of all actions performed in this piece. The swimming, the taping, the painting, the struggle within the confines of the boxes: these acts can be interpreted as a struggle of the subject to overcome its external regulation and emplacement. And as we have seen, in the symbolic universe of post–World War II Yugoslavia, the space and the self are most closely aligned in mass exercises performed each May. "Long live May 1" is a direct allusion, if not to Youth Day, then to May Day, which was ranked, along with Youth Day and the Day of the Republic (celebrated on November 29) as the top

Yugoslav state rituals. If through these mass displays of bodies, the idea of self-management became interlocked with the image of Caillois's "endless similarity," then hailing May Day in Milivojević's performance is a call for a reversal and undoing of this concept of the self. The second part of the title seems to suggest the direction of this transformation of the self-managing subject. The "Dress Rehearsal" could be a simple reference to the upcoming May Day celebrations: April Meeting, then, is a preparation and gearing up for the big festivity. However, it also suggests that the labor performed at the very opening of April Meeting heralds a new concept of labor, a labor to come, that will reverse the relationship between the subject and social apparatuses that always strive to regulate this subject. $Ž1M$ puts on display the difference between bodywriting and syntactical performance. Whereas the former scripturalizes the corporeal, the latter materializes the symbolic. Bodywriting coerces the bodies into a linguistic form of discourse; conversely, syntactical performance "invents" its own discourse that draws on language no less than on the corporeal and the instinctual to include gestures, senses of touch and smell, disgust, attraction, personal memories and fears . . . In doing so, syntactical performance reaches back to the idea of estrangement that precedes Brecht: to Viktor Shklovsky's idea of defamiliarization (*ostranenie*). The Russian formalist held that this poetic device brings to literature the insight that "an image is not a permanent referent for those mutable complexities of life which are revealed through it; its purpose is not to make us perceive meaning, but to create a special perception of the object—*it creates a 'vision' of the object instead of serving as a means of knowing it*" (Shklovsky [1917] 1965:18). While in the medium of literature this device "makes strange" poetic images, in the medium of live art syntactical performance defamiliarizes the language itself.

Syntactical performance not only points back before Brecht, but reaches past *Verfremdungseffekt* to psychoanalytic interpretations of alienation. In his seminar of 1964, Lacan followed his complaint about ubiquity of alienation with a disclaimer that in psychoanalysis this idea has nothing to do with what most of his readers would first think of: the inability of the subject to see itself in any other way but through a projection on the Other. For Lacan, alienation is the basic fact in the causation of the subject, that is, in its formation. The first fact of subject formation is the division. Lacan concludes the lecture that precedes "Alienation" with a summary of his idea of the unconscious, which is based on "the fact" that "being born with the signifier, the subject is born divided. The subject is this emergence which, just before, as subject, was nothing, but which, having scarcely appeared, solidifies into a signifier" ([1973] 1978:199). If the subject is formed in the

symbolic, it comes into being through division that is inscribed in the topology of the sign. Lacan illustrates the categorical nature of this division with the grammatical function of the word "or" in the phrase "your money or your life," which he designates as the *vel* of alienation (212).[72] It is only at this point that the Other enters the "drama of the subject" to introduce separation as the second dimension of alienation:

> By separation, the subject finds, one might say, the weak point of the primal dyad of the signifying articulation, in so far as it is alienating in essence. It is in the interval between these two signifiers that resides the desire offered to the mapping of the subject in the experience of the discourse of the Other, of the first Other he has to deal with, let us say, by way of illustration, the mother. It is in so far as his desire is beyond or falls short of what she says, or what she hints at, or what she brings out as meaning, it is in so far as his desire is unknown, it is in this point of lack, that the desire of the subject is constituted. The subject—by a process that is not without deception, which is not without that fundamental twist by which what the subject rediscovers is not that which animates his movement of rediscovery—comes back, then, to the initial point, which is that of his lack as such, of the lack of *aphanisis*. (219)

Lacan borrows Ernest Jones's term *aphanisis* to designate the "fading" and "annihilation" of the subject. If the subject comes into being through alienation marked by the double rift of division and separation, then, to put it somewhat crudely, suturing is the process that makes it possible for the subject to cohere. Of course, while *aphanisis* should not be confused with *instinct d'abandon*, they both represent the "lethal" threat to the subject. What differentiates these two forms of the subject's termination is the temporal dimension of the former:

> The signifier, producing itself in the field of the Other, makes manifest the subject of its signification. But it functions as a signifier only to reduce the subject in question to being no more than a signifier, to petrify the subject in the same movement in which it calls the subject to function, to speak, as subject. There, strictly speaking, is the temporal pulsation in which is established that which is the characteristic of the departure of the unconscious as such—the closing. (207)

As Oudart explains, in cinematic representation the operation of suture works by placing "the filmic subject, the spectator" in the position of the

Absent One, "which abolishes itself so that someone representing the next link in the chain (and anticipating the next filmic segment) can come forth" (38). From this perspective, in bodywriting, what we may call the performative subject is analogous to Oudart's cinematic subject insofar as it constitutes the imaginary subject of the narrative discourse that is taking place in front of it. Here the "cinematic field" is not metaphorical but actual (soccer field) no less than the kinesis ("cine") that unfolds on it. In this kind of spectacle, performance is completely taken over by the linguistic signifier, down to the writing executed in living, moving bodies. It represents, in its own right, the fantasy of the subject's complete absorption into discourse.

The time of "cinematic discourse" is articulated as sequential and linear, which allows Oudart to assume its structural identity with the chain of signification and focus precisely on that which this discourse has to produce (space, field). The time of performance is not only conventional (eight o'clock performance that runs for two hours with an intermission), but biological and pulsational. Insofar as this is the time of the subject, performance radically recasts the position of the "Absent One" or the lack: the subject of performance is not the receiver but the producer. If we go back to Miller's idea of the suture, we will see that he elaborates on it via Frege's schema of the number in which the concept precedes any kind of numeration. Taking number 1 as the designation of the concept of identity (with itself) and 0 of nonidentity, Miller proposes that "*the concept of not-identical-with-itself is assigned by the number zero* which sutures the logical structure" (1978:29). The radical outcome of this proposition is that, in order for performance to have its own "discourse," that is the field, not the chain of signification, the subject has to occupy the place of lack. That leads to what Miller calls "the central paradox" of the subject, which is that "the identical represents the non-identical, whence is deduced the impossibility of its redoubling, and from that impossibility the structure of *repetition*, as the process of differentiation of the identical" (32).

The radical proposition of the fading of the subject played out in artistic production of the 1970s in many variations that were often mistakenly subsumed under the proposition about the death of the subject. On the Yugoslav conceptual art scene it came most forcefully in the work of Goran Đorđević, the youngest member of the group of artists associated with SKC Gallery. Đorđević's interest in repetition not as mere tautology, but as removal of the temporal dimension of the subject is evident already in his earliest works, such as the installation *Two Times of One Wall* (*Dva vremena jednog zida*), which was on display in Belgrade's Student Cultural Center (SKC) in January 1974. Here he projected a photograph of a white wall on the same white wall, marking the temporal gap between the installation

Fig. 24. Goran Đorđević: *Oktobar 72*. SKC, Belgrade. From left: Slavko Timotijević, Jadranka Vinterhalter, Milan Jozić, Milica Kraus, Jasna Tijardović, Zoran Popović, Marina Abramović, Raša Todosijević, Goranka Matić, Dunja Blažević, Gergelj Urkom, Nikola Vizner, Slobodan Milivojević Era, Neša Paripović. Photograph courtesy of the artist.

and its object. That same year, his contribution to the SKC's *Oktobar* festival was a projection of the photograph of artists and art historians taken in SKC Gallery two years earlier. The photograph, which in the ensuing decades acquired something of an iconic status, was featured on the flyer for this exhibit, with the following text on the verso side: "This is a photograph of all participants and organizers of the exhibit OKTOBAR 72. It captures a certain state of the spirit and relationship within that group at that moment. By projecting this photograph two years later in the same place in which it was taken, I want to call attention to changes that happened in the meantime, so that the intervening time period becomes the immediate occasion and medium of my action" (in Dimitrijević 2003:149).

In these installations, Đorđević borrows from the cinematic apparatus

the mechanism of the projection of the image as a convenient index of repetition, while radically transforming the meaning of that projection. Here the work is condensed to a caesura that separates two instances of the same image. If materiality of the signifier provides the deferral (and therefore the very constitution) of meaning, this caesura constitutes a de-materialized signification: a traceless writing. It is an act detached from an actor: a pure effect.

ALIENATING THE UNALIENABLE

When, in the early evening of April 20, 1974, Marina Abramović stepped into a burning five-pointed star, having first clipped her finger- and toe-nails and cut some of her hair and thrown them into the flames, she entered into an intersection of art and politics, conceptualism and ideology, that was unique to post-1968 Yugoslavia.[73] This action, performed in the back-yard of Belgrade's Student Cultural Center (SKC), quickly became one of the defining works of her career, and as such became a subject of a number of interpretations, many of which mystified the event. My aim here is not to dispel mystifications, but to take this iconic performance as a starting point for discussion of a complex web of cultural and historical relations in Yugoslavia of the mid-1970s. At this historical juncture, the ideology of self-management was going through the most dynamic period of theoretical and legal reforms since the days of its inception in the late 1940s and early 1950s.

Marcuse was not alone in his appreciation of this Yugoslav brand of socialism. In an interview published in the bulletin of the third April Meet-ing (1974) after the screening of his film *Art in Revolution*, the German-English filmmaker Lutz Becker affirmed that during the April Meeting weeklong program of events, "the Student Cultural Center turns into an international center for creativity and exchange of opinions," going so far as to compare the atmosphere at this artistic gathering with the fever pitch of the early Soviet avant-garde that he tried to capture in his film (*Bilten* 1974:n.p.). Three decades later, he spoke about the SKC with undiminished excitement. Becker opens the essay he contributed to *East Art Map: Contem-porary Art and Eastern Europe*, edited by the Slovene art collective Irwin, by painting a stark Cold War image of the repression of "non-conformist art" and "hidden art" in the countries of the Warsaw Pact (Becker 2006:390). Then comes the standard turn of phrase: "The situation for arts and artists in Yugoslavia, however, was totally different; it evolved under very *excep-*

tional social and political conditions" (390; emphasis added). Becker makes the case for Yugoslav exceptionalism by emphasizing self-management, nonalignment, and the "internal internationalism" of various cultural traditions that came together within Yugoslavia's borders. Seen from the perspective of the packed room at the screening of *Art in Revolution*, the state that supported art institutions such as the Student Cultural Center had the power to create the impression of an "avant-garde society" so lasting that it outlived the country itself and the carnage that marked its demise. The underlying premise of Becker's essay, in itself an important eyewitness account by one of the foreign guests during the early days of the SKC, is his enduring impression of this institution's mission of "searching for equality between an artist and a society" (*Bilten* 1974:n.p.). When it comes to the SKC and other similar art institutions in the former Yugoslavia, this search was marked by tensions that in fact brought into question all political, institutional, and ideological premises that were routinely taken as foundational for its "exceptional" status within Eastern Europe.

Becker and other contributors to recently published anthologies such as *East Art Map* and *Impossible Histories* barely mention that the SKC, the ŠKUC, *Ideje*, and other youth institutions that constituted Yugoslav alternative culture in the 1970s were a small payoff the state offered in return for its ruthless stomping of the student movement that emerged in 1968. The immediate aftermath of "June" saw the suppression of autonomous student organizations, followed by arrests and prison sentences for the prominent members of student movement Vladimir Mijanović, Milan Nikolić, Pavluško Imširović, and Jelka Kljajić. In this wave of arrests, the film director Lazar Stojanović was tried and sentenced, and his film *Plastični Isus* (*Plastic Jesus*) banned.[74] The campaign against the so-called dark wave in cinema, theater, literature, and visual arts worked in a way that was less direct but as effective as the actions against the student movement. Again, most of the works that came under attack and eventually ended up censored were addressing, in one way or another, June 1968. Among the proscribed works were Aleksandar Popović's play *Second Door to the Left*, which featured iconic June images such as the blood-stained shirt; Želimir Žilnik's feature film *Rani radovi* (*Early Works*), and Dušan Makavejev's *WR: Mysteries of the Organism*, both of which were inspired by June events.[75] Arrests and prison sentences were just one part of the wide-ranging clampdown on the student movement. The Student Association at Belgrade University, the organization that strove to redefine the nature of sociopolitical organizations in Yugoslavia by transforming itself from a mere cogwheel for the transmission of the Communist League's power into an autono-

mous political body, was dismantled in 1974. In the course of that year, two leading scholarly journals dedicated to humanist Marxism, *Praxis* (Zagreb) and *Filosofija* (Belgrade) lost their funding and ceased publication. Also in 1974 the Korčula Summer School held its last session. Over the years following the June uprising, the state pressured professional associations and institutions of higher education to remove a group of reformist-minded professors from Belgrade University. When everything else failed, in January 1975 the General Assembly of the Republic of Serbia adopted a ruling according to which, because of their "moral and political unacceptability," eight professors were effectively expelled from the university.[76] To use Jelka Kljajić's assessment, "The result of political repression in the first half of the 1970s was the atomization of resistance and the disappearance of any form of an alternative public, or more precisely, the silencing and bringing under control of almost all 'channels' for the expression of critical thought" (1998:21). "Almost all" because the small gains that students made in 1968, specifically the SKC and *Ideje*, remained in place and provided the platform for critical discourse into the 1970s. But here also, in many ways, 1975 appears a cutoff date.

Still, it would be an oversimplification to interpret the blazing star into which Abramović stepped on April 20, 1974, as a symbol of violence perpetrated by the socialist state or the burning up of the revolutionary ideals of the Left. The situation in Yugoslavia was much more complex, and it might be more appropriate to read the five points of this burning structure as a constellation of mutually opposed forces at work in Yugoslavia at that time. The house would burn down once the precarious balance established at that time began to tip a decade or so later, in the mid-1980s.

Obviously, one of the most palpable forces within this constellation was the state oppression, which gave rise to a new generation of dissenters. Apart from their demands for the democratization of the society and a return to the revolutionary ideals of the Left, the June student movement coincided with a liberalization of public life, including relaxing constraints on public speech and the exchange of information. This opening galvanized public discussion of massive human rights offenses that took place in the aftermath of the 1948 Yugoslav split with the Soviet Union, which resulted in widespread persecution and the creation of the Yugoslav mini-gulag on the island of Goli Otok in the Adriatic Sea.[77] Although completely different in nature—one was the suppression of declared or even presumed Stalinists, the other of the new Left; one was random and massive, the other selective and limited—these two instances of political persecution separated by two decades were widely perceived as proof of the carefully con-

cealed violent nature of the Yugoslav state. It is not at all accidental that Živojin Pavlović's diary of the June unrest, *Bloodied Spittle* (*Ispljuvak pun Krvi*, 1984), concludes with a long letter from an anonymous former Goli Otok inmate, thus establishing an analogy between 1948 and 1968.

It is peculiar that, with the notable exception of Milovan Đilas, neither one of these two waves of political repression in Yugoslavia produced any notable dissidents. Whereas from the anti-Soviet uprising in Poland (1956) prominent public intellectual figures emerged, such as the philosopher Leszek Kołakowski and the poet Czesław Miłosz; and Prague Spring (1968) gave notoriety and fame to playwright Václav Havel, novelist Milan Kundera, and philosopher Karel Kosík, there were no public intellectuals from Yugoslavia who, in the aftermath of either 1948 or 1968, became internationally recognized as prominent critics of Yugoslav socialism.[78] Nor did the waves of repression in Yugoslavia result in the establishment of a parallel culture of samizdat publications or underground art actions, as it did in the Soviet Union. Even though many who were subjected to repression before and after 1968 considered themselves dissidents, they seemed not to be able to establish high public profiles comparable to those of repressed intellectuals in other socialist states. The sociologist Mira Bogdanović offers the explanation that political dissidence was a uniquely Cold War phenomenon within which Yugoslavia held a very ambiguous position. Dissidents could not have been what they were without what Bogdanović calls the "Cold War industry of anti-communist consciousness": an extensive network of funding, broadcasting, and publishing agencies that included, but was not limited to, the Congress for Cultural Freedom, Radio Free Europe–Radio Liberty, Free Europe Press, and the National Committee for a Free Europe. Drawing on the wealth of publications that emerged in the aftermath of the fall of the Iron Curtain, Bogdanović comes up with the definition of a Cold War dissident as "any person who, because of some of his or her personal traits, could become *one of the instruments of the US foreign policy, which was aimed toward, if not explicitly overturning, then at least weakening the Soviet Union either within its borders or in its satellite countries*" (2010:308).[79] So, if the purpose of Cold War dissidence was to erode the Soviet empire, she contends, in the eyes of the West Josip Broz Tito was an unequaled dissident (310). No Yugoslav dissenter could do more than he did to undermine the Soviet Union. Being useless in conducting large-scale ideological warfare, the internal critics of Yugoslav socialism were left without the support of the powerful network of the "Cold War industry of anticommunist consciousness" and were exposed to the winds of internal Yugoslav politics. Virtually all of them became victims in the internecine

struggles within the League of Communists of Yugoslavia that raged in the late 1960s and early 1970s.[80]

It is very tempting to see Abramović's *Flaming Star / Rhythm 5* as a comment on the ideological exchange that took place in Yugoslavia in the aftermath of 1968. Throwing her nail clippings and hair into flames before stepping into the fiery enclosure was suggestive of a ritual offering. This ceremonial exchange could be read as a reference to another force, less visible than repression but no less important: the perpetual traffic of ideas between official state ideology and its critics. The most obvious example of this traffic was the massive absorption of critical theory into official ideology. In the early 1970s, the publishing house Komunist, the official publishing organ of the League of Communists of Yugoslavia, released a series of anthologies meant to counter the new Left that emerged in 1968, but also to co-opt some of its leading figures. So in the anthology *Marksizam i umjetnost* (*Marxism and Art*) we find not only the past heroes of the communist and noncommunist Left such as Gramsci, Brecht, and Benjamin, but also its reigning stars Lefebvre, Adorno, and Marcuse. The choice of texts is no less significant: in the case of Marcuse, it is the short text "Society as a Work of Art" ("Društvo kao umjetničko delo"), the idea that would, as we are going to see, feed into justifications for the ongoing reconceptualization of self-management.

However, only international intellectual stars were the subjects of this kind of recuperation. The process was much more pervasive. In Yugoslavia, unlike in other socialist states, individuals were persecuted, not their ideas. Instrumentalization of dissidents in intraparty rivalries was mirrored in the similarly pragmatic use of their opinions. In order for this ideological appropriation to take place, it was important that the traffic of ideas went both ways. Examples of this discursive commerce are legion.[81] Relevant for an understanding of the uses of alienation in relation to art and self-management in Yugoslavia is the itinerary of the concept of creativity (*stvaralaštvo*) in its passage from a critical to a normative position. From the perspective of Praxis school, Western industrial and Eastern post-Stalinist societies were alike, to a degree, in their dehumanization of ordinary citizens. This two-pronged critique of the socialist East and capitalist West evolved throughout the 1960s and reached one of its high points in the Korčula Summer School of 1967, when a series of seminars on the general theme of "Creativity and Objectification" ("Stvaralaštvo i postvarenje")[82] was organized. The notion of creativity was discussed in a number of working groups that ranged from Freedom and Planning to Workers' Movement in Self-Management to Cultural Production and Societal Orga-

nization. Among the presentations by speakers from Yugoslavia, Romania, the United States, Switzerland, and elsewhere, Vanja Sutlić's remarks made in the working group Bureaucracy, Technocracy and Personal Freedoms stood out. Starting from the notion of human labor that is not defined by its division within capitalism, but rather labor defined in its "simple, constitutive moments," Sutlić argued that "labor is economy and power over itself and over everything that is" (1968:53). Seen in this way, labor is inseparable from creation: there is no power that is not already "empowered from that power (Labor) which 'creates' man to whom Labor . . . is his most basic need" (53). Unlike other Praxis philosophers, Sutlić departs in significant ways from the anthropocentric and humanist interpretations of alienation. In his book *Being and the Present: With Marx on the Path of Historical Thinking* (*Bit i suvremenost: S Marxom na putu k povijesnom mišljenju*) he presents labor as a production of existence out of Being. In this schema, man is not a creator of his world and himself (a sine qua non for reformist Marxism from Frankfurt to Korčula), but an intermediary between Being and essence. Therefore, "Man's every production is a reproduction of what Being 'produced' or 'birthed.' . . . *Changing of essence in its Being as man's production is a reproduction of the original production of nature itself*" (1967:17). This removal of man from the source of production grounds Sutlić's understanding of alienation: "*Fundamental alienation is a perversion of the production of essence from the Being into commodity-producing labor*" (31).[83] Correcting, in passing, numerous participants of the Korčula symposium who understood creativity in the narrow sense of art making, this philosopher turned to the common criticism of capitalism as an enemy, on the one hand, of "conscious and autonomous art," and on the other, of labor, which it reduced to the automatism of factory work. Sutlić suggested that, while not entirely incorrect, neither one of these two assumptions takes up the division of labor as the basic condition of capitalist production. According to him, "Labor" understood in the properly Marxist way as a "first life need" is "total work" that is not limited to science or art, and, at the same time, any action is creation (64–65). According to this Marxist analysis, strongly influenced by Heideggerian phenomenology, a "revolutionary turn" transforms any human action or performance into "total work" (or labor with the capital L), which, through that very turn, becomes a part of an authentic existence. In other words, revolution is the act of creation that *turns* mere subsistence into meaningful existence.

The proceedings of the 1967 Korčula Summer School seminars were published in the January–April 1968 issue of *Praxis*. The discourse of creativity was adopted not only by the striking students, but also by their op-

ponents. Here the politician-philosopher first comes to mind. In a series of undated speeches and papers delivered in the aftermath of 1968 and published a few years later in the book *Revolutions and Creativity* (*Revolucije i stvaralaštvo*), Veljko Vlahović, whom we already know from the debates about alienation from the early 1960s, adds creativity to the cache of ideological principles of socialist self-management. He distinguishes between two kinds of creativity, rebellious and revolutionary, and deems the former a destructive and the latter a productive force (1973:44).[84] The first, which, he is quick to emphasize, is often found in "some of [Yugoslav] recent publications," is an expression of "desperation and resignation" (17). This parsing of creativity is part of Vlahović's larger agenda of detaching an idea from the opponent and transferring it across the ideological divide with the goal of adding it to a completely different discursive formation. This hostile takeover still constitutes an exchange of sorts. So creativity is ripped away from "certain discussions of society's humanization, of humanization of social relations, of radical humanism that, instead of analyzing socioeconomic relations from which emerge future relations between men, are concerned with an abstract man." Creativity is repurposed to serve the dominant ideological discourse: "The opposition between labor and leisure cedes being the main problem of socialist society, that is to say of socialist culture, and its place is given to finding ways to engage people in free creative activity. Obviously, the center of gravity shifts from faceless cultural consumption to free and authentic creativity" (22).

From here the discourse of creativity within the mainstream ideological discourse develops on two parallel levels. On one level, the officialdom used the notion of creativity to justify purges in the arts or for their ideological obfuscation. In December 1973, a committee of Party members at the Association of Visual Artists of Serbia held a meeting on the topic of the "dark wave in painting." The discussions were summarized in a thirty-one-page unsigned document that sharply criticized the artists that gained prestige during the 1960s, most of them members of Mediala.[85] Surprisingly, a pushback against this summary attack came not only from painters and writers, but from Party officials themselves.[86] In his article published in *Komunist*, the daily of the League of Communists of Yugoslavia, Prvoslav Ralić wrote that the "Party is not an art critic" and that no one has the right to "in the name of the Party ideologically brand the art of Ljuba Popović, Vlada Veličković, and Dado Đurić as an art of negativity, destruction, aggression, and irony" (1975:96). While defending these artists, Ralić at the same time supported their critics, who, in a section of their report, condemned artists' "nonpainterly" discourse that strayed toward politics (97).

This double gesture, typical for the state's handling of cultural affairs during this period, was aimed at preserving the principles of socialist aestheticism while at the same time setting firm limits on what is "proper" for art. "The main subjects in the realization of the freedom of the creativity principle are the creators themselves. Freedom of creativity is won, not granted," observes this "liberal" party ideologue (196).[87]

On another level, a new generation of theorists, very well versed both in neo-Marxist theories and in new artistic practices, were harnessing the idea of creativity in the hope of transforming the institutional power structure from within. In a series of articles published between 1974 and 1975, Žarko Papić, one of the former *soixante-huitards* who tried to tread a thin line between official and critical discourse, proposed a vision of conceptual art as the basis for a future official art of Yugoslav socialism.[88] The articles that this trained economist turned professional politician published in the wake of the 1974 constitution were among the extremely rare instances in which fringe artistic practices entered dominant ideological discourse. Not surprisingly, Papić recognizes creativity as a point of intersection between these two, infinitely distant, discourses. His ideological pragmatism was informed by the fundamental tenet of Marxism, which sees the division of labor as the main cause of its degradation to commodity status. The division of labor, according to Papić, can be abolished only by "overcoming management as a historically specific form" of labor organization (1976:47). Turning to the distinction between political and social revolution, Papić argues that the latter abolishes the division of labor into intellectual and physical—and managing and managed classes as its inevitable corollary—by transforming labor into creation: through the "socialization of creativity," or the "intellectualization of the proletariat and proletarization of the intelligentsia" (20, 39).[89] Or, to use McKenzie's terminology, it is on the subject of creativity that the discourses of aesthetic and organizational performance come together. According to Papić, the condition of their integration is the abolishment of the aesthetic.

The starting premise of Papić's article "The Perspectives of Creativity" ("Perspektive stvaralaštva") is the notion of the end of art, seen from both Marxist/Leninist and conceptual art's point of view. First, the Marxist/Leninist: the problem of the opposition between creativity and politicization of the artist can be solved, Papić writes,

> only through the synthesis of creativity and revolution. This synthesis is possible only outside of art and against it, in the totality of the society and its creativity. The art of revolution is impossible without

revolution in the arts, without revolutionary abolition of autono-
mous artistic creativity for the purpose of general, societal creativity.
(1976:69)

And here the "revolution in the arts" is not limited to radical changes of
form, as was advocated by much of the historical avant-garde, but in the
radical abolition of the art object, its dematerialization. This point of view,
of course, comes from conceptual art. Deobjectification leads to the aboli-
tion of the boundaries that separate different arts, that is, toward the expan-
sion of artistic media. This abolition of limits is limitless in itself because
the elimination of the art object points to the possible transformation of
man and of human society in general. Papić starts from Marx's idea of rev-
olution as a shift from managing people to managing things:

> This objective historical process opens up the social possibility and
> necessity of an analogous socially objective process of the "transi-
> tion" of creativity from the world of objects to the world and exis-
> tence of man. Therefore, no longer should creativity be expressed in
> objects to which we then assign aesthetic qualities, but creativity of
> the people, among the people and for the people, incessant creativ-
> ity aimed at the emancipation of man, at the development of his hu-
> manity, at the humanizing of his existence, reality, practice, and so-
> cial relationships between men. (70)

At times, this ecstatic writing seems to want to enact that which it argues by
abolishing the boundaries between the reflective and the programmatic,
and between radical politics and radical art. Here we find the journal *Flash
Art* cited alongside the publications of Komunist (the official publishing
house of the League of Communists of Yugoslavia) and conceptual artist
Mel Ramsden cited alongside Yugoslav old guard apparatchik Dušan
Petrović "Šane."[90] At the same time, Papić never let go of his political prag-
matism. He pointed out that this new kind of art was not a distant possibil-
ity, but already existed and was thriving in student cultural centers in Bel-
grade and Zagreb (75). He held up these centers as examples of the free and
spontaneous collaboration of artists within state-supported art institutions
that potentially could serve as models for labor associations in general. At
the same time, he found that their activities contained an implicit critique
not only of Yugoslav art institutions, but of the institutionalization of art in
general: "The new art of overcoming art is possible only if it takes place
everywhere, in open spaces, in factories, parks, schools, everywhere where

people live and work, where untapped human creativity exists" (77). Here the possibility of dematerialized art, of art emancipated from objectness into an ongoing, continuous process appears as the only conceptualization of art consistent with the principles of socialist self-management. The final premise of this line of argumentation is that if self-management was to have an official art, then it had to be performance-oriented conceptual art, strikingly similar to the kind of art practice that some thirty years later received the name of "socially engaged art." The ultimate confirmation of this radical dematerialization of art is that self-management is a system of social relationships that arises from creativity and strives toward it. It is a total artwork in its own right:

> Creativity of the revolution in the "arts" is possible only as a totality of revolutionary changes; changes of content (social and personal commitment to revolution), change of form (expansion of media), and change of organization and economic relationships (association of creativity and labor according to the principles of self-management). (78)

The familiarity of this statement shouldn't come as a surprise. Here, for a brief instant, finally emerges a vision of conceptual art as a political economy of self-management, analogous and obverse to the role socialist realism held in command economies.

To close the full circle, this eclectic idea of creativity as a withering away of the art object resonates powerfully with, and is indebted to, the vision of one of the most prominent international artists of the 1970s. On April 19, 1974, in between his two well-documented trips across the Atlantic, Beuys conducted a public dialogue at the SKC in Belgrade.[91] Writing about this performance-lecture, Denegri emphasized Beuys's assertion that dialogue represented the most important aspect of his work. Here, Denegri wrote, not only the form of oral communication is important, but also its "thematic, which is both universal and radically specific in its character, therefore, philosophically grounded and politically engaged" (2003:64). The *April Meeting Bulletin* published a series of texts on Beuys, among them the Italian art critic Achille Bonito Oliva's 1971 interview with the artist. Here, Beuys spoke of his political engagement in terms that resonated with his Yugoslav audience:

> Now I'm going to unify art and science into a still larger concept: in the center stands creativity. The problem has many sides and em-

braces several concepts. In fact, freedom is connected to man's individuality, to man as an individual. In the moment man comes to a realization of this individuality of his, he wants to be free. As a result of this anti-authoritarian desire for self-government and self-determination the concept of the self-determination of man doesn't make any sense if it doesn't start out from the concept of freedom. (Beuys 1974:3)[92]

The previous year, the Group of Six (sans Slobodan "Era" Milivojević) performed at the Richard Demarco Gallery in Edinburgh, where they saw Beuys's action *From noon to midnight. 12 hour public lecture.* The German artist also saw their performances, liked them, and accepted the young artists' invitation to present his lecture/performance at the next April Meeting. Beuys's visit did not end with the lecture. He actively participated in the proceedings of April Meeting, occasionally collaborating with local artists.[93] Some of these engagements were planned, such as Braco Dimitrijević's *Cocktail*, and some were not, and it remains uncertain if they happened at all. Denegri describes the image "seared in memories" of those who were present at Abramović's *Flaming Star / Rhythm 5* of "Beuys entering the burning star, picking up the artist who had lost consciousness, carrying her in his arms out of the fire, and kissing her on the forehead" (1996:102). In Abramović's biography, largely based on extensive interviews with the artist, Beuys is given a considerably smaller role. James Westcott writes that, according to his source, Beuys "warned" Abramović not to do it, but that once she did, it was Radomir Damnjanović "Damnjan" and Gergelj Urkom who "jumped over the flames and hauled Abramović to safety" (Westcott 2010:67).[94] In the larger scheme of things, it turned out that the force of international influences was most significant both for the fate of Yugoslavia and for the career of the author of *Flaming Star / Rhythm 5*.[95] As for Beuys's passage through fire, it appears to have foretold the fate of the documentation of his visit to Belgrade. The audio recording of his lecture and the blackboard with drawings he bequeathed to the SKC were damaged beyond repair in the fire that destroyed part of the building in 1981.

1968/86/89

In his article "The Year 2000: Efficiency of Economy and Perspectives" ("Godine dvehiljadite: efikasnost privređivanja i perspektive") published in January 1969 in the inaugural issue of the journal *Direktor*, factory man-

ager, politician, and trained economist Miloš M. Sinđić predicted that by the end of the millennium Yugoslavia would "definitely" join the group of developed countries. Basing his calculations on the country's economic growth for the period from 1949 to 1969, he estimated that by the year 2000 per capita income in Yugoslavia would reach $2,500 and that the gross domestic product (GDP) would increase to 6.3 times the current level (Sinđić 1969:23). As it turned out, in the year 2000 in much of what used to be Yugoslavia, the GDP was almost nonexistent and the first priority was not economic growth but burying the dead, the resettlement of refugees, and the pursuit of war criminals. Of course, it is all too easy to be cynical about past predictions, especially if they concern a country that, instead of leaving the club of "developing" in order to join the much coveted league of "developed" nations, ceded nationhood status altogether. Instead of seeing that final push toward its goal of economic strength in the last decade of the twentieth century, Yugoslavia went through a violent disintegration.

The launching of *Direktor* as a journal dedicated to professional managers can be seen as an important symbolic moment in the dismantling of the system of centralized planning and the implementation of a socialist market economy in Yugoslavia, which went hand in hand with the development of self-management. The transfer of decision-making power from central political and economic bodies to workers' councils of self-managing enterprises did not mean that professional managers became obsolete. Quite the opposite: it became clearer than ever before that decisions made by the workers' councils needed professionals who would ensure their execution. Making a business decision does not in and of itself guarantee competent implementation. Sinđić stated as much by pointing to the improvement of "economic efficiency" as the main purpose of the journal to which he contributed his article (19). The purpose and content of *Direktor* can be seen as an indicator of the desire of the proponents of Yugoslav self-management to depart from the organizational model prevalent in countries of real socialism and align itself conceptually with the organizational principles of postindustrialist economies. Based on what McKenzie called "scientific management" (characterized by a Taylorist approach to the organization of labor), the former were becoming increasingly anachronistic, left over from the era of mass industry, while the latter moved toward more sophisticated organizational principles of "performance management." The purpose for reinforcement of the manager's role in Yugoslav enterprises was to curb the "Illyrian effect" that hit the Yugoslav economy hard in the mid-1960s.[96] This shift from scientific to performance management is clearly reflected in Sinđić's focus on the West in his assessment of human-

ity's progression toward what the classics of Marxism considered its final stage. He concludes his survey of the latest technological advances, most of which were associated with Western Europe and the United States (bioscience, information technology, etc.), by asserting that "we are closer to achieving communism in our production forces than to achieving communism in our production relations"; then he credits Yugoslavia for its "historical achievement" of contributing to the "resolution of this *contemporary contradiction*" through its "program of socialist self-management" (20).[97]

Sinđić draws heavily on the special issue of *Dædalus: Journal of the American Academy of Arts and Sciences* entitled "Toward the Year 2000: Work in Progress" and specifically on Herman Kahn and Anthony J. Wiener's article "The Next Thirty-Three Years: A Framework for Speculation." But that is not all: at one point, he quite literally inscribes Yugoslavia in a graph of the median annual GDP growth for some thirty countries worldwide that was originally published in *Life* magazine. It would not be far-fetched to read "The Year 2000: Efficiency of Economy and Perspectives" as a similar inscription of Yugoslavia into a new managerial discourse, which was for Sinđić, as well as for his Western counterparts, epitomized in Jean-Jacques Servan-Schreiber's *The American Challenge*, first published in France in 1967 (*Le Défi américain*) and promptly translated and published in Yugoslavia (in 1968, the same year it was published in the United States). In his extremely popular book, Servan-Schreiber argued for abandoning the traditional forms of organization predominant in France and for adopting the American model of management. It is the emergence of this kind of managerial discourse in Europe in the late 1960s that French sociologists Luc Boltanski and Ève Chiapello identified with the emergence of the "projective city."[98] According to them, transnational corporations that emerged from the deregulation of the 1970s are an epitome of the projective city: this city is not contained in one place or even to a single hemisphere, and unlike in the imperialist phase of capitalism, its main principle is not hierarchical subordination but networks. Here, anything could "attain the status of *project*, including ventures hostile to capitalism. . . . Utterly different things can be assimilated to the term 'project': opening a new factory, closing one, carrying out a re-engineering project, putting on a play" ([1999] 2005:111). If anything "can attain the status of project" it is because the project's main purpose is to appropriate the unforeseeable. Not surprisingly, for the authors of *The New Spirit of Capitalism*, the events of 1968 represent the watershed between industrialist and "projective" capitalism.

Instead of studying the resonances of 1968 in philosophy, art, or the history of social movements, Boltanski and Chiapello focus on the effects that

'68 had precisely on that against which it rebelled: the world of big business. Starting with the late 1960s, they trace the ways in which political and academic discourses that the uprising of students and workers helped articulate and popularize fed into negotiations between labor and big business during the crisis-prone 1970s and 1980s, marked in France by the socialist government of François Mitterrand, and led all the way to the full acceptance and institutionalization of new management techniques in the 1990s. Boltanski and Chiapello argue that what was unique for the crisis of 1968 was its combination of "social critique" characterized by its demand for security and "artistic critique" characterized by its demand for autonomy. This crisis then provoked a whole series of responses on the part of the industrialists and the state that stretched across the following decade. When workers insisted on denouncing paternalism, authoritarianism, and Taylorist separation between design and execution, and proclaimed their "demands for autonomy and self-management," big business responded by relaxing the rules of workers' participation in decision-making and by individualizing working conditions (170). Looking for solutions, both industrialists and organized labor searched far and wide. One of these initiatives is particularly telling. In the early 1970s, the prominent organization of managers, Association Nationale des Directeurs et Cadres de la fonction Personnel (ANDCP), sent its delegations to Japan and Yugoslavia to study the management models used in these countries, and published their findings in two special issues of its journal, *ANDCP*. The findings of ANDCP's mission to Yugoslavia reflect the official state ideology of self-management. The authors note that Yugoslav "self-management is concerned with human beings, whom it regards as the only factor in the collective process" and that "self-management is a system in which orders are to be avoided and instead people are to be persuaded" (*ANDCP* in Boltanski and Chiapello 2005:214). But not everyone was so gullible, and a number of activists and theoreticians of *autogestion* in France saw the intentions of post-1968 reforms in Yugoslavia for what they were.

In its booklet *Autogestion, State, Revolution* (*Autogestion, état, révolution*) Groupe Noir & Rouge wrote that Yugoslav self-management remained under the weight of the governmental decree by which it was founded. The authors argued that when it comes to Yugoslavia, one could not speak of "self-management, not even a co-management, but simply of stewardship" on the part of workers (1972:101). A few years later, Yvon Bourdet, one of the leading historians and theoreticians of French *autogestion*, asserted that "in Yugoslavia there is no true self-management, but a simple participation [of workers] in corporate management bodies" (1975:17). Yugoslavs were

not far behind when it comes to their assessment of post-1968 development of *autogestion* in France. While acknowledging strides that French leftist parties, unions, and individual theorists made toward an understanding and implementation of self-management, in his book *French Left and Self-Management* (*Francuska levica i samupravljanje*), Bogdan Trifunović levels critique on all of them for approaching "self-management more as a demo-cratic political right than as a fundamental political and economic relation-ship" (1976:195).[99] In short, if in the 1950s and 1960s Yugoslav practice of self-management served as an ambiguous source of French theorizations of *autogestion*, in the aftermath of 1968 it lost any respect it might have had with French intellectuals and labor leaders. At the same time, increasingly conservative ideologues of Yugoslav self-management saw as insufficient any partial demands for self-management in France and other Western Eu-ropean countries.

Along with significant differences, there were profound similarities in the follow-up to 1968 in France and Yugoslavia, especially in the 1980s. As in France, the dissident discourse returned in Yugoslavia during that pe-riod; and as in France, it was focused on victims of the Gulag, including Aleksandr Solzhenitsyn, Varlam Shalamov, and Yugoslav Gulag survivor Karlo Štajner, and not on victims of the persecution from the 1970s.[100] In her penetrating study of the cultural perception and historical narrativiza-tion of the students' and workers' uprising in France, *May '68 and Its After-lives*, Kristin Ross points out that in France the "official ideology of dissi-dence . . . amounted to a 'moral rearmament of capitalism' by shifting attention away from the masses of Algerian workers on the outskirts of French cities to the plight of a few well-known scientists and intellectuals, the dissidents of Eastern Europe" (2002:173). In order to be recuperated, the political agenda of '68 had to acquire a form that could be easily dis-posed of. Ross argues that the slow emergence of the "official story" that presented "May" as a generational clash and a lifestyle statement effec-tively depoliticized the events of May and June 1968 (Ross 2002:6). Even the temporal designation of the French uprising as "May," which highlights the student rebellion and obscures the general strike that took place in June, separates, in cultural analysis and historical memory, students from workers. Ross argues that this "temporal reduction" is just the most visible side of a much broader political reduction of the French spring that shifts its emphasis from the political demand for solidarity and equality to the cultural, or more narrowly artistic, demands for individual freedoms.[101] Because of its "staggeringly rich inventory of the doxa, narrative strategies, rhetorical devices, and personalities," Ross takes the 1988 television show

Le process de Mai as epitomic of the "dominant revisionist rendering of '68" that took place in the 1980s (154). In this TV "trial" of '68, the final judgment comes in the guise of comments on the mass student protests that shook France in conveniently anagrammatic '86. In the show staged in front of a TV "jury," Laurent Joffrin, an expert on the student demonstrations of '86, asserts that "today's youth are pragmatic and conservative, distrustful of politics and ideology," an assessment with which students in the "jury" agree. (153).

In his report on the '86 movement, which he wrote from Paris to the Slovene youth magazine *Mladina*, Slavoj Žižek, at that time a young philosopher who was quickly rising into prominence as a public intellectual, portrays the movement of '68 in strikingly revisionist terms. Starting from Lacan's retort to students protesting in 1968, "Hysterics, you wanted a master, now you got one," he asserts that

> the movement of '86 . . . was not a movement of desire, but of demand: the movement established a clear, unequivocal demand, which "is just what it is," behind which there is nothing hidden, not getting caught in the "dialectics of desire" while uncompromisingly persisting on literalness of that demand. Conversely to flexibility of '68 movement, this movement is obstinate: "I don't want anything more than what I asked for, but this I want without reserve." As Lacan notes somewhere, by stubbornly insisting on a demand, we make the other—the addressee of the demand—to become histericized. . . And this was perhaps the movement [of 86]'s lesson to us: don't get trapped in dialectics of desire, but set certain demands and then stick to them. (1989:11)

Žižek's uncritical subscription to the image of '68 developed by French media in the 1980s may surprise many of his readers thirty year later:

> It is not difficult to conclude that this "less" of the demand in regards to desire (we want that which we demand, nothing more, not to change the world) is actually "more." That the movement of '68 let itself get recuperated into that which it became—that is, that it was adopted by existing discourses (for example, bureaucratic revolutionary), or that it ended up in sad displays of degenerate junkies, poetasters, and aged hippies, all of that did not happen regardless of its radicalism, but because of it. The movement of '86, in accord with its seeming "modesty," while failing to "change the world," truth-

fully realizes the big "more": namely, it is clear that the emphatic "apocalyptic-ness" of movement '86 signalizes its opposite—that it established a new form of political practice which transformed the entire political field. (11)[102]

Žižek could so successfully channel reactionary responses to '68 from France because this kind of imagery was already fully operational in Yugoslavia. Here the managing of the student uprising's "afterlife" went from suppression to trivialization. The first period lasted almost a decade: from the early 1970s to early 1980s. It included prosecution of protagonists of 1968, censorship of journals, books, and films, and incrimination of prominent intellectuals; as late as 1983, Nebojša Popov's sociological study of student rebellion in Yugoslavia, *Oppositions: Social Conflicts— Challenge to Sociology* (*Sukobi: Društveni sukobi/izazov sociologiji*), was banned, and the following year Živojin Pavlović's diary of June '68, *Bloodied Spittle* was proscribed and all printed copies were destroyed. Then, between 1983 and 1985, three prominent works, Slobodan Šijan's film *How I Was Systematically Destroyed by an Idiot* (*Kako sam sistematski uništen od idiota*, 1983), Milisav Savić's novel *A Poplar on the Balcony* (*Topola na terasi*, 1985), and Goran Marković's film *Taiwan Canasta* (*Tajvanska canasta*, 1985) were released and went into wide distribution without any obstruction. What differed in these works was the way in which the ex-participants of "June" were portrayed. If, as Ross argues, in France the "official story" about "May" created a certain cliché in the media, literature, and film about *soixante-huitards* as egocentric liberals, the unofficial story about 1968 produced in Yugoslav culture of the 1980s was the image of '68ers as outsiders, eccentrics, and cynical and corrupted careerists. Toward the end of the decade, the relationship to 1968 became less ambiguous, but still more complex than in France.[103] In Yugoslavia, the inversion is more intricate than the neat '68/'86. And it has a lot to do with the recognition on all sides that they had to stick to their demands—no more, no less, than what was rightfully theirs.

In 1989, agitated students again gathered on the plaza between Student City's dormitory buildings. According to newspaper reports, around midnight on Monday, February 27, large groups of students started pouring out of their rooms.[104] It took minutes for the group to swell to five thousand. Soon, for the first time since 1968, a massive student column was marching again from New Belgrade toward the city center. This time there was no underpass, and the narrow cobblestoned road had been replaced by a broad two-lane boulevard; and this time, police were not blocking pas-

sage.[105] In fact, as some reporters recounted, "Two blue police cars slowly, like an advance guard, escorted the students to the parliament building" (Lopušina 1989:8). Unlike in '68, students were greeted by the inhabitants of New Belgrade's residential high-rises, many of whom were members of the police and the military. In Student City, Belgrade University provost Slobodan Unković and other high-ranking university officials had already positioned themselves at the head of the column of protesters. As they walked, students chanted, "Students have risen!" Drivers from passing cars honked back, and many citizens joined the march. An excited student exclaimed to the reporter, "This is not '68, this is '89" (8).

Indeed it wasn't '68. This time, students easily reached the goal that students twenty-one years earlier valued above any other, but never got close to accomplishing: joining forces with workers. Even as they walked across New Belgrade, taxi drivers gave protesters rides free of charge, honking along the way to wake up sleepy Belgraders. Once the column reached the Yugoslav Parliament Building, student "activists" started making speeches, and finally at 3:30 a.m. the president of the Serbian parliament, Borisav Jović, addressed the crowd. Unlike the officials twenty-one years earlier, he did not plead with them to go back to their dormitories, but expressed resolutely his support for their cause. In the early morning hours, as the crowd began to disperse, a new wave of support came from masses of workers as they walked out from their factories. Victory, but for whom? For what?

This idyllic alliance of students and workers, cabbies and cops, retirees and clerks, Serbs and Montenegrins, was not fueled by demands for political and economic equality or for social justice, but by the politics of the day. The march occurred at the beginning of one of the most massive and advantageously timed meetings of support for Slobodan Milošević. The trigger for the student protest was a televised broadcast of a gathering in Ljubljana, Slovenia, organized in support of striking miners at the Trepča mines, located in northern Kosovo. The strike itself was not driven by labor issues, but by the national politics that jolted Yugoslavia in its final years. This mass demonstration initiated by the students was the last in a series of massive gatherings across Serbia and Montenegro that secured Milošević's dominant position in regions populated by ethnic Serbs, and paved the way for constitutional changes that would strip the Serbian regions of Vojvodina and Kosovo of the autonomy granted to them by the Yugoslav constitution of 1974. In response to these constitutional changes, in November 1988 there were mass demonstrations of ethnic Albanians in Kosovo, which were brutally suppressed by Serbian security forces. Milošević used the

mass gathering in front of the Yugoslav parliament to put pressure on federal authorities to declare a state of emergency in Kosovo.[106] What numerous commentators saw as an anachronistic direction of the Serbian leadership was in fact in perfect accord with the development of the projective city through recuperation, distortion, and revision of the spirit of '68: emancipation was turned into mobilization, solidarity into pragmatism, and calls for equality into promises of freedom.

| Disalienation Defects

A FEDERATION OF INTERESTS

The emergence of conceptual art in Yugoslavia coincided with the period of dismantling of a socialist market economy and return to a conservative form of socialism under the guise of a better and improved self-management introduced by a new constitution in 1974 and the Law of Associated Labor in 1976. According to official histories of Yugoslav self-management, alongside with nationalism, centralism, and "leftist deviations," "the tendency toward increasing strength and independence of techno-managerial social forces" was perceived as one of greatest threats to Yugoslav socialism. Dušan Bilandžić and Stipe Tonković, the official historians of Yugoslav self-management, write that if "until the early 1960s the dominant position in the society was held by political structures," then "especially after the 1965 economic reform, social processes started working in favor of 'technocrats' and 'managers.' It is important to note that they sought their legitimization in the very concept of self-management" (1974:162). Here, if professionalization of management is recognized as being the main problem, then the solution would be its return under the reign of political structures. The path to this solution did not lead back to a centralization of government, but toward a certain polycentrism, which came with a decentralization of the country's political and economic structure. Not surprisingly, Bilandžić and Tonković indicate 1971 as a watershed year (166). That year, they explain, constitutional amendments established republics as centers of sovereignty, while the federation held only those "rights" that were agreed upon by all republics (155). This effectively meant abdication of the idea of the self-managing subject, and the first step back toward traditional notions of subjectivity and sovereignty, which are based on property rather than on labor. This called for the rigorous dismantling of all aspects of integral self-management in Yugoslavia. That was accomplished with Yugoslavia's last constitution, proclaimed on February 21, 1974.

The constitution of 1974 has been heavily criticized, especially in Serbia,

for its unjust and unequal political and territorial organization of the federation.[1] Most histories of Yugoslavia's demise point to this legal document as the main cause of the political strife that ended in the series of wars in the 1990s. According to conventional criticism, the 1974 constitution was an attempt by the aging rulers of the Yugoslav League of Communists to consolidate its grip on power. It was criticized for serving local leaderships of the Yugoslav republics, thus effectively turning the Yugoslav federation into a confederation. In addition, many observers were quick to note that the cumbersome "delegate system" established through this constitution, which was heralded as a decisive step toward direct democracy, in fact displaced real decision-making from the bicameral federal parliament and put it in the hands of the closed offices of Party leadership.[2] While correct on many points, this kind of criticism ignores the significance of the constitution for the reorganization of the national economy, especially of self-management. In fact, the largest part of the 1974 constitution is dedicated to self-management, not to the territorial organization of Yugoslavia. Similarly, while it made small (but in some cases nevertheless significant) interventions in the status of republics and autonomous regions, it made the most detailed and substantial changes in the very structure of self-management.

Yugoslavia's 1974 constitution not only provided the new framework for the political and territorial organization of the federation and for the reorganization of factories and other institutions of employment; it also tried to legislate the deep crisis that came into the open in June 1968, and it did so by removing the worker from the position of Yugoslavia's foundational political subject. This displacement of the worker from the place of the political subject is indicated in the name of the basic production unit of the Yugoslav self-managing economy: the Basic Organization of Associated *Labor* (Osnovna organizacija udruženog *rada* or OOUR), not the Basic Organization of Associated *Laborers* (Osnovna organizacija udruženih *radnika*). The possibility of political subjectivity and agency is thus already removed on the level of language. The authors of the constitution were counting on the power of political interpellation to keep the workers from "associating" into viable economic *and* political organizations. June '68 showed not only that a new form of community—or, in Blanchot's words, a new form of communism—in Yugoslavia was necessary, but also that it was possible.

In the doctrine of associated labor, the notion of subjectivity acquires a double valence. The subject is at the same time a revolutionary subject and an economic subject. This double status of the subject is fully realized in the

working class (as the subject who carries out the social revolution) and more specifically in the worker (as owner of the means of production). Workers' political subjectivity is defined by a clearly defined set of rights that include, to name just some, the right to work with socially owned means of production, to "associate" one's labor with other workers, to organize production and income, and to participate in management and decision-making. As Slovene economist Aleksander Bajt explains, the entire theoretical doctrine of self-management is based on conflation of the subject of decision and the subject of work (Bajt 1988:153). If as an ideological operation, "associated labor" foreclosed the political potential of self-management to catalyze the emergence of spontaneous community, then as a legal practice, it tried to invent a norm for all economic, political, and cultural relationships. Each Basic Organization of Associated Labor was presumably an autonomous unit that could be integrated into a Complex Organization of Associated Labor (Složena organizacija udruženog rada, or SOUR), which were, in turn, coordinated within regions and republics, while the republics synchronized their decisions on the federal level.

This rhapsody of associations and unifications, however, is not limitless. If engineers of associated labor had, as one of their goals, to prevent any potential for integral self-management, another goal was to secure the Party's control of top management. These two goals are reflected in the dual structure of management in OOURs and SOURs: collective management in the hands of workers' councils and personal management in the hands of the director. This structure was in place prior to the 1974 constitution, but in it the manager was, ideally, a facilitator rather than decision-maker. The new constitution enshrined the company director in Article 103: "In every organization of associated labour there shall be a business board and/or an individual business executive in charge of the organization of associated labour" (*The Constitution* 1974:138). Clear and simple enough. However, this is precisely where the poetry of ideology steps in. As we have seen, what sets apart the constitution of 1974 from other similar legal documents is its authors' attention to language. On the one hand, it was marked by linguistic invention ("association of labor and means," "self-managing contracts," "past labor," etc.), and on the other, linguistic renovation. The most significant example of the latter is the term for the company manager. "The individual business executive" is too bland a phrase to render the expression *inokosni poslovni organ* from the original text of the constitution (*Ustav* 1974:31). This phrase is the punctum that binds a legal document with the larger, and largely unspoken, ideological fabric that gives the laws their form and power and is protected by them at the same time. Why *inokosni or-*

gan? What does this say other than "individual business executive"? The word *inokosni* is an archaism that in ethnographic literature mostly designates a form of family organization in rural areas in the lands of the southern Slavs. As turn-of-the-twentieth-century legal ethnographer Valtazar Bogišić explains, up until mid-nineteen century, in most of these areas the common form of family organization was a rural cooperative (*zadruga*) comprising several brothers, their wives, and their children. An exception from this form of family organization was *inokoština*, or what we would call today a nuclear family consisting only of a married couple and their children (Bogišić 1986:222). The word fell into semioblivion with industrialization, which brought the demise of traditional rural cooperatives in the late nineteenth century. By transferring *inokosni* from a preindustrial economy to a society that aspired to join the postindustrial world, the authors of the constitution wanted to the point to the tradition of cooperative forms of organization in the region that became Yugoslavia. However, the discourse of ideology always goes beyond the speakers' intention. The word *inokosni* designates a family unit that is not common: in the *Serbian Dictionary* (*Rečnik srpskog narodnog jezika*) Vuk Karadžić translates the root word *ino* as *aliud*, "other," and *inokosan* as "single" (*einzeln*) and "without other related heads of families" (*ohne andere Verwandte Familienhäupter*) ([1852] 1969:232). While this rendering still contains the reference to family structure, in Vuk Karadžić and Đuro Daničić's translation of the Old Testament, this word appears in pure adjectival form. For example, in Isaiah 49:21 the people who forget their Lord are compared to a woman without kin: "ko mi ih rodi, jer bijah sirota i inokosna." The King James rendering of the same passage is "Who hath begotten me these, seeing I have lost my children, and am desolate, a captive." In short, *inokosnost* designates otherness and desolation, and accordingly represents perhaps the oldest expression of psychic and social alienation in Serbian and Croatian language(s). By dusting off this ancient expression, the ideology of associated labor has enshrined alienation in the very constitution of Yugoslavia. And indeed: alienated from a self-managing structure of governance, company directors became the Party's main power mechanism for exerting its control over the economy.[3]

That the introduction of OOURs, SIZs (Samoupravne interesne zajednice, Self-Managing Communities of Interest), and other organizational units was an attempt at further decentralization without really doing so is clear from investment patterns before and after 1974. Starting from the well-established rule that centralized economies use high levels of investment to stimulate growth, Bajt observed that Yugoslavia was no exception in the immediate post–World War II period. From 1965 to 1974 investments

were significantly decreased, only to shoot up, in the period from the adoption of the new constitution (1974) to the beginning of the debt service crisis (1980), to levels that exceeded the era of centralized planning (1947–53): "It is obvious that the state is responsible for this upsurge, since it is simply impossible that this kind of investment rate can be the result of free decision-making of economic subjects" (Bajt 1988, 162). In many ways, the overhaul of self-management that took place in the mid-1970s represented an attempt to go back to a centralized economy, while keeping the appearance of economic and political liberalism that would make this economy (and ideology) appear safe and attractive to international moneylenders. If we take this into consideration, it comes as no surprise that the system of "associated labor" quickly declined into hypernormativization. The 1976 Law of Associated Labor had 976 articles, deemed excessive by most legal experts. That was just the beginning: by the early 1980s the hyperproduction of legal norms led to the implementation of some 2.5 million "self-managing general regulations" and almost 2 million "self-management agreements" (Jovanov 1983:86).[4] Sociologist Neca Jovanov wrote in the early 1980s that "legal norms . . . especially those regulating behavior in general, and especially that of participants in self-management, are multiplying to such an extent that there is no real social space for any action of self-managing workers" (89). In addition to their regular employment, workers were required to participate in the meetings of workers' councils, which had little real power and served to legitimize decisions made in Party circles. As Jovanov wrote, instead of transferring power from state institutions down to the citizens, self-management was, through this hyperregulation, turned into an *"expanded self-reproduction"* of the state apparatus (91). This excessive reliance on self-managing "agreements" and "regulations" prompted some analysts to proclaim the post-1974 economic system a "contractual socialism," as opposed to the "market socialism" of the previous period (Mencinger 1987:401). The constitution of 1974 and Law of Associated Labor ushered Yugoslav self-management into its last phase, in which all of political, economic, and theoretical gains made over previous three decades were obliterated. During this period, the core idea of self-management was transformed beyond recognition and defeated. For the sake of conceptual clarity, in this chapter I will treat associated labor as a period-specific aberration of self-management, which represents a much broader set of ideas and practices. We can say that associated labor represents a specific ideologization of self-management in Yugoslavia, and that as such it deeply marks a decadent phase in which Party leadership

tried to stage a conservative turn under the thin veil of progressive politics. Associated labor is the name of that flimsy ideological cover.

One of the paradoxes of Yugoslav politics of the 1970s that contemporary readers may find most mind-boggling is that this conservative turn, which resulted in a foreclosure of the revolutionary potential of self-management, did not mend Yugoslavia's ties with the USSR and the Eastern bloc. Precisely the opposite: it led to ever closer ties with Western governments and financial institutions. In other words, the conservative turn in Yugoslavia during the 1970s paralleled the conservative backlash that followed 1968 in the West, except that it followed a different ideological pattern.

During the 1970s the USSR, that island in the worldwide moment of 1968, entered an era of slow but steady stagnation; its satellite states in Eastern Europe, badly shaken by that same moment, entered a period of "normalization" marked by oppression. Unlike the rest of socialist Europe, Yugoslavia was going through a very dynamic period in which it was trying to address challenges that emerged from the student revolt and its aftermath; and unlike the United States and Western Europe, it was trying to reconcile two kinds of neoconservatism: internal (socialist), which came from the Yugoslav leadership and the rank-and-file old-guard Party members, many of whom returned from semiretirement back into active political life; and external (liberal-capitalist), which came from the West, on which Yugoslav economy was becoming increasingly dependent.[5] Deregulation of international money markets in the late 1960s and early 1970s had a direct impact on Yugoslavia. As in the past, the money kept coming from the West, but this time it was not in the form of war reparations, aid, or low-interest credits, but in the form of commercial loans. Susan Woodward makes a well-substantiated argument that socialist Yugoslavia, throughout its history, had remained extremely vulnerable to global political and economic trends. She concludes: "The dynamic of public policy was driven neither by electoral competition between political parties representing labor or capital at home, nor by a domestic business cycle, but rather by the federal response to international events" (1995:256). The overhaul of the Yugoslav economic and political system, epitomized in the 1974 constitution, was a two-pronged response to this two-headed neoconservatism: retrograde socialism at home, and neoliberalism abroad.

Answering the challenge of retrograde socialism, Yugoslav authorities resorted to measures that were characterized by repression against a critical minority and gratification of the masses. The former resulted in a cam-

paign against progressive intellectuals (shutting down the journal *Praxis* and the Korčula Summer School in 1974, removing eight professors from Belgrade University in 1975, etc.) and artists (cracking down on "the dark wave" in film, censoring books and theater performances). At the same time, the general population was inducted into a culture of socialist consumerism that had all the external features of prosperity: factories and department stores were popping up almost daily across the country, and employment was on the upswing. Socialist consumerism was not limited to tangible goods, but to a significant degree included cultural consumption as well. It was the golden age of festivals, which ranged from alternative theater to film and classical music; of World War II film spectacles; and of pop culture that easily flowed into socialist culture.[6] On a more fundamental political level, the authors of the Yugoslav constitution repositioned the League of Communists of Yugoslavia away from the realm of politics proper into the very fabric of society. Writing at the crest of the 1974 constitutional reforms, Edvard Kardelj pointed out that the LCY was not a "classical political party that rules over society" because it promoted the "development of a new kind of democracy": a "self-managing socialist democracy" (1977:34). Once the new constitution shifted it from an organizational principle of industrial democracy to the fundamental premise of state ideology, self-management began to conflate society and state, two interwoven but discrete and often opposed forms of social composition (and became associated labor). Well-intentioned critics pointed out the paradox: the ideologues of associated labor presented it both as a continuation of the political revolution and as a normative system. In other words, it was both a process and a structure.[7] Following this fundamental paradox, the Party was an agent of the process and of the order, or in other words, both the reformer and the conserver of state institutions. Kardelj's statements—such as the one proclaiming that the LCY and the Socialist Alliance were not "mediators between man and power, man and organs of self-management, man and the assembly, in the way that political parties in a classical parliamentary system are," but were instead "first and foremost the factor that shapes social consciousness"—clearly indicate that the Party did not position itself at the top of the social system (as it did in other Soviet-style states in Eastern Europe), but instead wedged itself between various "decentralized" institutions: republics and communes, communes and enterprises, sociopolitical organizations and state institutions, and so on. (32). In short, starting from the Stalinist model of an axis of power positioned at the center of society, it transformed itself into a flowing and decentered medium: a universal mediator of all social exchanges, or a currency. By the end of the

1980s, the conservative repositioning of the Party became so obvious that comparisons with East European totalitarianisms suddenly began to make sense for the first time since 1948.

The response to external neoconservatism was more subtle, and it was folded in with economic reform that came together with and was inseparable from constitutional reform. That associated labor was both a process and an order meant that Yugoslavia was perpetually in a state of transition, a process that was manifested in a series of reforms that seemed to dismantle one mechanism of state socialism after another, but could never get rid of all of them for the simple reason that it was also generating them. Historically, when it came to the organization of work, Yugoslav self-management did not introduce radically new work methods and technologies, and its track record in improving working conditions was very uneven. Its most significant departure from industrial capitalism and étatist socialism was the expansion of workers' participation in decision-making. The empowerment of workers was one currency that was subject to careful regulation. (For example, in various periods of the development of self-management, workers' councils had more or less say on wages, employment, investments, etc.). The other currency closely related to it was labor, which was positioned at the very center of ideological and political discourses. If productivity in the Yugoslav self-managing economy was, at best, erratic and highly dependent on capital import, the one area in which it certainly distinguished itself was the production of a discourse about work. Still, this kind of discourse was not the exclusive property of Yugoslav self-management. As early as the 1930s period of industrialization in the Soviet Union, labor entered ideological discourse through its aestheticization.[8] The Yugoslav turn to self-management in the wake of 1948 split with Soviet Union was motivated, in part, by an attempt to emancipate labor from its ideologization, which was so evident in the political economy of socialist realism. The idea of integral self-management, or self-management that was not managed by the Party, was a logical and unavoidable consequence of this emancipatory move. Suppression of spontaneous self-management required positing a social bond even more fundamental than labor and class solidarity. What was unique for the Yugoslav ideology of associated labor was the discovery and promotion of *interest* as the core value that *associates* subjects into a viable society.

It is not an exaggeration to say that Kardelj's entire elaboration of associated labor rests on the notion of interest.[9] His promotion of interest as a central component of a productive economy is the result of a dual effort. On the one hand, interest is a form of disalienation. It is in the personal in-

terest of the worker to take control of her labor power. In that sense, in Kardelj's theory of the emancipation of the working class, interest has a role similar to that of class consciousness in the writing of Lukács.[10] Kardelj's elevation of interest as one of the pillars of the revised self-management in the 1970s can be seen as a return to the classical works of Marx and Engels, who in *The Communist Manifesto* used precisely this idea to set the Communists apart from other "working-class parties" (Marx and Engels 1962:22).[11] On the other hand, Kardelj posits interest as a solution for the problem created by socialism's removal of financial motivation for labor from the economic system. In a Stalinist economy, gain and profit are replaced by other goals; labor is presented in terms of every individual's ethical responsibility to the proletarian class (Dobrenko 2007:177). It is precisely through this labor of representation (of labor) that socialist realism became an instrumental part of a command economy. In rejecting the Soviet political economy, Yugoslav self-management rejected this external motivation for labor and returned the power back to the individual worker.

Kardelj recognizes the importance of interest in all facets of associated labor. For example, centralized planning was one of the first aspects of the command economy that self-management had to do away with. According to the new notion of "social planning," a plan is an "expression of the need for the coordination and harmonization of workers' interests" (Kardelj 1979:60). Likewise, interest is the central term of his definition of self-management (that is, associated labor): "The system of socialist self-management is not only a form of democratic rule by workers over conditions and means of production, but also the starting point of self-managing in the transformation of the entire society on the basis of the leading role of the interest of the working class" (1977:11). It is lodged at the very center of the tautological relation between the working class and progress: "The working class's historical interests are the moving force of the general societal progress," and because of that, it is necessary to give that process a direction that will "secure the leading position of these interests" (22). Interest is not only the main motivator of the working class, but also of every individual. The "workingman's interest" is broader than the "material conditions of life" and includes cultural, spiritual, and other needs (12). It is at the very center of Kardelj's theorization of labor:

> A worker's true goal and interest is to distribute newly formed value in "pure income" in such a way that it secures the growth of his own living, social, and cultural standard, but also to secure the necessary conditions for the growth of the productivity of his own labor, that

is, the development of techniques and technologies for his own labor and creativity. . . . Motivation to struggle for income, then, essentially differs from the motivation to struggle for profit. (27)

According to Kardelj, under conditions of associated labor, interest is not a spur that drives one individual against another, but instead a mortar that bonds them together into a sustainable community. Interest is not something that is external to work, nor is it an abstract value. Theoreticians of Yugoslav self-management put it at the center of the very definition of labor as a mode of human behavior. In his elaboration on the main tenets of Kardeljian self-management, the sociologist Eugen Pusić explains that "men fulfill their interests in their natural environment" by means of "all kinds of activities, which can be defined as behaviors to which an individual attaches certain meanings." Therefore, "We will call labor any activity that is intentionally and specially aimed at attaining certain interests" (1968:68). In this way, performance (broadly construed) in Yugoslav self-management is inherently tied to self-interest. Post-1974 theorizations of associated labor placed interest, and not some other value traditionally associated with proletarian struggle, such as solidarity or equality, at the very core of the ideology of "associated labor." In doing so, they moved self-management away from the modernist project of emancipation of labor in order to bring it closer to the neoliberal idea of its randomization and deregulation.

In his important early work, *Knowledge and Human Interests* (1968), Habermas places Marx within the tradition of European Enlightenment. At the very source of this history is Immanuel Kant's idea of disinterested thought. Here, explains Habermas, "The concept of 'interest' is not meant to imply a naturalistic reduction of transcendental-logic properties to empirical ones," but precisely the opposite, "to prevent just such reduction" ([1968] 1971:196). According to this schema, in his critique of idealist philosophy, Marx is still not erroneously reducing labor to pure empiricism. If "Kant takes formal logic in order to derive the categories of the understanding from the table of judgments," and if "Fichte and Hegel take transcendental logic in order to reconstruct respectively the act of absolute ego from pure apperception and the dialectical movement of the absolute notion," then Marx's synthesis in the materialist sense "takes place in the medium of labor rather than thought" so that "the substratum in which it leaves its residue is the system of social labor and not a connection of symbols" (38). This substitution of labor for thought and economy for logic does not take Marx outside of the enlightenment project, but expands the

basic premise of this very project: "Self-consciousness is not an ultimate representation that might be able to accompany all other representations: it is an action that goes back inside itself and thus in its own accomplishment simultaneously makes itself transparent—an act that becomes transparent to itself in the course of its own achievement" (38). This transparency of consciousness to itself comes from its detachment from interest, and as such constitutes the ground for any claim of scientific objectivity.

It is precisely this ideal of disinterested critique that Habermas sees as being under assault at the end of modernity. In his 1980 address "Modernity versus Postmodernity" he summarizes his analysis of the Enlightenment from *Knowledge and Human Interests* and other subsequent works by asserting that "the project of modernity formulated in the 18th century by the philosophers of the Enlightenment consisted in their efforts to develop objective science, universal morality and law, and autonomous art, according to their inner logic" (1981:9). Following in the footsteps of the Frankfurt School's analysis of the history of the Enlightenment, Habermas concludes that "the 20th century has shattered" this ideal (9). He recognizes the crisis of the modernist project in a "climate" that has engulfed "more or less the entire Western world," which "furthers capitalist modernization processes as well as trends critical of cultural modernism" (13). Indeed, it is "the postmodernism of neoconservatives" that embraces and promotes "technical progress, capitalist growth and rational administration" and at the same time promotes "a politics of defusing the explosive content of cultural modernism" (13). In *Knowledge and Human Interests* Habermas objects to Marx's privileging of instrumental over communicative action. The varied importance that Marx attaches to these two fundamental modes of human action ultimately results in his sophisticated analysis of labor as a form of self-consciousness and at the same time in his reduction of politics to class struggle: "Marx conceives institutional framework as an ordering of interests that are immediate functions of the system of social labor according to the relation of social rewards and imposed obligations. Institutions derive their force from perpetuating a distribution of rewards and obligations that is rooted in force and distorted according to class structure" (1971:277). As a result, the notion of interest remains fairly undeveloped in Marx, and it remains attached to the idea of class struggle and class interest of the proletariat. This clearly does not give Kardelj enough material for his insertion of the notion of interest into the very core of the Yugoslav ideology of associated labor. If, following Castoriadis, we agree that the real socialism of the Soviet model was nothing more than state capitalism, then Yugoslav post-1974 socialism can be seen as an attempt to take state capitalism past

the industrial age and to follow capitalism in its passage into a postindustrial society. Furthermore, it was this endemic political neoconservatism that introduced Yugoslavia to political postmodernism even before the arrival of its cultural counterpart.

The ideologeme of interest demands a deeper alignment of the projected ideological order with past economic formations. As Albert Hirschman explains in his important work *The Passions and the Interests*, the emergence of capitalism was made possible not only by changes in industry and trade, but also by a massive reassessment of values in the Western world. In the course of the seventeenth century a "curious change" occurred in which the feudal idea of elevating glory over riches was called into question and eventually overturned. The medieval hierarchy of passions was gradually eclipsed by the perspective that one passion counteracted another. In this new taxonomy of passions Hirschman recognizes a moral foundation of the new social order. This new taxonomy of lesser and graver passions led to a new doctrine, according to which "one set of passions, hitherto known variously as greed, avarice, or love of lucre, could be usefully employed to oppose and bridle such other passions as ambition, lust for power, or sexual lust" (1977:41). This doctrine based on manipulating an individual's private passions is easily translatable into a principle of "engineering social progress" (26). Long before the recognition of the market, the "invisible hand" was that of interests. According to Hirschman, from the early political economy of James Steuart's *An Inquiry into the Principles of Political Economy* (1767) to Adam Smith's *Wealth of Nations* (1776) the doctrine of interests traversed a path from a bold new proposition to generally accepted truth. The evolution of the word brought a "semantic drift" in which the meaning of "interest" shifted from avarice as an individual passion to an economic sense of concern, aspiration, and advantage. "Injection of an element of calculating efficiency" into human behavior helped this idea, as Hirschman writes, "survive and prosper both as a major tenet of nineteenth century liberalism and as a central construct of economic theory" (1977:19). And furthermore, "From France and England the idea traveled to America where it was used by the Founding Fathers as an important intellectual tool for the purposes of constitutional engineering" (28). It is precisely as this kind of ideological tool that we find "interest" in the work of the mastermind of the last Yugoslav constitution.

The idea of interest provided Kardelj with the means to address one glaring weakness that self-management brought to Yugoslav statecraft. Self-management was impulsive; it worked in the times of crisis and great emotional charge, but it was notoriously difficult to maintain the high level

of engagement from day to day, or, in theatrical terms, from night to night. The great social upheavals that shook Yugoslavia at the end of the 1960s and the beginning of the 1970s showed, furthermore, that the "Diderot dilemma" cuts both ways. Self-management was promoted as an alternative to Stalinism and as a less repressive way on the part of the state to control the society. Because of its potential for universal equality and empowerment of the subject, as an idea self-management was inherently opposed to the state. The history of socialist Yugoslavia is a history of a self-managing society slipping away from the control of the state, and the state's attempts to regain its control over society. In the mid-1970s, "interest" became a very effective tool in this struggle. Ideologues of associated labor used it in the same way as the statesmen in the eighteenth and nineteenth centuries. In the new economy of passions, avarice is useful because of its universality and insatiability. As a perfect example of this attitude Hirschman brings up Hume's observation that "avarice, or desire for gain, is a universal passion which operates at all times, in all places, and upon all persons" (54). Unlike other appetites, the passion for accumulating money seems unquenchable, and in that sense it introduces an unusual sense of constancy in the market-world torn apart by conflicting and destructive urges. It was not only its ability to increase the total wealth in a society that made the passion for acquisition a useful tool for statecraft; it was its capacity to promote behavior that is at once engaged and obedient. In his early writings on political economy, James Steuart noted that if a "people [were] to become quite disinterested," then "there would be no possibility of governing them" (in Hirschman 1977:50). It is not at all surprising, then, that the notion of interest resurfaces in Michel Foucault's work on governability from the 1970s.

Outlining the differences between the three systems—legal, disciplinary, and security—Foucault writes that "the law prohibits and discipline prescribes, and the essential function of the security, without prohibiting or prescribing, but possibly making use of some instruments of prescription and prohibition, is to respond to a reality in such a way that this response cancels out the reality to which it responds—nullifies, or limits, checks, or regulates it" (Foucault [2004] 2007:47). This "cancelation" of reality is accomplished through discourse. For example, a security society doesn't conceptualize labor as pragmatically as a disciplinary society does—as a set of "best actions for achieving a particular result" (57)—but as a relationship between discourse and body, and institutions and assemblages of multiplicities. Crucially, security societies transform the notion of discourse as much as they do the body and its actions. In a security society, the discourse

does not consist of legal decrees, scientific propositions, or political decisions, but includes all of the information, calculation, and anticipations that go into the regulation of society. Discourse is not external to power, but inherent to it; it is not its representation, but its mode of operation. Foucault argues that in security societies economy is no longer a science of regulation and distribution, but of the collection of information, the creation of statistical averages, and estimation based on this data. In this reckoning, "There is at least one invariant that means that the population taken as a whole has one and only one mainspring of action. This is desire" (Foucault [2004] 2007:72). In security societies, desire receives a new elaboration:

> *Desire is the pursuit of the individual's interest.* In his desire the individual may well be deceived regarding his personal interest, but there is something that does not deceive, which is that the spontaneous, or at any rate both spontaneous and regulated play of desire will in fact allow the production of an interest, of something favorable for the population. The production of the collective interest through the play of desire is what distinguishes both the naturalness of population and the possible artificiality of the means one adopts to manage it. (73; emphasis added)

It is via interest, and not via more or less superficial features of a market economy, that Yugoslavia joined the broad spectrum of security societies that emerged in the second half of the twentieth century. As a result, the art of governing in Yugoslavia involved an equal measure of the sovereign's firm control and of predicting and calculating contingencies. In order to regain balance and stability in the late 1970s, Yugoslav authorities employed repressive measures limited to intellectuals and artists (disciplinary modality) while promoting consumerist behavior among the general population (security modality).

Conceptual centrality of interest for the new doctrine of associated labor was fortified through the establishment of Self-Managing Communities of Interest (Samoupravne interesne zajednice, or SIZs). The institution of the SIZ addressed the question of funding for segments of the economy that were not directly engaged in material production, and previously were funded by ministries through taxes and the redistribution of funds. According to this new funding scheme, there were five kinds of SIZs, in charge of education, science, welfare, health, and culture respectively. Kardelj spoke of them as an integral part of the "social exchange of labor"

through which "working people" could exercise control over spending in all kinds of nonproducing areas, and, even more important, as a "self-managing integration of interests" (1977:30). What is important here is not only funding, but also the taxonomy of labor. In his elaboration of the "self-managing integration of interests" Kardelj speaks of forms of "immaterial production" that don't represent just "spending but also [are] an integral part of social labor"; according to him, the purpose of Self-Managing Communities of Interest is to mediate between "productive and so-called non-productive labor" (31).

In a very similar fashion, neoliberal capitalism will, in its infinite adaptations, undertake an informalization of labor. Boltanski and Chiapello suggest that the emergence of post-Taylorist business enterprise in industrialized societies coincided with the rise of service industries and the specific forms of labor prevalent among them. This comes down to the very organization of the workplace: "Given that what matters most is *intangible, impalpable, informal* — a term that characterizes both *relations* and the *rules of the game*, which are invented as one goes along — the most appropriate organizational mechanisms are thus likewise interpersonal," observe Boltanski and Chiapello (2005:118). Here work is organized through interpersonal relationships, rather than through its relationship to the object of labor. What Boltanski and Chiapello describe without naming it is the security mechanism at the very heart of neoliberal capitalism. In ridding itself of the disciplinary techniques of the Fordist factory line, capitalism is not giving up on its primary objectives of growth and expansion. The room for this growth is no longer geographical, as it was at the height of imperialism, or demographic, as in the decades of mass industrialization, but "interpersonal" and behavioral. The introduction of Self-Managing Communities of Interest as a way of regulating "immaterial production" preceded by almost three decades the critics of neoliberal capitalism and their recognition of the emergence of this kind of labor.[12]

It would be a crude oversimplification to say that ideologues of associated labor were ahead of their time, and that they anticipated the future development of labor organizing. Rather than a vanguard of flexible capitalism, Yugoslav self-management, which over three decades made a full circle from direct command economy to self-management to indirect command economy (associated labor), was something like its side-guard. It developed separately from, and in relative synchrony with, security societies of the West. In its own marginal and skewed way, Yugoslavia participated in transformations that shaped capitalism over the second half of the twentieth century — up to and including her own demise.

THE OTHER LINE

Between 1971 and 1973, a member of the Belgrade group of six conceptual artists, Zoran Popović, produced a series of works under the common title *Axioms*. It consisted of basic geometrical figures (circle, diagonal line, cross, square, point, vertical line, crossed diagonal lines), executed in linocut and other techniques, including performance. This is his description of his action at the exhibit *Axioms* he held at the SKC in 1972:

> The room in which I perform is in complete darkness. When the audience is ready, with the beginning of first sounds, which are selected especially for this occasion, small bulbs attached to the tips of my fingers slowly come on. The sound that accompanies the performance of *Axioms* is very intense, and it seems to fill the entire room. It has the purpose of an instant inclusion of spectators. It is asynchronous with the performer's movements. At the end, the bulbs attached to my fingertips are slowly turned off. The basic idea is that this kind of presentation, which affects the senses powerfully, leaves no room in the spectator for creation of any other kind of images except those that are in front of him or her. During the performance, any narrativity is strictly circumvented, and so is any pictorial interpretation, that is, any analogism. (Popović 1983:37)[13]

In his sophisticated elaboration of *Axioms*, Popović suggests that because of their "'metalinguistic' structure" these "geometrical diagrams" are "as much critical, as they are aesthetic," that is, that they are "as ideologically manipulative as they are equivocally self-reflexive" (1983:25). If that is the case with the whole series, then performance additionally enhances the signifying potential contained in this structure. It is here, perhaps more than anywhere else, that Deleuze's insistence on the "unbridled manual power" of the diagram comes into prominence. "Being manual," writes Deleuze, the diagram "must be reinjected into the visual whole, in which it deploys consequences that go beyond it. The essential point about the diagram is that it is made in order for something to emerge from it, and if nothing emerges from it, it fails" (2003:128). So what emerges from *Axioms*? In the very least, a certain number of lines. Depending on the medium, these lines are produced by scratches on a surface (linocut), or by traces on paper. In performance, they are produced by hand gestures. These gestures are made visible by attaching light sources to tips of the performer's fingers. This underlines the manual nature of gestures and

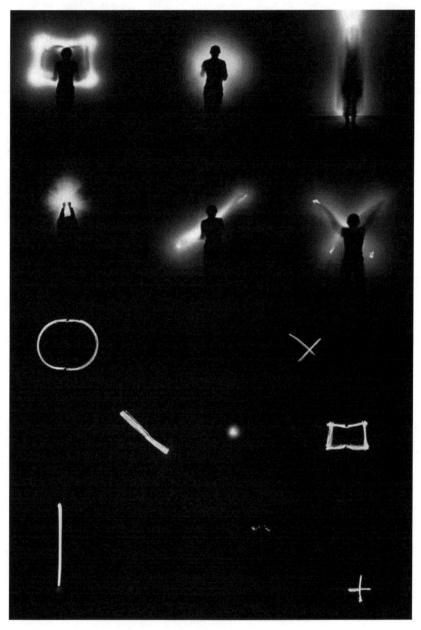

Fig. 25. Zoran Popović, *Axioms*. Belgrade, 1972. Photographs by Vladi-mir "Kića" Dobričić. Courtesy of the artist.

their proximity to labor. Now, attempts to give labor an inspectable form have their own place in the history of scientific management.

Chronophotography, the very same technique Popović used in his performance of *Axioms*, was used early in the twentieth century by Frank and Lillian Gilbreth in their time-motion studies. These early followers of F. W. Taylor also resembled Popović in their use of different media. While he used lithography, photography, performance, and other forms to reproduce the same set of geometric figures, they were using various methods in an attempt to achieve reproducibility of gestures. Placing a laborer in front of a black background divided in a Muybridge-inspired grid, they would first take the motion study photographs by attaching small bulbs to workers' fingertips. Then they would use these images, which they called "cyclegraphs," to create three-dimensional wire models. The purpose of creating these casts of bodily gesture was to train workers to perform their tasks in the most efficient way. This takes scientific management to an extreme, and at the same time represents the most literal example of disciplinary techniques in their striving to produce a docile body. Here this docility reaches the point of the complete negation of a worker's subjectivity. As Sharon Corwin points out, these "models function as abstract representations of labor in which the worker is wholly excised from the act of work, leaving only a reified trace of labor in its most efficient form" (2003:146). Therefore, *Axioms* is placed at the intersection of two kinds of abstraction that in many ways defined modernism: nonfigural painting in art and systematization of labor in industrial production. Insofar as it pointed to the quiet transition to an indirect command economy that was happening in Yugoslavia exactly at the time when he was working on *Axioms*, Popović's early conceptual work was much more politically incisive than he might have anticipated or intended.

Having spent 1974–75 in New York City, Popović and his (then) girlfriend Jasna Tijardović established a living link between the Belgrade conceptual art scene at the SKC and the New York conceptual art of the mid-1970s. Early in they stay, they got in touch with the conceptual artist Joseph Kosuth, who offered to let them stay in his loft on Bond Street in SoHo. This gave them open access to New York conceptual art scene, in which they, Popović asserts, participated as equals. Only a few months after their arrival in New York, Tijardović and Popović published their article "A Note on Art in Yugoslavia" in the inaugural issue of the journal *The Fox*, a platform for ideas that emerged from the radical left wing of the New York conceptual art scene.[14] According to Popović, they directly participated in the creation of the intellectual "climate" that led to the launching of this

journal. It was a two-way street: on the one hand, during their stay in New York in 1974–75 this couple actively participated in debates with the radical wing of the Art & Language group, which, claims Popović, "at the last moment corrected many of their naïve political positions, and helped them get rid of many political illusions"; and on the other, he saw this collaboration as the "practical beginning" of his "work on 'artistic action of direct political speech'" (Popović 1989:28).[15] In Popović's artistic activities, this direct political speech of the work of art "stripped of its exclusive self-reflexivity" culminates in his piece *Worker, Typographer Miodrag Popović: On Life, Work, Leisure* (Radnik, tipomašinista Miodrag Popović: o životu, o radu, o slobodnom vremenu). The group of conceptual artists gathered in the SKC engaged in "direct political speech" in *Oktobar '75*, an art event that was isolated in its attempt to address directly the massive turn in Yugoslav politics of the mid-1970s.

Even though in *Six Years: The Dematerialization of the Art Object from 1966 to 1972*, Lucy Lippard enthusiastically announced that "by 1970 . . . Yugoslavia had also kicked in" as part of the worldwide progression of postobject art, its development was by no means imitative of or analogous to that in United States or Western Europe (Lippard 1973:xix).[16] Conceptual art in Yugoslavia was highly specific for its social environment, and in that sense, it differed significantly in its content, if not in its form, from similar movements in the capitalist West and in the socialist East. In the United States and Europe conceptual art was driven, in part, by artists' opposition to the institution of art as it was deeply implicated within the structures of advanced capitalist societies. They saw dematerialization of art as its decommodification. Their critique of institutions was first and foremost ideological, not aesthetic. Unlike in countries of postindustrial capitalism, in Yugoslavia the shift "from art object to the *subject* of the artist" was not taking place within an art market dominated by art dealers, galleries, and private art museums (Denegri 2007:102; emphasis added). At the same time, in distinction from conceptual art in the USSR and other countries of real socialism, where artists presented their works in private apartments and studios, in Yugoslavia this kind of art was shown in public art museums and galleries. In other words, it was taking place within the culture of socialist aestheticism established on the basis of the tacit agreement between artists and authorities to uphold the boundaries between the political and the aesthetic. When, for example, Prvoslav Ralić insisted on the separation of artistic practice from artistic discourse, where the former was beyond and the latter well within the realm of ideological criticism by the Party, he spoke from the well-established positions of socialist aestheti-

cism. Dematerialization of art in Yugoslavia meant, first and foremost, its stepping out from the realm of the aesthetic. In doing so, it exposed the ideological function of the seemingly politically neutral mainstream art.

More difficult than understanding the differences of general political and economic context in Yugoslavia and other countries that produced significant conceptual artworks, is recognizing the differences in the conceptualization of the very idea of an "art institution" that was subjected to this critique. We need go no further than comparing, for example, artistic statements like Guerrilla Art Action Group's (GAAG) "A call for immediate resignation of all of the rockefellers from the board of trustees of the museum of modern art" (1969) and Raša Todosijević's "Edinburgh Statement: Who Profits from Art, and Who Gains from It Honestly?" (1975). One of Art Workers' Coalition (ARW) splinter groups, GAAG distributed their pamphlet in a guerrilla action performed in New York's Museum of Modern Art on November 19, 1969. Without warning, they ripped each other's clothes and exploded concealed bags of fake blood, then fell on the floor playing dead among scattered leaflets in which they accused the Rockfellers on MOMA's board of trustees of using "art as a disguise" and as a "cover for their brutal involvement in all spheres of the war machine" (GAAG in Alberro and Stimson 2009:86). This and other actions organized by GAAG reflect, in a radicalized form, ARW's engagement in a wide spectrum of social questions such as the struggle against racism and sexism, antiwar protests, and the struggle for artists' rights. As Julia Bryan-Wilson recognizes, artists gathered in ARW, GAAG, and other similar groups active in New York and Los Angeles were aware of "how their art circulated" and of "its symbolical and ideological 'use' that challenged previous claims of autonomy" (2009:17). Todosijević's statement, first published in English translation in the catalog of Richard Demarco's gallery show of Yugoslav artists and subsequently in several Serbian editions, speaks about the position of art in a society in which modernist autonomy of art was abolished during the period of socialist realism, never to be fully restored. Here the artist is not a small entrepreneur competing with other "small businesses" in a market, but a "worker" fully integrated in a vast symbolic economy of social conformism. Todosijević's statement is a long list of institutions that "profit from art." It begins with "factories, which produce materials" and, from there, moves on to their workers, to galleries (nonprofit and otherwise), to other cultural institutions and all of their employees (from experts to janitors), to media, bookstores, antique shops, banks . . . all the way to "cheap politicians who have, in this 'mysterious way,' through relatives, friends and connections, seized at a sinecure, brainwashing artists and

making enough money for two life times through this nonsensical business" (1975:n.p.).[17] In his contribution to *New Art Practice* exhibition catalog, art critic Ješa Denegri amplified Todosijević's point by asserting that "the representatives of the new artistic conceptions have revealed . . . the appalling internal configuration of 'art systems' in Yugoslavia, bringing in an unprecedented way into the open the symptoms which bespoke of, among other things, the outmoded methods of artistic training, the inertia within galleries and other institutions in charge of exhibiting art, of a vast majority of critics out of touch with new developments, and finally, of concealed but verifiable existence of a specific market mechanism which is different from that in the West, but is no less powerful and ruinous in its own way" (Denegri 1978:13). In other words, like no other group of artists before them, the representatives of "new art practice" uncovered the conditions of socialist aestheticism in Yugoslavia and its mechanism that deeply implicated—to use ARW terminology—art workers in a system of backward and corrupt institutions.

Like that of dematerialization, the discourse of expansion (April Meetings were subtitled Festivals of Expanded Media) took on new meanings and applications once it was taken out of the context of the American counterculture of the late 1960s and transposed to the cultural context of socialist Yugoslavia. Texts published in April Meetings bulletins outline the transformation of "expanded media" from a convenient art historical category into a critical term at the boundary between arts and politics. In their program notes about the festival, the organizers of the first April Meeting (1972) used the phrase "expanded media" to indicate their intention to depart from medium-specificity in the arts: "Expanded medium is the term that encompasses a very broad range of creation, research, and thinking within interdisciplinary regions of traditionally compartmentalized arts, and we use it in its most inclusive sense" (*Bilten* 1972:1). In their use of the term at this early stage, the festival organizers already departed from Gene Youngblood's New Agey arguments for "expanded cinema" as a broadening of consciousness that would go "beyond mere political revolution" (1970:52). A specifically Yugoslav politicization of this label is recognizable in the statements by the former Mediala member Vladan Radovanović, who, in the roundtable discussion held at the second April Meeting (1973), suggested that "since expanded media is not an art movement or a style in art, it encompasses not only various currents and styles, but also something that is still art but at the same time tends toward non-art" and that, in its constellation of meanings, this term should include the "expansion of attitude toward the artistic and toward the medium" (in Zečević 1974:n.p.).

Constitutional changes in Yugoslavia in the early 1970s radically altered the meaning of "nonart," that is, the everyday into which art was expanding. It was no longer an amorphous, more or less utilitarian existence, but everydayness was held together (and pulled apart) by a vast network of agreements and regulations.

Yugoslav contractual socialism was an attempt to reconcile a postrevolutionary society, which produced a new figure of the charismatic leader, with the tradition of contractual democracies that significantly curtailed the power of the sovereign. In the United States and Western Europe, conceptual art engaged precisely this political texture of Western democracies. In his much-discussed essay "Conceptual Art 1962–1969: From the Aesthetic of Administration to the Critique of Institutions," Benjamin Buchloh called attention to the shift from aesthetic to institutional discourse in post-object art:

> Beginning with the readymade, the work of art had become the ultimate subject of a legal definition and the result of institutional validation. In the absence of any specifically visual qualities and due to the manifest lack of any (artistic) manual competence as a criterion of distinction, all the traditional criteria of aesthetic judgment—of taste and of connoisseurship—have been programmatically voided. The result of this is that the definition of the aesthetic becomes on the one hand a matter of linguistic convention and on the other the function of both a legal contract and an institutional discourse (a discourse of power rather than taste). (1990:118)

Instead of using art institutions of Yugoslav "contractual socialism" to legitimize their own practices, conceptual artists used these institutions as a critical platform within which they strove to develop modalities of self-organization that were radically opposed to the increased ossification of self-management. Much of this struggle took place within the Student Cultural Center. In 1976, *The Fox* published Jasna Tijardović's report on the situation in the SKC, "The 'Liquidation' of Art: Self-Management or Self-Protection." Even though most readers of *The Fox* were unacquainted with the social and political situation in Yugoslavia, it is clear from Tijardović's text that by 1975, the SKC found itself caught between two concepts of self-management: one imposed on it from without through the funding structure of SIZs, and one resisting from within, constituted mostly by artists and theoreticians who spontaneously gathered around this institution and were active in shaping its identity from the very beginning. "The Gallery

[within the SKC] wants to be socially justified, which means it is not neutral. It wants to adapt to society, to the aim of this society—self-management. The same is true of certain artists/collaborators (of whom I am one): we too are devoted to self-management, and to socially useful work—but in the form of art"; and "Self-management was supposed to teach me to work and act independently—without fear; more free; free, without self-censorship" (Tijardović 1976:98, 99). While Buchloh complained that conceptual art "in its bureaucratic rigor and deadpan devotion to the static collection of factual information, came to refuse any transcendental dimension whatsoever," Tijardović snapped at arguments for the "liquidation of art" justified by discourses of dematerialization (Buchloh 1990:141):

> The term "transcendence" or "liquidation" is too imitative—it comes from politics. This is an unhealthy, masculine idea. It reveals the extent to which repressive forces are stored up and the extent to which they can appear as a distorted form—in this case the idea of "transcending" art reminds me too much of the transcendence and liquidation of people. . . . Art (as a whole) is being disarmed because (certain) art questioned the bureaucratic, financial power of the SCC; essentially art isn't the issue at all. (Tijardović 1976:99)[18]

Tijardović article exposes a deep rupture between the integral and self-management of interests. They both derive from the experience of 1968. However, whereas the first form of self-management stands for independence, freedom, and absence of fear and self-censorship, the second one promotes interdependence, institutionalized socialization (however paradoxical it may seem), and, ultimately, full assimilation of art into social practices. It is easy to recognize in the latter one Žarko Papić's argument for a "withering away" of art as a discrete activity within a self-managed society. In turn, Papić proposed this idea with the hindsight afforded by the events that were taking place in the SKC at the time of his writing.[19] Namely, in the fall of 1975, the group of artists and curators gathered around the SKC organized one of its boldest actions to date. Instead of running its traditional "Oktobar" event, they decided to publish a series of statements on art and Yugoslav society. So instead of hosting performances, discussions, and art installations, as they had over the previous four years, that October the SKC released a mimeographed publication, *Oktobar '75*.

This collection of statements, ranging from one to nine pages in length, by eleven artists and art critics (Dunja Blažević, Raša Todosijević, Jasna Tijardović, Ješa Denegri, Goran Đorđević, Zoran Popović, Dragica

Fig. 26. The Cover of *Oktobar '75*. Courtesy of Student Cultural Center, Belgrade.

Vukadinović, Slavko Timotijević, Bojana Pejić, Vladimir Gudac, and Nena Baljković[20] is a radical implementation of the conceptual art premise of transforming the artwork from an object to a mental process and a theoretical proposition. Furthermore, considering that each of these statements engaged, in one way or another, the question of art and society, this dematerialization of art was all but ideologically neutral and insensitive to anything specific to the local cultural scene. In fact, *Oktobar '75* stands in radical opposition not only to the socialist aestheticist privileging of the object, but also to its demand for artists to remain mere object-makers and not engage in any political debates, or discursive production of any kind.[21]

In *Oktobar '75* the artwork is identified with discourse. It would be wrong to assume that by embracing discourse as a mode of artistic expression, the organizers of *Oktobar '75* automatically renounced all media, for the fifty-odd-page mimeographed booklet printed on rough paper belonged fully to the new culture of contractual socialism that was emerging at that very moment. The most widespread medium of that culture bespoke the annihilation of the self-managing subject through hypernormativization. That medium was not the newspaper, or radio, or even television. It was the mimeograph. As an example, Jovanov cites that the printed materials for a single session of a federal committee of a union branch could weigh over two kilos and contain as many as 476 pages (1983:48). Documents mimeographed on cheap paper flooded meetings in Basic Organizations of Associated Labor and Communal Associations (Mesne zajednice), principalities (*opštine*), and sociopolitical organizations (*socio-političke organizacije*). This textual overproduction was a palpable manifestation of the shift of emphasis from workers' direct decision-making to legalistic regulation of behavior, or in other words, from economic to legal ownership over the means of production. *Oktobar '75* pointedly suggested that the last opportunity for setting self-management on the right track was expiring right in front of the drowsy Yugoslav population. Afterward there were other manifestations in the SKC and elsewhere that addressed both progressive politics and progressive art: in 1978 (the unmentioned and unmentionable tenth anniversary of June 1968!) a performance meeting was organized at the SKC; also, the same year the SKC hosted the first feminist conference in Yugoslavia, "Comrade Woman: The Women's Question—A New Approach?" ("Drugarica žena. Žensko pitanje—Novi pristup?"). Still, *Oktobar '75* was the last public action that questioned self-management and art in such an urgent manner.[22]

Although they never mentioned 1968 explicitly, artists and critics who participated in *Oktobar '75* made a powerful statement of their refusal to

reduce its legacy to an aesthetic experience, or even worse, to a "lifestyle." Regardless of their mutual differences, they argued for a politicization of art and its potential as a critical and corrective mechanism in relation to dominant ideological discourses of the day. That is already present in the questioning of the relationship between artists and institutions that figures prominently in several contributions. Their attempts to understand the SIZ as a still new and unknown funding body suggests that this concern is neither general nor abstract. For example, in her contribution "Art as a Form of Proprietary Consciousness" ("Umetnost kao oblik svojinske svesti"), Dunja Blažević, the artistic director of SKC Gallery, writes that the SIZ represents a "completely original" and "essentially new" "nonproprietary" relationship between art and society. This innovative form of funding of the arts asks for new art forms, for "it would be extremely comical and nonsensical to try to build self-management using political means borrowed from a feudal or bourgeois structure, as much as it would be impossible to make the art of a new society on the level of ideas and means of the above-mentioned structures" (1975:3). In a tone that foreshadows her article in *The Fox*, Tijardović asked pointedly: "If we accepted Marxism as ideology, if we are developing self-management and through it associated labor and exchange of labor, and if we see in the SIZ a possibility of an equitable relation between base and superstructure, how in all of this functions the model of *universal art* and, as its component, the model of *monumental tragicalness*?" (1).[23] Here Tijardović takes the "monumental tragicalness" as an example of a pathos-laden style as a shared linguistic property of artistic practice and art criticism in Yugoslavia at that time. Indeed, the question of language emerged as a dominant theme in most statements gathered in *Oktobar '75*. Raša Todosijević opens his text "Art and Revolution," the longest in the collection, by setting up a direct relationship between politics and language in artistic production: "The complex politics of artistic engagement takes place through internal criticism of linguistic procedures, and not on the plane of external presentation of FIXED VALUES" (1). Consequently, the problem of art's alienation is inseparable from its language: "UNCLEAR ARTISTIC CONCEPT IS THE FIRST PRECONDITION FOR ALIENATION OF THE ARTWORK. Such work is not capable of resisting random interpretations and abuses," and further:

> Alienation of art comes from two directions: ideology and its politics tolerate only practical application of art, significantly ignoring demands of its internal practice. Conversely, art is naturally concerned with its own language, and it's not surprising that it resists any in-

strumentalization. As long as there exists this categorical breach in the understanding of art's FUNCTION, the problem of alienation will persist. Any society that strives toward dogmatic stabilization of its own mechanism and its own values asks for an unchanging and un-dialectical idea of art. That is why our critics and artists are unable to understand the identity or linguistic position of "art for art's sake" and "art" known as socialist realism. (8)

The concern with alienation is not limited to Todosijević's contribution, but constitutes a distinct thread that runs through several texts published in *Oktobar '75*. In the title of his contribution, "Art as a Form of Religious Consciousness," Goran Đorđević already indicates that, far from being immune from alienation, art represents one of its main instruments. Approaching this question from a distinctly art historical perspective, and addressing the position of art in the industrialized West, Denegri points to the specific mechanisms of the art industry: "This basically alienated position of contemporary art gives to its otherwise very resilient organism a possibility of permanent regeneration, considering that in the nature of artistic labor survives an awareness of a real danger of final and definitive degradation that art does not accept as its sole destiny" (3). It seems that the participants in *Oktobar '75* agree that, if art has a unique insight into the ossification of language into a commodity object, then it also has a unique responsibility to refuse the separation of labor and language. Young art critic Bojana Pejić broadened this interrogation of the politics of the signifier to include work in both senses of that word:

Ideologically and practically [our society] wants to prove that it made a step in the direction of overcoming the differences between the two kinds of labor. Art, finally, has the accepted legal status alongside all other social developments. However, now that it can exist without restrictions, this very same art, which claims to have been oppressed in the course of history, comes up with the same problems with which it was dealing in the past. It is that very art which is still obsessed with the *results* of its efforts (objects), and not with that which is immanent to artistic creation: the process. It is as if it was paying back the society; it pays its debt in the material (tactile, visible) form. It again stays at the level of the phenomenal. (3)

In the political economy of socialist aestheticism, in which the main consumers of high art are national museums, factories, and sociopolitical insti-

tutions, an art object is commodifiable insofar as it is not engaging in reflection on the nature of the circulation in which it participates. *Oktobar '75* made explicit that conceptual art produced in the SKC and other institutions in Yugoslavia never entered this economy.[24] Furthermore, it proclaimed this exclusion the very content of this art event. Namely, by stripping itself of objectness and aestheticism in order to turn itself into discourse, art proclaimed its ability to join, on an equal footing, political discourse. Mimeographing only underlines this claim for art's thorough politicization: like labor, it is a process, and furthermore, true to the principles of associated labor, it is both contractual and discursive. Precisely because of this formal identity with ideological discourse, this art becomes unassimilable and impossible to appropriate. For the first time in the history of socialist Yugoslavia, instead of providing an ersatz commentary on the perils of alienation, artists engaged social issues by alienating themselves both from mainstream art and from the society that condoned it.

Like European modernism from which it drew, socialist aestheticism valued innovation and originality. Art critic Ješa Denegri correctly recognized that it was precisely for this reason that post-1968 Yugoslav artists insisted not so much on the new as on the different or the *other* ([1980] 2007:92). While appropriating Michel Tapié's catchphrase "une esthétique autre," which in the 1950s referred to Art Informel, Denegri deploys it in a completely different way in his writings about radical artistic practices in the Yugoslavia of the 1970s. In his important article "Art around '68: The Other Line," Denegri identified *otherness* as the central feature of this art. While proto-conceptual, conceptual, and performance art in Yugoslavia shared some other properties, such as propensity for collective work (from Gorgona in Zagreb and Mediala in Belgrade, to the informal group of six artists in Belgrade, to OHO in Ljubljana and the Group of Six Authors in Zagreb), artistic nomadism, and openness toward ideas coming from theoretical discourses (KÔD and (∃ in Novi Sad, Grupa 143 in Belgrade), their main characteristic, argues Denegri, was their "separateness," which was either "imposed from without or sought after by the artists themselves" (88). This separateness pertained both to the content of the artwork and its positioning vis-à-vis art institutions. On the one hand, "the status of an artistic operation was contained . . . in the transfer of conceptualization and realization of the artwork from visual and morphological to a conceptual (mental) plane of its formation and reception" (90); on the other hand, while few of these artists argued for total abandonment of traditional art forms in favor of innovation, they all "insisted on the difference ('otherness') in the way in which they used and applied (seemingly) traditional art procedures" (91).[25]

Denegri argued for "the other line" in a series of articles he published in the 1970s and 1980s, and he gave a précis of this long argument in the catalog for a survey exhibit he curated in Sarajevo as the twilight of this "line" and of the country in which it was forged was clearly approaching. In his program notes for *Yugoslav Documenta '89* (*Jugoslavenska dokumenta '89*), he wrote that the other line refers to

> a cluster of developments within contemporary art in Yugoslav cultural space, developments that differ or are intentionally separate from the main currents in this culture, in order to establish a distinct zone that has as its most fundamental characteristic a demand for radicalization of the idea of art, and following on that, radicalization of artistic behavior. The set of phenomena here understood as the other line is not a clearly identifiable artistic language, but more of a mentality, a way certain artists or artistic groups responded to the existing cultural and social conditions. It is, in fact, a way of circumventing integration into these conditions in order to search for and adopt an independent and unique artistic, which is to say, existential position. ([1989] 2007:97)

Denegri is very clear in identifying (art) historical, sociological, and conceptual aspects of the "other" line, but leaves its ideological content insufficiently examined. Which idea of "otherness" did the "other line" rely on and promote? And further, in relation to what politics is the "other line" "separate" and "other"? If the idea of something alien is strongly implied in "otherness," then how does the "other line" relate to the discourse of alienation in Yugoslav humanist Marxism?

DID SOMEBODY SAY ALIENATION?

Just as much as with Tapié, the idea of the "other line" resonates with Max Horkheimer and other critical theory philosophers' reflections on "totally" or "entirely Other." Even though Denegri does not reference the founder of the Frankfurt School, in "Art around '68: The Other Line" he takes Marcuse's discussion of the desublimation of culture from *An Essay on Liberation* as one of the fundamental theoretical premises for his argument about the other line. Looking more specifically at the Yugoslav situation, the chronological and terminological proximity of humanist Marxist philosophy and the new art practice lead Denegri to hypothesize a dual valence in the last

word of this phrase. He writes that while the term "practice" refers to "processes, operations, doings, undertakings, performances, and developments of artistic actions and behaviors," in "domestic context" it is also "reminiscent of the philosophical concept of *praxis,* which could point to the meaning of activism, efficacy, social critique, and political engagement" (Denegri 1996:23). However, the relationship between the new artistic practice and Praxis philosophy in Yugoslavia was much more complex, and it by no means can be reduced to semantic proximity of keywords that associated with these two distinct phenomena. On the one hand, even though the journal *Praxis* and the Korčula Summer School coincided with the period of emergence of new art in Yugoslavia, their participants showed little interest in art, and no interest whatsoever in new artistic practice.[26] On the other hand, artists, critics, art historians, and philosophers associated with new art in Yugoslavia kept a distance from the brand of Marxist humanism advocated by the Praxis school. Far from being its expression, the new artistic practice offered an alternative to, and even a critique of, Praxis philosophy.

If, aesthetically, the new art practice in Yugoslavia was positioned as the other line in relation to the dominant socialist aestheticism in culture, then politically this group of artists was no less "other" to the Yugoslav brand of critical theory. Many of them were participants and witnesses of the student movement of the late 1960s in Belgrade, Zagreb, and Ljubljana, and they instantly recognized how easily the political and cultural establishment appropriated Marcuse-inspired ideas about art as the "kingdom of freedom," of play, and of "erotization" of labor. In fact, this brand of politicized art is one of the main targets of Todosijević's wrath in "Art and Revolution," the text he contributed to *Oktobar '75.* Going straight to the point, he argues that the "political strategy of the so-called Engaged Art and Protest Art is more than miserable. The ceremonial and easily exploitable strategy of Protest Art is shaky for one reason only: it uses an already existing language that, as such, belongs to the hierarchy of values of politics it is protesting against" (2). Todosijević unmistakably recognized some of the shared values of the Yugoslav establishment and its critics who came from the position of humanist Marxism:

> Art is an inherent part of the critique of social practice; therefore, it is a revolutionary mechanism aimed at its qualitative change. However, this phrase is nonsensical and useless if it comes without a proper understanding of art's function in that role. Most existing declarations, proclaimed in the name of humanism and freedom of creativity, are so random and DIALECTICALLY UNDEVELOPED that

this optimistic ignorance and determination become a fertile ground for a dogmatic understanding of art ... ONLY IN ITS FUNCTION OF SELF-CRITICISM AND ANALYSIS OF ITS OWN LANGUAGE IS ART CAPABLE OF INITIATING THE QUESTION OF ANALYSIS AND THE CRITIQUE OF SOCIAL PRACTICE, AND ASKING FOR ITS CHANGE. (8)

This insistence on the linguistic properties of art points simultaneously in two directions. First, the political relevance of art comes from its nature as a signifying practice, and only as such it can engage with other social practices. Second, precisely because of that, revolutionary politics is inseparable from the revolutionarization of artistic language. In that sense, Denegri is completely justified in his assertion, which he stated on multiple occasions, that concrete and visual poetry was a "catalyzer" for the emergence of new art practices in Yugoslavia.[27] However, as it turned out, it was formative not only for the development of new art practices but also for new critical practices that played a major role in the dethroning of humanist Marxist philosophy as the indisputable alternative to the ideologized Marxism of the Yugoslav establishment.

While being an important platform for the exchange of ideas with reformist Marxists from both East and West, through its editorial and curatorial decisions in *Praxis* and the Korčula Summer School, Yugoslav humanist Marxists also filtered out some prominent new ideas that started emerging in the 1950s and 1960s. For example, while tolerating Sartre and keeping closely in touch with French Marxists such as Lucien Goldmann, Henri Lefebvre, and Kostas Axelos, they ignored or actively excluded much of the French Marxist theory of the period. In his reminiscences on the first years of *Praxis*, Kangrga relates an anecdote about a fifty-page article the journal editors received in 1965 from an unknown French Marxist philosopher. "I wrote a devastating review and concluded my evaluation of the article by stating that it is below the level of *Praxis* publications because it was written from the positivist-Stalinist positions" (2001:19). The name of the author was Louis Althusser, and Kangrga leaves little doubt that the article he submitted was one of his most celebrated works, "Ideology and Ideological State Apparatuses": "Afterward, Althusser published that article in the Parisian procommunist journal *La Pensée*, and—in a development that is not only symptomatic but also characteristic of so-called Western Marxism—it was precisely on the strength of that essay that Althusser became the 'star' and one of the most important and most illustrative representatives of that Stalinist-oriented Marxism in Europe and the world" (19).[28] The stumbling block between humanist Marxists and Althusser was exactly the same as

with the Soviet diamat "philosophers": their theorization of alienation, or the lack thereof. However, while the two coincide in their devaluing of Marx's *Early Writings*, they differ diametrically in everything else. While Soviet diamat Marxists deny or explain away the notion of alienation, in the above-mentioned article Althusser describes it as an effect of ideology, not as its cause or its main feature, as Praxis philosophers saw it. Specifically, Althusser writes that Marx's position in *Early Writings* is "false" because "it seeks and finds a cause for the imaginary transposition and distortion of men's real conditions of existence, in short, for the alienation in the imaginary of the representation of men's conditions of existence." He argues that, following Feuerbach, young Marx sees these conditions as being "dominated by the essence of alienated society" while overlooking that "it is not their real conditions of existence, their real world, that 'men' 'represent themselves' in ideology, but above all it is their relation to these conditions of existence which is represented to them there" ([1970] 1971:154). This repositioning of alienation demands a more rigorous interrogation of the question of the subject, a challenge that Yugoslav humanist Marxists were unprepared and unwilling to take up.

From its beginnings in the 1950s, Yugoslav Praxis philosophy has been at odds with the philosophical and ideological establishment in Yugoslavia. At the same time, precisely because of this more or less open opposition to dogmatic Marxism, it has built a reputation both at home and abroad as a progressive and creative branch of Marxist thought. Humanist and dogmatic Marxism in Yugoslavia formed an uneasy partnership in which they validated one another: the first by opposing officialdom, and the second by tolerating this kind of opposition. An unofficial historian and former member of the Praxis school, Božidar Jakšić, points out that even in its heyday, the Praxis group went through periods of crisis marked by political "campaigns" against its members. In 1966, Edvard Kardelj published a book, *Notes on Our Social Critique* (*Beleške o našoj društvenoj kritici*), in which he objected to "contemporary Yugoslav intelligentsia" for its "abstract humanism" and its "confusion of Marxism with metaphysical subjectivism," alleging that "as a class it is more inclined to conservatism than to progress" (in Jakšić 1989:256). With the turn in Yugoslav post-1968 politics, the Praxis group gradually lost its support, until the funding both for the journal and for the summer school ceased in 1974. While scholars from Zagreb University associated with the Praxis school kept their posts, their colleagues in Belgrade were forced out of work through an unprecedented legal action by the Parliament of Serbia. This was accompanied by attempts to discredit Praxis philosophers that came from scholars close to the politi-

cal establishment, such as Živojin Denić, who in his book *Marx and the Yu-goslav "Holy Family"* (*Marks i jugoslovenska "Sveta porodica"*) attacks Praxis philosophers' writings on alienation from a Stalinist position (which by then even diehard diamat philosophers had given up) that it was Marx's minor interest in his early writings, and abandoned in his mature works. These kinds of ideologically inspired and anachronistic critiques could not inflict any philosophical damage to Praxis philosophy in Yugoslavia. What they inadvertently accomplished was to conceal the critique of this philoso-phy that emerged in the aftermath of the social movements of the late 1960s. The true outcome of 1968 in Yugoslav philosophy was not the inten-sification of the conflict between dogmatic and humanist Marxism, but pre-cisely their ideological proximity, which is best exemplified in their shared neglect of the theory of the subject, which resulted in a largely mechanical and predictive critique of alienation. As Yugoslav humanist Marxist's cri-tique of ideology was limited by the idea of the subject to which the politi-cal establishment also subscribed, all they could do is point to the internal inconsistencies of state ideology, leaving its deep conservatism well be-yond the reach of their critique.

Zagorka Pešić-Golubović's short article "What Is the Meaning of Alien-ation?," published in the international edition of *Praxis* in 1966, conveniently encapsulates the basic idea of alienation that permeates the vast literature on this subject that the Praxis group produced in the 1970s and 1980s. In line with the Praxis group tradition of keeping a check on the main terms of their theoretical endeavor, Pešić-Golubović wrote this text in response to the pa-per "Alienation Revisited" that young American philosopher John Lachs presented in the 1965 session of the Korčula Summer School (subsequently published in international *Praxis* in 1966), in which he offered a rough sketch of Marxist and psychiatric uses of this term. Pešić-Golubović reprimanded her young colleague, warning him that as a philosophical and sociological category, alienation should not be confused with its uses in medical pathol-ogy. Here, as in most other theorizations of alienation by Praxis group members, the idea of the subject is circumvented by invocation of the hazy concept of "human nature." Pešić-Golubović explains that Marx's "concept of human nature" "contains at the same time both the general presupposi-tions of the human race (as the potentialities of single individuals) and the historically determined limits for the realization of these potentialities" (1966:358). In a somewhat mechanistic way, she concludes that "the philo-sophical meaning of alienation is that it expresses the conflict between man's historically originated (but still enduring) anthropological structures and the concrete historical social conditions in which he lives" (359). Here,

the "human race" and "anthropology" are blanket terms that camouflage the gap that the neglect of the theory of the subject opens up in the very center of this critique of alienation. They unmistakably point to basic operations that, as Julia Kristeva argued in "The Subject in Process," support the idea of a unitary subject in traditional Marxism. The first operation is "the anthropomorphization or rather the subjectal unification of the Hegelian dialectic in the form of human unity, the man of desire, the man of lack," which "turns into the notion of the proletariat as the way towards total mastery and the absence of human conflict," and the second is close to what Pešić-Golubović identifies as the idea of "historicity,"

> the direct and exclusive anchoring of man in the state or more generally in the social machine and in social relations which are regulated by need and suffering among men. In the machine of social conflicts and contradictions, of production and class, man remains an untouchable unity, in conflict with others but never with "himself," and in this sense, man remains neutral, an oppressed or oppressive subject, exploiter or exploited, but never a subject in process corresponding to the objective process which was brought to light by dialectical materialism, in nature and society. (Kristeva [1973] 1998:136)

One important legacy of 1968 in Yugoslavia was the diversification of Marxist theory. While often (mis)understood as an affirmation and continuation of Praxis philosophy, 1968 was an opening for the forms of critical thinking previously absent from Yugoslav Marxism. One important channel that introduced French structuralist Marxism to Yugoslavia was the journal *Ideje*, which in its first year of publication already featured Althusser's "Lenin and Philosophy."[29] This scholarly periodical, self-described as a "Yugoslav student journal," was the first outside Slovenia to open its pages to a young philosopher and a staunch supporter of structuralism, Slavoj Žižek. While later he became one of the most prominent advocates of Lacanian psychoanalysis, at the outset of his career, in the early 1970s, Žižek gave the highest praise to the authors gathered in the journal *Tel Quel*, in whose texts, as he wrote, "all the talk about signifying practice, about writing/reading that produces sense while having no inherent sense and no desire to 'express' it, aims at estrangement of the ideological presumption of language as a means of communication, of expression, carrier of meaning, sign that tells us something, etc., and to demonstrate the genesis of this presumptiveness in the economy of the Symbolic order. This is the step that is perhaps even more difficult than Marx's" (1974:520). Kriste-

va's reframing of Lacan's theory of the subject was instrumental for young Žižek's theorization of signifying practice.

In his first *Ideje* article "Enjoyment-Labor-Speech"—published in 1972, the same year as his first book, *The Pain of Difference* (*Bolećina razlike*)—Žižek was already arguing for a recasting and expanding of the very notion of practice in Marxist philosophy.[30] Taking as his starting point the notion of speech in Husserlian and, especially, Heideggerian phenomenology, Žižek argues that the concept of labor, and therefore practice, operative in critical theory is "naive" in its exclusion of speech (1972:38). He explains the absence of a discussion of speech in Marx's early writings (that most cherished intellectual source of Praxis philosophy) by the German philosopher's assumption of language as inherent to human practice: "Since 'animal also produces,' that is still not man's specificity; production becomes universal only with a relation, that is to say, speech" (33). Žižek expands on this idea his article "Marxism/Structuralism: An Attempt at Demarcation," which was featured in the important anthology *Marxism—Structuralism: History, Structure*, published two years later by the journal *Delo*. Here he draws more directly on authors close to *Tel Quel*, primarily Roland Barthes and Julia Kristeva, to argue for the vitality of textual production for the reinvigoration of Marxist theory. According to Žižek, the capacity of speech to generate an unproductive "excess of meaning" that remains beyond the reach of capitalist economization of life becomes especially assertive in poetry. In this

> new understanding of "poetry," which is not seen as a "departure" from "ordinary" language, or as an "all-encompassing" code that includes both "common" and all other languages, or as an hypo-code of a general language, but as a "potential infinity of codes—the languages of poetry are literally *all languages* (in *plural*, not a universal Language!)—it is an irreducible multitude of codes that are incessantly transforming each other, the speech that in its own process of enunciation always changes its own code: "poetry" is the only speech from which productivity was not repressed. To attain the place of the "proletariat" repressed by the Symbolic order means attaining the place of the inherent productivity of the signifying practice that is manifested in "poetry" (we put this word in parentheses because it is not a "separate region" but a "primary destructivity" of language itself). (1974:522)

Žižek's work of the early 1970s was decisively informed by the broad understanding of language he acquired through his engagement with new

artistic practices such as experimental poetry and performance, evident in his early publications, which came on the cusp of the momentous events of 1968. Early in 1967 he published two articles on the work of the Slovene experimental poet Aleš Kermauner in the culture section of the student weekly *Tribuna*.[31] Like Kermauner, Žižek was affiliated with the Slovene experimental art group OHO. The group's name is a portmanteau word comprising Slovene words *oko* (eye) and *uho* (ear). As the group members put it in their publications from that period: OKO + UHO = OHO (Šuvaković 2010:29). This wordplay in the group's name already speaks of its members' interest in experimentation at the intersection between poetry and visual arts. The group was founded in the early 1960s by Marko Pogačnik and Iztok Geister, who were in 1966 joined by an American, David Nez. By the late 1960s the OHO group evolved into OHO Katalog, a broad and loosely organized group of young poets, artists, and theoreticians. Žižek was said to have belonged to the outer circles of the group. During the period between 1967 and 1971, the core OHO members Milenko Matanović, Marko Pogačnik, Andraž Šalamun, Tomaž Šalamun, and David Nez produced a number of installations, visual artworks, and performances in Ljubljana, Zagreb, Novi Sad, and Belgrade.[32] At the very outset of this period, in November 1967, Žižek published in *Tribuna* a short, two-part article entitled "Hoopoe" ("Smrdokavra"). The structure of the article, if not its content, points to the two-sided nature of culture in Yugoslavia. The heading of the first section, "Introduction," is followed by a parenthetical explanation "Theory of Reflection," a direct reference to Plekhanov's principle at the heart of the post–World War II aesthetic doctrine of socialist realism in Soviet Union. However, that this could be read also as a reference to contemporary performance and its intense focus on the subject (theory of reflection as theory of mirroring) is suggested by the heading of the second section, "Theory of Happenings (Based on A. Kaprow)." Both sections consist of text so densely packed with wordplay and neologisms that it becomes hermetic and nearly impenetrable to the reader. This is the English approximation of the second part, "Theory of Happenings":

> 3. Approach (of a "pop art exhibition"). The "I" approaches the article. The happening is directed into the exhibited article, which is not there just like that, but in order to be there just like that. The article is arbitrary and determined (i.e., eliminated from the environment) by this arbitrariness. The I's choice is not arbitrary; the "I" is limited precisely by this arbitrariness.
> 2. Entry (of a "pop-art of the street"). The "I" enters the article. The

happening is directed into an arbitrary article, which is there just like that. But the "I" itself is not arbitrary because it enters arbitrariness.

1. We tread in the same ("happening"). The "I" (source) is arbitrary. A happening is happening: delirium. There is snow outside and water inside.

A happening is at the same time an entry and an approach because it is the treading of both. (Žižek 1967b:11)[33]

Here young Žižek investigates the relationship between the self ("I"), the sign ("article"), and the artwork. The countdown (3, 2, 1) indicates a certain reduction, but the reduction of what? Perhaps of the representational nature of the work of art? From "pop-art exhibition" to "pop-art of the street" to "happening," the relationship between the self and the signifying form changes, until in the last instance it turns into a "delirium." "Cartesianische meditations," another experimental text Žižek wrote at this time and published two years later in the OHO Katalog publication *Pericarežeracirep*, further reinforces his view of happenings as an antirepresentational art form.

What does the ob-ject (ob-iacere , to throw before) throw itself before? Before the sub-ject (sub-jacere, to throw under). The ob-ject is posited by the sub-ject and throws itself before it. The sub-ject therefore "recognizes" itself in it. The composition is esse-ntially masturbatory.

What if this what is nothing? In the light of the world the ob-ject throws itself before, it pushes forward into appearance. Space is a free pace of ob-jects pacing in the arbitrariness of sel-ection. Of the DASEIN. Being is in appearance: the ob-ject peers through being. The ob-ject throws itself before being and nothing-s it.

The esse-nce of the world is in nothing-ing being, which is this nothing itself: the light-ing en-lightens the world into an arbitrary entity (ob-ject), which is being. The presence of an arbitrary entity is (pr)essence. An arbitrary entity is sel-ected in a RITUAL. The street ad-vertizes the heard (what is given to the ear) and de-lights the EAR. The street ad-vertizes the seen (what is given to the eye) and de-lights the EYE. Con-stant-ly moving com-positions (roles): clamour, laughter, melody, noise, cry. RITUAL takes place at train stations, on roofs, walls, clothes, fences, cars. (Žižek 1969:n.p.)[34]

Žižek's involvement with experimental writing carries over to some of his early theoretical texts. For example, his essay "Marxism/Structuralism"

starts with a paragraph labeled zero, in which the author announces that his goal is to "designate the place of the theory of writing within the very field of Marxism, in that way identifying the zero degree of structuralism's encounter with Marxism as our very location" (1974:500). Here, perhaps less assertively than in "Hoopoe" and "Cartesianische meditations" but certainly no less engagingly, the prose text becomes an intricate web of references that produce a surplus of meaning: "zero" is the starting numerical of the paragraph, but also the Barthesian "zero degree" of writing; at the same time it designates the author/subject as a Lacanian empty set. . . . Žižek's interest in experimental poetry may have led him to the early work of Julia Kristeva, whose psychoanalytic reading of the literary avant-garde in *Revolution in Poetic Language* looms large in her early writings. While in his other articles from this period, such as "Hermeneutic Circle in Structuralism" ("Hermeneutički krug u strukturalizmu," 1973) and "Exercises in Xenophilia" ("Vježbe iz ksenofilije," 1973) he turns more directly to Lacan, in his book *Sign/Signifier/Writing* (*Znak/Označitelj/Pismo*, 1976) he summons him and other representatives of "French theory" to mount a massive critique of the Frankfurt School brand of Marxism.

Like his early theoretical essays, *Sign/Signifier/Writing* is deeply marked by Žižek's experience with experimental poetry. Here his approach to the nondiscursive "syntax" is not limited, as in Lacan, to algorithms and diagrams, but pertains to complex arrangements of bodies, actions, objects, images, and discursive signs that in his experimental prose he designated as "happenings" and "rituals." This notion of the "text" asks for a certain strategy of reading that Žižek names the "rebus procedure." He points to Sigmund Freud's work on dreams as its source: "In rebus, we should replace each element *separately* by a different syllable . . . ;" therefore, "it is important not to miss the meaning of Freud's directions: the passage from interpretation 'en masse' to interpretation 'en detail' is in fact the passage from imaginary field of the *signified*, that is 'the connectedness of ideas' or 'things,' to the *signified*, the autonomous connectedness of its elements" (Žižek 1976:26). The unconscious does not discriminate between words and images, images and things, shapes and spaces, and if it is structured like language, it is so only in the basic structure of the sign, and not in the sequencing of signs into linear narratives.[35] This open recognition of Freudian reading protocols leaves obscured and unacknowledged other, less theoretical and more poetic and performative sources of Žižek's "rebus procedure." It is not difficult to recognize theses from "Theory of Happenings" in his elaboration of nonarbitrariness of the sign as one of the basic premises of this procedure. "The only solution to the dispute around arbi-

trariness or nonarbitrariness of the sign is the incursion of the very dimension of the sign into the field of signifying differentiation" (30). The rebus procedure excludes arbitrariness precisely because the signifier is the sensory aspect of the sign: sensory because it is perceptible, but also because this perception involves not only vision, but also other bodily senses.

One important line of argumentation in *Sign/Signifier/Writing* is that the exclusion of the "rebus procedure" leads to a misunderstanding of the very process of subject formation. The passage from the conjoined relation with the mother into an imagined unity (the Imaginary) in which the infant fills the mother's lack (phalos), with respect to their separation involves the integration of this lack into the functioning subject. "The Third, which the infant and the mother unsuccessfully seek in each other, turns out to be the object *a*, *lack*-in-another, the lack which is opened up by the Symbolic" (113). Žižek emphasizes that the importance of a Lacanian understanding of subject formation is not in establishing its genesis according to which the Oedipal structure, the structure marked by lack and castration, follows—in a temporal and successive fashion—the "anal" pre-Oedipal phase. In *Sign/Signifier/Writing*, he argues that Lacan shows how loss and repression (the integration of lack) retroactively inform that which preceded them. This "pre-repression," marked by *a*, is the fact of subject formation. "What remains is the *abyss* of this fact, and any search for its cause is in vain"; and further: "Because of its groundlessness, it is impossible to establish/mediate socially the 'fact' of pre-repression (for example, as 'internalization of social repression')" (113). Žižek takes this understanding of the subject as the starting point for his critique of the theory of alienation, championed by the Frankfurt School.

We will recall that Marcuse's theorization of alienation is based on the posteriority of repression. The assertion that a "non-repressive civilization is impossible" inherently places the subject in opposition to repression and opens the possibility of a nonrepressed subject (Marcuse 1955:17). In modern society, it is precisely work that becomes the instrument of this repression: "labor time, which is the largest part of the individual's life time, is painful time, for alienated labor is absence of gratification, negation of the pleasure principle. Libido is diverted for socially useful performances" (45). Instead of being part of the larger labor of signification, performance is instead, in Marcuse's schema, narrowed down to enforced labor as a means of choice for the repressive civilization. Emphasizing its primacy, Marcuse gives it the name of "surplus-repression," which he describes in terms of a reality principle specific to modern civilization as a *performance principle,* in order," as he explains, "to emphasize that under its rule society

is stratified according to the competitive economic performances of its members" (44). The performance principle as a form of alienation is, then, inherently opposed to the pleasure principle. What Žižek objects to in this "vulgar reading of Freud" is Marcuse's neglect of the "pre-repression," that is, the participation of repression in the very structure of pleasure. "In other words, culture's *no*, the instantiation of the (Name of) the Father, is not the result of the transformation of the organism 'from the subject-object of pleasure to the subject-object of labor,' that is to say, the appearance of the subject to whom is opposed an 'adversarial and scarce environment.'" Žižek asserts that before "repression," enforced by the rule of reality principle, comes a "pre-repression at the very subject-object of pleasure" (Žižek 1976:155). To a certain degree, alienation is constitutive of the subject, and not only enforced from without. The production of social alienation is not an imposition of something "foreign" onto a "human nature" but an appropriation of an alienating potential that is dormant in the subject. Or, as Žižek puts it elsewhere in the book, "In its very core desire itself is 'culture,' symbolic production, 'desire of the Other' and not a sublimation of a natural substrate" (294). Ultimately, his charge against critical theory is its failure to observe the distinction between the irrationality of the "managed world" and the irrationality (contradiction) of the desire.

If one constant in Žižek's early writing is his claim for the necessity of structuralist theory for the recovery of Marxist theory from the "breakdown" it suffered precisely at the moment of its "Renaissance" in the first decades of the twentieth century, the other is his argument against critical theory as a brand of Marxism that emerged precisely from this defeat (298). In his article "Enjoyment-Labor-Speech" he asserts that "the provision of 'praxis philosophy' is the *society*," which it understands as a "totality of social praxis" based on labor "in its universality as a social work," from which this philosophy excludes "speech" or, in other words, signifying practice (1972:39). Along the way, Žižek made a number of hints to the Yugoslav Praxis school to indicate, without ever naming it specifically, that it is not exempt from his critique of critical theory. So in "Marxism/Structuralism" he, almost in passing, points to structuralism's encounter with critical theory's "ideological premise of speech as a means of communication" as a "demystification of that which bourgeoisie pompously calls creativity" (1974:520). And in *Sign/Signifier/Writing* he points to the very basis of Yugoslav humanist Marxists' critique of Soviet doctrine in philosophy: "A gap opens up in otherwise justified critique of diamat's ontologism/objectivism from the position of 'praxis philosophy' because this critique *too hastily finishes with the problem of nature* by designating it a 'social category' i.e. by

looking at it in its social mediation and its inclusion into totality of the social subject" (306). In short, Yugoslav Praxis philosophy was not spared Žižek's objection to the critical theory in general, that the "gap" and the "abyss" at its center marked the absence of the critique of the subject.

The introduction of psychoanalysis, or more precisely its structuralist variant, into Marxist theory reveals the limits of the theoretical reach of *"praxis philosophy in all of its variants"* (Žižek 1976:305; emphasis added). Its limit is the limit of the enlightenment project:

> The dialectic of the Enlightenment demonstrates that the basic position of Marxism as "philosophy of praxis" is not sufficient for theoretical explanation of "administered world" and for its practical challenge, that is, for the unique reflective/practical "engagement" with this historical reality because the very foundation from which it contests the alienation of the existing [society] still contains an unreflected Enlightenment position of mastery that has that very "administered world" as its historical truth and its realization. (305)

In other words, Žižek reproaches Praxis philosophy for its commitment to preserving the transcendental subject, while trying to mount a critique of the "world" this subject produced. Because of its commitment to the idea of the Enlightenment, critical theory limits praxis to productive (labor) while neglecting signifying practice (text). For critical theory philosophers, charges Žižek, "violating the limit of enlightenment means stepping into madness," so that the horror of that violation has a double significance: "Alongside preserving a rational-critical position it maintains a distance toward the 'masses' that threaten to 'speak'" (323). Following Kristeva, Žižek contends that precisely through this schizoid and poetic speech, signifying practice joins productive practice to establish properly Marxist categories of praxis and of the proletariat.[36] Here he touches on the category of the interest that was, as we have seen, fundamental to the ideology of associated labor that was reaching its completion in Yugoslavia at the very moment of this writing: "The very *historical interest of the proletariat* from which the classical Marxism speaks and on which it counts is marked by the traces of mastery and repression of the nameless desire of the masses. The 'masses' truly begin to 'speak' only through radicalization of the position of the proletariat of production into the position of the proletariat of signifying practice" (324). What is at stake here is not only the expansion and revision of the idea of revolutionary subject that was lost with the wreckage of Marxism that came in the moment of its renaissance, but the

revision of the idea of practice as being both revolutionary and signifying, or, more precisely, of being revolutionary precisely because it signifies. Criticizing Marcuse's reductive reading of Marx's parable about the "kingdom of necessity" and "kingdom of freedom" in which he assigns politics and seriousness to the former and art and play to the latter, Žižek proposes that "the double abolition of the kingdom of necessity should be reinterpreted as abolition of *alienated* labor and abolition of *labor itself*" (328). He backpedals almost instantly by adding that this is not to say that "we should 'stop producing,' but that *we enter into the process of production as new subjects*" (329). However, this makes things even worse. In the light of the developments that ensued only a few years after their publication, these words lose their meaning of a call for new emancipatory politics and become a dark premonition of the *aphanisis* of the subject.

We are entering the final round. It's a spiral: in the beginning, everything seems light, ironic, and playful. By the time we get out of the final bed in its path, at the end of the next section, it will become clear that the "production of the new subject" amounts to its eradication. That awareness informs the radical artistic practice of the Socialist Federative Republic of Yugoslavia's final decade.

THE STRANGE

When I first walked into the SKC in Belgrade, a wide-eyed teenager in the early eighties, I stumbled into Happy New Gallery on the ground floor. I don't recall which show was on display at that time, but I remember a postcard on sale that immediately caught my attention. It featured a color photograph of the SKC facade facing Marshal Tito Street (Ulica Maršala Tita) with a long banner suspended underneath the row of windows with a large handwritten slogan that read "THIS IS NOT MY WORLD" ("OVO NIJE MOJ SVIJET"). This was the work of Croatian artist Željko Jerman, who made and displayed the banner in the spring of 1976, during the sixth April Meeting. It was one of several actions that Jerman performed together with five other young artists from Zagreb who collectively participated in that year's April Meeting: Boris Demur, brothers Sven and Mladen Stilinović, Vlado Martek, and Fedor Vučemilović. They were members of a loosely organized group of artists who started working together in the early 1970s. From the very beginning they set themselves apart from the first generation of conceptual artists in Zagreb and beyond through their approach to the artistic media, the way they produced and exhibited their work, and

their engagement with the politics of the day. Jerman, Demur, the Stilinović brothers, Martek, and Vučemilović started exhibiting collectively as a group of friends in 1975, without having a manifesto or a program that would frame their activities. They participated in a landmark survey exhibit, *New Art Practice*, and as the exhibit curator Marijan Susovski testified later, Nena Baljković's article about the group had no title because the group itself was nameless. Before the catalog went into print, the curator and the author of the text decided on a descriptive title that stuck as the group's name: The Group of Six Authors (Grupa šestorice autora) (Susovski 1998:12).

Performed less than a year after *Oktobar '75*, the Group of Six Authors' actions in the 1976 April Meeting speak tellingly about the differences between them and the generation of conceptual artists that immediately preceded them. Demur performed the action *Fact* (*Činjenica*), in which he wrote the word "fact" on the pavement next to the SKC, on a panel placed in front of the building, and in the gallery. On April 5, Jerman wore a shirt that said, "This is my youth," which he then hung in the gallery. *Raw Art* (*Sirova umjetnost*), another action he performed on this occasion, is even more characteristic of the Group of Six Authors: "Make a mixture for noodles. Water is boiling in the heat-resistant glass. I show the audience a small piece of the mixture on a spoon, then throw it into the boiling water. It changes its shape, swells, becomes a noodle, and I pronounce these changes to be an aesthetic value. Cooked noodles are offered to spectators to eat. However, the water does not boil. I said: there is no art, the water won't boil, you can eat raw art" (Šimičić 1998:250).[37] Mladen Stilinović took fifty pictures of a clock showing different times in succession and placed them on the floor inside the SKC, spaced so that walking from one photograph to another at normal pace takes exactly the same time as shown in the pictures; a spectator/walker who stops to observe the work automatically falls behind. Martek performed an action of public writing by inscribing a slogan on a poster, "The Situation of Expanded Art Expands." Sven Stilinović performed an action with toilet paper, and Vučemilović offered his camera to passers-by in front of the SKC to take pictures of him, and then exhibited them in the gallery window. Disregard for boundaries between artistic genres (use of writing as a painterly procedure, of photography as a public action, etc.); a comparable indifference for gallery conventions (exhibition-action, or art exhibit without previously prepared artworks); use of nonartistic and perishable materials (dough, toilet paper, chalk, markers); a tendency to display the works not only outside of the protective gallery walls, but in lowly places and situations that make the work even more perish-

able (pavements, walls, windows, floors); randomization and deskilling of the artistic techniques, either through deployment of aleatory procedures or the exposure of the process of art making; direct address of the audience either through the artist's presence or through messages written on various materials: all of this speaks about an intentional degradation of the work of art, its radical integration into the fabric of the everyday, and, ultimately, depriving artists of any exclusive position that the society assigns to them. The work of the Group of Six Authors is poor, but without any pretense of profundity and pathos; it is as communicable and everyday as any street advertisement, and just as difficult to accept as a work of art. In short, it fully embraces the condition of nonart.

And here, the "non" is more important than "art." Consider, again, Jerman's "THIS IS NOT MY WORLD." The postcard hides as much as it reveals: for example, it doesn't show the material from which the banner was made and with which the slogan is written; also, it remains silent about the process of its making and the way it was presented to the audience. At the same time, all of these elements are as significant as the phenomenal aspects of the work that the postcard captures. Trained as a commercial photographer, Jerman started working on art photography but soon turned to crude photographic procedures. Giving up a camera altogether, he turned to "elementary photography" and worked directly on photographic paper. For example, in the Group of Six Authors' first public exhibit-action, which they performed on May 11, 1975, on the bank of the river Sava in Zagreb, Jerman spent an hour lying on a large sheet of undeveloped photo paper, thus making an imprint of his body on the paper produced by the sunlight. The following year in the April Meeting, he again used large sheets of photographic paper that he laid down on the sidewalk next to the SKC, and then wrote the slogan "THIS IS NOT MY WORLD" in hypo. As an elementary photograph, the banner could be read as a denial of its photographic nature. Along the same lines, it echoes Magritte's famous painting *Treason of Images*, which shows a pipe with the inscription underneath that reads "This is not a pipe" (*Ceci n'est pas une pipe*). In Jerman's case, this denial pertains not only to the treacherous image, but to the work as such: since it was hung underneath the windows of SKC Gallery, it could refer to the "world" of galleries, museums, and institutional art in general. Taking an artwork out of an institutional setting exposes it to a number of contingencies, which in this case played out very effectively. According to some witnesses' accounts, the banner stayed on the facade for a very short period of time because "it had to be taken down at the insistence of some people form the management of the SKC" (Šimičić 1998:250). The political career

of Jerman's piece went through another sharp turn after the SKC published it as a postcard. In this way, as a permanent object aimed at circulation, it could address more viewers than in its original condition. At the same time, through this very circulation it joined a different medium, that of kitschy tourist souvenirs that reference a particular location ("Greetings from . . ."). By rejecting its own location, this image becomes an antipostcard of sorts. We could go on enumerating possible meanings contained in Jerman's polyvalent piece, but what emerges as paramount is its gesture of renunciation.

This gesture that ranges from the work of art, to society, to, at its extreme, self-renunciation of the artist, belongs to that form of *"affirmative negativity"* and *"productive dissolution"* which Kristeva identified as expulsion (*la rejet*). Drawing from Georges Bataille's notion of expenditure and from Freud's work on psychic negation, Kristeva explains that "what we call *expulsion* is nothing other than the logical mode of this permanent aggressivity, and the possibility of its being positioned, and thus renewed. Though destructive, a 'death drive,' expulsion is also the mechanism of relaunching, of tension, of life; tending towards a state of equilibrium, inertia, and death, expulsion perpetuates tension and therefore life" ([1973] 1998:144). The Group of Six Authors' associations of art with that which is unproductive and useless include the way they present their art (on streets and city squares, sea beaches and riverbanks, where it gets "spent" and literally washed away), the media in which they produce it (ordinary plastic bags, newspapers, and other everyday objects that easily get categorized as trash), and the figure of the artist as an outsider who is not integrated in any way in the (still functioning) institutions of the political economy of socialist aestheticism. However, their gesture of rejection goes beyond this obvious connotation of waste to engage in linguistic procedures that, as Kristeva has it, show expulsion as a "path from object to sign" (145). On the one hand, the use of everyday consumer products as art material points to expulsion as a way of reconstituting "real objects" and "the creation of new objects; in this sense it reinvents the real and re-semiotizes it" (147). On the other hand, the Group of Six Authors' poetic practice points to the other side of this semiotization. Let's first hear Kristeva:

> If expulsion includes the moment of "excorporation," or "expectoration" (in Artaud's words), or of "excretion" (in Bataille's words), this motor discharge or corporeal spasm invest themselves [sic] in an already separated *other*, in language. Expulsion reintroduces and deploys within language the very mechanism whereby separation of

words from things is produced, and it has no other way of doing this than opening out, dislocating and readjusting the *vocal* register. ([1973] 1998:147)

This register, as it were, has its own phonetics. Annette Michaelson identifies it with the moment in language acquisition in which "velar sign *k* and its twin *g*" detach "themselves and in opposition to the dental sound *d* and its twin *t*. *Dada* and *kaka* or *caca*, then, are linked in the paradigm of the secondary stage of language formation" (1988:23). Addressing, like Kristeva, the avant-garde of the first decades of the twentieth century, Michelson finds the phoneme *ka* resonating in poetic experiments across Europe, which prompts her to conclude that "grammar and genitality are both subsumed in the delighted insistence on the body as text to be ambivalently read as it is polymorphously enjoyed" (17). An expulsatory tendency is recognizable in Mladen Stilinović's early visual-poetic works, or writingpainting (*pismoslikarstvo*) as he came to call them, such as *Hand of Bread* (1974, 1975), which consists of a simple and nonsensical inscription in Croatian "ru*ka* kruha" on "poor" surfaces such as a plastic bag or a piece of white paper.

This trace of *kak* doesn't mean that those members of the Group of Six Authors who have been involved more extensively in poetic practice, Mladen Stilinović and Vlado Martek in particular, limited their writerly activity to nonsense poetry, or even that this kind of poetic practice occupied a prominent place in their work. Quite the contrary, the same way they resemiotized discarded objects, they engaged in resemiotization of ossified forms of everyday public discourse. This is particularly relevant for Martek's "prepoetry," which is an attempt to find a fundamental condition for poetry in the same way primary painting and elementary photography do for their media, and to expand poetic production beyond writing in the narrow sense of the word. The simplest form of prepoetry consists in establishing a juxtaposition between the object and the word: the word "table" on a table, "book" on a book . . . until a wrong word disrupts the series: "comb" on a table, for example. Martek explains that by "taking things for granted, we actually lose them. My *prepoetry* is actually an injection of life into poetry, its reanimation. In that way, I fulfill my desire to keep killing poetry and resuscitate it at the same time" (Martek [1996] 2011:154). This *practice of poetry* carries over to Martek's "placard poetry" and "action poetry": for example, he made posters with the inscriptions "Read Mayakovski's Poems" and "Read Miljković's Poems" and pasted them in public places reserved for political placards;[38] also, in art exhibition openings he

distributed cookies with the inscription "Lie to the state" on them and fly-
ers with a message "Artists, take up arms" (Stipančić 1998:102). His self-
published chapbooks from the later 1970s feature similar poems-slogans:
"Death to the state—freedom to art," "Down with the exploiters of anar-
chy," "State, I shall disfigure you with art," and "I am in love with the state,
long live adultery" (102). "Death to the state—freedom to art" pointedly
echoes the most frequently used political slogan in post–World War II Yu-
goslavia, "Death to fascism—freedom to the people" ("Smrt fašizmu—
sloboda narodu"). This is not only an ironic variation—or a derivative—of
a well-known slogan, but estrangement of an important political idea
stripped of its value through ideological instrumentalization.

Similarly, in his installations and writingpaintings, Mladen Stilinović
collected and exhibited fragments of political discourse emptied of mean-
ing (if they had any to begin with) through repetitive usage. In his 1981
installation *Submit for Public Debate* (*Staviti na javnu raspravu*), he arranged
five rows of chairs in a way similar to how they were set up in worker coun-
cil meetings. Instead of a customary dais, the chairs were facing a wall on
which he hung cardboard posters with inscriptions containing phrases
such as "concrete measures," "important factors," and "common interests"
(Stilinović [2005] 2011:169). This revaluation of political discourse as artistic
material was also prominent in Stilinović's solo show *Sing!* (*Pjevaj!*), held in
Zagreb's Modern Art Gallery in the fall of 1980. It consisted of a series of
"reflections": on work, color, language and society, and money. Reflections
on work demonstrate the paradoxical position of work in Yugoslav ideol-
ogy of associated labor. Stilinović's handwritten notes exhibited in this
show are riddles addressing the position of work and workers in Yugoslav
society. "I work for two" ("Radim za dvojicu") is a phrase used commonly
to describe an exceptional effort but also the ratio between productive
workers and bureaucrats in Yugoslavia, while here, additionally, it may
refer to an artist's work, which always addresses both the artist and the
spectator. "Work cannot not exist" ("Rad ne može ne postojati") points to
work as a negation in both phenomenology and Marxist philosophy. The
reference to phenomenology is underlined in a variation of this work, in
which this slogan is crossed out in the similar way in which Derrida, fol-
lowing Heidegger, puts the word "being" "under erasure." And if the de-
constructionist strategy of placing a concept "under erasure" still leaves its
linguistic representation visible, in his writingpaintings Stilinović often
juxtaposes the absence (erasure) of the concept and its linguistic designa-
tion. Probably the best example of this approach is his piece *Work Plan* (*Plan
rada*, 1974): it is a piece of paper with the phrase "Work Plan" at the head,

Fig. 27. Mladen Stilinović: *Artist at Work*, 1978. Photograph courtesy of the artist.

followed by a column of numbers one through five with no items next to them. The photographs comprising the installation *Artist at Work*, which show Stilinović asleep, seem to wrap up the artist's reflections on work's necessary absence.

This engagement with artistic process as labor that decrees the position of the artist not as exceptional, but instead as deeply integrated into social fabric, was not limited to Stilinović and the Group of Six Authors. Stilinović dedicated the artist book version of *Artist at Work*—a set of photographs bound together with a thread into a crude booklet—to Neša Paripović, the member of the conceptual art circle at the Belgrade SKC who was known for his reluctance to produce artworks, which was often associated with "laziness." More to the point, Goran Đorđević tried to organize an international artists' strike. In 1979, he sent an invitation to a large group of artists in several different countries to boycott art institutions. The short circular letter read, in part: "As a protest against the art system's unbroken repression of the artist and alienation from the results of his practice, it would be very important to demonstrate the possibility of coordinating activities independent from art institutions, and organize an international strike of artists. This strike should represent a boycott of the art system in a period of . . . months" (1980a:43). The invitation leaves the exact dates and dura-

tion to be determined later and asks recipients to spread the word. Some forty artists responded, most of them expressing their reservations about the possibility of organizing such a complex international action. Even though the boycott didn't happen, a number of artists and critics responded to Đorđević, including Sol LeWitt, Daniel Buren, Vito Acconci, Stefan Morawski, and Carolee Schneemann. All of this points to the other, more politically overt meaning of the idea of refusal, which was articulated with particular urgency by the Italian workerist movement.

As Italian theorist from the "Autonomia" group Franco "Bifo" Berardi points out, there were three distinct tendencies in interpretations of alienation in the 1960s, the first being "humanistic," which emphasized the continuity of Marx's thought with the Hegel of *The Phenomenology of Spirit*, where the "missing link" was Marx's *Early Writings*; the second tendency Berardi identifies as "structuralist," noting that it called for a rereading of *Capital*, while emphasizing Marx's "epistemological rupture" with Hegel; while the third tendency, which underscored the importance of *Grundrisse* "while maintaining conceptual links with phenomenology," he associated with theorists on the radical left in Italy, such as Mario Tronti, Raniero Panzieri, and Toni Negri, who published in magazines *Classe operaia* (*Working Class*) and *Potere operaio* (*Working Power*) (Berardi 2009:35).[39] Berardi observes that "workerist" theoreticians replaced the word "alienation" with "estrangement" in their arguments in which they claimed that the position of workers in rapidly industrializing Italy of the 1960s was that of "estrangement, situating itself outside the logic and general interest of capitalistic society." To the point, "The concept of estrangement implies an intentionality that is determined by an estranged behavior" (46). Estranged from what, and how? The answer that the influential "workerist" theorist Mario Tronti offered in his pamphlet "Struggle against Labor!" is painfully straightforward: separation from capitalism through refusal of labor. Going against the grain of leftist critiques of capitalism dominant in the 1960s, such as that of Henri Lefebvre or the Situationist International, Tronti argued that "it is true that *Trennung*, separation, division is the normal relation in [capitalist] society."

> Yet it is also true that keeping together what is divided is the real power of capital; it has run its course, and it will continue to follow what is left of its future. Keeping the working class inside itself and against itself, and on its basis impose on society the laws of its very development—this is the life of capital, and for this reason there is no life other than this. ([1966] 2012:36)

The only course that industrial workers can take against this monolithic totality of capital is the abolition of labor itself. In a vertiginous turn, Tronti suggests that the working class can destroy the work of capital by fighting itself, that is, its own subjugation to the economism of labor. The direction of emancipation is not toward the outside, but inward; not a leap into disalienation, but burrowing into it. He asks for *"the organization of alienation,"* which is "one of those miracles of organization that are possible only from a worker's point of view" (Tronti in Matarrese 2012:10). The meaning of estrangement is this radical separation from capitalist society through an abolition of labor.

In their work, the members of the Group of Six Authors bring together two meanings of alienation: the Brechtian V-effekt (*Verfremdungseffekt*), as an artistic strategy of making unfamiliar that which is familiar, and Marx's estrangement (*Entfremdung*), which, as Berardi put it, "refers to the confrontation between the consciousness and the scene of exteriority, and to the creation of an autonomous consciousness based on the refusal of its own dependence on work" (Berardi 2009:23). This confluence of the artistic and the political, in which art *refuses* to become the means of politics and instead takes politics as its medium, is perhaps best exemplified in Stilinović's *On Work* (*O radu*, 1980–84). It consists of nine cardboard panels covered with red paper. On each of them is pasted a newspaper photograph taken in high-level Party meetings. Juxtaposed with the photographs are phrases cut from newspaper titles, such as "Affirmation of Work and Self-Management" ("Afirmacija rada i samoupravljanja"), "Stakhanovite work" ("Udarnički rad"), "Validating through Work Only" ("Dokazivanje samo radom"). This use of politicalese is often seen as ironic, especially since it came at the point of a pronounced economic crisis in Yugoslavia during the early 1980s. However, there is more to it than plain irony and political satire. The meaning of refusal on the part of the most radical art in Yugoslavia of that time was in resistance against the social *aphanisis* or "annihilation" and "fading" of the subject. Both psychoanalytically and politically, refusal is inseparable from the assertion of the subject. Kristeva leaves no doubt that "the concept of expulsion should apply to the *practice of the subject*, in this case a signifying practice which supposes an 'experience of limits' on the part of the subject" ([1973] 1998: 139). Berardi is no less adamant in his assertion that the workerists saw the proletariat "no longer as a passive object of alienation, but instead as the active subject of a refusal capable of building a community starting out from its estrangement from the interests of capitalistic society" (23). This double movement of expulsion/refusal is hinged on an active rejection of the notion of alienation as the loss of some uniquely human "nature."

In Yugoslav context, this movement was caught in the scissors of the official Marxism and its critics, both of which subscribed precisely to this idea of alienation. While in his early publications Žižek offered a rigorous critique of "praxis philosophy in all of its variants," he was not interested in providing a consistent alternative to its theory of alienation. While some workerist ideas found their way to Italy's eastern neighbor—not surprisingly, through articles published in *Ideje*—the dynamics of work and capital in Yugoslavia were radically different than in the society from which these ideas originated.[40] At the same time, various post-Praxis critiques of alienation never cohered into a unified theory, even if they were published in the same journal. One such isolated engagement with the subject of alienation was Vladimir Gligorov's essay "On the Strange" ("O stranom").[41] Even though published on the pages of the same journal that published reports from Italy and Žižek's early essays, neither one of them explicitly engaged with one another. Gligorov takes his reflections on ideas of the strange and estrangement away from the well-trod path of Marxist humanist theory of alienation and engages in considerations of strangeness, distance, and subjectivity instead. He begins by asserting that "the strange is tied with the ambition of subjectivity" and that "the strange here stands only as the negative that is always appearing when there is an ambition to prove and establish subjectivity," and concludes with an assertion that the society based on interest is a lethal threat to the subject: "The society is no longer comprised of mutually connected subjects on the path of realization of a certain goal, but the set of norms, institutions, roles, etc. within which the man finds his place, pushes forward, and finds his way about. Therefore, the society itself becomes the new space of strangeness" (Gligorov 1974:134). This space of strangeness forecloses any collective action: "The subject emerges simultaneously with the strange. This dividedness makes possible an awareness of the strange and the relationship between the subject and the strange in general. This very formation of both the strange and the subject has its source in violence." In the final analysis, Gligorov hypothesizes that "it is possible to strive toward subjectivity of an individual limited only by his aloneness" (134). This indicates a turn from class to individual interests and from collectivity to the atomization of a society that marked post-1968 politics and culture in Yugoslavia. As we have seen, this shift is also recognizable in the theoretical transformation of the status of alienation. What was the broader meaning of this turn from "human nature" to the theory of the subject? How did it relate to massive social processes in the final ideological mutation of Yugoslav self-management and in political economy of associated labor?

MONEY AS THE MEDIUM

In a section from *One-Way Street* entitled "A Tour through the German In-flation," Walter Benjamin observed that "it is impossible to remain in a large German city, where hunger forces the most wretched to live on the banknotes with which passers-by seek to cover an exposure that wounds them" (1996:452). The image, then, of the society engulfed by inflation is that of a cityscape dotted with rips that are patched over with worthless money. All mending is in vain: each cover is just another wound that wid-ens as the banknote that is supposed to hold things together disintegrates. Stilinović's collages from the early 1980s paint a similar picture. With the debt crisis, a whole new area of ephemerality opened up: that of the money devaluated by inflation. The repertoire of "poor media"—elementary pho-tography, prepoetry, primary painting—now expanded to include shoddy currency: money not as a value, but as an object that is eroding in its own-ers' hands without them being able to do anything about it.

A comparison chart published in *Ekonomska Politika* in January 1990 placed Yugoslavia among the countries with highest debt and highest in-flation in the world: the monthly inflation rate in Argentina reached 32% in June 1985, in Bolivia it came up to 66% in August 1985, and in Yugoslavia the monthly inflation rate for December 1989 reached 59%, which trans-lated to an annual inflation rate of 2,733%, commonly used as a threshold figure of hyperinflation.[42] Historically, inflation has been one of the most persistent problems plaguing the Yugoslav economy. As early as the mid-1960s, Slovene-born British economist Ljubo Sirc warned that the Yugoslav economic performance was suffering from inflation caused by systemic de-ficiencies. Skeptical of the Organisation for Economic Cooperation and De-velopment's (OECD) support for Yugoslavia's dynamic growth at the ex-pense of higher inflation, which it expressed in the "Economic Survey of the SFR of Yugoslavia" for 1965, Sirc cautioned that inflation in Yugoslavia was the result of deep flaws in its economic and political structure. In addi-tion to Benjamin Ward's "Illyrian model" of wage increases, he also called attention to the emission of primary money through loosely controlled credits issued to enterprises (Sirc 1966:9). If the establishment of self-management in Yugoslavia in the early 1950s can be seen as a displacement of democratization from politics to industry, its unraveling in the 1980s was driven by the politicization of the economy.

In the late 1970s, Yugoslav associated labor had something in common with military juntas in Chile and Argentina, the Mexican *democratura*, and, for that matter, Poland's "real socialism": an easy access to loans from a

booming transnational private banking sector.[43] In their research on the debt crisis of the 1980s, Stephany Griffith-Jones and Osvaldo Sunkel point to the expansion of private investment in international capital markets as one of its primary causes. They observed that, whereas it was nonexistent in the 1940s, the proportion of external finance coming to debtor countries from private sources increased in the period 1961–65 to 39.8%, and that by 1978 it had skyrocketed to 92.7% (1986:61). They suggest that this turn-around was facilitated by several factors, most prominent among them the deregulation of international banking and the predominance of the Euro-dollar in the 1970s. One of the most significant outcomes of deregulation was the relaxing of oversight of the borrowers' use of these funds. In other words, the privatization and deregulation of international financial struc-tures resulted in the separation of lending and management. In most Latin American debtor countries, this led to a vast increase in dubious invest-ments, capital flight, and military spending. In their analysis of the 1970s borrowing spree in Latin America, Griffith-Jones and Sunkel point out that "governments and entrepreneurs have had great freedom to obtain and allocate vast quantities of external resources, but this increased freedom has not necessarily been to the advantage of the countries receiving that plentiful inflow of private capital" (66).[44] In the case of Yugoslavia, changes in international banking coincided with the internal transformation of self-management imposed by the new constitution of 1974. Yugoslavia, for the most part, resisted many economic and political anomalies that were syph-oning funds from Latin American and other developing countries. Indeed, it was very much committed to a development policy, diversification of the production system, and social justice.[45] However, the implementation of reforms in the aftermath of the 1974 constitution resulted in a number of economic and organizational idiosyncrasies that contributed to its indebt-edness. In a striking similarity to the international financial markets, dur-ing this period the Yugoslav economy went through a deregulation of sorts. Instead of being privatized, however, it was fragmented into repub-lics, into communes, and finally into individual enterprises (OOURs). In his analysis of the debt crisis in Yugoslavia during the 1980s, David A. Dyker cites abandonment of the federal balance of payments and its repub-licanization as one of the most striking examples of Yugoslavia's organiza-tional "peculiarities" (1990:118). Instead of being managed on the federal level, investment and borrowing decisions were made on the level of the republics. This led to endemic duplication of capacities on all levels: from republics, each of which had almost the same set of industries, to commu-nities and enterprises overburdened with administration. This, along with

a decrease in labor productivity and the "Illyrian model" of wage forma-
tion, led to financing growth from borrowing and Yugoslavia's plunge into
what Griffith-Jones and Sunkel describe as the "financial fools' paradise"
of 1970s international private lending (66). In Yugoslavia, this heavy bor-
rowing was used to finance a new ideological conservatism. This marriage
of foreign capital and homegrown politics resulted in an *ideology of debt* as
a specific facet of associated labor: socialist consumerism went hand in
hand with a piety toward the revolutionary past, and common citizens'
"indebtedness" to World War II communist guerillas, President Tito, Peo-
ple's Heroes, and so on. In the early 1980s, as high Party functionaries such
as Edvard Kardelj, Vladimir Bakarić, and Tito himself passed away, this
ideology acquired an increasingly melancholic tone. The mournful tenor of
late socialism sounded the tipping point at which the culture of socialist
baroque reached its completion and began to decline.

Stilinović's work *88 Roses for Comrade Tito* (*88 ruža za druga Tita,* 1991)
captures the complexity of the ideology of debt like no other work that
comes from Yugoslavia during that period. One of the prominent examples
of Stilinović's "works with money," this piece replicates the commemora-
tive bill issued in the 1980s that features Tito's portrait, with designation of
monetary value consisting of 88 zeros. This is not just a catchy visual pun
referencing hyperinflation. The "88 roses" from the title refer to Tito's age
at the time of his death and even more to the cult of Tito that emerged in the
aftermath of his passing. The number 88 was the final piece of this ideo-
logical edifice, before it crumbled down at the end of the decade. Accord-
ingly, this work also belongs to the larger theme of mourning that runs
through Stilinović's works of that period. In *To the Fallen Comrades* (1981) he
painted twelve crosses on a ten-dinar bill, and on several occasions he ex-
hibited banknotes with a black mourning ribbon tinted into its upper right
corner, as was the custom with photographs of recently departed high-
level politicians displayed in shop windows across Yugoslavia.[46] Here,
money appears as an integral part of funeral rites, together with other
kitschy accouterments; money as mourning, but also mourned money: all
those banknotes are stacked with zeroes that speak of the inevitability of
loss that permeates inflationary economics. The melancholy logic of infla-
tion turns on its head the capitalist principle of money's self-reproducibility.
Writing at the tail end of this period and on the other side of the globe,
Peggy Phelan summed up this principle in capitalism's laconic imperative
that "money is supposed to be reproductive: spend money to make money,
multiply paper and multiply power" (Phelan 1991:131). The logic of infla-
tion turns this imperative upside down: the more paper, the less wealth

and less power. Here time does not mean accrual, but waste: the more money you have, the less value you end up with, so that, paradoxically, accumulation ends in zero and in a total loss. Stilinović captures this close interlacing of empty reproduction and death in his series of picturewritings entitled *Images—Graveyards* (*Slike—groblja*, 1982). Here each image has a black background with constellations of yellow, white, or red crosses and the inscriptions "Interest rate," "Inflation," "Production Assurance," and "Market" painted on them.

Stilinović produced his first work with money as early as 1973 in his artist's book *They Told Me Told You* (*Govorili su mi su ti*), in which he made a collage with a two-dinar coin pasted on a page and the inscription "Spit that out" ("Pljuni to iz usta") (Stilinović and Stipančić 2008:103). As the inflation in Yugoslavia picked up in the late 1970s and into the 1980s, banknotes appeared with an ever greater frequency in the work of the Group of Six Authors. For example, in June 1976 Martek performed the action *Tearing Banknotes* (*Drapanje novca*) on the beach in the seaside village of Mošćenička Draga, and in 1980 Sven Stilinović made the piece *Marx-Stilinović*, in which the photograph of the artist lying down with his face covered with coins is juxtaposed with a handwritten quote from Marx. By that time, banknotes were a regular feature in his brother's work: Mladen Stilinović used them as a surface for drawing (*Double Offense, Similarities and Differences*, 1980), made collages from torn banknotes (*To Hans Arp*, 1980), hung paper money from a gallery ceiling while covering the floor with coins (*Money Environment*, 1980), and used them as a writing surface: in *Time Is Money* (*Vrijeme je novac*) he wrote, "I am in a hurry" ("žurim") on a ten-dinar bill, and he added a zero to another ten-dinar bill in the work entitled, simply, *0* (1980).[47]

The use of actual bills gave Stilinović an opportunity to compose visual essays on the subject of money itself. Most often commented on is his collage *Sing!* (*Pjevaj!*), which consists of a black-and-white photograph of the artist with a real one-hundred-dinar bill pasted on his forehead and the inscription "Sing!" underneath. The first association a Yugoslav beholder would get from this image is to the custom from smoky roadside taverns, where drunken guests usually tip musicians by spitting on a bill and pasting it on their foreheads, while making a song request or simply ordering: "Sing!" This gesture of reward and humiliation inevitably points to the relationship between artists and their patrons. But this does not exhaust the range of possible readings offered by this image. If the patron state sees art only in terms of hired labor, then artists also see their work as something to be sold or hired out for a fee. The artist is no longer an activist and a public

thinker, not even a worker, but Homo economicus, someone who has money on his mind—and quite literally so.[48] Stilinović also used a one-hundred-dinar banknote in his piece *Surplus Value* (*Višak vrijednosti*, 1980), in which he inscribed the phrase "Višak vrijednosti" across the bill, with the last syllable ("ti") running over its edge, thus literally indicating an excess or a surplus. I already mentioned his piece *Time Is Money* (*Vrijeme je novac*), in which he inscribed the phrase "I am in a hurry" on a ten-dinar bill. In a different work with the same title, he wrote the phrase "vrijeme je novac" on a piece of paper and pasted a coin above each letter. This series of shiny one-dinar coins that correspond neatly to the letters below them can be seen as a literalization of Ferdinand de Saussure's theory of linguistic value. In *Course in General Linguistics*, Saussure suggested that the value of a sign, like that of a coin, is composed of its property to be exchanged for a "*dissimilar* thing," "the value of which is to be determined" (goods, commodities) and for "*similar* things that can be compared with the thing of which the value is to be determined" (other currencies) (Saussure [1916] 1959:115). However oblique, this connection to Saussurian semiotics is not at all accidental. In statements on his money pieces, Stilinović gives a prominent place to Italian linguist Ferruccio Rossi-Landi, who took the correspondence between linguistics and economy way beyond Saussure's initial idea.[49] In *Language as Work and Trade*, Rossi-Landi writes that "as distinct from use-value, the *'value' of a word* can be taken to be *its position within the language*, just as the 'value' of a commodity is its position within the market" ([1968] 1983:56). The position of an individual word within language is determined by its circulation, that is, by its capacity to engage in multiple exchanges. For Rossi-Landi, the source of linguistic alienation is the same as the source of alienation of labor: just as the commodity status of the object of exchange objectifies the production worker, the discursive status of the word objectifies the linguistic worker. The irony of linguistics is that, like economics, it can't set itself apart from its own ideological setting, so that it actively participates in the process of alienation it tries to describe (and even criticize). It takes the words and messages in themselves, so that

we lose contact with the human and historical reality that brings into being these words and messages as *these* words and *these* messages. Then the consequences of what we may well call *the fetish character of words and messages* unfold before us, incomprehensible to our eyes. This fetish character lies in the fact that the production and exchange of words and messages at a certain point becomes so regular and systematic that it seems to be something that no longer requires a

work felt to be particular and personal. Then the words and mes-
sages, which are, in reality, the products of sign-work, take on the
appearance of autonomous existence. (78)

While he takes the correspondence between sign and commodity as one of
the major instances of "nonverbal language," Rossi-Landi recognizes that
the analogy between language and economy has its limits. Some of them
are obvious, such as the status of private property, which can be said to be
nonexistent in the case of the former. The *loss* of linguistic value comes
from the limited use of a word, its restricted communicability. This is in
strict opposition to the loss of monetary value that comes from its hyper-
production and unlimited circulation. Linguistic value, then, is tied to the
speaker as a reproducer. The moment the "linguistic worker" fails to repro-
duce verbal models that are approved and accepted by the society that
"employs him," "the price he must pay consists in nothing less and nothing
more than *expulsion* from the linguistic society" (64). In economic terms, the
expulsion—and coincidence with Kristeva's writing on the subject is any-
thing but incidental—means poverty; in linguistic terms, it is marked by
either madness or poetry. The specific contribution of postconceptual art in
Yugoslavia, which the Group of Six Authors and Goran Đorđević explored
from different directions, was in approaching economic poverty linguisti-
cally. In his collages and writingpaintings, Stilinović takes an object below
the threshold of symbolization, and, conversely, he isolates "messages"
that have been thoroughly fetishized. This poverty is completely different
from "poor art" strategies that emerged from Art Informel. The difference
in the status of "found" writing in Šejka's action *Declaration* and Stilinović's
installation *Submit for Public Debate* is that the former is an integral part of a
large explanatory mechanism, an entire pseudometaphysical system that
lends *value* to the ephemeral act, while the latter rejects any such elabora-
tion and instead lays bare the mechanism of ideological (d)evaluation of
language within political discourse. Similarly, whereas Gattin degrades the
canvas to the level of a piece of charred fabric and in doing so infuses it
with painterly symbolism, Stilinović always uses recognizable commodi-
ties in order to designate their loss of capacity to engage in the chain of
exchanges: from newspapers, to broken pencils, to plates, to food (bread,
cakes), to that ultimate commodity: money. Ultimately, *autre* art of the
1950s produced works that eventually could be appropriated by the very
political economy from which it was exiled. The strategies of strangeness
and refusal that radical Yugoslav artists of the late 1970s and early 1980s
espoused can be seen as the politics of the last resort: an attempt to make a

distinct and legible statement that is resistant to appropriation by art institutions and to persecution by political institutions: a work of art that is as lowly as a one-dinar coin battered by inflation, but still validated by its symbolic status as "money."[50] Still, "rebuses" involving banknotes as ready-made elements could not fully capture the experiential dimension of inflation. Hence, in the "Reflections of Money" segment of his 1980 show *Sing!* Stilinović exhibited the following writingpainting: "1/31/1980 at six o'clock in the morning I'm listening to the radio—a report on the exchange rates by the Zagreb Economic Bank" (1980:n.p.).

By the late 1970s, the banking system was much more prominent in Yugoslav power structures than workers' councils, unions, or other sociopolitical organizations. After 1968, all of them were reduced from potentially autonomous workers' organizations to mere conduits of the Party's decisions. The power of the banks came from their place at the intersection between producers of real economic value (factories, agriculture, and other producing branches of national economy) and political institutions that were in charge of the distribution of funds. Sociologist Neca Jovanov argues that by the late 1970s, the Yugoslav banking system was used for the "expropriation of the lion's share of income created in productive industries" (1983:63). Yugoslavia, Jovanov claimed, became a country with an unusually high number of investment banks, which, although meant to provide service to "associated labor," were de facto exerting total dominance over it. Since, unlike other socialist states, Yugoslavia did not have a class of professional politicians (nomenklatura), the banking system was an important instrument for the degradation of Yugoslav workers from actual into nominal self-managers and decision-makers. The horizontal connections among workers were powerfully opposed by what Susan Woodward correctly recognized as the "vertical links of monetary control and economic interest in Kardelj's political system," which "ran on two tracks: the Communist party, and the parliamentary and conciliar representation of economic interest" (1995:352). The first track consisted of the members of the League of Communists of Yugoslavia, which, to use Woodward's phrase, was gradually transformed into a "craft union of managers and politicians" (325). The second was the system of delegates, which, according to the constitution, was supposed to ensure an unobstructed flow of industrial into political democracy. A reverse process was established in practice: if banks (and communities, republics, etc.) had workers' delegates on their boards, these delegates were quickly assimilated—with the crucial aid of the "craft union"—into a class of interest brokers. These two "columns" of power were harmonized through monetary flows facilitated by

the banking system, which reaped huge benefits from this intermediary position. Jovanov points to the fact that, since the late 1960s, manufacturing industries in Yugoslavia had been on average barely breaking even, while banks and other intermediary institutions (SIZs) were regularly reporting large surpluses (1983:68).

This apparent inequality in income distribution resulted in a wave of worker unrest in the 1980s. Strikes were not a new phenomenon in Yugoslavia. In his book on workers' strikes in Yugoslavia, Jovanov writes that in the decade between 1958 and 1969 there were some 2,000 recorded strikes in Yugoslavia. With the debt crisis of the 1980s, this number increased significantly: in the first year of the crisis (between 1982 and 1983) the number of work stoppages and strikes rose by 80%, and by 1987 there were 1,570 strikes involving 365,000 workers (Woodward 1995:353). Most often, the strikes were triggered by late or insufficient wages. Jovanov finds a deeper cause of the strikes in the "suppression of workers and their influence from the entire institutional structure of economic and political power" (1983:178). The main features of workers' strikes in Yugoslavia remained unchanged over decades: they were short (rarely longer than a day) and limited to industry and mining; further, they were aimed at factory management and never at larger political structures, which explains their local nature (there were no general strikes even in the darkest days of the crisis in the 1980s), and, importantly, they had a very high rate of success (180). The firms' directors tried to find (and mostly succeeded in finding) ways to quickly satisfy workers' demands in order to avoid admonishment from their higher-ranking Party bosses. However, all of this hardly gets close to explaining the apparent paradox of workers' unrest (strike, work stoppage) in the system of self-management, where the means of production are supposedly in workers' hands.

During the 1980s, a number of Yugoslav economists pointed to the ways structural weaknesses and outright faults were built into the system of associated labor. Jože Mencinger, for example, argued that, in order to remove one of the major sources of instability, Yugoslav authorities needed to redefine "social property" from "a concept that does not include provisions for vested claims of the workers to a concept that would include such provisions and would in fact change social property into collective property" (1987:403). What this means is that the concept of "social ownership," which the 1974 constitution transformed into the abstract legal category of the "association of labor and means of production" ("udruživanje rada i sredstava"), made income earned from labor, not from ownership, legal and socially acceptable. This had the effect of diminishing workers' con-

cern for the very property they used and operated. It is not surprising, then, that the decrease of labor productivity was a constant feature of Yugoslav economic performance after 1976. Mencinger warned that "if the existing concept of social property is retained, inflationary investment financing can be only substituted by limiting rather than increasing the rights of workers to decide on income distribution and/or by taxing wages and collecting funds for equalizing ex ante savings with investment" (403). In other words, after 1974 the right to determine wages was the only decision left to workers in the system of associated labor. The concept of social ownership quickly deteriorated from a mechanism for emancipation of workers into an indirect instrument of Party control over the economy. The typical strike in Yugoslavia, in which the workers would stage a brief work stoppage or in the worst case walk out of the factory, thus forcing management to meet their demands in very short time, can be seen as a perverse transposition of the Illyrian model of state syndicalism into the late socialism of associated labor.

Paradoxically, it was precisely its efficacy that limited the strike's potential as a weapon in the workers' struggle in Yugoslavia of the 1980s. Because of its brevity, pragmatism, and local nature, the strike never evolved into a situation in which the workers would congeal into a class that has political, not only economic, demands. Much deeper, more corrosive, and harder for management to engage with was the passive resistance of the workers. This refusal to work can be traced back to the concept of hidden unemployment, which plagued the Yugoslav economy during post-World War II industrialization. For the same reason that strikes were efficient, layoffs were an unpopular measure and almost never used to increase productivity. As Woodward argues, the very concept of employment in Yugoslavia was highly politicized, which makes it hard to determine the number of unemployed at any point. "In contrast to the standard measure in developed capitalist economies, where the rate [of unemployment] is a proportion of the total population of the potential labor force," in Yugoslavia "it was the unemployed portion of the social-sector employment pool—those currently employed in the public sector *with rights to self-management* and those formally registered as seeking work" (196). In other words, employment was not tied to the needs of enterprises, but to the needs of political institutions, which created "unemployment *hidden* in the workplace" (198). The workplace was not a place of work, but of formal employment. In the absence of a labor market, which made job loss almost impossible, avoidance of work reached the status of an unwritten right. The debt crisis and inflation justified it and gave it a meaning of silent protest, which mush-

roomed to massive proportions. Slovene sociologists Veljko Rus and Frane Adam, who studied Yugoslav industry in the 1980s, called this form of passive resistance a "white strike" (1989:217). If work stoppage requires minimal organization and shared responsibility among those who initiate it, the "white strike" asks for no organization and no responsibility whatsoever.[51] It corresponds closely to the idea of refusal that Tronti spoke about in his call for abolishment of labor: "As workers were looking for a single response to capitalist production and the official workers' movement, the response could only be this: a specific form of self-organization, entirely carried out within the working class itself, based on the spontaneity of passivity; an organization without organization, which meant workers' organization without bourgeois institutionalization" ([1966] 2012:38). All we need to do is replace "capitalism" with "associated labor" and this statement will hold true for Yugoslavia, all the way to the last phrase about institutionalization. Unlike in capitalist economies, in Yugoslavia passivity was fully institutionalized and integrated into the doctrine of associated labor. In a tacit agreement characteristic of the political economy of socialist aestheticism, "Actual power holders (management) were incapable of overcoming passive resistance," while at the same time actors of passive resistance could not modify the management. "In that way, immobilization and self-obstruction are built into power structure" (Rus and Adam 1989:219). This led Rus and Adam to conclude that while the "Yugoslav self-managing system, of course, is not totalitarian," in the long run "it is doomed to stagnation" because of "the high level of resistance and entropy" (220). Empirical research on workers' attitudes in Slovenia that Rus and Vladimir Arzenšek discuss in their sociological study *Labor as a Destiny and as Freedom: Division of Labor and Alienation* (*Rad kao sudbina i kao sloboda: Podjela i alijenacija rada*) supports their theses about the sense of disempowerment and "anomie" among production workers (1984:399). Stilinović summed up the vicious circle of the political economy of (late) Yugoslav socialism in his 1981 slogan "Work is a disease—Karl Marx," to which he later added Martek's aphorism, "Work is a shame."[52]

At the outset of the debt crisis, the Yugoslav federal government tried to improve the country's import-export ratio through short-term measures such as rationing consumer goods. In 1982, Prime Minister Milka Planinc resorted to issuing special coupons for purchasing imported consumer goods such as detergent, sugar, coffee, and cooking oil. Gasoline was rationed by a special regulation that permitted owners of personal vehicles to use their cars on alternate days, determined by their odd or even registration numbers. Finally, in the fall and winter of 1984 the government tried to

increase the country's exports of electricity, which resulted in massive power outages throughout Yugoslavia. These austerity measures made but a dent in Yugoslavia's foreign debt, and their real, and perhaps intended, effect was to demonstrate to international financial bodies the seriousness of the Yugoslav government in tackling the country's economic problems. Their unintended effect was the creation of a texture of economic existence entirely new to Yugoslav citizens, best exemplified in the emergence of a language of scarcity. The Zagreb-based sociolinguist Ivo Žanić observed that, during the period of austerity measures, from 1982 to 1984, "the terminology of shopping disappeared from everyday language to make room for the jargon of the hunt" (1986:8). What was once a routine and forgettable activity of making a quick visit to a nearby grocery store, all of a sudden turned into an endeavor steeped in uncertainty and anxiety. Shoppers were no longer purchasing meat and cooking oil or pumping gas, but "finding meat," "catching cooking oil," and "hunting for gasoline" (8). In some respects, the modes of production and reception reverted to nineteenth-century practices. (My record player idle, I remember going overboard with high school literature assignments that included the volumes of Fyodor Dostoyevsky and Leo Tolstoy, which I enjoyed by candlelight, the way these books were encountered by many of their first readers).

Government-induced shortages during the first half of the 1980s did not stop the inflation. Instead, they induced the atmosphere of "white strike" in the entire population. This, in turn, justified an internalization of guilt that Žanić identified in his discourse analysis of inflation. As the inflation accelerated, there was an almost ritualistic repetition of culpability in public statements about the failing economy: "We all carry our share of responsibility for this" (in Žanić 1986:37); "we relaxed too much . . . took loans abroad without much good judgment, and did not rely enough on our own sources" (59). Žanić cites a study that the Belgrade-based Institute for Social Studies did on a representative sample of 4,500 Yugoslavs working in socially owned enterprises, according to which a third of the participants selected the option "We are all responsible" as their answer to the question about accountability for the Yugoslav economic crisis (41). This collective guilt was perceived as a summation of accumulated errors: inflation, reported a daily newspaper from Split, Croatia, is a "synonym for all our troubles and the result of all the mistakes we made" (in Žanić 1986:57). A commentator in *Ekonomika*, a Belgrade magazine, pointed to confusion of the Yugoslav economy's systemic weaknesses for the wrongdoings of politicians. According to some "experts" and their "economic theories," this commentator wrote, "the main responsibility for inflation rests with its

main victim: the working class. It is they who 'eat' accumulation; it is they who don't achieve the desired level of productivity; it is they who are not sufficiently motivated for work" (36). Indeed, one of the most significant effects of inflation—economically, experientially, and politically—is the disappearance of work. If ideology of associated labor replaced workers with an abstract category, the hyperinflation completely marginalized them as social agents.[53] Žanić has observed that "mythological thinking" sees inflation as an enemy that "challenges the community to a duel" rather than "giving it a creative impulse" (1986:212). More significantly, "work as a category has no place in the rhetoric of crisis," in which *ratnik* (warrior) takes the place of *radnik* (worker). "The worker [*radnik*] subsists at the margin of history, while the warrior [*ratnik*] exists at its very center, actively participating in its creation" (235). Inflation created a situation in which the "working class as the ruling class hardly makes ends meet. It introduced a grand leveling into economic life, because when the prices run wild, earning based on labor productivity becomes a dead letter. . . . When the industrious and the indolent, qualified and unqualified, have similar incomes, the motivation for work disappears, productivity declines, the production goes down, and waste goes up, and in that way every aspect of economic life deteriorates" (105). If the purpose of inflationary financing was to sustain the illusion of decision-making by laborers, its ultimate effect was the destruction of labor itself. The full meaning of the politicization of the economy in Yugoslavia of the 1980s: together with the very concept of associated labor, ideological uses of macroeconomics abolished the worker as the political subject.

POSTCONCEPTUALIST POLITICS

In college at the time of the hyperinflation of the late 1980s, I remember a professor recommending Stefan Zweig's autobiography, *The World of Yesterday* (1943), when I asked for help with literary representations of inflation. And I also remember being charmed by Zweig's prose while at the same time being disappointed with the way he spoke about German hyperinflation in 1923. Literary reports on the financial chaos in the Weimar Republic, such as those by Zweig and Elias Canetti, were shaped by that which came after. Zweig saw in it a foreboding of the doom that came with Hitler's rise to power: "Nothing ever embittered German people so much—it is important to remember this—nothing made them so furious with hate and so ripe for Hitler as the inflation" ([1942] 1943:315). More

perceptively, but still misleading when it comes to Yugoslavia's galloping inflation in the 1980s, Canetti in his psychological analysis of German hyperinflation in 1923 pointed out that this economic disturbance resulted in a loss of self-appreciation: "A man who has been accustomed to rely on [money] cannot help feeling its degradation as his own. He has identified himself with it for too long and his confidence in it has been like his confidence in himself. Not only is everything visibly shaken during an inflation, nothing remaining certain or unchanged even for an hour, but also each man, as a person, becomes less" ([1960] 1962:187). This depreciated sense of self-worth is a lasting effect of inflation, Canetti argued. In order to shake it off, worthless survivors of inflation (it is always survived by almost everyone: inflation ruins livelihoods while sparing lives) have to find someone even less valuable then themselves. This explanation of economic and ethical disasters in Weimar are just as convenient and just as misleading as analogies between the short-lived German republic of the 1920s and Yugoslavia's last decade. However, unlike in Weimar, in which the economic collapse led to the rise of totalitarianism, in Yugoslavia, the inflationary spikes of the late 1980s and the 1990s were closely entwined with larger political developments. In other words, the war was not the consequence of economic catastrophe: they were two sides of the same disaster, which fed into one another. In the 1980s, this doomsday mechanism was still obscured by the spectacle of the decay of Yugoslavia's ideological edifice. It was economic, not humanist Marxist or nationalistic discourse that produced the first trenchant criticisms of Yugoslav socialism; and likewise, it was not the triumph of capitalism, but the breakdown of the Yugoslav political economy that hollowed out the idea of self-management.

Risking a sweeping generalization, one can submit that if the 1970s were the decade of expansion (of media, art, politics), the 1980s were the decade of proliferation (of images, slogans, commodities . . . banknotes).[54] This, of course, was not limited to Yugoslavia. Reflecting back on the 1980s, Elinor Fuchs recalled the flood of new scholarly topics and disciplines in the United States ("hermeneutics, semiotics, reception theory, Lacanian psychoanalysis, deconstruction, post-Marxism, postmodernism, feminism, the new historicism . . ." and here we can add performance studies) which she described as "the 1980s theoretical inflation" (1996:142). In itself, proliferation of theoretical discourses was often seen as one of the principal characteristics of postmodernism. Most of the high hitters of postmodern theory were translated and published in Yugoslavia in a fairly timely manner. However, because of this country's "peculiarities," a relatively minor text eclipsed more celebrated (and deserving) writings on this subject. The case

in point is Charles Newman's long essay "The Post-Modern Aura: The Act of Fiction in an Age of Inflation," originally published in the journal *Salmagundi*, where it created some controversy.[55] Sections of Newman's essay were translated and published in *Delo*, one of the leading literary journals in Yugoslavia; and furthermore, the journal adopted this title for a series of four thematic volumes, each some five hundred pages long, dedicated to postmodernism. In "The Post-modern Aura," Newman claimed that "the Post-Modern era represents only the last phase in a century of inflation," and that it can be regarded "in terms of *climax inflation*—not only of wealth, but of people, ideas, methods, and expectations—the increasing power and pervasiveness of the communications industry, the reckless growth of the academy, the incessant changing of hands and intrinsic devaluation of all received ideas" (Newman 1984:6). In this essay dedicated primarily to American post–World War II literature, Newman uses inflation as a frame to bring together the "cultural" and "political" strands of postmodern theory. Whereas the former was concerned with a general shift in post-1968 art characterized by the alleged demise of the avant-garde and its withdrawal from direct political action, the latter was occupied with the crisis of capitalism in the 1970s and the epistemological, economic, and political changes that came with it.

Most theorists who wrote about postmodernism recognized that these two areas fed into each other: literary, cultural, and art-historical interpretations saw the "postmodern turn" in terms of openness, plurality, and the abandonment of imperatives imposed on art by other societal institutions; at the same time, a broader cultural and political critique emphasized that this openness and plurality came from the neoconservative triumph and that it represented a reversal of the modernist egalitarian ideal that was finally exhausted in the counterculture of the 1960s. In his landmark work *The Postmodern Condition: A Report on Knowledge*, Jean-François Lyotard explains the crisis of revolutionary politics—which historiography identified as one of the main properties of modernism almost by fiat—in terms of a change in the very concept of power: "No one, not even the least privileged among us, is ever entirely powerless over the messages that traverse and position him at the post of the sender, addressee, or referent" ([1979] 1984:15). In his no less influential *Postmodernism, or The Cultural Logic of Late Capitalism* Fredric Jameson recognized in the "universal surrender" to "market ideology" "a virtual delirium of the consumption of the very idea of the consumption: in the postmodern, indeed, it is the very idea of the market that is consumed with the most prodigious gratification" (1991:269). There is a certain homology between the conservative turn in postindus-

trial societies and in still-industrializing Yugoslavia that took place in the 1970s. As I suggested earlier, in Yugoslavia this turn was more complex because it required a balancing act between pressures coming from deregulated international money markets and the old guard's imperative to maintain political monopoly at home.

If associated labor was a political economy, it was a fatally schizophrenic one: following the international markets, the economy was trying to find its unique path to deregulation, while the politics sought its legitimacy in revolutionary action, that hallmark of modernism. With great precision and stealth, the symptom of this untenable situation broke out as soon as 1976, the same year in which the Law of Associated Labor was inaugurated (and only two years after the new constitution), in the polemic that followed the publication of Danilo Kiš's *A Tomb for Boris Davidovič* (*Grobnica za Borisa Davidoviča*). Initially acclaimed by critics and literary scholars, the book incited several prominent writers and critics to accuse the author of plagiarism. A heated polemic that followed shook the very foundations of socialist aestheticism in Yugoslav literature.[56] Kiš and his defenders made a case for the use of citation and documentary materials as literary devices, both of which came to be recognized as staple strategies of postmodernist literature. The deeper political significance of the "Kiš affair," as it came to be known, was that it wrested creativity away from the notion of authenticity, thus divorcing what the Party ideologues saw as the foundational principles of socialist self-management.[57] Coming from a completely different background and having no formal connection to this literary affair, in his work of the late 1970s and early 1980s Goran Đorđević engaged in a comprehensive and unsparing extrication of the modernist tangle of authenticity and creativity. His actions such as the (failed) international artists' strike and his contribution to De Appel's gallery project *Works and Words*, held in Amsterdam in the fall of 1979, were, in his words, attempts "to find the most distant position in relation to everything that was considered the most radical and the most avant-garde in art" and to "depart as far as possible from 'New Art' while still remaining on the terrain of art" (Đorđević 2003:164). But what did it mean, in the Yugoslavia of the late 1970s and early 1980s, to assume a position more radical than radical art, and more subversive than "new artistic practice?"

At first, it may seem surprising that this radicalization of artistic practice led Đorđević back to conventional media of drawing and easel painting, albeit in a highly unconventional way. Beginning in 1979, he made a series of copies in pencil on paper of some of the landmark works of conceptual and postminimalist art from internationally recognized artists such

as Joseph Kosuth, Daniel Buren, and Carl Andre. The following year, he organized his first exhibition of copies, held in the SKC and entitled *Against Art* (*Protiv umetnosti*), which included the above-mentioned drawings and his own doodles and sketches of his own amateurish painting *The Harbingers of the Apocalypse* (*Vesnici apokalipse*), which he had made in 1969 while still a freshmen in electrical engineering at the University of Priština. After the exhibit, which lasted only a week, he started making copies of *The Harbingers of the Apocalypse,* a painting he was ashamed of and deemed worthless.[58] He also invited other Yugoslav and international artists such as Mel Ramsden, Raša Todosijević, Zoran Popović, Braco Dimitrijević, and Lawrence Weiner to make their own copies of this painting, The only rule was that all contributors to the exhibit had to make their copies as exactly as possible, and in traditional painterly media.[59] He started exhibiting copies of this painting in his New Belgrade apartment. *Against Art* and *The Harbingers of the Apocalypse* were the first in a series of Đorđević's actions in the 1980s, involving different objects and different media, but always focusing on the act of copying. In 1983, he staged a public session in which he copied a Mondrian in Belgrade's National Museum; the following year he published in the academic journal *Theoria* four copies of *The Harbingers* under the title "Philosophical Tractatus on Nonsense" ("Filozofski traktat o besmislu"); and in 1985 he staged *The Last Futurist Exhibition 0.10,* again in his apartment. Đorđević's copy-works were more or less public experiments in the cultural and semantic position of the copy and were focused on undermining notions of both creativity and authenticity. Even more radically, whereas the "new artistic practice" of the 1970s tried to destabilize traditional art by opting for impermanent media, most importantly performance—thereby potentially turning the artist him- or herself into a commodifiable art medium—Đorđević's acts of copying employed traditional media (painting, drawing) to undermine the author as the solid center of all traditional arts, as well as the institutions and industries that are associated with them. Đorđević's razor-sharp focus on the copy pointed beyond art in the narrow sense to underline its relationship with such building blocks of a functioning economy as reproduction, proliferation, and exchange. Through his production and theorization of copies, Đorđević investigated the relationship between art and authenticity much more explicitly than Kiš and the debate his book engendered, or, for that matter, any other artist in Yugoslavia until that point. Even though he never directly addressed inflation, the relationship of Đorđević's work to this endemic feature of the Yugoslav economy is striking.

As it turned out, *Oktobar '75* was a watershed moment in the history of

the SKC and of conceptual art in Belgrade. This event was followed by a change in the curatorial staff of SKC Gallery and in artistic directorship of the SKC in general. This was a result of pressures from the state institutions that provided funding for the SKC, but also of internal rivalries. Art historian Branislav Dimitrijević recognized three distinct factions or "conceptual tendencies" within the SKC's curatorial staff of the mid-1970s. He named the first tendency "emancipatory or manipulative, depending on the angle from which it is viewed" (Dimitrijević 2003:151). According to him, the main proponent of this faction was Dunja Blažević, the artistic director of the gallery. Dimitrijević holds that this "tendency" was hoping that the SKC could become the meeting place between the "youth culture" ("especially its left radical manifestations") and the political establishment, "especially young and forward-looking socialist leaders who recognized that the new times should support new art" (151).[60] The second "tendency" was epitomized in Biljana Tomić, an art historian who replaced Blažević at the helm of the SKC's gallery. Dimitrijević writes that this faction wanted the SKC to facilitate an encounter between an "autonomous artistic process and possible recognition of that process within the framework of a newly constituted community." Markedly less political than the first faction, the artistic practices the second one supported ranged "from internationally relevant non-institutional uplift of new art to ghettoization and *white kitsch*" (151).[61] Finally, the third faction worked toward making the SKC a "living site within urban life, a part of a total urban culture that goes beyond the autonomy of art and engages with a broader pop-culture environment" (151). The proponent of this tendency was Slavko Timotijević, a longtime art director of Happy New Gallery, which worked within the SKC and was distinct from its main gallery. Dimitrijević writes that the change in the artistic leadership of SKC Gallery in 1976, in which Tomić replaced Blažević as the artistic director, marked the moment of the SKC's rejection of a "radical left (even Maoist) critique of culture and art" and the beginning of "depoliticization of artistic practice in the SKC" (150).[62] The change in the SKC was symptomatic of a larger realignment of alternative art in Belgrade and in Yugoslavia. While Đorđević moved away from "new art practice," Dunja Blažević moved on to mass media in her work on television. She saw this as a natural continuation of the "democratization of art" attempted by the "new artistic practice" (2010:157). Starting in 1981, she collaborated with Television Belgrade (the only TV station in Serbia at that time) on the art programs *Other Art* (*Druga umetnost*) and *TV Gallery* (*TV Galerija*), which brought the latest artistic explorations to the largest spectatorship imaginable, the television audience. Although both *Other Art* and *TV Gallery* were broadcast in late-

night slots and had low ratings, they represented an "expansion" of video into the medium of television, thus constituting a rare instance of art television, nearly unimaginable in competitive and commercial TV.[63] If in her curatorial work Blažević went from a relatively isolated and marginal art institution to a still marginal position in television, her new medium (TV) had a much wider reach than the old one (gallery). It was through programs such as *Friday at 22*, which hosted Blažević's *TV Gallery*, that the new work, previously limited to the SKC, reached a wider audience.

In the meantime, student cultural centers across Yugoslavia (the SKC in Belgrade, Ljubljana's ŠKUC, and the Student Center in Zagreb) became hubs for the alternative music scene, which set itself in direct opposition to the pop mainstream. It can be said that in the first decade of its existence, the SKC traversed the arc from being Belgrade's version of the ICA to its CBGB: whereas in the 1970s the likes of Joseph Beuys, Gina Pane, and Simone Forti performed there, in the 1980s it saw performances by Angelic Upstarts, The Pixies, and the entire range of bands from the exploding postpunk scene in Yugoslavia.[64] Student centers were not only concert venues, but active facilitators of collaboration between musicians, visual artists, theoreticians, and film directors. Their collaborations extended to the music videos, record covers, and alternative magazines that were shaping youth culture across Yugoslavia. As Lidija Merenik writes, the new wave in Yugoslavia was an "urban and generational art dialect" that adopted an "antagonized, hostile, unpopular, and alternative attitude of passive resistance" (1995:24). If average Yugoslav television viewers saw the iconography and language of bands as impenetrable if not outright hostile, they could easily recognize the attitude Merenik is talking about. If the first wave of British and New York punk made little impact on Yugoslav youth, then the second wave (also known as the new wave or postpunk) coincided with the onset of the crisis. It arrived with an already established repertory of behaviors, attitudes, tonalities, and images that could respond to the atmosphere of hopelessness that was becoming pervasive in a Yugoslavia gripped by debt crisis, government-imposed restrictions, and ever-accelerating inflation. As Dick Hebdige recognized already in his 1979 book *Subculture: The Meaning of Style*, "In punk, alienation assumed an almost tangible quality. It could almost be grasped. It gave itself up to the cameras in 'blankness,' the removal of expression (see any photograph of any punk group), the refusal to speak and be positioned" (1979:28). If upbeat pop tunes and watered-down hippie attitudes shared with the official ideology a promise of an ersatz disalienation, the establishment now had to recon with the youth culture that openly glorified alienation. Who could

imagine a postpunk band in a Youth Day performance? For the first time since the late 1960s, youth culture was beginning to coalesce into a cultural (if not political) force clearly opposed to socialist aestheticist officialdom. The most insidious were those projects that didn't limit themselves to the music scene, but instead presented themselves as more complex multimedia initiatives. For example, in 1980–81, the Belgrade youth journal *Vidici* became a platform for the launching of Dečaci (The Boys), which started as a media project masterminded by the photographer Dragan Papić and ended as one of the most successful new wave groups, Idoli (The Idols).[65] Their first record was issued in the spring of 1980 in an issue of *Vidici* dedicated, significantly, to antipsychiatry.

In sharp distinction from the previous two generations of rock musicians in Yugoslavia, who based their acts almost entirely on the impersonation of models coming from Western culture—from covers of foreign hits in the 1960s to idealization of prog-rock guitar virtuosos in the 1970s—the new wave bands of the early 1980s found an unexpected object of identification at home. Instead of trying to be "cutting edge" by emulating the style of contemporary British and American punk rockers, Dečaci/Idoli turned toward the past and took up the look of Yugoslav pop singers from the 1950s. In Slovenia, the postpunk group Laibach went even further back, into the 1940s and the "totalitarian styles" of Nazism and socialist realism. With their public image of a slightly strange but not threatening bunch of adolescents, Idoli quickly took off as one of most popular new wave bands in Yugoslavia; conversely, with its sound of industrial rock and image consisting of quasi-totalitarian iconography Laibach remained limited to the alternative concert circuit and rarely appeared in the mass media. At the same time, while in Belgrade the collaboration between new wave bands with alternative youth institutions was short-lived and limited in its reach, in Ljubljana this kind of synergy produced lasting cultural and political effects.

THE USE-VALUE OF POSTMODERNISM

By now, Laibach's rise from Ljubljana's industrial suburb of Trbovlje is almost the stuff of legend.[66] No less significant than the emergence of the band in 1981 was its ability to establish connections with other like-minded artists and theoreticians from their generation. Their most significant collaborators have been the art group Irwin, which was founded in 1983 under the name Rrose Irwin Sélavy, an obvious reference to Marcel Duchamp's pseudonym. Soon thereafter the group's members condensed the

title to R Irwin S, and in 1984 it was further shortened to Irwin. This coincided with the establishment of Neue Slowenische Kunst (NSK), an association of Slovene art groups that brought together Irwin, Laibach, and Scipion Nasice Sisters Theater.[67] In Irwin's key statement from that time, "Retro Principle" (1984), the group professes its commitment to "retro" aesthetics and artistic eclecticism, which turns *l'art pour l'art* (art for art) into *l'art de l'art* (art from art). Because of this, the group claimed, the "retro principle makes use of tradition in a direct and indirect way (quoted in original purity). Due to the current interest in it, even a complete identification (a quotation) acquires a historically specific productive character" (New Collectivism 1991:111). What this meant for the artistic practice not only of Irwin, but also of Laibach and of Neue Slowenische Kunst in general, was the ability to freely choose various images and "language models" from the past and to emphasize the ideological content of these images through their juxtaposition. While Irwin and Scipion Nasice Sisters Theater used "quotations" from high modernism and the avant-garde (Kazimir Malevich, Wassily Kandinsky, Piet Mondrian, and even Edward Ruscha), Laibach and New Collectivism (Novi kolektivizm), a design group consisting of members from all "branches" of the NSK, became known for their investigation of the dark side of twentieth-century modernism, primarily the visual art of the Nazi era in Germany and socialist realist art from Slovenia and beyond. One of their most provocative strategies from the mid- and late 1980s consisted in collapsing these two kinds of art into a paradigmatic image of "totalitarian art." The most famous instances of this kind of juxtaposition were Laibach's performances and New Collectivism's design of the 1987 Youth Day poster.

"The stuff of legend" that comes from detailed scholarly and journalistic renderings of Laibach's history removes the initial mystique that followed the group—and the entire NSK—throughout the 1980s. Consider the opening of an article about the NSK published in the high-circulation Croatian newsmagazine *Start*, one of the first in-depth reports about the group outside of Slovenia:

> A 28-year old man, who a few days earlier introduced himself to me in Ljubljana as "Laibach's collaborator," met me late at night at the train station in Trbovlje. As I learned later, he was a legitimate group member, one of four from its current lineup. He was one of two "Laibachites" who grew up in Trbovlje and one of three members of the mysterious art movement called Neue Sloweniche Kunst who live in that unpretty place.

I had already memorized the first of ten points of the Covenant, an internal statute of sorts that prescribes the rules of conduct and behavior for the members of Neue Sloweniche Kunst: "LAIBACH works as a team (collective spirit), according to the principle of industrial production and totalitarianism, which means that the individual does not speak; the organization does. Our work is industrial, our language political."[68] They agreed to meet with me as a journalist under the condition that I am not going to reveal their names. (1986:51)

Like the first-generation British punks who incorporated Nazi symbols into their aesthetics of ugliness, Laibach was initially perceived as menacing. However, this sense of threat came just as much from the group's principle of negation of its members' individual identity as it did from the iconography they employed. If their appearance was merely offensive, the principle of anonymity was threatening. No alternative group or movement in Yugoslavia has ever even considered contesting the state's monopoly on violence. Neither did the NSK; however, it was the first group to challenge the state's monopoly on secrecy. The NSK's elaborate internal bylaws that lacked individual signatories, and their principle of distancing from the public even in situations of live performance, successfully mimicked the performance of institutions in a corporate state. The real challenge that the NSK posed to Slovene and Yugoslav socialism was not on a symbolic, but on an organizational level. As it turned out, the responses that the republic and the federation offered to this parainstitutional appearance of the NSK were diametrically different. The NSK became a litmus test of tolerance for Yugoslav socialism, as federal and republican reactions to the group were consistent with their responses to the crisis.

Whereas in the mid-1980s the federal government became identified with repressive institutions (the army, secret police) and measures (restrictions), Slovenia became the beacon of liberalizing initiatives, most of them spearheaded by the Union of Socialist Youth of Slovenia (Zveza socialistične mladine Slovenije, or ZSMS). In the brief period spanning 1985–86, ZSMS launched a number of proposals for changes previously deemed unmentionable in Yugoslavia, such as a demand for abolishment of compulsory military service, special status for political prisoners, abolishment of the "crime of speech" (notorious regulation 133 of the criminal code), a ban of arms exports, abolishment of death penalty . . . and withering away of the Youth Relay and Youth Day spectacle.[69] ZSMS saw the NSK's activities as part of the legitimate progression of demands from freedom of expression

to freedom of organization. Marina Gržinić, who was the director of Lju-
bljana's Student Cultural Center (ŠKUC) during this decisive period in the
1980s, explained this situation of institutional regrouping as an attempt "to
overcome the countercultural discourse, the mentality and the attitude to-
ward institutions in general. We were striving for the formation of our in-
stitutions and communicative networks" (1992:43). The ZSMS and ŠKUC
lifted the NSK from its status of quasi-institution to the position of an au-
tonomous member of the emerging network of alternative institutions.

As the economic crisis intensified, Yugoslavia's "permanent nucleus of
identity" quickly eroded. By the mid-1980s, all that was left of the "perfor-
mance state" was an empty shell of baroque socialism exemplified in the
expensive ritual of the Youth Baton relay race (by then, parts of its itinerary
were traversed in black Mercedes sedans), and lavish stadium spectacles.
General dissatisfaction with Youth Day festivities, which increased after an
especially kitschy stadium performance in 1983, first turned into an open
protest in Slovenia. In 1986, a group of students from Ljubljana's Art School
dragged a huge wooden log to the city center and performed a public ac-
tion of carving a gigantic Youth Baton, while activists collected signatures
on a petition for the abolishment of Youth Day festivities. Shortly thereaf-
ter, on the occasion of the Youth Day, ZSMS awarded its annual prize to the
NSK. The following year, it was Slovenia's turn to host the start of the
Youth Relay, and according to custom, the local ZSMS union had the honor
of proposing design solutions for the poster and the baton. Contrary to
most subsequent accounts of the "poster affair," it was the design of the
baton, not of the poster, that initially drew most criticisms from federal in-
stitutions in charge of organizing the Youth Day festival in 1987. Printed
media across the country reported that the meeting of the Federal Commit-
tee for Youth Day Celebration held on February 25 lasted three hours, and
most of that time was spent on terse debates about proposed festivities in
Slovenia and the design of the baton.

In accordance with the Yugoslav market socialism's "permanent nu-
cleus of identity," the emphasis in Youth Day celebrations has always been
on movement and circulation. In sharp contrast with this traditional festi-
val of mobility, New Collectivism (Novi kolektivizem, NK) and Slovene
youth organizations proposed that, after departing from the mountain of
Triglav, the Youth Baton "rest" for a week at Lake Bohinj. The design of the
baton placed an even greater emphasis on stasis. On February 27, Belgrade
daily *Politika* published a special report on the design of the baton, which
cites Roman Uranjek's explanation of its symbolism.[70] Instead of the stan-
dard variation on the staff-like shape, NK proposed a cone-shaped struc-

Osnutek štafete mladosti.

Fig. 28. New Collectivism: Youth Baton, drawing, 1987. Courtesy New Collectivism.

ture that consisted of eight parts, symbolizing Yugoslavia's six republics and two autonomous regions. The cone was supposed to be placed on top of a special casing that would house a videotape with recorded messages from Yugoslavia's youth. Obviously playing on the excessive allegorization of numbers in Youth Day celebrations, NK proposed that the cone should be 37 centimeters high in commemoration of Tito's ascendance to the helm of Communist Party of Yugoslavia in 1937. That is not all: according to NK's design, the whole structure was supposed to be mounted on four pillars fastened to a marble base in the shape of Yugoslavia. The purpose of the VHS tape was to bring technologies of the 1980s to this public ritual and replace a scroll with a written messages that was traditionally placed inside cylindrical Youth Batons.

The committee squarely rejected the proposed design, objecting that it

was impossible for a single person to carry this sculptural "baton" while running, and that it would be extremely difficult for multiple runners to carry the structure simultaneously. Missing the NK's point about stagnation, some of the committee members objected that the proposed structure resembled a stool more than a baton, and once descriptions and images of this design reached the media, there were speculations that the cone resembled a pharaoh's pyramid more than Yugoslavia (Tijanić 1987:12). The shift of emphasis among the critics from the performative to the symbolic dimension of the NK's proposal happened almost instantly once *Oslobodenje* published on the cover page of its weekend issue on February 27, 1987, the news about the obscene source for one of the proposed Youth Day posters.

To a certain degree, the "poster affair" obscured the prominence of performance in the NSK's work in this pivotal period of its history, which ranged from Laibach's concerts to Irwin's exhibition openings, and which culminated in the theatrical production of Scipion Nasice Sisters Theater's *Baptism under Triglav*. Theater director Dragan Živadinov saw the Scipion Nasice Sisters Theater as a project limited in time to four years: as was the custom with NSK projects, the establishment of this theater was proclaimed in "The Founding Act," which indicated October 13, 1983, as its starting date and announced its planned self-destruction in 1987 (1991:162). The first year of Scipion Nasice Sisters Theater's existence was marked as an "underground" period. In one of its "above ground" actions, the group published "The First Sisters Letter," which opens with a thinly veiled denunciation of the theatrical concepts of Jerzy Grotowski and Peter Brook, whose ideas shaped European theater of the 1970s: "Theater does not exist between the *Spectator* and *Actor*" and "Theater is not an empty space"; instead, "Theater is a *State*" (163). Continuing in the same vein, "The First Sisters Letter" elaborates on the relationship between theater and state: "The formal tendency of the *State* is stability and power, while in terms of content every state is basically disorganized. The Scipion Nasice Sisters Theater proclaims this relation as a fundamental, all-embracing and eternal *Aesthetic* issue. . . . The Scipion Nasice Sisters Theater is apolitical. The only truly *Aesthetic* vision of the *State* is the vision of the impossible State" (1991:163). The Scipion Nasice Sisters Theater's first production, *Retrograde Event Hinkemann*, was performed in a private apartment in Ljubljana in January 1984. In May of the following year, they opened their second production, *Retrograde Event Marija Nablocka*. Both of these productions were performed in small spaces and for limited audiences: in *Hinkemann*, the members of the group met individual spectators in previously arranged

locations in the city and then escorted them to an apartment where the performance was taking place, and in *Marija Nablocka* the spectators were positioned beneath the stage floor with their heads protruding through small openings, so that the entire performance was happening above and around them.

In February 1986, the Scipion Nasice Sisters Theater produced their third "Retrograde Event," *Baptism under Triglav (Krst pri Savici)*, a multimedia spectacle and the largest production of the NSK ever. Unlike the previous two productions, *Baptism under Triglav* was performed in the largest and flashiest indoor venue in Slovenia available at that time, the Great Hall of the Congress and Cultural Center Cankarjev Dom in Ljubljana. Directed by Živadinov, designed by Irwin, and with music by Laibach, this monumental production relied on ample support from the Republic of Slovenia, whose aspiration toward full statehood was debated with an ever-increasing openness. The choice of the subject closely matched the political situation of the day. *Baptism under Triglav* was loosely based on a long poem of the same title by the nineteenth-century Slovene Romantic poet France Prešeren. Reworked by one of the leading Slovene modernist writers, Dominik Smole, it focused on the imagined historical baptism of the Slovene tribes upon their arrival to the upper Balkans. As announced in "The Third Sisters Letter," instead of being "based on a drama text," this spectacle "expressed itself with the language of fine arts attractions," which consisted of "sixty-two paintings" (1991:176). The stage images that served as both a backdrop and an active stage element in performance with seventy actors and dancers (and, at one point, ten German shepherds), were theatrical restagings of the painterly avant-garde's iconic images, such as Vladimir Tatlin's *Monument to the Third International* and elements of Kazimir Malevich's suprematism (triangle, cross, circle), with Oskar Schlemmer's *Pole Dance*, originally performed at the Bauhaus—all of this juxtaposed with dancers in Laibach-style uniforms and made-up symbols of Slovene national art, such as deer antlers.

By 1986 Slovene authorities recognized that they could build up the profile of their republic as a beacon of democratization in Yugoslavia by embracing and supporting alternative culture. As Slovene sociologist of alternative movements Gregor Tomc put it somewhat crudely, "If the relation of top LSY [League of Socialist Youth] officials to the punk subculture was more or less limited to declarations of intent, it was for the simple reason that punks were of no 'use value' to them. Laibach, however, became a love at the first sight for the official youths" (1994:126). The same recognition carried over to the League of Communists of Slovenia, which

resulted in an ambivalent mainstreaming of the NSK in the mid-1980s. The state invested heavily in *Baptism under Triglav*, and as a result, this "retrograde event" was by far the most expensive theater spectacle produced in Yugoslavia to date. The cost of this production was some 30 million dinars (over $75,000), an astronomical sum at a time when the country was deep in economic crisis and inflation (Hudelist 1986:48). Whereas some postmodern theorists explained the "return to painting" of the 1980s by transformation of the status of the image in relation to other media, in *Baptism under Triglav* the image was literally transformed through its transposition from easel to stage and from the pages of art history to live performance. This transformation of the image vitally depended on the infusion of capital by the state: the cost of a stage scene that "reproduced" a painting by Wassily Kandinsky was three million dinars, and of Ed Ruscha's gas station painting some five million (Hudelist 1986:50).

While in Slovenia the postmodern art scene was clustered under the umbrella of the NSK, which enabled artists to position themselves in relation to art institutions and, ultimately, the state, in Serbia the situation was much more dispersed and unhinged. In the former, the ideological boundaries of the group were carefully negotiated among its members; in the latter, there was no such coordinated group positioning, so what was considered "postmodern art" ranged from the sophisticated and radical leftist interventions of Goran Đorđević, to the work of artists who advocated conservative political ideas, such as Dragoš Kalajić.[71] Finally, if in Slovenia the mainstreaming of postmodernism was temporary and theatrical, in Serbia it had no time limitations and was primarily literary. The publication in 1984 of Milorad Pavić's *Dictionary of the Khazars* (*Hazarski rečnik*) marked the enthroning of postmodernism as the leading literary style in Serbia. Like *Baptism under Triglav*, *Dictionary of the Khazars* revolves around the theme of conversion. Further, as much as Živadinov's production is a theatrical spectacle, Pavić's novel is a literary one. Quickly translated into a number of languages, the novel captivated international publishers and readers with its formal inventiveness and intricate textual and paratextual games.[72] Unlike Živadinov in *Baptism under Triglav*, Pavić was not drawing on the legacy of the avant-garde painting, but on baroque literature. In line with the baroque strategy of ambiguity, the drama of conversion in his novel does not concern directly the Serbs (as it does the Slovenes in *Baptism under Triglav*), but the tribe of Khazars; and unlike in Prešeren's Romantic work, this drama doesn't just affirm a national identity, but warns against the deadly threat of its loss. As Andrew Wachtel correctly observed, by the early 1990s Pavić's equivocations about the Khazars' symbolism in his

book could no longer hide his increased identification with the Serbian na-
tional movement, in which he was "playing an important role in providing
intellectual support for the Milošević regime through his activities in the
Serbian Academy of Sciences" (1997:639). The last and the most grandiose
project of the Scipion Nasice Sisters Theater remained unperformed: it was
supposed to be the 1987 *Artistic Event Youth Day,* an open-air festival on
Lake Bohinj that, were it performed, would have involved the making of an
artificial island that supports a cone much like the one from the NK's ba-
ton. In a published statement, the group declared that the relationship be-
tween theater and state announced in the "First Letter" had now reached
the level of "state creativity:"

> The ARTISTIC EVENT OF YOUTH DAY, which was dedicated to the cel-
> ebration of the YUGOSLAV youth, is the last theatrical project of the
> SCIPION NASICE SISTERS THEATER. With this project, the observation
> of the relation between the THEATER and the STATE and the THEATER
> AS A STATE has achieved its climax. That is why the ARTISTIC EVENT
> OF YOUTH DAY IS ALSO AN ACT OF SELF-DESTRUCTION OF THE SCIP-
> ION NASICE SISTERS THEATER AS A STATE institution and STATE.
> (1991:180)

Faithful to their performance of bureaucracy, Novi Kolektivizem marked
this statement as "Document B2, 1987." It is followed by "Document D2,
1987," which declares simply: "THE ARTISTIC EVENT OF YOUTH DAY was
also abolished by the SOCIALIST REPUBLIC OF YUGOSLAVIA" (181). This and
similar proclamations led some to believe that the Youth Day festival "was
not held again after 1987" (Monroe 2005:98). That is simply not true: the
organizers scrambled to get new designs for the poster and baton in time
for the Youth Day spectacle in May 1987, a tired blend of recycled choreog-
raphies and slogans spiced up by performances of some of the most popu-
lar Yugoslav pop singers. The last Youth Day spectacle took place the fol-
lowing year, on May 25, 1988. It was the first Youth Day performance
without a Youth Baton and without the participation of army units and el-
ementary school children. The aim of the organizers was to turn the Youth
Day event into "primarily a theatrical, artistic experience," reducing its
political symbolism to date only (Ast 1988:23). The event, entitled *Socialism
according to Human Measure (Socijalizam po meri čoveka),* was directed by
Paolo Magelli, an Italian director who worked mostly in Yugoslavia, where
he had built the profile of a cutting-edge theater maker. He put together a
creative team of theater professionals who worked together with some one

thousand high-school youths from Zagreb, Sarajevo, Skopje, Pančevo, and Belgrade.[73] A long disclaimer an actress and an actor read at the opening of Magelli's "choreodrama" reflected a short-lived hope that the political economy of socialist aestheticism, including the subsidies for a wide range of professional and amateur theaters, would somehow outlive the state that created them in the first place and survive simply as an aestheticism:

> We dedicate this performance to all heralds of good news; we dedi-cate it to the theater and to our spiritual keen: to Meyerhold, Kan-dinsky, Malevich, Chagall, Mayakovsky, Rosa Luxemburg, Stro-heim, Toller, Horváth, and all great artists who believed in the new; we dedicate it to birth, life, love, home; we delicate it to simple and eternal elements. We hope that in the future years this occasion will bring us Pina Bausch, Robert Wilson, Maurice Béjart, Šparemblek, Roland Petit, and other true artists, who will make something com-pletely different while opening the same field of true aesthetic en-joyment. This is an open invitation to all of European intelligence. Let this become this big world's big performance.[74]

Next year, the Youth Day was no more. In the summer of 1989, the group that put together stadium spectacles in 1985 and 1986 (Žarko Čigoja, Rado-man Kanjevac, Jugoslav Ćosić, and Slobodan Vujović) was hired to pro-duce the celebration of the six hundredth anniversary of the Kosovo Field battle, which Slobodan Milošević, already an undisputed ruler of Serbia, used as a platform to announce his ambitions, which went beyond the bor-ders of his native republic (Leposavić 2005:178). Does one need a better proof that Živadinov's claim about theater and state was not a gimmick, and that the only way to make sure that the state doesn't absorb the theater was for the latter to self-destroy?

This brings into question Žižek's "overidentification" thesis, which be-came the definitive theoretical reading of the NSK's political performances of the 1980s. Repeated on many occasions and in many forms, this formula-tion from his article "Why Are Laibach and NSK not Fascists?" sums up the thesis: "Laibach 'frustrates' the system (the ruling ideology) precisely inso-far as it is not its ironic imitation, but over identification with it—by bring-ing to light the obscene superego underside of the system, over-identification suspends its efficiency" (Žižek [1993] 2003:49). Here Žižek strategically cir-cumvents his own analysis of ideology from the same period, in which he argues that the "'ideological' is a social reality whose very existence im-plies the non-knowledge of its participants as to its essence" and that "'ide-

ological' is not the 'false consciousness' of a (social) being but this being itself in so far as it is supported by 'false consciousness'" (1989:21). In other words, ideology owes its efficacy to its ability to conceal itself within an order of things that it presents as "natural," historically inevitable, just, and even enjoyable. It "works" precisely because it constitutes a blind spot in the consciousness of its subjects. This "eternal" order becomes visible only at the moment when it starts disintegrating: ideology becomes perceptible, that is to say distant and alien, once its smooth mirror surface begins to crack under the weight of its own contradictions. By 1987 and the peak of the NSK, the ideological facade of Yugoslav socialism was badly scarred by years of political and economic crisis. The very fact that it could be presented as totalitarian was actually a sign of the emergence of a new ideological order that was as invisible as it was effective, and which could be glimpsed precisely in Laibach's concerts. The structuring absence of this ideological matrix was not contained in silences hidden beneath the surface, but precisely in the most assertive and "visible"—that is to say audible—aspect of Laibach's performances.

In his book on Laibach, Alexei Monroe offers a variation of Žižek's overidentification thesis by asserting that the band "produced ideological tone pictures of a series of regimes, rendering audible the presence of the state in the sphere of music and vice versa, denying in advance the possibility of politically neutral music (of any genre)" (2005:203). In order to support the idea of the "audibility" of ideology, Monroe turns to Jacques Attali's book *Noise*. Even more than that: he presents the relationship between Laibach and Attali not only as that of mere complementarity, but of programmatic identification: "Attali and Laibach share the same basic thesis: that music (as a reflection of political power) can function as a regime in itself. Laibach 'sample' Attali's book *Noise* as they do so many other theorists and politicians" (203). Monroe doesn't offer any examples of this direct quotation, so that at the very least this argument speaks of how he hears Laibach.[75] What is "audible" in Laibach is a "new form of socialization" that Attali started developing in *Noise: The Political Economy of Music* and completed in the 1980s—the very time of the "sampling" that Monroe talks about—during the time he served as one of President François Mitterrand's top advisors. In *Noise*, Attali takes "composition" as a broad metaphor for a new kind of social organization, "a network within which a different kind of music and different social relations can arise. A music produced by each individual for himself, for pleasure outside of meaning, usage and exchange" ([1977] 1985:137). If this sounds like yet another program of disalienation, it is: "by subverting objects," the new composition "heralds a new form of the col-

lective imaginary, a reconciliation between work and play." In this way "music becomes the superfluous, the unfinished, *the relational*" (141; emphasis added). *Noise* can be said to constitute an overture to the book Attali published the following year, *The New French Economy* (*La nouvelle économie française*, 1978). Here he argued that, dominated by consumers, capitalism in the information age generates new contradictions that can be addressed only through new organizational strategies. According to him, "communal life" is at the center of capitalism's crisis, and as such holds the potential to respond to it (1978:169). The solution to the crisis, proposes Attali, lies in establishing a "relational socialist society" by granting demands for "networks" (169). The new model of "relational jobs" and relational society replaces the old model of "fixed jobs" and industrial society. Although they pronounce the Mitterrand years as the triumph of the "third spirit" of capitalism in France, Boltanski and Chiapello never take into consideration the ideas of one of his prominent advisors; and similarly, even though they spend a lot of time on "critiques" of capitalism in the 1970s, they don't even mention one of their most unorthodox sources, such as French biologist Henri Atlan's theory of noise.

In the aftermath of 1968, proponents of *autogestion* looked far beyond art for alternative models of organization. One such source was Atlan's theory, which he outlined in his 1972 article "Noise as a Principle of Self-Organization." Here, "noise" stands for the ability of natural organisms to incorporate "parasitic and random phenomena" (Atlan 2011:96). According to Atlan, self-organizing configurations produce greater variety and, over time, increase their own complexity. He argues that an attention to noise brings a "shift in the notion of information, from something transmitted in a channel of communication to something contained in an organizing system" (102). Obviously, these properties of self-organization have a special significance for social configurations. In Atlan's words: "The quantity of information that is measured no longer signifies a lost quantity of information at all, but rather an augmentation of variety in the entirety of the system or, as one says, a diminution of redundancy" (102). In *Noise*, Attali puts forward an idea of noise formally similar to Atlan's, but with a diametrically opposite ideological valence. Whereas for Atlan noise is a redundancy within a certain social or biological system, Attali speaks of noise in quite a literal sense as a property of modern music (be it Jimi Hendrix or Arnold Schoenberg) and of politics in general: "Any theory of power today must include a theory of the localization of noise and its endowment with form. . . . And since noise is the source of power, power is always listened to with fascination" (6). In both cases, the "noise" stands for that which

came to be identified as "live," the key property of performance. In his book Attali succeeded in recasting the live from a phenomenon of plurality to a phenomenon of volume. In other words, where Atlan sees noise in terms of species, Attali sees it in terms of degree. This is not only a question of the definition of "noise" or "performance," but of the ways in which late capitalism comes to terms with the live.

It is not surprising that Monroe places Attali's theory of noise side by side (and within) Laibach's "totalitarian" performances, or that Boltanski and Chiapello skirt both him and Atlan while talking about processes in which they were deeply implicated. Atlan-Attali is one particularly striking instance of two very different discourses coming in close proximity, which makes it possible for metadiscourses such as that of Boltanski and Chiapello to treat them almost interchangeably. This is relevant for the discussion of the ways in which modernist ideas are circulated, "sampled," and retrofitted into unrecognizability. To track just one of these genealogies, Attali's "relational socialism" stands out as an unacknowledged source of Bourriaud's "relational aesthetics." What is usually seen as a single historical "line" of socially engaged art that goes from the avant-garde to conceptual art of the late twentieth century, to socially engaged art of the 2000s, in fact comprises two distinct and even mutually opposed strands of artistic and political practices. To take the Atlan-Attali intersection as a starting point and look backward from there, Atlan's investigation of chance procedures points back to Dada experiments, while Attali's emphasis on sound recalls bruitism and the Italian Futurists as the main proponents and users of this technique; and looking forward, Atlan's notion of noise as chance points to the principle of self-organization and, ultimately, *autogestion*, while Attali ties "noise" to relationality, the principle of flexibility, and ultimately, neoliberalism.

If the crisis of 1968 was initiated by industrial capitalism's excessive reliance on an ego-centered subject it presumed was completely adapted to hierarchical structures, what came out of this crisis was a recognition that social relationships need not be ordered top-down, but also laterally, diagonally, in all possible directions. A short period after 1968 witnessed the emergence of a number of psychoanalytic, economic, political, organizational, and artistic visions that attempted to look beyond the autonomous, discrete, and fortified subject, which was often criticized as an ideological illusion. Each in their own way, they understood that intersubjectivity is not established on a presumed sovereignty of the subject, but on complementarity that comes from its decenteredness, insufficiency, and incoherence. The disaster that capitalism inflicts on the subject is not in imposing a

structure that is alien to it, but in appropriating its foundational property of compensatory sociality. What Attali's and other similar revisions accomplished was effectively to turn the idea of self-organization on its head: from self-management as a nonhierarchical principle of a society based on universal equality to the management of the self as a means of survival within postindustrial society in which individual flexibility comes together with an unquestionable rigidity of hierarchies.

THE MANAGEMENT OF THE SELF

As paradoxical as it may seem at the first sight, Irwin and the NSK were the last Yugoslav art movements. At least, that is how Irwin positioned itself in a diagram *Retroavantgarde*, which was included in Irwin's 1997 exhibit in Vienna's Kunsthalle.

In a gesture of mirroring Alfred H. Barr's diagram on the cover of the catalog for the exhibit *Cubism and Abstract Art* held at New York's Museum of Modern Art in 1936, Irwin places a twentieth-century timeline on the vertical axis. Whereas Barr starts his chronology of the emergence of abstract art at the top of the image with 1890 and ends at the bottom with 1935, Irwin starts at the bottom with 1900 and ends with the year 2000 at the top. In the diagram, Yugoslav Dadaist group Zenit occupies the point of origin. Next to Zenit, which was active in Zagreb and Belgrade between the world wars, is Mangelos, the pseudonym of Zagreb-based art historian and artist Dimitrije Bašičević, a member of the Gorgona group and one of the most remarkable representatives of proto-conceptual art in Yugoslavia. The central axis marked as "Roots" is topped with a triangular structure with Mladen Stilinović at its bottom corner, thus connecting the Zenitism-Mangelos line with the triangle. Two side limbs, indicated by dotted lines, point to the 1970s and the conceptual artist Braco Dimitrijević (on the right-hand side of the diagram) and Laibach Kunst, which references the first public statement that this group made in 1981. Finally, the two upper corners of the triangle, equidistant in relation to the axis Zenitism-Stilinović, are occupied by Irwin and "Malevich, Belgrade 1986." The former are, of course, the authors of the diagram. But what about the latter?

This was the same Malevich who signed a letter published in the September 1986 issue of *Art in America*. In this communication to the journal, Malevich expressed his dismay over his recent popularity with American painters such as David Diao, whose painting of the only surviving photograph from *The Last Futurist Exhibition 0.10* (Petrograd, December 17,

Fig. 29. Irwin: *Retroavantgarde*. Mixed media, 120 × 200 cm, 1996. Courtesy Galerija Gregor Podnar Berlin.

1915–January 19, 1916), was featured in the March issue of the same journal. "Malevich" went on to inform *Art in America* readers that he remounted the same exhibition exactly seventy years later, from December 17, 1985 to January 19, 1986, in a private apartment in Belgrade. The letter concluded with a question: "I know that for most of you this letter will come as a great surprise, since it is generally believed that I died in 1935! I know . . . Suetin's coffin . . . the great burial procession along the streets of Leningrad . . . the Black Square on the grave . . . Yes, there are many people thinking that I died. But did I?" (*Art in America* 1986:9). The letter is accompanied with a tiny photograph from the Belgrade "remount" of *The Last Futurist Exhibition 0.10*, which literally inverses Diao's procedure: while he painted a photograph of a painting, this was a photograph of paintings of paintings.[76] Finally, the signature—"Kazimir Malevich. Belgrade, Yugoslavia"—seemed to suggest that not only was the great modernist painter alive, but that he had moved from the former capital of Russia to the capital of Yugoslavia.

The Belgrade remount of *The Last Futurist Exhibition 0.10* was arranged in a small room of a private apartment located on 106 Third Boulevard in New Belgrade. The apartment belonged to conceptual artist Goran Đorđević. Asked some seventeen years later if Malevich was his pseudonym, Đorđević

vehemently replied that it wasn't: "That was not my alternative name of any kind. Not a part of my biography. Importantly, I don't think Malevich was ever anywhere as a person. It is more reminiscent of a character from a story, as Benjamin would put it" (Đorđević 2003:175). But which Benjamin? And where? While Đorđević is clear that the "Malevich" of the *Art in America* letter is not his nom de plume, he admits that it was "well known" that he was "involved in some way" in this exhibition as well as in other similar actions, such as a lecture "Mondrian '63–'96" that a Walter Benjamin held in Ljubljana's Cankarjev Dom gallery in June 1986.[77] On this occasion, the lecturer recounted an incident in which, during a visit to a National Museum, he encountered two identical paintings by Piet Mondrian.

> Suddenly, we feel that the earth beneath us has begun to shake. We quickly look at the wall. It, too, is shaking. We are struck by the thought: earthquake! . . . But what is happening to our painting? It is completely still—it is actually floating in its nonexistent space, as though what is happening around it does not concern it. . . . Still shaken by the previous dramatic events, we make ourselves a cup of coffee, sit on the floor, light a cigarette; and when we think about everything that has happened, our eyes accidentally, almost absent-mindedly, flow off to the wall where we have placed the painting. In an almost empty and half-lit room, on a wall, which once was white, two Mondrian's [*sic*] are hung: an original and a copy. (in Gržinić 2000:82)[78]

The situation described here pointedly resembles another public performance in which Đorđević was involved very directly. In 1983 he held a public painting session during which he copied the painting by Piet Mondrian that is exhibited in Belgrade's National Museum (Narodni muzej). This session was documented in photographs that were published, not at all accidentally, alongside two major interviews in which Đorđević discussed his work.[79] The photograph published in 1985 shows the situation depicted in the lecture: Mondrian's *Composition 2* (1929) displayed on a museum wall next to Pablo Picasso's canvas *Head of a Woman* (1909), and right in front of it an easel with a copy of *Composition 2*.

At first sight, the procedure of replicating an already existing painting resembles the technique of appropriation, which in the 1980s became one of the most representative characteristics of American postmodern painting. Đorđević was very well acquainted with the art scene of the 1980s, especially in New York, where he spent the years 1982 to 1984 on a Fulbright

Fig. 30. Goran Đorđević: *How to Copy a Mondrian*, 1983. Courtesy of the artist.

stipend. During this time, he participated in several group shows, includ-ing the exhibit *Artists Call*, held in January 1984 at Judson Memorial Church. This show, organized in protest against U.S. involvement in El Salvador and Central and South America, featured several emerging appropriation artists, such as Walker Evans and Sherrie Levine. Đorđević participated in this exhibit with five copies of Malevich's paintings made on cardboard.[80] Asked about the difference between appropriation art and his work on copies, Đorđević suggested that "appropriation is, basically, an extension of pop art," that is to say, appropriation artists such as Sherrie Levine and Richard Prince were engaging in "copying of other paintings primarily on the level of iconography." He explained further: "They used the procedure of copying *implicitly*, so to speak, and did not see, or did not want to see, the true potential of the copy and its, essentially, subversive potential" (2003:169).[81] A copy does not only reproduce, it brings into question the ontological and institutional status of that which it replicates:

> The subject of the artist's interest was the copy itself and its relation to the original. What we have before us, therefore, are two paintings, which are the same, but with two completely different ideas hidden

behind them. We see in the original what its idea is, but we could not say the same for the copy. This means that the copy contains the idea of its ideal, as well as its own idea: the idea of the copy. Hence it follows, paradoxically, although seemingly truly, that the copy can be multilayered in its meanings and more complex than its original. (in Gržinić 2000:82)

In 1984, Irwin organized the exhibit *Back to the USA* in Ljubljana's ŠKUC, in which were displayed copies of paintings from a blockbuster art show of the same name that was touring Europe at that time — and which Yugoslav art institutions had no means of hosting.[82] Alongside copies of paintings by Jean-Michel Basquiat, Keith Haring, Julian Schnabel, and other representatives of American art of the 1980s was a "considerably enlarged copy of the copy of Đorđević's *The Harbingers of the Apocalypse*, done in the style of a graffiti painting by Jonathan Borofsky at the end of the 1970s" (Gržinić 2000:72). Gržinić explains that at that time Đorđević had already started working on his replicas of *The Harbingers of the Apocalypse* and had asked Borofsky and others to make a copy of his painting (the works that ended up in the exhibit in his apartment in 1980). Also, this was not the first time that a copy (of a copy) of *The Harbingers* was shown in Ljubljana: after Đorđević's apartment, *The Harbingers of the Apocalypse* copy collection was shown in Berlin's Museum für Sub-Kultur, Expanded Media gallery in Zagreb, and in Ljubljana's ŠKUC. Upon his return from the United States, Đorđević worked on a series of paintings in which he reproduced depictions of abstract art in magazine cartoons, which he exhibited a show entitled *Scenes of Modern Art* (*Prizori moderne umetnosti*), mounted in 1985 in the SKC's Happy Gallery and Ljubljana's ŠKUC. This was, as he put it, "the last exhibit of the author Goran Đorđević," and it was followed by projects such as *The Last Futurist Exhibition* and Benjamin's lecture.

Đorđević's exit from the art scene involved a rejection of conceptual art and of institutions that validated this kind of work as art, or, for that matter, any art since the advent of modernity. The latter is important for this discussion because it is tied up with the production and validation of art within a specific historical and political formation called the Socialist Federative Republic of Yugoslavia. What could it mean for someone who was in some, even marginal, way engaged in art production in Yugoslavia in its final decade, to renounce art institutions, even the most experimental ones, such as the SKC? At the very basic level, Đorđević's shift from the public space of the gallery to the private space of his apartment can be read as a critical comment on Yugoslav society. In the 1960s and 1970s, the main dif-

ference between the institutional position of alternative art in Yugoslavia and in other socialist countries was that in Yugoslavia it was produced and received in public art spaces, whereas elsewhere in Eastern Europe it was made and seen clandestinely, in private apartments and studios. By removing his art from the public into the private sphere, Đorđević seemed to assert that art as an institution, and Yugoslav ideology in general, had moved back in time, or even worse, that structurally it had never been different from totalitarian societies of the Soviet kind. But the artist's intervention doesn't stop at a mere comment on the political and social issues of the day. He goes further to renounce not only "the institution of art" as an abstract social entity, but all of its central categories, including the work of art and the artist him- or herself. Đorđević indicated his comprehensive refusal of the art already in the note printed on the card that accompanied his 1980 exhibit *Against Art*: "The work of art expresses, among other things, an attitude toward art. The works on display in this exhibit are not the works of art. They are only attitudes about art; or more precisely, attitudes against art. I think it is the last moment for art to decisively remove its manicured mask of freedom and humanism and reveal its true face: that of a faithful and obedient servant" (in Đorđević 2014:13). The decisive moment in this renunciation came four years later, in the interview he gave to art historian Slobodan Mijušković, in which the (former) artist established a direct causal relationship between the copy and the question of authorship: "If there are attributes characteristic for modern art, then they are the new, the original, the authentic, the imaginative. And copying is a direct opposite of all of that: it repeats, reproduces, is imitative, sterile, and unimaginative" (1985:9). Once initiated, the refusal doesn't stop at a single artistic action or even a series of events. It is not a project. In the final analysis, by denying the properties of uniqueness, distinctiveness, and ingenuity it questions not only the artist, but the modernist idea of the subject.

By leaving behind art institutions and his authorial "self," Đorđević joins the debate about the "death" of the author that started in the late 1960s and peaked in the mid-1980s (this timeline fits very precisely his own biography from the moment of "entering" art to stepping away from it).[83] Consider, for example, Gilles Deleuze's mini-tract "The Powers of the False" from *Cinema 2: The Time-Image*, published in 1985, in which he observed that "there is no unique forger, and, if the forger reveals something, it is the existence behind him of another forger. . . . The truthful man will form a part of the chain, at one end like an artist, at another, the nth power of the false" ([1985] 1989:134). This is because "the power of the false cannot be separated from an irreducible multiplicity. 'I is another' ('*Je est un autre*')

has replaced Ego=Ego" (133). In Rimbaud's cry we find the seed of an alternative *autre* art, a truly subversive second line, which rejects the idea of the artist as a personification of the self-identity of the modernist subject. But, to speak of the destruction of the myth of the unitary figure of master author is one thing, to do it is another. The article "On Copy"—first published in 2013, but which Đorđević nonetheless frequently already references already in his 2003 interview—presents the copy's destabilization of the work of art, including the very notion of authorship. The starting premise of this article is that the modernist definition of the author as "an exceptional and unique individual" precludes the authorial status of a copyist. "The maker of a copy could not be an author. Furthermore, in a copy we still see only the original and its author, while the maker of the copy completely disappears" (2013:22). This makes the copy—a supposedly worthless object—as a stand-in not only of the "original" and its author, but also of the author of the copy itself. By his or her participation in the art market, the artist at least partially (at most, completely) renounces his or her position as a discrete subject endowed with intentionality. An artwork stands in for an artist in the same way a copy replaces the original. What acts here is the object, not the object-maker. A copy is not contained either in the first iteration (the "original") or in its repetition: it is a figural and material form of negation. Whereas "new art practices"—and performance more than any other among them—appear to resist media while actually never ceasing to be one, a copy thrives on media (of any kind, especially traditional) but maintains its own ambivalence as an art medium. The price is its exile at the distant margins of art, in the netherworld occupied by kitsch and forgeries: in nonart.

The direct political consequence of the refusal of authorship is a demystification of art through its deskilling. In his 2003 interview, Đorđević makes this point in a deadpan way: "When in 1983 I held a public session of copying Mondrian, I brought my easel, set it up in front of the painting, and started copying. From the point of view of the common reasons for copying—the acquisition of painterly technique—this was a complete idiotism. Even a museum guard approached me and asked why didn't I choose some more complex painting to copy" (168). Translated into the language of Marxist theory, if the modernist work of art preserves a certain premodern idea of the touch of the producer and as such epitomizes the "living" or "concrete" labor as the source of political subjectivity, then copies belong to the realm of "dead" and "abstract" labor, deprived of authenticity and productivity. In other words, within capitalist conditions of production, nonart is tied up with nonwork. Following this logic, Đorđević's

turn to the production of copies not only demystifies art as a form of production endemic for capitalism, but also points to its role in the political economy in which unskilled factory work is depreciated to the point of ethical condemnation. By giving up art in favor of copies, Đorđević recasts himself, a former artist, to the position of a nonartist or an unqualified mass worker of the kind Tronti spoke about. Đorđević's attributes of the copy— repetitiveness, passivity, unimaginativeness—exactly match Tronti's program for the organization of alienation in an act of refusal.

In the case under consideration here, this refusal of art and art institutions, including their prince, the artist, took place within a paradoxical ideological order of associated labor that was, as we have seen, defined by simultaneous (museum-like) enshrinement of the worker as the political subject, which came hand in hand with the (copy-like) economic depreciation of this same subject. Đorđević's withdrawal from art was entirely different from Vasilije Popović's exit from the theater in the 1950s and Ivo Gattin's from painting in the 1960s. The case of the director of *Waiting for Godot* is clear: disappointed with the ideological hypocrisies of theater as an institution, he merely opted for a medium that gave him more autonomy while not questioning the overall meaning of art in Yugoslavia. Gattin was certainly more consistent in his refusal: instead of changing registers, he went silent upon exhaustion of the expressive possibilities of art-making techniques he explored to their very limit. The key difference between these early refusals and Đorđević's gesture of stepping out from the art world in the 1980s is that the latter illuminated the meaning and the stakes involved in ideological (un-)suturing. If, politically, the principle of suturing can be said to designate a particular way in which the subject ties itself to the chain of ideological signifiers, then the last Youth Day spectacle in 1988 represents a glaring example of a false unsuturing: by asking for complete aesthetic autonomy and purity of the work of art—to the point, a mass performance—while maintaining its economic dependence on the state, Magelli and company did not break away from the ideological signifying chain, but tried to redefine the suture in seemingly apolitical terms. That makes the final Youth Day spectacle the failed masterpiece of socialist aestheticism. Đorđević understood very well that every act of artistic representation amounts to a certain staging of the subject. His turn to copies gives a special pertinence to Miller's point about the meaning of repetition in the process of (ideological) suturing. We can put it this way: if "the definition of the subject comes down to *the possibility of one signifier more*," then "repetition itself is produced by the vanishing of the subject," or we can add, its *aphanisis* ([1966] 1978:33). Seen in the context of Yugoslavia's wan-

ing days, Đorđević great project of the refusal of author status is deeply political. His work is not *about* disintegration of the narrative called the Socialist Federative Republic of Yugoslavia. Instead, it is fundamentally informed by the insight into the conditional nature of institutions commonly deemed eternal, such as homeland, identity, artist, and artwork. In 1988, he adopted the pseudonym Adrian Kovacs, and under this name he joined Jedinstvo, an amateur art society. Until 1991, Kovacs participated in Jedinstvo's collective exhibits with his black-and-white self-portraits, still lifes, and copies of Cézanne. His vanishing from the Belgrade art scene went almost unnoticed, drowned in tens of thousands lost to death, impoverishment, depression, and exile.

Afterword: "A" is for . . .

A-effect? Afterword? Afterlife? This is where the bottom falls off; where the big fracture yawns to swallow people, images, performances, stories, buildings, relationships . . .

In December 1988, unable to curb inflation, the prime minister of Yugoslavia, Branko Mikulić, resigned. This was the first resignation of a politician in such a high post in the history of Yugoslavia—and the last one. The following March, Ante Marković, an engineer by training with a long career in management in some of the leading enterprises in Croatia, was named the prime minister. His government implemented an aggressive reform program that curbed hyperinflation within months. This program, proclaimed on December 18, 1989, set up the process of dismantling many principal features of self-management, such as privatization of socially owned property and the removal of limits that regulated private ownership of arable land. Most features of self-management survived into the 1990s, only to be dismantled in the bloodiest process of transition from socialism in all of Eastern Europe. No doubt, atavistic nationalist ideologies played a major part in the country's demise. However, the vital significance that the defeat of self-management had in the unraveling of Yugoslavia is too often ignored.

As late as 1991, Asef Bayat claimed that "the Yugoslav experience represents a uniquely alive model to which every theoretical debate and practical experiment in workers' participation and self-management makes reference" (1991:20). Starting in the early 1950s and going into the 1980s, Yugoslav self-management served as an important case study for the transfer of the principles of workers' participation from industrialized countries to the Third World.[1] However, as Bayat himself observed, the advance of "flexible" capitalism in the 1980s coincided with an "almost overwhelming . . . lack of interest in workers' control" (40). Yugoslavia fared no better than movements in the West that advocated forms of labor organization that were adverse to the "new spirit of capitalism." It treated Yugoslav self-management in very much the same way it did other, internal, demands for

workers' full participation in decision-making and the profit distribution process: it either stomped it out or retooled it for its own purposes. A quarter century had passed, and from this vantage point it seems that no variant of socialism could survive in Europe, no matter how laissez-faire it was. The cataclysm of Yugoslav "soft" socialism exposes the hard core of neoliberal capitalism.

Self-management was not the cause of Yugoslavia's collapse. Workers' councils did not engineer the wars, nor did they have the power to stop them. In the end, it was precisely those mechanisms and structures that were rigidly hierarchized and thus inherently opposed to self-organization and self-management—the army, the police, and the Party—that were instrumental in the violent dissolution of the country. Self-management was never banned or prohibited. All governments that emerged from Yugoslavia's ruins, regardless of their relationships with one another, or how they have revamped their ideological state apparatuses, have one and only one thing in common: their scorn for self-management. Self-management had to be ruthlessly discredited and obliterated to make room for the transition to capitalism. In its routine form, the discrediting of self-management involves the projection of its decadent phase, that of associated labor, to its entire history. As a result, what emerges is the image of yet another totalitarian communist regime like the other in the Eastern bloc, only more hypocritical. This obliteration is so thorough that self-management remains unmentioned even during the waves of nostalgia that occasionally sweep through the region. It is a supplement and a blemish on the face of the fondly remembered past. A waste product of history. If self-management was a defining characteristic of the second Yugoslavia, then this radical caesura serves to make it into a discrete historical object safely deposited in the past. "A," than, could be seen as standing for an artifact, a distant object alien to the present. However, this artifact is not a dead thing. It has a dynamic form that Benjamin names an "afterlife," which he considers "the foundation of history in general" (Benjamin 1999:460). "A" is for afterlife; for that which goes on living. A lot has been said about postsocialism and its relation to postmodernity, about post-Yugoslav condition and post-Yugoslav "space," but not a word about post-self-management. It seems that it simply doesn't lend itself to the discourse of post-ness. The historical evidence from the past century suggests that the proper time of self-management is that of what Benjamin called "now-time" (*Jetztzeit*), which "comprises the entire history of mankind in a tremendous abbreviation" (2003:396). In this temporal schema, socialism was the antechamber for the

(second) coming of communism. Asserting itself in this way, it eradicated the true potential for revolutionary change:

> In reality, there is not a moment that would not carry with *its* revolutionary chance—provided only that it is defined in a specific way, namely as the chance for a completely new resolution of a completely new problem [*Aufgabe*]. For the revolutionary thinker, the peculiar revolutionary chance offered by every historical moment gets its warrant from the political situation. But it is equally grounded, for this thinker, in the right of entry which the historical moment enjoys vis-à-vis a quite distinct chamber of the past, one which up to that point has been closed and locked. The entrance into this chamber coincides in a strict sense with political action, and it is by means of such entry that political action, however destructive, reveals itself as messianic. (402)

This is the meaning of the afterlife of the historical moment, and self-management is not a model but a moment in the full sense of the now-time. It is a communism without an heir: without progeny, with no current actors to claim their future custodianship of the present (and in that very gesture rush it into the past), and in doing so exhaust it of the chance that each now carries. That would be the structure of post-ness. Self-management, like performance, belongs to an after-ness that evades sequentiality and causality. There is no doubt that it is always already safely deposited into the past, but the meaning of this depositing remains an open question. That is to say: "A" is for an afterchamber that remains accessible only to those who have no present awareness of its existence, for they are no heirs.

Yugoslav self-management and all of its properties, such as social ownership over the means of production and collective decision-making, have been wiped out without a trace. (And that is good, as Benjamin would say.) To a great degree, this stomping out of existence of the last vestiges of memory about the experiment with the empowerment of workers in Yugoslavia is yet another proof of the aggressive imposition of free-market fundamentalism that took place in Eastern Europe during the period of transition from socialism. As it turned out, this trivializing, ridiculing, and eradicating of self-management was a function of just one phase of its radical reconstruction: at the other end, it emerges as one of the strategies in a vast economic and ideological toolbox of neoliberal capitalism, alongside securitization, risk management, disaster economics, and new wars doc-

trine, to name some. According to Randy Martin's assessment of the economy during the so-called war on terror, "The promise of a better future and the interest of capital in its own utopian aspirations have largely been abandoned in favor of a rather disenchanting ethos of self-management. Despite the advertised enthusiasm that all should be managers of their affairs, the ethos of responsibility is not shared, and people are left to manage the mess that the imperious investors deposited before taking flight" (2007:15). Transubstantiated by "flexible" capitalism, self-management is no longer a clarion call for solidarity and equality, but a keyword for an every-man-for-himself ethos. This is where the great normalization turns (A-)effects into effort, efficiency, efficacy (effing A!). On the other side of the coin (and, as it were, of the world), these very neoliberal policies lead directly to the renewal of the idea of integral self-management in the Argentine recovered-factory movement. Following the collapse of the Argentine economy under pressure of IMF-imposed measures, mass protests erupted in December 2001 in which workers started reclaiming bankrupt factories that their owners had fled. As Graciela Monteagudo shows in her ethnographic work on one of these factories, the workers' occupation of the workplaces they lost resulted in new forms of "heterarchy" that allowed for a "egalitarian hegemony" that does not owe its existence and survival to ideological models enforced by political parties, but precisely to a rigorous opposition to them (Monteagudo 2008:198). In the late 1980s, Yugoslavia went through a similar IMF-induced crisis. At its peak, political leaders changed the basic criterion of political subjecthood from labor to ethnicity. Unlike in Argentina, where the workers stormed factories left by the owners, in Yugoslavia the unemployed workers left the factories that they legally owned, and stormed each other's neighborhoods and households. That is the crude outline of the story that unfolded all around me in the dark days of Yugoslavia's disintegration; however, in this very darkness I saw the sparks of spontaneous self-organization that served as a foundational experience in the writing of this book.

Notes

INTRODUCTION

1. After the Eleventh Istanbul Biennale, where it was presented from September to November 2009, *Perestroika Timeline* was installed in the exhibition *Without Reality There Is No Utopia / Sin realidad no hay utopía*, held in Centro Andaluz de Arte Contemporáneo in Seville from April 14 to July 11, 2011, and at San Francisco's Yerba Buena Center for the Arts from February 15 to June 9, 2013. In their curatorial statement, Alicia Murría, Mariano Navarro, and Juan Antonio Álvarez Reyes make a direct link between the collapse of communism and the 2008 market crash: "The fall of Berlin Wall," they wrote, brought in its wake "ideological and programmatic changes of extraordinary depth, the final structure of which has been definitively consolidated, while simultaneously positioned in its appropriate perverse and damaging perspective by the ferocious crisis triggered, only two decades later, in the very sustainability of the Capitalist system and its single thought discourse" (Murría, Navarro, Álvarez Reyes 2013:3).

2. *Perestroika Timeline* is available at Chto Delat? website: http://www. chtodelat.org, last accessed on October 28, 2013.

3. http://www.ressler.at/alternative_economics/. Last accessed October 30, 2013.

4. For an excellent discussion of this aspect of recuperated factory movement, see Victoria Fortuna's dissertation "Poner el cuerpo: Buenos Aires Contemporary Dance and the Politics of Movement" (Northwestern University, 2013). In 2008 the Danish group Superflex, in collaboration with art historians and curators Cristina Ricupero, Will Bradley, and Mika Hannula, published *Self-Organisation / Counter-economic Strategies*, a compendium of essays and case studies on noncapitalist modes of organization that features an article on the Argentine recovered-factory movement. While the article is informative, the quality of essays in this collection is uneven.

5. Because of that, the theory and practice of recent socially engaged art often rely on activist pedagogy such as Paulo Freire's *Pedagogy of the Oppressed* (1968) and Jacques Rancière's *The Ignorant Schoolmaster: Five Lessons in Intellectual Emancipation* (1987).

6. Helguera cites relational aesthetics as SEA's "immediate predecessor" (3). In his *Education for Socially Engaged Art: A Materials and Techniques Handbook*, Helguera offers this kind of historical narrative in a broad outline. Shannon Jackson discusses this in more detail in *Social Works: Performing Art, Supporting*

Publics (2011) and so does Claire Bishop in *Artificial Hells: Participatory Art and the Politics of Spectatorship* (2012).

7. In the twentieth century, there were three different incarnations of state that went under the name of Yugoslavia. The Kingdom of Serbs, Croats and Slovenes (Kraljevina Srba, Hrvata i Slovenaca) was established on December 1, 1918, and its name was changed to Kingdom of Yugoslavia (Kraljevina Jugoslavija) in 1929. The "second" Yugoslavia was established after World War II under the name Federal People's Republic of Yugoslavia (Federativna Narodna Republika Jugoslavija, or FNRJ), and its name was changed in 1963 into Socialist Federal Republic of Yugoslavia, or SFRY (Socijalistička Federativna Republika Jugoslavija, or SFRJ). Whereas the first Yugoslavia was monarchist and unitarist, the second Yugoslavia was socialist and federative. It consisted of six republics (Slovenia, Croatia, Bosnia and Herzegovina, Serbia, Montenegro, and Macedonia) and two autonomous regions (Vojvodina and Kosovo, both within Serbia). Upon disintegration of the SFRY, the third Yugoslavia emerged: the Federal Republic of Yugoslavia (Savezna Republika Jugoslavija), which consisted of Serbia and Montenegro. It lasted from 1992 to 2003.

8. A note on terminology: Serbian, Croatian, and Slovene share the same word *samoupravljanje* (the Macedonian version is *samoupravuvanje*; the large Albanian minority in Serbia, Macedonia, and Montenegro use the Albanian word *vetëqeverisje*; the Hungarian word is *önigazgatás*). In order to maintain a distinction between Yugoslav *samoupravljanje* and French *autogestion*, in discussion of the former I will use the standard English translation, "self-management," and leave the latter in the original.

9. We can also add Cornelius Castoriadis's more pragmatic definition: "What is to replace the social division between directors and executants and the bureaucratic hierarchy in which it is embodied is self-management [*autogestion*], namely, the autonomous and democratic management of various activities by the collective action of those who carry them out. Self-management requires the actual exercise of power by collective bodies of those directly concerned in their own area, that is, the widest possible direct democracy; the election and permanent revocability of each delegate with any particular responsibility; the coordination of activities by committees of delegates also elected and liable to recall at any time" ([1968] 1993:135).

10. Some historians of Yugoslav self-management even speculate that Yugoslav communists who volunteered for the Spanish Civil War and eventually became high Party functionaries were exposed to "experiments in workers' self-management carried out by Catalonian anarchists," an experience that could have played a role in their choice of an alternative to the Stalinist model of socialism (Terzuolo 1982:216). In his article "Workers' Management" Ašer Deleon sketches a genealogy of Yugoslav self-management that is indicative of the breadth of sources that early Yugoslav theoreticians of self-management were embracing: "This idea, and this aspiration of the working class to determine directly their own destiny, have been kept alive since the time of the Utopian socialists: during the German revolution of 1848, in Marx and Engels' vision and scientific elaboration of a socialist and communist society; during the

preparations for the constituent assembly of the First International; in the ephemeral but very rich experience of the Paris Commune, in the groupings of anarchist organizations everywhere in Europe, towards the end of the last century; through the almost timid aspirations of the new-born European trade union movement; in the eclectic and inconsequent essays of Kautsky, Bauer and Adler; in the first miners' committees in Germany, in certain joint bodies born of the necessities of the First World War in many industrial countries; in the Whitley Councils, the Shop Steward Committees, the undertaking and works councils, the factory committees, the 'workers' Soviets' and workers' supervisory committees during the early years of Soviet rule; in the organs set up during the German uprising and inspired by the October Revolution; in the workers' committees of Béla Kun's Soviet Hungary; in the first Austrian Undertaking Councils Act immediately after the First World War; in numerous speeches by Lenin in which he foretold the need for workers to take a part in direct decisions and to be prepared for workers' management; during the occupation of the factories by Italian workers in the twenties of this century; in the revolutionary experience acquired during the Spanish Civil war in factory management" (Deleon 1959:50).

11. For the first, see Dragan Marković, Miloš Mimica, and Ljubiša Ristović's *Factories to Workers: Chronology of Workers' Self-Management in Yugoslavia (Fabrike radnicima: hronikao radničkom samoupravljanju u Jugoslaviji;* 1964), and for the second, Yvon Bourdet and Alain Guillerm's *Self-Management (L'Autogestion;* 1975). Anton Pannekoek was a Dutch proponent of council communism and a harsh critic of Lenin's doctrine of armed revolution.

12. It seems that the most active among them were Edvard Kardelj, Boris Kidrič, and Milovan Đilas. However, with Kidrič's premature death in 1953 and Đilas's political downfall the following year, Kardelj remained the most influential ideologue promoting Yugoslav self-management. Of course, this is not to say that it was entirely his brainchild. Other high officials contributed significantly to this system, Tito included.

13. The internal mechanism of self-management was complemented by Yugoslavia's leading position among nonaligned nations. Together with Egypt and India, Yugoslavia was a founding member of the Non-Aligned Movement (NAM), which held its first conference in Belgrade in 1961. For Yugoslavia, this was a very convenient way of opening up the country without falling into either one of the two military blocs. (It was equally convenient for Western democracies, the former colonizers, because the adoption of Yugoslav-style socialism by countries such as Egypt prevented these countries from coming under the sway of the USSR the way Syria did.) Further, because the establishment of the Non-Aligned Movement came at the height of decolonization, it provided Yugoslavia with ever-expanding economic opportunities and political alignments.

14. After the war, Ristić was the Yugoslav ambassador to France, and starting in 1948 he presided over the influential Commission for International Cultural Liaisons (Komisija za kulturne veze sa inostranstvom). Other former surrealists held important positions in cultural institutions: Milan Dedinac was the

editor of the major Belgrade daily *Politika*; Dušan Matić was the dean of the School of Theater and Film; and Oskar Davičo was a founding editor of the important literary journal *Delo*.

15. The museum opened in October 1965 in a brand-new facility built near the confluence of the rivers Sava and Danube, designed by the prominent Yugoslav architect Ivan Andrić. Instrumental for the setting up of the museum (and for the establishment of socialist aestheticism in painting) was the painter and art historian Miodrag B. Protić.

16. Over time, the distinctions between self-management and associated labor, both as political and economic concepts and as distinct periods in the history of Yugoslavia, became blurred in popular representations of the Yugoslav past. This was compounded by politicians, who don't hesitate to blame cumbersome bureaucratic mechanism of associated labor, which they routinely label as self-management, for economic troubles that eventually led to the wars of the 1990s. There has been very little scholarly effort to bring some clarity to the historiography of self-management in Yugoslavia.

17. Different authors offer slightly different periodizations. For example, writing in the early 1980s, Predrag Matvejević speaks of four periods, the fourth one beginning in 1981 with the crisis of the associated labor system (1982:138). Among authors who assign special significance to the constitution of 1974 is Dejan Jović (2009), who takes it as a watershed between the third period, or Tito's Yugoslavia, and the fourth, which he designates as Kardelj's.

18. As Mislav Kukoč points out, by the mid-1980s over four works on this subject had been published in Yugoslavia (Kukoč 1985b:725).

19. See *The Encyclopedia of Philosophy*, vol. 1, pp. 76–81 (New York: Macmillan and Free Press, 1967).

20. The ultimate irony of these early assessments of Sartre's existentialism in Yugoslavia was that Supek and Ziherl soon ended up in opposing ideological camps: while the former became one of the key members of the Praxis group, the latter steadfastly adhered to his diamat positions.

21. The recognition of Sartre in Yugoslavia stepped up with his visit to Belgrade in 1960 and culminated with the 1983 publication of the Serbo-Croatian translation of his selected works in twelve volumes. This was an honor bestowed on few foreign contemporary thinkers in a country that was in the early 1980s on the verge of an economic crisis of vertiginous proportions. Another notable example is Erich Fromm, whose selected works, also in twelve volumes, were published in 1986.

22. This view about self-management as a palliative against alienation was not limited to Yugoslav ideologues and social scientists. See, for example Alan Whitehorn's paper "Alienation and Workers' Self-Management" in which he argues that "polyarchy" is "inversely related to the presence of alienation" and then goes on to demonstrate that Yugoslav self-management of the 1960s and 1970s is a "poliarchic" system (1974:175).

23. For an informative survey of Lyotard's changing opinions on the subject of alienation, see Claire Pagès, *Lyotard et l'aliénation* (2011).

24. In the mid-1980s, right before his breakout on international scene, Žižek

became known to a broader audience in Yugoslavia as a supporter and inter-
preter of the postmodern art scene in Slovenia.

25. Then he goes straight to the point: "Of course, some minorities, such as
the Frankfurt School or the group *Socialisme ou barbarie*, preserved and refined
the critical model in opposition to this process. But the social foundation of the
principle of division, or class struggle, was blurred to the point of losing all of
its radicality; we cannot conceal the fact that the critical model in the end lost its
theoretical standing and was reduced to the status of a 'utopia' or 'hope' [. . .]"
(Lefebvre ([1979] 1984:13).

26. Translations from "L'aliénation" are by Jasminka Jakovljević.

27. Here I reverted to Artaud's original French to restore the ambiguity he
gives to the word *aliénation* in his other writings from this period, such as his
poem *Aliénation et Magie Noire* (1995:160). In Artaud's *Selected Writings*, edited
by Susan Sontag, the translator, Helen Weaver, renders this phrase as "authen-
tic madman" (1976:485). For the original, see Artaud 1974:17.

28. The title of this essay is "The Politics of Ecstasy," an obvious reference to
Timothy Leary's book of the same title.

29. McKenzie writes: "Nor am I posing performance in opposition to disci-
pline; rather, performance is, in part, a displacement of discipline, a breaking
down, transformation, and reinscription of its discourses and practices within
an entirely different milieu of forces, one that generates statements and visibil-
ities unimaginable within disciplinary societies of the eighteenth and nine-
teenth centuries" (2001:179).

30. According to Boltanski and Chiapello, the first phase of capitalism, or its
first "spirit," is characterized by bourgeois entrepreneurship based on owner-
ship of the means of production. The second phase, or the "second spirit of
capitalism," overlaps with industrial capitalism. The first "spirit" is relegated
to the nineteenth century (the period of Marxian analysis), and the second to
the mid-twentieth century, from the 1920s to 1960s. The first features of the
"third spirit" of capitalism, in which globalization and multinationals replace
national economies, where networks are preferred to hierarchical structures,
and projects to stable enterprises, emerges during the crisis-ridden 1970s, and
it fully settles in during the 1980s to become the dominant organizational model
in the decade that follows.

31. Since its publication in 1998, Bourriaud's idea of "relational aesthetics"
has attracted a lot of adherents in the art world, but it has also been the subject
of sharp criticism. See, for example, Claire Bishop's "Antagonism and Rela-
tional Aesthetics" (2004). For an especially insightful critique of Bourriaud's
project, see Eric Alliez's article "Capitalism and Schizophrenia and Consensus:
Of Relational Aesthetics" (2010).

32. The most glaring recent example of this kind of wholesale approach to
Eastern European art is the anthology *East Art Map: Contemporary Art and East-
ern Europe*, edited by the Slovene collective Irwin. The group's claim about a
level art territory that stretches from the Adriatic to the Pacific is an oversimpli-
fication, to say the least.

33. The argument for performance specificity I am making in *Alienation Ef-*

fects is at the same time a critique of Boltanski and Chiapello's "artistic critique." One of the problems of their "artistic critique" comes from collapsing various creative traditions and practices into a vast and nebulous category of "bohemia" or "art world." This pertains not only to their discussion of the historical avant-garde, but also to critiques of capitalism in the 1970s, which they by and large limit to a discussion of unions' demands and responses from the "employer class."

34. A proper history of the first still waits to be written; on the second (and on the experimental theater scene in Zagreb in the 1970s), see Marin Blažević's excellent book *A Defeat Won: New Performance in Croatian Theater from Gavella to . . .* (*Izboren poraz: Novo kazalište u hrvatskome glumištu od Gavelle do . . .*) (Zagreb: Disput, 2012).

35. "Geological" precisely in the sense in which Lacan speaks of psychoanalysis's debt to this science (Lacan 1988:74).

36. Analogous to French "May," this is the shorthand used in Yugoslavia to refer to the student uprising in June 1968.

CHAPTER 1

1. New Collectivism was in charge of design. The other groups within NSK were the music group Laibach, visual art group Irwin, Sisters of Scipion Nasice Theater (Gledališče sester Scipion Nasice), the theory section in the Department of Pure and Applied Philosophy, architecture by Constructors (Graditelji), and multimedia by Retrovision (Retrovizija).

2. In her article "The Poster Scandal: New Collectivism and the 1987 Youth Day" Lilijana Stepančič gives a slightly distorted account of events. According to this version of the story, the author of the article in *Oslobođenje* was "a certain engineer Grujić," whose article was picked up two days later by Belgrade daily *Politika* (Stepančič [1994] 2003:44). In fact, an article about the scandal published in *Politika* on Sunday, March 1, 1987 (a day after *Oslobođenje* broke the story) included a blurb, "How Was the Deception Unmasked?" which stated that "geophysics engineer Nikola Grujić" had called the editorial office two days earlier (Friday, February 27, the day when *Politika* published the image of the poster on its front page) with the disclosure about the source of the Youth Day poster (Stojančič 1987:5). It remains unclear how this information reached the editors of *Oslobođenje* in Sarajevo.

3. According to official birth records, Josip Broz was born on May 7, 1892, in the Croatian village of Kumrovec. During the pre–World War II years of his activity in the (then) outlawed Communist Party of Yugoslav, and during the years he spent as the head of the communist guerrillas during World War II, many mystifications surrounded his identity, including his real name and his place and date of birth. According to one of the legends about Tito, in 1944 the Nazi occupying forces tried to apprehend him on May 25, the assumed date of his birth. After narrowly escaping the enemy paratroopers, he reportedly stated that he felt as if he was reborn. Judging by the initiative that was started the following year, his associates took this literally.

4. This witness-participant account comes from the monograph about Tito's *štafeta* published in 1981. Thus, it belongs to a deluge of celebratory publications produced immediately after Tito's death. The author obviously confuses dates and times. The Munich Olympics were held in 1972. The last Olympics before World War II were the so-called Nazi Olympics held in Berlin in 1936. This image of the torch at dusk, which established a direct link between mass ceremonies in socialist Yugoslavia and Nazi Germany, comes as an unlikely anticipation of the Youth Relay in 1987, for which New Collectivism designed a poster based on a Nazi poster for the 1936 Olympics.

5. Citations are from, in order of appearance, Zogović 1949:4, Franičević 1947:576, Tošić 1949:17, Franičević 1947:577, Volokitinačić 1947:14, Burina 1949:3.

6. Yugoslav communist guerillas formed the leading antifascist force during World War II. This native liberation movement and its armed forces were one important feature that distinguished Yugoslavia from other countries in East, Central, and Southeast Europe that were "liberated" by Soviet troops.

7. High Party official Milovan Ðilas boasted that by the end of the Second Five-Year Plan, Yugoslavia would "catch up with England in industrial production" (Woodward 1995:75).

8. This division was introduced in the second year of the plan.

9. See, for example, discussion of Maksim Gorky's article "About the Struggle against Nature" in Dobrenko 2007:80.

10. Born into a peasant family in southern Serbia, Ilić lost his hearing at age twelve, and thereafter had a spotty education. He was eventually admitted first to the School of Fine Arts, from which he graduated in 1945 in the class of Milo Milunović, a pre–World War II modernist, who after the liberation tried his hand at socialist realism. With his paintings *Vjazma* and *Sondage of the Terrain in New Belgrade*, both first exhibited in 1948, Ilić overshadowed his teachers and the entire generation of prewar artists who were trying to adjust to the demands on artists made by the new authorities. He was hailed as the epitome of the new artist, unspoiled by bourgeois approaches to art. Most of the accompanying legends are about the unusual reception of his work: for example, his biographer claims that each of his new paintings was pompously announced in the media, and his old professor spun tales about Party functionaries breaking into his studio to see his works in progress. The peak of Ilić's career was the inclusion of *Sondage of the Terrain in New Belgrade* in the first postwar Yugoslav pavilion at the Venice Biennale in 1950. Ilić's sudden and speedy downfall came that same year. With the change of cultural policies, he was first ridiculed and then forgotten. For decades he survived on meager welfare checks. Late in his life, this deaf painter supported himself by making violins.

11. Abbreviation of Udruženje likovnih umetnika Srbije, Association of Visual Artists of Serbia. It is a professional organization of painters in Serbia founded in 1945.

12. Two years into the Five-Year Plan, the Brotherhood and Unity highway and the construction of New Belgrade became projects that received absolute priority among Party and state leadership. On January 10, 1949, the Politburo of the Communist Party of Yugoslavia's Central Committee decided that these

two sites would need some 160,000 voluntary youth workers, and two weeks later the Economic Council determined that the highway alone needed 155,000 workers (Selinić 2005:89). This shift from the railroad as the epitome of the disciplinary regime to the highway as perhaps most illustrative of the security system's mode of operation can be seen as indicative of the changes Yugoslavia was going through at that time.

13. The word *udarnik* is commonly translated into English as "shock worker," which is linguistically inaccurate. This translation became standardized in translations from Soviet sources in the 1930s.

14. Critics on the left have traditionally taken Gustave Courbet's 1849 *The Stonebreakers* as the painting that sets up the paradigmatic problem of representation of labor under capitalist conditions of production. As late as 1973, T. J. Clark wrote that in this depiction of two stooped workers "Courbet wanted to show an image of labor gone to waste, and men turned stiff and wooden by the routine" (Clark 1973:79). In his take on the same painting, Michael Fried glosses on Clark's "labor gone to waste" as "alienated labor," and goes on to ask: "how are we to understand the relation between the alienated labor of stonebreaking and the nonalienated labor of painting as these (and that relation) are represented in the *Stonebreakers*?" (Fried 1990:262). The ambition of socialist realism is to put an equation sign at the center of this relation, and by doing so, to revert the process of alienation of physical labor into a creative process akin to art.

15. In *Planning Theory and Philosophy* Marios Camhis points out that there was a significant change in planning theory after World War II. It moved "away from the old idea of blueprint production and towards the new idea of 'planning as continuous series of controls.'" In other words, it "shifted from changing reality to managing reality according to certain criteria" (1979:4–5). Following McKenzie, we can say that, together with the theory of management and futurology, planning theory emerges as a new science of the performance society.

16. Đorđe Andrejević Kun (1904–64) was one of the leading Serbian realists of the prewar generation who, as a founding member of artists' group Život (Life) in 1934, introduced socialist realist themes into Serbian painting. In 1941 he joined the communist guerillas, thus actively joining the resistance. After the war, he became one of the most celebrated painters in the nation.

17. Oto Bihalji-Merin was one of those interwar Yugoslav intellectuals who was comfortable in more than one culture. Born in Zemun, he joined the Communist Party in 1924 at the age of twenty. The same year he left for Berlin to study art, where he joined leftist circles and met Bertolt Brecht, George Grosz, and John Heartfield. In 1928 he returned to Yugoslavia and helped his brother Pavle found the journal *Nova literatura* (*New Literature*), which grew into Nolit, one of the most renowned publishing houses in post–World War II Yugoslavia. In 1930, he attended the International Congress of Revolutionary Writers in Kharkov, USSR, where the doctrine of socialist realism was established. A member of the German delegation, he read his report titled "Proletarian and Revolutionary Literature of Germany." In 1933 he became the founding director of Institut pour l'étude du fascisme (INFA), which operated as a front for Soviet propaganda in Western Europe. He was also an editor of the journal *Die*

Linkskurve, which severely attacked Sergei Tretyakov and other Soviet avant-garde writers. In 1934 he visited Moscow at Gorky's invitation, then traveled back to Switzerland, Spain, and Paris. He spent the war years in German camps and, after World War II, returned to Yugoslavia. He published widely and was one of the main advocates of socialist realism. In his latter years, he became an internationally recognized authority on primitive and outsider art.

18. In 1952 it was renamed the Communist Party of the Soviet Union (Kommunisticheskaya partiya Sovetskogo Soyuza, or CPSU).

19. Both documents were published in Volokitina et al. 1997.

20. Fred Warner Neal points out that Tito suffered his first gall bladder attack at the time of the resolution, and that Boris Kidrič confessed to him that during this time he "struggled with conscience so much" that his "skin broke out" (Neal 1958:4).

21. For example, in his "Political Exposé," presented at the CPY's Fifth Congress, held in July 1948, the Party Secretary-General Josip Broz Tito, addressed each accusation, expressing his hope that VKP's leaders would give the CPY a chance to prove that these accusations were inaccurate (Broz 1948:165). As we are going to see, soon thereafter he changed his tone completely.

22. Established in 1949, Goli Otok prison was active until 1956, when tension with the USSR eased. It is estimated that over forty thousand people were imprisoned in Goli Otok and other prisons, where thousands died. Many more were expelled from the LCY, which amounted to a public stigmatization.

23. By the end of the 1940s, a number of nondogmatic Marxists viewed the Paris Commune as a revolutionary festival. This idea was initiated by Marx himself in *The Civil War in France,* and continued by Lenin in his article "Two Tactics of Social Democracy in the Democratic Revolution." Surrealists embraced this idea in the 1930s.

24. Historians of Yugoslav self-management saw this law as the first step toward decentralization. See, for example, Bilandžić and Tonković 1974:28.

25. According to the mythology of self-management, the first workers' council was established in the "Prvoborac" factory in Solin, near the Dalmatian city of Split on December 31, 1949.

26. Eugen Pusić writes that "almost simultaneously with the establishment of the first people's liberation committee in the city of Krupanj in May 1941," there was "the first committee of workers' management" in a "local antimony processing plant" (Pusić 1968:50).

27. In an interview that was conducted for a collection of documents about the history of self-management, Gabelić was asked to comment on the existence of "committees of experts" that always included the most experienced laborers and shock workers (Alavantić and Ristović 1960:30).

28. Dobrenko cites the example of Stalin's *Economic Problems of Socialism in the USSR,* in which he praises Lazar' Kaganovich, the People's Commissar for Transport Communications, for his readiness to put the experience of workers over the abstract knowledge of scientists (2007:175). We find a similar juxtaposition of engineers and workers (and the privileging of the latter) in Josip Broz's exposé on the First Five-Year Plan (1949:15).

29. This initial identification with the Paris Commune as an epitome of social-

ism under siege eventually turned into a permanent historical source of Yugoslav self-management. See, for example, Strahinja Popović's "Self-Management in the Paris Commune" ("Samoupravljanje u Pariskoj komuni") (1971).

30. According to Bilandžić and Tonković, this also amounted to the Yugoslav Communists' declaration of their own authenticity and their return to the source of communist politics in Europe, which began with Marx's Communist league (Bilandžić and Tonković 1974:32).

31. A couple of years later, in general discussion at the first conference "Marx and the Present" ("Marks i savremenost"), which became an annual event, young philosopher Dragoljub Mićunović energetically questioned this idea: "Recently, there has been a lot of mention of 'total man' or 'integral man.' However, that term is not clear enough, and I would like to see it explained. What is total or integral man anyway? If we look at the literature, we will see that it received different interpretations. In one of Engels's sketches about the 'principles of communism,' he imagines him as a universal person who is hunting for a few hours, then solves mathematical problems, then plays violin, then works on political issues, etc.; . . . There is another interpretation of this term, according to which this is that whole person which managed to realize all of her potentials. But which potentials? Is that a reference to some specific aptitudes or something else that she needs to have developed in order to become a total person? We can try with a negative definition—that the total man is the one who is not alienated—but then we get into circular thinking" (Mićunović 1963:183).

32. The state's role in legal ownership of property varied in different periods of self-management in Yugoslavia. Basing his assessment on economic parameters, Bajt assesses that the state had the least sway over social property during the period 1965–74 (1988:162).

33. He returns to this experiment briefly in *Four Fundamental Concepts of Psychoanalysis* (1978:145).

34. Don Virginio Orsino, whose letter Stephen Greenblatt quotes in his introduction to *Twelfth Night* (Shakespeare 1997:1762).

35. The opposite can be argued as well: performance as a form of symbolic exchange entered capitalism as a remnant that survived from archaic economic models.

36. For an excellent discussion of postrevolutionary festivals in France, see Mona Ozouf's *Festivals and the French Revolution* ([1976] 1988).

37. One of the earliest pan-Slavists was the Croatian seventeenth-century scholar and missionary Juraj Križanić, whose ideas were adopted in the early nineteenth century by the Illyrian movement, which argued for the unity of the South Slavs and the national liberation of Croats from the Habsburg monarchy.

38. See Dušan Cvetković, *Sokoli i sokolski sletovi* (Belgrade, 1998), 21.

39. It is precisely in this lack of a common national mythos that the historian Dejan Đokić finds one of the main reasons for the failure of the interwar idea of Yugoslavism (2003:139).

40. For a range of in-depth discussions on the notion of Yugoslavism, see Dejan Đokić (2003).

41. Arguments for the transformative nature of large-scale celebrations underlie most of the contributions to the volume *Celebration: Studies in Festivity*

and Ritual (1982) that Victor Turner edited in conjunction with the exhibit he curated for the Smithsonian Institution in Washington, DC, *Celebration: A World of Art and Ritual.*

42. Most of these attempts consist in overreadings of the "Aesopian language" or in consideration of accidents that had no political significance whatsoever: sluggishness of the officials or poor performance due to the underpreparedness or drunkenness of the participants. The author herself admits as much: "While the actions of celebration participants were hardly aimed at overthrowing the Soviet government, the Soviet leaders' own discourse about enemies defined even the most trivial mistakes or non-conformist holiday behavior and language as overt challenges to Soviet power" (Petrone 2000:9).

43. The report on the carnival was published in the journal *Narodnoe tvorchestvo* 8 (1937):46. I used ellipses to occlude the culture-specific references. The first ellipsis replaces "waltz and tango, slow and fast fox-trot," the second "the Ferris wheels," and the third "Moskva." The other ellipses are in the text from which I am quoting.

44. If, as Frederick Hammond points out, the parade in a baroque *festa* is always oriented toward a goal, then the Youth Relay can be seen as a parade enlarged to such a degree as to include not only a single square or a city, but an entire state (1994:122).

45. There were only three exceptions: in 1967 and 1968 Tito again received the Youth Baton in front of the White Palace, and in 1976, it was carried all the way to his residence on the Adriatic island of Brioni.

46. For more information, see the Arhiv Jugoslavije, fond II, fascikla 20.

47. This message addresses Tito's dual significance as the victor in World War II and as the promoter of the principle of "active peaceful coexistence" in the bipolar world of the Cold War.

48. The first amount corresponds to approximately US$200,000 in 1972, and the second to US$290,000.

49. The author of the introduction to this volume was Predrag Vranicki, who soon became one of the leading members of the group of revisionist philosophers at Zagreb University.

50. See Vasetski and Butenko 1958. See also Butenko's *Against Contemporary Revisionism in Philosophy and Sociology* (*Protiv sovremennogo revizionizma v filosofii i sotsiologii*, 1960).

51. Rehar was a Slovenian-born literary and film critic, a former Communist guerrilla fighter who settled in Belgrade after the war. His polemic with Ziherl consisted of carefully selected quotes from Ziherl's article juxtaposed with Sartre's original text, which exposed the insufficiency of Ziherl's criticism. Rehar died of tuberculosis in 1957, having published only during the brief period from 1952 to 1956. According to Sveta Lukić, Rehar was a solitary representative of "engaged literary criticism" in Yugoslavia of the early 1950s (Lukić 1986:160).

52. The conference conveners Raymond de Saussure (the son of the linguist Ferdinand de Saussure), Paul Ricœur, Mircea Eliade, Robert Schuman, Guido Calogero, and François Mauriac readily acknowledged the existentialist origins of the conference theme. Recontres internationales de Genève started in 1946, and prior to 1953 it had the following themes: L'esprit Européen (1946), Progrès

technique et progrés moral (1947), Débat sur l'art contemporain (1948), Pour un nouvel humanisme (1949), Les droits de l'esprit et les exigences sociales (1950), La connaissance de l'homme au XXe siècle (1951), and L'homme devant la science (1952).

53. All translations of the conference proceedings are by Jasminka Jakovljević and the author.

54. In his 1972 book of essays, *Prywatne obowiązki (Private Obligations)* Miłosz offers a different picture of his initial response to *Waiting for Godot*. For the reception of Beckett in Poland (which contain translations into English of long excerpts from Miłosz's essay), see Kędzierski 2009.

55. The performance in Geneva is hardly ever mentioned in production histories of *Waiting for Godot* and in biographies of Beckett and Blin. In *Samuel Beckett: A Biography*, Deirdre Bair notes that in September 1953, "in order to satisfy curious Parisians who had missed the much-talked-about first engagement" (from January of the same year), Blin mounted a second run of the play, again at the Théâtre de Babylone, and again with the same cast, save for Lucien Raimbourg, who played Vladimir in the original production (1978:439). While she mentions that the second run also went on tour through France, Switzerland, Italy, and Germany, Bair does not discuss either the reception or impact the production had in these countries.

56. Miłosz was not the only one to attack the play so strongly. Ironically, the German representative at the conference, Ernst von Schenk, was equally critical of *En attendant Godot* (see Saussure 1954:239–40).

57. Invoking tensions between the Soviet Union and the capitalist West, he spoke of an "anguished, incoherent humanity, possessing no other unity than anguish" (Bataille [1967] 1991:147).

58. In the reminiscences of the conference he wrote more than two decades later, Matić claimed that the comparison with the *Lower Depths* came in his discussions with the "representatives from Poland and others," who objected that, unlike Gorky's *Lower Depths*, Beckett's play doesn't feature a "character that carries a promise of hope" (in Popović 1978:7). Miłosz was not exactly representing Poland, but as we have seen, his criticism of the play is consistent with Matić's description. As for "the others," the most likely candidates for the attackers on Beckett were French poets Pierre Seghers and Claude Roy, who were at the time close to the French Communist Party, one of main exponents of Soviet politics in Western Europe.

59. Born in 1926, Vasilije Popović joined the communist resistance in 1944. After the war, he studied economics before entering the School of Drama in 1949.

60. It was followed by a number of survey exhibitions of contemporary art in the West. Among these is the landmark 1956 exhibit *Contemporary American Art* from the collection of Museum of Modern Art in New York, which featured the complete generation of abstract expressionists and representatives of the generation that came after them, such as Robert Rauschenberg and Jasper Johns.

61. In a case that clearly indicated the vulnerability of the self-managing collective of actors to outside pressures, in 1952 Anouilh's prewar play *Thieves' Carnival* was taken out of the theater's repertory because a high Party function-

ary, Moša Pijade, found it morally offensive and inappropriate for a socialist society (Marković 1996:399).

62. For an English translation of these articles, see Milovan Đilas's *Anatomy of a Moral* (1959). Đilas was the first high-ranking Communist functionary in a socialist state to openly criticize the policies of his own government. There is extensive literature in English on the "Đilas case." See, for example, his landmark book *The New Class: An Analysis of the Communist System* (1957), and Stephen Clissold (1983).

63. "Society is the state's property. Art is the product of society" (Haraszti 1987:68). Theorists of Yugoslav socialism had precisely this order of ownership in mind when they spoke of state capitalism prevailing in the East. The question of property ownership was notoriously complicated in Yugoslavia. According to the Yugoslav doctrine of self-management, the means of production were not owned by the state or even by collectives, but by the associated workers.

64. Artistic director Predrag Dinulović was not in the theater on the day of the rehearsal/performance. Later, he vouched with his "life and honor" that there was no pressure to close the show from politicians outside the theater (in Pašić 1992:20). His assistant, Minja Dedić, claimed the opposite: "I think that this decision was made outside the theater. Not only do I think that—it was!" (19). Most participants suggest that the order to lock the theater actually came from Dinulović. However, when, years later, he was asked directly about this incident, he dodged the question by claiming a lack of knowledge and failings of memory (Popović 1978:26–27).

65. Interestingly, as late as 1978, the authors of the Soviet university textbook *Istoria zarubezhnoi literaturi posle Oktyabarskoi revolutsii. Chast vtoraia 1945–1970* (*The History of World Literature after the October Revolution*) used Armand Lanoux's phrase "rebellion of the snobs" to describe the "antidrama" of Beckett, Ionesco, and Adamov (Andreev 1978:68).

66. Feliks Pašić reports that she asked for two million dinars (approximately US$3,200 in 1954), which was a very large sum of money in Yugoslavia of that time. To the surprise of the group, this amount was granted, and that made possible the conversion of the conference room into a black-box theater (Pašić 1992:47).

67. Under this pseudonym he published a number of successful novels, among them *Tople pedesete* (*Warm Fifties*, 1990) about the "Godot affair." *Waiting for Godot* remained in the repertoire of Atelje 212 until the 1973–74 season, with the cast (sans the boy) that performed in the clandestine performance at Staro sajmište. It was remounted in 1981 with the same cast and performed on a regular basis over the next four years. This twenty-two-year run makes *Waiting for Godot* one of the most successful productions in the history of post-World War II Yugoslav theater.

68. Atelje 212 went on to become a landmark theater in Belgrade and Yugoslavia. Under the artistic direction of Mira Trailović, it carved for itself a niche on the cultural map of Belgrade in which it maintained the image of an alternative theater, while receiving state funding like all other "administrative" theaters. Starting in 1967, Atelje 212 became the home of BITEF (Belgrade Interna-

tional Theater Festival), which through government support and the convenient position of Yugoslavia on the political map of Europe, quickly became one of the leading theater festivals in Europe. It was one of rare places where productions by Yuri Lybimov and Robert Wilson, Antoine Vitez and Anatoly Efros could be seen in one place. In 1969, art historian Biljana Tomić organized the Bitef gallery, an early platform for conceptual and performance art and a predecessor of the Student Cultural Center of the 1970s. The Bitef gallery was a very rare instance in which this institution made room for vibrant domestic experimental art production. I speak in more detail about the aestheticization of the avant-garde in my article "The Theater of the Absurd and the Historization of the Present" (Jakovljević 2010).

69. This conversation was recorded and subsequently published both in Poland and in Yugoslavia: "Wczoraj i dziś," *Kultura*, Warsaw, December 1, 1963; and "Juče i danas," *Politika*, Belgrade, December 8, 1963.

70. Literature on this phenomenon in English is scarce. The only article I am aware of is Ješa Denegri's excellent work "Inside or Outside 'Socialist Modernism'? Radical Views on the Yugoslav Art Scene, 1950–1970," in *Impossible Histories: Historical Avant-Gardes, Neo-avant-gardes, and Post-avant-gardes in Yugoslavia, 1918–1991* (Šuvaković and Djurić 2003).

71. Yugoslavia's showing at Brussels Expo 58 was the most successful in the short history of its socialist period: Croatian architects Vjenceslav Richter and Emil Weber were awarded first prize for their project *Diksi 2* in the second round of the competition for the Yugoslav pavilion. For more details, see Galjer 2009.

72. The exhibit was held in the premises of Architects' Society of Croatia (Društvo arhitekata Hrvatske), and it featured geometric abstractions by Vlado Kristl, Božidar Rašica, and Ivan Picelj. For more about EXAT 51 and beginnings of abstraction in socialist Yugoslavia, see Denegri and Koščević 1979.

73. Octavian Saiu's article "Samuel Beckett behind the Iron Curtain: The Reception in Eastern Europe" is not particularly useful for tracking a production history of Beckett's plays in the socialist bloc and in Yugoslavia. His dates for the Yugoslav production are inaccurate, and other information is not much more reliable. This article demonstrates the leveling effect of the "behind the Iron Curtain" approach. As the author acknowledges, writing a survey on the reception of Beckett (or any other author) in Eastern Europe and Yugoslavia is a "task for which more space, time, energy and resources would have been indispensable" (Saiu 2009:251).

74. "Old" because after World War II a new complex of exhibition pavilions was built on the opposite side of the river Sava. In David Albahari's 1998 novel that deals with this site, *Götz and Meyer*, Staro sajmište is translated as "Fairgrounds."

75. In subsequent decades, all four had rich careers in theater, film, and television. Tadić became one of most prominent theater and film actors of his generation, and Marković one of the first Yugoslav film stars in the full sense of the word. Rastislav Jović played the boy.

76. No relation to the director of the play, Vasilije Popović. Art historians accorded Mića Popović's first solo show in 1950 with the status of a landmark

cultural event. Miodrag B. Protić speaks for mainstream Serbian art history when he characterizes this exhibit as a breaking point with socialist realism and as an event that helped restore the continuity of modernism's development in Serbia (1970:391–92). One of Popović's paintings from this exhibition, *Self-Portrait with a Mask* (*Autoportret sa maskom,* 1947) is paradigmatic of a series of dramatic revisions and self-criticisms he went through over the following decades: from social realism, to individualism, to Informel, to social criticism, to nationalism. Popović spent his painterly and intellectual career in a search of an elusive authenticity. His wife, Vera Božičković-Popović, was an important representative of Informel art in Serbia and Yugoslavia.

77. Semlin is the German name for the city of Zemun, located on the left bank of the Sava, downstream from Sajmište. Zemun was an outpost of Austro-Hungarian Empire. After the formation of Yugoslavia, the Sava was no longer an international border, and eventually (in 1934) Zemun became a part of Belgrade.

78. There was no attempt to mark the history of the site in any way. In his study on the culture of the commemoration at Staro sajmište, Jovan Byford observes that the reasons for this oblivion were primarily ideological: "The brigadiers were engaged in building the *future,* and in that sense they were not encouraged to look back on the past and remember it" (2008:4).

79. Pavle Ugrinov notes that at that time, the remnants of the camp, such as guard towers and barbed wire fences, still surrounded the pavilions at Staro sajmište (Ugrinov 1990:73).

80. Years later, the costume designer, Danka Pavlović, laconically recalled that they were never returned: "No one signed when we borrowed the costumes . . . and because it was not signed, it was forgotten" (Popović 1978:29).

81. Hartman is here citing Victor Turner, *The Ritual Process: Structure and Anti-Structure* (1969:95).

82. Drawing on the writings about concentration camps by Bettelheim, Primo Levi, and others, Giorgio Agamben quotes from Wolfgang Sofsky a particularly evocative description of this form of (in)human life, characteristic of the camps: "*Like the pile of corpses,* the *Muselmänner* document the total power over the human being. Still nominally alive, they are nameless husks" (1999:48; emphasis added).

83. In an interview he gave toward the end of his life, Vasilije Popović/Pavle Ugrinov recalled how, as a high-school student in the northern Serbian city of Petrovgrad, he watched as Nazis loaded incarcerated local Jews onto a barge on the river Tisa in order to transport them to Staro sajmište camp (Ugrinov 1997:5).

84. Depiction of life at the periphery would become one of the permanent themes of the so-called dark wave in Yugoslav cinema during the 1960s and early 1970s.

85. Lacan opens this part of his lecture in *Four Fundamental Concepts of Psychoanalysis* with a reference to Matisse. However, he starts the entire discussion of departures from trompe l'oeil by invoking a series of painters he puts under the rubric of "expressionism," although formally they were representatives of disparate artistic movements in interwar Europe: Edvard Munch, James Ensor,

Alfred Kubin, and André Masson (1978:109). Generally speaking, these paint-
ers can be grouped as predecessors of Art Informel.

86. Art Informel quickly picked up in Eastern Europe, particularly in Po-
land, Hungary, and Czechoslovakia. For more see Piotr Piotrowski's *In the
Shadow of Yalta: Art and the Avant-Garde in Eastern Europe, 1945–1989* (2009).

87. Probably the most significant instance of this kind of turn from canvas to
text was Kazimir Malevich's. After he painted *Black Square*, he stated in his
pamphlet *Suprematism: 34 Drawings*: "It seems that one cannot attain with the
brush what can be attained with a pen" (Malevich 1968:127).

88. This statement was originally composed in Italian, and in it the word
"happening" appears in English.

89. Here again Malevich comes to mind, this time with his verses: "the end
of music/silence" (Malevich 2001:113). More recent examples of departures
from art-making as a conscious artistic decision include Tehching Hsieh and
Goran Đorđević.

90. This runs somewhat contrary to Siegfried Kracauer's argument about
these kinds of performances as manifestations of the spirit of capitalism: "The
hands in the factory correspond to the legs of the Tiller Girls. Going beyond
manual capacities, psychotechnical aptitude tests attempt to calculate disposi-
tions of the soul as well. The mass ornament is the aesthetic reflex of the ratio-
nality to which the prevailing economic system aspires" (Kracauer 1995:79).

CHAPTER TWO

1. On the Rome posters, see Barry Kātz's *Herbert Marcuse and the Art of Lib-
eration: An Intellectual Biography* (1982:186).

2. The core of the so-called Praxis group consisted of the members of the
editorial board of the journal *Praxis*: Gajo Petrović, Rudi Supek (editors in
chief), Danko Grlić, Milan Kangrga, Ivan Kuvačić, and Predrag Vranicki. The
"Praxis school" also included philosophers and sociologists from around the
country, most prominently a group from Belgrade University that included Mi-
hailo Marković, Ljubomir Tadić, Svetozar Stojanović, Zagorka Golubović, and
Nebojša Popov. The history of the Praxis school is long and complex, and it
extends well before and after the dates of the journal and the Korčula Summer
School (1964–74). In his book *Praxis: Marxist Criticism and Dissent in Socialist
Yugoslavia*, Gerson S. Sher covers only the period until the mid-1970s. The
Praxis group, especially its Belgrade section, proved unable to resist the on-
slaught of nationalism in the 1980s: Marković became a founding member and
one of the main ideologues of Slobodan Milošević's Serbian Socialist Party
(Socijalistička partija Srbije, SPS), which brings into question all of the work he
did within the Praxis group. Similarly, Stojanović became a close associate of
Dobrica Ćosić, the leading ideologue of the new Serbian nationalism.

3. In the first years, the school's sessions ran for two weeks, but were even-
tually reduced to a week (Kangrga 2001:227).

4. In his translation of this fragment, Fredric Jameson inserts a bracketed

description "dialectician" in the second sentence: "But the true thinker [the dialectician] does not make this distinction" (Jameson 1991:65).

5. At the time of this conference, Vlahović was a member of the executive board and presidency of the Socialist Association of the Working People of Yugoslavia (Socijalistički savez radnog naroda Jugoslavije, SSRNJ), and was a long-serving member (since 1948) of the Central Committee of the League of Communists of Yugoslavia. He joined the then clandestine Communist Party of Yugoslavia in 1935, and in 1937 he fought in Spanish Civil War, where he rose to the rank of political commissar of the international battalion Dimitrov. He was one of the most respected pre-World War II Communists, and held a number of high-ranking offices until his death in 1975. During the student protest, he was one of the main negotiators on the side of the authorities during the overpass confrontation on June 3, 1968.

6. Gerson Sher, an early historian of the Praxis group, observed that its members "have been careful . . . to distinguish between self-management as an immanent principle and . . . an existing reality" (1977:158). It is important to note that this was written in the aftermath of repression of the journal *Praxis* and the Korčula Summer School.

7. Gajo Petrović was the most prominent Heideggerian among the Praxis philosophers. He was not alone in his attempt to think about Marx alongside Heidegger: we find the same philosophical trajectory in the Czech philosopher Karel Kosík and the French-Greek Kostas Axelos, both of whom were published in *Praxis* and participated in the Korčula Summer School. For Praxis philosophers, Heidegger's phenomenology was not just a fashionable addition to Marxism, but also the subject of vigorous debate. Milan Kangrga was the most outspoken critic of this move toward the reconciliation of German existentialism and Marxism. See his *Praxis Time World: Essaying the Revolutionary Thought (Praksa vrijeme svijet: Iskušavanje mišljenja revolucije*, 1984).

8. Bloch's discussion was published in the Yugoslav edition of *Praxis* in a Croatian translation, and I rendered that text into English. The discussion in the original German was published in the international edition of *Praxis*, no. 5 (1969:323–25).

9. From the historical distance of four decades, Marcuse's argument for the new revolutionary subject appears naive: "The working classes in the advanced capitalist societies, in spite of their standard of living, indeed live under intolerable conditions. Discussions during this Conference have emphasized several times that there are intolerable conditions other than those of impoverishment, misery, *Verelendung*" (1955:327).

10. Some members of Praxis group considered self-management and self-government interchangeable. This is evidenced in the title of the two-volume anthology *Self-Governing Socialism*, edited by prominent members of the *Praxis* circle, Mihailo Marković and Rudi Supek, as well as Branko Horvat, who was closely associated with the group. Predrag Matvejević makes a strong case for distinguishing between these two terms: according to him, whereas self-government implies certain territorial autonomy and independence, self-management addresses the organization of labor in a strict sense. This organi-

zational principle then becomes the foundation for a broader social structure (1982:134). Instrumental to the demise of Yugoslav self-management was precisely this equating of self-management and territorial self-government and self-determination, which began with the constitution of 1974.

11. See Aleksandar Kron 1968:1609–10. Milan Kangrga relates that the following year (1969) students decided to take the matter into their own hands. In response to the increased government pressure on the student movement, they covered the stone walls of the old town with graffiti. The outcome of this rebellion-in-a-teacup was that the mayor of Korčula threatened to cancel the summer school (Popov 2003:55–56).

12. Throughout Yugoslavia, these centers were known as "workers' universities" (*Radnički univerziteti*).

13. Beginning on June 24, 1968, and concluding with the caravan's performance two days later, Roy Thinnes's visit was featured daily on the front page of *Večernje novosti*.

14. Without exception, historians and commentators on Belgrade June ignored this economic explanation of the initial spark that ignited the student uprising.

15. The clashes with police in and around Student City on June 2, 1968, were not the first student rebellions in socialist Yugoslavia. There had been other isolated incidents over the previous fifteen years, pointing to social inequalities that developed during the years of Yugoslavia's rapid development. In 1954, also in New Belgrade's Student City, students demonstrated against the poor quality of their food and a rent hike. That protest was brutally suppressed by the mounted police. In 1959, in Skopje, the capital of Macedonia, and in Zagreb, the capital of Croatia, a large number of students protested, again because of poor living conditions. According to some witness accounts, in Zagreb a ten-thousand-strong mass of protesters was brutally suppressed by a police force that included cavalry (Popov 2003:64). This disturbance was so significant that it deserved mention in President Tito's speech on the occasion of the 1959 Youth Day celebrations. In a departure from protocol, which called for speeches riddled with ideological phrases and upbeat slogans, Tito criticized the students in Skopje and Zagreb for protesting against the "supposedly low quality of food," so that "now both in the East and West they are saying that hungry students are marching in Yugoslavia . . . I condemn most strongly these excesses, comrades, because they were inappropriate. Students that took part in them were taken in naively by the class enemy from abroad, and that is not in the least to their credit" (in Kastratović-Ristić 2005:31, 38).

16. The author of the editorial was Đorđije Vuković, the editor in chief of *Student*, who became one of the leaders of the student protest at Belgrade University (see Savić 1985:456).

17. According to witnesses' accounts, the policemen were especially brutal to young women. Živojin Pavlović, a novelist and a prominent filmmaker of the "dark wave" of Yugoslav film, noted this brutality in his diary of the protest, *Bloodied Spittle*: "The girls suffer the worst humiliations. Deprived of sleep and dizzy from excitement and heat, they sat at the side in small groups. The wave of law enforcement's severest anger spills over them. Provincial cops, mad

from sleeplessness and primordial peasant hatred toward city dwellers, impassionedly attack their manes, their thin and transparent skirts and their white flesh that glows through their torn clothes. They beat them up, step on them, and tear their shirts and bras, yelling: 'Whores!'" (Pavlović 1990:31). See also Dennison I. Rusinow's report, *Anatomy of a Student Revolt, Part 1* (1968a:4), and also witnesses' accounts in Želimir Žilnik's documentary *Lipanjska gibanja (June Turmoil,* 1969).

18. Aleksandar Ranković, the federal chief of police, was allegedly the second most powerful man in the nation before his downfall in 1966. A Serb and a political conservative, he was accused of unitarism and of spying on the highest state officials, including Tito himself.

19. The development of self-management in Yugoslavia after 1968 represents a complete reversal of this idea: the constitution of 1974 placed interests at the conceptual center of self-management, which functioned through a delegate system. More in the third chapter.

20. Among the many French intellectuals Bojović interviewed in the spring of 1968 were Roland Barthes, Roger Garaudy, Lucien Goldmann, Eugène Ionesco, Henri Lefebvre, Michel Leiris, and Alain Robbe-Grillet.

21. The commission never got further in their investigation than the second clash at the underpass before it fell apart.

22. For example, the demand for "removing bureaucratic forces" was tempered by the rhetorical request for a "more rapid development of self-management" (Hodžić 1971: 140); the key demands for stepping up the "process of democratization of all sociopolitical organizations, especially the League of Communists" and for democratization (that is to say, freedom) of the media, were followed by the request for prevention of "all attempts to degrade public property and to convert it into joint-stock property," which, in the country with strictly regulated and almost insignificant private entrepreneurship, seemed exaggerated (140).

23. Part of Žigon's performance is available in Želimir Žilnik's documentary *Lipanjska gibanja (June Turmoil,* 1969).

24. One of the extremely rare theoretical and historiographic attempts to bring together self-management and performance studies is a text on the Paris Commune theater law, published in the summer 1969 issue of *The Drama Review.* Not surprisingly, Darko Suvin, the author of this article, hailed from Zagreb, Yugoslavia, and had only recently joined the bustling downtown art scene in New York. In his comments on the transcripts of the Communards' debate about theater law, Suvin speaks of "socialized theatre" as "scenically-organized insight into, and understanding of, contemporary *possibilities*—latent as well as actual—for human relations" (29). Later in the text he mentions that the kind of revolutionary practice aimed at establishing of self-management envisioned in the Commune was accomplished "in the Soviet Union of the 1920's and Yugoslavia of the 1950's and 1960's" (34).

25. For an excellent and detailed discussion of Lefebvre's idea of revolution as a festival, see Gavin Grindon, "Revolutionary Romanticism: Henri Lefebvre's Revolution-as-Festival" (2013).

26. "Extreme sensibility makes middling actors; middling sensibility makes

the ruck of bad actors; in complete absence of sensibility is the possibility of a sublime actor" (Diderot 1957:20).

27. In fact, Tito visited Prague August 9–12 and used his popularity there to boost his standing at home. Also, he used the Soviet invasion of Czechoslovakia to introduce a near state of emergency in Yugoslavia, which helped not only to draw attention away from domestic problems, but also justified suppression of the student movement.

28. The outline of this action was published in the monograph *Hvala Raši Todosijeviću / Thank You, Raša Todosijević*: "1. Dying the four ficus trees, 2. Playing with a live carp, 3. Sprinkling of salt over body, 4. Dying the ear, 5. Body power and electric battery power" (Todosijević 2002:30). In an interview conducted on September 1, 2011, Todosijević indicated to me that the order of the second and third actions was reversed in both performances of *Decision as Art* (Todosijević 2011).

29. In this regard, Todosijević makes a distinction between performance art in the United States and in Europe. Whereas in the former, "the artist's self is impersonalized, devoid of elements of symbolic, psychological or sociopolitical references," in the latter "there are performances which insist on revealing, indicating, or demonstrating a person's psychological details" (1981:60). There are, of course, multiple examples that could evidence the opposite on both sides of the ocean. Still, in the literature on performance art, American and European performances are routinely conflated, and there is little effort at rigorous investigation of their possible differences. This can be said to represent the beginning step in the general leveling of the field, which has recently expanded to Eastern Europe, South America, and beyond. For an attempt to distinguish between American and European neo-avant-garde, including performance art, see Bonito Oliva 1976.

30. When I asked him if this performance was in any way informed by debates about self-management that surrounded constitutional reforms of the early 1970s, Todosijević insisted that it was not his intention to do that (Todosijević 2011). This, however, does not prevent his audience then and now from reading the performance in relation to its social and political surroundings.

31. This was the first major exhibition abroad by this group of artists, all of whom over the following decades made significant artistic careers in the Yugoslavian and international art scene. Marina Abramović performed a piece that she would call *Rhythm 10*, and Raša Todosijević together with his wife Marinela Koželj performed *Decision as Art*; Gergelj Urkom did his action *Mental and Physical Works*, which consisted of dismantling and reassembling a chair; Zoran Popović presented his film and photographs entitled *Action*; and Neša Paripović exhibited his series of photographs *Portraits* (see Richard Demarco Gallery 1973).

32. The first institution of this kind, Studentski centar (Student Center, SC) in Zagreb, Croatia, was founded in 1961. Študentski kulturni center (Student Cultural Center, ŠKUC) in Ljubljana, Slovenia, opened in 1972. Along with the network of youth cultural centers (*Dom omladine*) and, to some degree, museums of modern art, student cultural centers provided institutional support for avant-garde and experimental art in Yugoslavia during the 1970s and 1980s.

33. In early 1990s, the street was renamed Street of Serbian Heroes (Ulica Srpskih vladara), which was later changed to its pre-World War II name, Ulica Kralja Milana (King Milan Street).

34. For a detailed architectural and institutional history of the SKC, see Zečević 1996:19–32.

35. These public hearings were held over four days (December 25–27, 1969, and January 10, 1970) in packed university amphitheaters. For transcripts, see Moljković 2008. Nebojša Popov, the chronicler and participants of these events, recorded that the students' resistance was countered by an unprecedented mobilization among Party cadres (in Moljković 2008:11).

36. *Ideje* was among the first in Yugoslavia to publish the writings of Louis Althusser, whom the members of the *Praxis* circle considered a Stalinist. See Althusser's "Lenin and Philosophy" in *Ideje* (1970:83–228). For the members of the *Praxis* circle on Althusser, see Kangrga et al. 2003:30.

37. Ješa Denegri and Biljana Tomić, *Primeri konceptualne umetnosti u Jugoslaviji*, Salon Muzeja savremene umetnosti, Belgrade, 1971.

38. Yugoslav art historians and critics had access to foreign art magazines, and texts by leading artists and art critics writing about conceptual art were translated into Yugoslav languages soon after their original publication. One of the most exemplary publications was the February 1972 special issue of the journal *Polja* dedicated to conceptual art. It featured Joseph Kosuth's "Art after Philosophy," texts by the Art & Language group, French art historian Catherine Millet's "L'art conceptual comme sémiotique de l'art," and a series of articles by domestic and foreign artists and theoreticians.

39. OHO group performed their happenings in Atelje 212 in 1968 and staged their first Belgrade exhibit the following year at the gallery of Dom omladine (Youth Center).

40. The core members of the group were Attila Csernik, László Kerekes, Katalin Ladik, Slavko Matković, and Bálint Szombathy. The name of the group was a reference to Hieronymus Bosch and the tools manufacturer of the same name. The group ceased to exist in 1976. For more on this and other groups, see Vinterhalter 1983.

41. This short-lived group (core members: Slavko Bogdanović, Miroslav Mandić, Slobodan Tišma, and Mirko Radojičić) worked at the intersection of literature and conceptual art. The name of the group (*kod* is Serbian word for "code") bespeaks their interest in semiotics.

42. Like KÔD, the members of this group—Ana Raković, Vladimir Kopicl and Miša Živanović—were interested in literature and conceptual art. The two groups merged to form KÔD (Ǝ, but had already ceased their collective public activities by 1973.

43. "Era" is Slobodan Milivojević's nickname. Even though it is a homonymous with the English word "era," it is pronounced differently: "Ae-ra," with the first sound similar to that in, say, Andrew.

44. Gergelj Urkom (b. 1940), Neša Paripović (b. 1942), Slobodan "Era" Milivojević (b. 1944), Zoran Popović (b. 1944), Raša Todosijević (b. 1945), and Marina Abramović (b. 1946) met in the early 1960s in a preparatory fine arts course, and eventually they all passed the highly selective entrance exam to the

Academy of Fine Arts at Belgrade University. Between 1969 and 1973 they participated in a number of exhibits in Belgrade and elsewhere in Serbia and Yugoslavia. After 1973 they dispersed, never to exhibit together again.

45. "We were joking about attaching the label 'Center for Amplified Ego' on Marina Abramović's postal box in the lobby of her apartment building in Makedonska 32" (Todosijević 2010).

46. The Serbian word *susreti* is the plural form of *susret*, which means meeting in the sense of encounter, and not a gathering. The proper translation of *susreti*, then, would be encounters. However, I decided to follow the English translation of the title of this art festival that has been used since its very inception. The catalogs were published in Serbian and English, and the organizers used the phrase "April Meeting."

47. Avala is a mount near Belgrade, a popular weekend destination, where the university had its own lodge. Citations for *Bilten* include the year and issue number; there are no author names or page numbers available.

48. In winter 1966, the journal *Film Culture* published "Expanded Art Special Issue" (no. 43). The centerpiece of this issue was George Maciunas's "Expanded Arts Diagram." Gene Youngblood adopted and in many ways limited this discourse in his book *Expanded Cinema* (1970).

49. See the statement by Petar Ignjatović, the president of the April Meeting organizing committee, published in *April Meeting Bulletin* (1972:2).

50. Marina Abramović's *Igra* (*Dance*) was listed among the projects that were not realized because of technical difficulties (see *Bilten* 1972:8).

51. The complete list of participants is Dušan Makavejev, Paul Pignon, Bora Ćosić, Ješa Denegri, Biljana Tomić, Jovan Ćirilov, Vladan Radovanović, Dragan Klaić, Slobodan Mašić, Ljubiša Ristić, Boda Marković, and Božidar Zečević.

52. This comment was, in fact, in line with the observations of Pane's Western critics, which were conveyed to the April Meeting audience through an artist portfolio published in the bulletin on the day of her performance. The portfolio contains the textual section of her action *Life-Death-Dream*, Pierre Restany's article "Gina Pane: Acqua alta/Pali/Venezia" (originally published by Galerie Rive droite, Paris, 1970), François Pluchart's article "Gina Pane's Biological Aggressions" (originally published in Pluchart's journal *arTitudes* 3, December 1971–January 1972:10), and a selection of Pane's statements about her own work. No other artist, international or domestic, in the first April Meeting had such a detailed presentation in the bulletin.

53. For example, Jennifer Blessing argues that her shift from object- to "idea-driven" works was the direct outcome of the "events of May 1968" (2002:25).

54. François Pluchart specifies that *Nourishment/TV News/Fire* took place on November 24, 1971, at 6:30 p.m., at Rue des Thermopyles 32, Paris 14 (1972:10).

55. I am grateful to Sophie Marchand for sharing with me the documentation of Gina Pane's performance.

56. In her conversation with Effie Stephano, Pane conveyed her belief in the universality of gestural language: "When I make use of milk, fire, blood and suffering—I restore a vocabulary which can be universally understood. There are no idiom barriers whether it's Yugoslavia or France" (Pane 1973:22).

57. Judith Butler's critique of Julia Kristeva's theorization of poetic language

as "prediscursive" and "maternal" is very relevant here. She writes that "her postulation of a prediscursive corporeal multiplicity becomes all the more problematic when we discover that maternal drives are considered part of 'a non-symbolic, nonpaternal causality.' This pre-Symbolic, nonpaternal causality is, for Kristeva, a semiotic, *maternal* causality, or more specifically, a teleological conception of maternal instincts" (1990:120).

58. Syntactical performances differ significantly from pieces produced by some body artists during this same period, such as Vito Acconci, Chris Burden, and Marina Abramović and Ulay. Their works such as *Seedbed, Shoot,* and *Expansion in Space* can be described as performance act rather performance art. I am not making this distinction in order to introduce a new taxonomy of post-1968 performance, but to point to its diversity.

59. For detailed descriptions of this action, see Anne Tronche 1997:94–97, and Kathy O'Dell 1998:25–26.

60. Pane responded to Stephano's observation that her work is "often classified as masochist" by saying that her critics "refuse to let themselves assimilate" her language, so they "immediately place the artist in a pathological class to get rid of him. I'm really an optimist, I love life and I hate pain and suffering—it gives me no pleasure. But I undergo it because I feel it's necessary in order to reach an anesthetized society" (Pane 1973:24). Despite her formidable attempts to depathologize (and thus destigmatize) masochistic impulses and her success in demonstrating that these impulses have their own place in subject formation, in her writing on Pane, Kathy O'Dell neglects the direct connection that this artist establishes between social alienation and self-infliction of pain. See O'Dell's discussions of Pane in *Contract with the Skin* (1998:25–29 and 45–50).

61. Bloch's essay "Entfremdung, Verfremdung" was published in the first volume of *Verfremdungen* (Frankfurt am Main: Suhrkamp Verlag, 1962). I am quoting from the English translation published in *TDR* 15:1 (1970).

62. The second volume of Bloch's book was published in 1964, Lacan held his seminar the same year, and Klajn's article was published in 1966.

63. In Serbia and many other parts of the former Yugoslavia, it is customary for the family of the deceased person to announce the burial by placing placards on the facade of the family house, poster kiosks, lampposts, and other public places.

64. Milivojević shared Pane's discomfort with the term "performance." In an interview from the late 1970s, Pane insisted on calling her live work "actions" or "body art" and not "performance" because she found the latter term too general. "The term 'performer' is like the term artist," said Pane: "Nowadays we have to specify the activity of each performer. I consider myself a 'body artist' specifically speaking. I make actions and body-art and imply the language of the body" (in Kontova 1979:37). In describing his actions Milivojević uses the Serbian word *predstava*, which, similar to the French word *représentation*, refers both to a theatrical staging (show, production, performance) and to a mental image. He insists that his concept of "theater" is emptied of its classical content, and that accordingly it constitutes a completely new medium that is as different from traditional theater as video is from film (Milivojević 2010). Eventually,

he came up with the term "art session" to describe his art as essentially proces-
sional, regardless of the media used in its production. As he related to Jovan
Čekić, a Belgrade-based conceptual artist and theoretician, the art session "in-
cludes something of a ceremony, the rules of which are established at the mo-
ment they are carried out; even if they are given beforehand, it is possible to
change them within the session itself. The session can also be understood as a
meeting or an encounter of the body with an institution, like a courtroom or a
jury panel which, by its very presence and its participation in the ceremony, has
an impact on its meaning" (Milivojević 2001:144).

65. For a description and photographs of Jonas's performance, see Cantz
2001:44–45.

66. In Acconci's *Airtime* the situation is completely the opposite: the primary
symbolization completely excludes socialization. Here, for forty minutes Acco-
nci sits in front of a mirror and talks to himself.

67. In his extraordinary book of reminiscences about Milivojević's perfor-
mance *Mir je obeležje revolucije* (*Peace is the Attribute of Revolution*) presented at
the second April Meeting in 1973, Žarko Radaković, an author and Milivojević's
former collaborator, writes that Milivojević instructed each performer in his
early actions to "work on their own and yet all together, according to my in-
structions, suggestions, but individually, freely, each in the position to fully
express him- or herself" (Radaković 2010:21).

68. See, for example, Aleksandar Nejgebauer's article "Happening—the Art
of Projective Simulation" ("Hepening—umetnost projektivne simulacije"),
published in the journal *Polja* in April 1969, or Branko Andrić's "Introduction to
the Basics of Mini-Happening" ("Uvod u osnove mini-hepeninga"), published
in June–July issue of the same journal.

69. Lacan returns to Caillois in his 1964 seminar, published as *The Four Fun-
damental Concepts of Psychoanalysis*. That this return was all but casual is sug-
gested by the paralexis "René Caillois" Lacan made in his March 4 lecture, on
which he promptly commented in the next session (Lacan 1978:109).

70. This is Claudine Frank's translation; both essays were published in her
2003 translation, *The Edge of Surrealism: A Roger Caillois Reader*. John Shepley
translates it as "instinct of renunciation" (1984:32).

71. In his discussion of *Muselmann*, Bettelheim takes into consideration this
kind of catatonia: "What was startling about the experience in the camps was
that though the overpowering conditions were the same for many prisoners,
not all succumbed. Only those showed schizophrenic-kind reactions who felt
they were not only helpless to deal with the new situation, but that this was
their inescapable fate" (1967:65).

72. "This alienating *or* is not an arbitrary invention, nor is it a matter of *how
one sees things*. It is a part of language itself. This *or* exists. It is so much a part of
language that one should distinguish it when one is dealing with linguistics"
(212). And here comes the example "Your money or your life!"

73. In the *April Meeting Bulletin*, the action was listed as *Zvezda od vatre* (*Star
of Fire*), and some critics referred to it as *Događaj s vatrom* (*The Event with Fire*;
see Denegri 2003:74). By the following year (1975), this and four other perfor-

mances were presented as a series of "rhythms" in her solo exhibit *Ritam 10, 5, 2, 4, 0* (*Rhythm 10, 5, 2, 4, 0*) at the Museum of Contemporary Art in Belgrade.

74. For a detailed account of the *Plastic Jesus* affair, see Stojanović (1998). For an excellent discussion of the dark wave in Yugoslav cinema, see Pavle Levi's book *Disintegration in Frames: Aesthetics and Ideology in the Yugoslav and Post-Yugoslav Cinema* (2007).

75. It is important to note that both *Early Works* and *WR: Mysteries of Organism* promote alternatives to idolized self-management. Inspired by the events of 1968, Žilnik's film investigates the possibility of a community that emerges from this event. In his film, Makavejev engages with the ideas of Wilhelm Reich, especially his book *The Mass Psychology of Fascism*. There Reich promotes the idea of "work-democracy" as an alternative not only to fascism but to all existing ideological formations: "Work-democratic process demands that the social ideologies and institutions be brought into line with natural needs and interpersonal relations, in the same way as it is clearly expressed in natural love, vitally necessary work, and natural science" (Reich 1970:311). Following highly public defamation of their films, Žilnik and Makavejev left Yugoslavia and spent the rest of the 1970s in voluntary exile.

76. Zagorka Golubović, Trivo Inđić, Mihailo Marković, Dragoljub Mićunović, Nebojša Popov, Svetozar Stojanović, Ljubomir Tadić, and Miladin Životić. For a detailed account of this affair, see Nebojša Popov's book *Contra Fatum: Slučaj grupe profesora Filozofskog fakulteta u Beogradu* (*Contra Fatum: The Case of the Group of Professors at Belgrade University's School of Philosophy*, 1989).

77. In the fall of 1969, Jugoslovensko dramsko pozorište (Yugoslav Drama Theater), one of the premier theaters in Belgrade and in the nation, staged the dramatization of Dragoslav Mihailović's novel *Kad su cvetale tikve* (*When Pumpkins Blossomed*), which dealt with 1948. The production was removed from the theater's repertoire following its condemnation, which Tito himself made in a public speech (Pašić 1992:103).

78. One significant exception is, of course, Milovan Đilas, whose book *The New Class: An Analysis of the Communist System* (1957) was one of the first major denunciations of Stalinism after World War II that came from an insider in Communist officialdom. Unlike many other anti-Stalinist exposés that came in its wake, it figured as an effective critique of political establishments in other one-party socialist states, including Yugoslavia.

79. "Anyone could become a dissident," she continues: "smart and stupid, scoundrel and angel; an honest person, a crook, and a naïve person; communists, former communists, religious fanatics and atheists, nationalists and internationalists" (Bogdanović 2010:308). This list of character profiles fits very well the political landscape that emerged in the republics of the former Yugoslavia in the late 1980s. Among Bogdanović's extensive list of sources are Frances Stonor Saunders's *Who Paid the Piper: The Congress for Cultural Freedom, the CIA and the Cultural Cold War* (1999), Giles Scott-Smith's *The Politics of Apolitical Culture: The CIA and the Postwar American Hegemony* (2002) and Volker R. Berghahn's *America and the Intellectual Cold Wars in Europe* (2001). Yugoslavia is hardly mentioned in any of these works.

80. For a survey of the phenomenon of dissidents in the Yugoslav context see also Katarina Spehnjak and Tihomir Cipek 2007. There are still no solid historiographic accounts on the internal power struggles among the top-ranking Yugoslav officials in the early 1970s. So far, the information about this period, which in many regards determined the fate of the Socialist Federative Republic of Yugoslavia, can be glimpsed in journalism of the day and in autobiographic literature. On the mass movement in Croatia, see Miko Tripalo 1990 and Jovan Kesar, Djuro Bilbija, and Nenad Stefanović 1990. On the purge of Serbian leadership, see Slavoljub Đukić 1990. All of these books were published at a time of intense war-mongering in Serbia and Croatia, and should be read with this in mind.

81. One such example was 1964 conference "Marx and the Present" ("Marks i savremenost"), which I discussed briefly earlier in this chapter.

82. This makes an especially apt wordplay, as in both Serbian and Croation the word *stvar* (object) serves as a root for "*stvar*alaštvo" (creativity) and "*post-var*enje" (objectification, commodification).

83. For an insightful reading of Sutlić's theory of alienation, see Mislav Kukoč's *Critique of Eschatological Mind: The Problem of Alienation and Croatian Praxis Philosophy* (*Kritika eshatologijskog uma: Problem otuđenja i hrvatska filozofija prakse*) (1998:97–99).

84. "Just as there are two nations in each nation," writes Vlahović, "and two national cultures in each national culture, so there are two kinds of creativity. One reflects a state without prospects and escapism from history and from one's own self, and the other reflects historical reality, the movement of history" (1973:44).

85. An unsigned article entitled "Dark Wave in Painting" ("Likovni crni talas") containing extensive excerpts from this document was published in the youth magazine *Mladost* on January 5, 1974, 16, 19.

86. Critical responses to this conference were published in the influential daily *Politika* (an article by renowned painter Peđa Milosavljević was published on January 12, 1974) and in the weekly newsmagazine *NIN* (an article by Oskar Davičo, a former surrealist, was published on January 13, 1974).

87. The arc of Prvoslav Ralić's career was characteristic for Party apparatchiks of his generation and deserves a brief sketch. After graduating from the School of Philosophy, he was hired by the editorial board of the journal *Socijalizam*. During the purges of the 1970s, he became known as the regime's hired hand, a reputation he carried into the 1980s. Skillful in recognizing the winning side, he joined Slobodan Milošević's circle soon after the Eighth Congress of the League of Communists of Serbia, held in September 1987. He held high offices during Milošević's reign, and continued supporting him after he was put on trial at International Criminal Tribunal for the Former Yugoslavia in The Hague. Among his last books were *White Book: The Truth about The Hague Tribunal* (*Bela knjiga: Istina o Haškom tribunalu*, 2001) and a collection of religious poems *Hilandar Poems: The Experience of Fall and Ascendance* (*Hilandarske pesme: iskustvo pada i voznesenja*, 2002).

88. At the time of the publication of the articles discussed here, Papić held

high positions in the League of Communists of Serbia. In 1972 he became a member of the influential Belgrade City Committee and in 1974 of the Central Committee of the League of Communists of Serbia. His involvement with the SKC and the art world in general came from his 1968 activism and from his relationship with the art historian Dunja Blažević, who was the artistic director (curator) of SKC's gallery. An early critic of Milošević, Papić withdrew from politics in the mid-1980s. In the 1990s, both Papić and Blažević (by then no longer a couple) left Belgrade and moved to Sarajevo.

89. Humanist Marxists extensively discussed the idea of revolution's dual nature. For example, in his opening lecture of the Korčula Summer School session in August 1968, Rudi Supek argued that while in itself a result of a *political revolution*, the dictatorship of the proletariat is the *social revolution* that effects the "positive development of a socialist community, which is to say, more advanced social, economic, and cultural conditions" (Supek 1969:7). In the coming months and years, the thesis about political and social revolution became widely discussed among Yugoslav philosophers and sociologists in their interpretations of "Belgrade June." According to this interpretation, the political force that came into power through political revolution used its might to suppress the students, who demanded a wider social revolution.

90. Dušan Petrović "Šane" was a World War II communist guerrilla war hero. At the time of Papić's writing, he was the president of the Yugoslav Socialist Alliance of Workers, the largest sociopolitical organization in Yugoslavia.

91. In January 1974 Beuys made his first visit to the United States, during which he conducted his *Public Dialogue* at the New School for Social Research in New York and also lectured in Chicago and visited Minneapolis. In May he made his second trip to New York, where from the twenty-third to the twenty-sixth he performed the action *I Like America and America Likes Me* at the René Block Gallery.

92. Stipe Dumić's Serbo-Croatian translation was published in the third April Meeting *Bilten*, on April 18, 1974. I am here quoting from an English translation of the same interview that was included in a publication issued by the Minneapolis-based Dayton's Gallery 12 on the occasion of Beuys's visit in January 1974.

93. Even though Beuys's Belgrade lecture-performance was well received by the audience and acclaimed by critics and art historians who were promoting new artistic practices, the editors of *April Meeting Bulletin* decided to publish a scathing critique by a young philosophy student from Kosovo, Shkëlzen Maliqi. Starting from Hegel and ending with Lenin, Maliqi argued that "expansions of media are formal and logical, therefore meta-artistic, operations that challenge all existing art forms because they take them outside of their boundaries, and within the border-case of art. Anticipation of what might come out from that or even positing of a liberatory social function of art is nothing but mere vanity of imagination" (Maliqi 1974:n.p.). This at times confused and at other times strangely conservative critique conveys a certain recognition that shuttling of international art stars between vastly different cultural and political contexts creates an illusory idea of art as an autonomous sphere.

94. Westcott notes that he received this information from Raša Todosijević. This is one of the rare instances in his biography where the information comes from witnesses rather than from Abramović herself.

95. Susan L. Woodward identifies "international adjustment" as one of two main reasons for Yugoslavia's demise, the other being "economic ideology" (1995:371).

96. Instead of using disposable income for new investments, workers' councils often opted for an increase in their own wages. As David A. Dyker points out, in the period from 1965 to 1967, average personal income in Yugoslavia grew by 24%, while national income grew by only 11% (Dyker 1990:66).

97. This alliance of Yugoslav self-management with Western managerial practices is manifested on the level of vocabulary used in economic and organizational sciences, as is evident in Sinđić's discussion of Yugoslav economy in terms of its "performance" (19).

98. Using the metaphor of the city, Boltanski and Chiapello recognize six paradigmatic organizational models of societies in the West: the inspirational city, defined by the figure of the saint (but also the artist); the domestic city, organized along the social model of seniority; the reputational city, where status replaces seniority; the civic city, in which groups elect their representatives; the commercial city with its paradigmatic figure of the merchant; and the industrial city that values efficiency and effectiveness ([1999] 2005:24).

99. Trifunović's trajectory was strikingly similar to that of Prvoslav Ralić, only less spiritual: he turned from a young Party intellectual in the 1970s to a firm supporter of Milošević's brand of nationalism and one of the reliable bureaucrats in his war machinery.

100. Štajner was the author of the autobiographical work *7000 dana u Sibiru* (*7000 Days in Siberia*), which was published in Yugoslavia in 1971 and translated into French in 1983. The "discovery" of this book in France prompted its rediscovery in Yugoslavia.

101. It is enough to look at Luc Ferry and Alain Renaut's *French Philosophy of the Sixties: An Essay on Antihumanism* (published in France in 1985), the landmark publication of the revisionist discourse about 1968, to understand Ross's argument about the depoliticization of 1968. Of the eight "possible readings" of 1968 that the authors list, not a single one points directly to the political content of the actions conducted by students, workers, and peasants in France. They list the following: May '68 as a conspiracy, university crisis, outbreak of adolescent rebellion and fever, crisis of civilization, new type of class conflict, social conflict of a traditional type, political crisis, and chain of circumstantial events (Ferry and Renaut [1985] 1990:34–37), and go on to proclaim May '68 as the "victory of individual subject . . . over collective subjects (nations, classes)" and to blame the "contemporary cult of private pleasure" on May's individualism (45).

102. Compare this to Žižek's numerous statements on the subject he made in 2008, on the occasion of fortieth anniversary of "May." For example in his paper "In 1968, Structures Walked the Street—Will They Do It Again?" he claims that '68 was not a "single event" but a "split and ambiguous one." "So there is 'their' and 'our' May '68. In today's ideological memory, our basic idea of the

May demonstrations, the link between students' protests and workers' strikes, is forgotten" (Žižek 2009:20). "Pragmatic" 1986, for which he argued so fervently, played a major role in that forgetfulness.

103. Apart from numerous articles in newspapers and magazines, two publications are of special importance for this appropriation of the narrative of '68. The first one, the publicist Milo Gligorijević's *Accidental History* (*Slučajna istorija*), which deals with censorship in Yugoslavia in and around 1968, was published in 1988. The following year, the Center for Marxism at Belgrade University published *Belgrade University and '68: Collection of Documents about Student Demonstrations* (*Beogradski univerzitet i '68: zbornik dokumenata o studentskim demonstracijama*), the first book of this kind since *June 1968: Documents* (*Jun-Lipanj 1968: Dokumenti*), published by Praxis in 1971. The collection from 1989, unlike the one from 1971, gave ample room to documents from Party meetings.

104. Here I am using Marko Lopušina's article "Gnev posle TV prenosa" ("Anger after TV Broadcast," 1989) and Luka Mičeta's article "Miting za Jugoslaviju" ("Meeting for Yugoslavia," 1989).

105. The underpass was torn down when, in the 1970s, the railroad was displaced from this part of New Belgrade. In an eerie coincidence, a construction project going on at the time of these events revealed the overpass foundations. This last remnant of the '68 landmark was soon torn down to make room for a new building.

106. For a detailed analysis of this mass performance, see my article "From Mastermind to Body Artist: Political Performances of Slobodan Milosevic" in *TDR* (2008:51–74).

CHAPTER THREE

1. The main objection concerned the status of the autonomous regions of Vojvodina and Kosovo within Serbia. The autonomous regions had almost the same constitutional rights as the republics, so that Serbia ended up divided into three poorly defined and coordinated administrative entities.

2. Characteristic of this kind of criticism is Vojin Dimitrijević's paper "The 1974 Constitution as a Factor in the Collapse of Yugoslavia or as a Sign of Decaying Totalitarianism." While insightful and much more balanced than assessments of this constitution that came from various nationalist camps, Dimitrijević's critique is characteristic of what Kristin Ross calls a "human rights approach" in the 1980s. Note Dimitrijević's reference to June 1968 as a "curious revolt" (1994:7).

3. As such, *inokosni poslovodni organ* became instrumental in the demise of self-management in Yugoslavia. For a very instructive depiction of the role of company directors in the pseudotransition of the 1990s, see Aleksandar Molnar's article "The Collapse of Self-Management and the Rise of Führerprinzip in Serbian Enterprises" (1996).

4. "Samoupravni opšti akt" and "samoupravni sporazum" are legal terms almost untranslatable into English.

5. The USSR was not completely excluded from these external influences:

in the course of the 1970s, Tito and Soviet leader Leonid Brezhnev engaged in a politics of reconciliation, which started with their three-day talks in 1971—at the end of which Brezhnev signed a pledge of noninterference in Yugoslav politics—and continued throughout this decade.

6. For more on socialist consumerism in Yugoslavia, see Igor Duda's study *Affluence Found: Everyday Life and Consumer Culture in Croatia in the 1970s and 1980s* (*Pronađeno blagostanje: Svakodnevni život i potrošačka kultura u Hrvatskoj 1970-ih i 1980-ih*).

7. See, for example, Neca Jovanov 1981.

8. As Evgeny Dobrenko argues, socialist realism was the chief mechanism for this transformation of labor into discourse. He quotes Gorky's dictum: "The fundamental task of our realism is the assertion of socialism by means of a picturesque representation of facts, people, and interpersonal relations in labor processes" (in Dobrenko 2007:161).

9. Renata Salecl is one of the rare theoreticians from the former Yugoslavia who paid *any* attention to this central term of Kardelj's theory of associated labor. In her essay "The Crisis of Identity and the Struggle for New Hegemony in the Former Yugoslavia," she quickly glosses over Kardelj's phrase "plurality of self-management interests," paying more attention to the notion of "plurality" than "interests" (Salecl 1994:208).

10. "The revolutionary workers' council (not to be confused with its opportunist caricatures) is one of the structures that the consciousness of the proletariat has striven to create ever since its inception. The fact that it exists and is constantly developing shows that the proletariat already stands on the threshold of its own consciousness and hence on the threshold of victory. The workers' council spells the political and economic defeat of reification" (Lukács [1923] 1971:80).

11. In section entitled "Proletarians and Communists" Marx and Engels write: "The Communists are distinguished from other working-class parties by this only: 1. In the national struggles of the proletarians of the different countries, they point out and bring to the front *the common interests of the entire proletariat*, independently of all nationality. 2. In the various stages of development which the struggle of the working class against the bourgeoisie has to pass through, *they always and everywhere represent the interests of the movement as a whole*" (Marx and Engels 1962:22, emphasis added).

12. Consider Michael Hardt and Antonio Negri in *Empire*: "Since the production of services results in no material and durable good, we define the labor involved in this production as *immaterial labor*—that is, labor that produces an immaterial good, such as a service, a cultural product, knowledge, or communication" (2000:290).

13. In a detailed personal communication on the history of the complex series of *Axioms*, Popović informed me that *Performance Axioms* was first done during sixth BITEF festival in 1972, as a part of Gallery 212, which Biljana Tomić organized as a part of the festival. He subsequently performed *Axioms* in 1972–73, 1975–78, and as recently as 2004 and 2008 (Popović 2014).

14. During his second stay in New York, Popović made a documentary film *Struggle in New York*. Astonishingly, this extraordinary depiction of the radical

art scene in New York of the mid-1970s was never shown in New York or any-where else in the United States.

15. Later on, right before the *Oktobar '75*, Popović and Tijardović organized at the SKC a three-day seminar with Andrew Menard and Michael Corris, the members of the Art & Language group.

16. Here, Lippard is referring to the Slovene group OHO, which, in an ironic turn of events, as soon as the following year ceased its public activities by estab-lishing a commune in Šempras.

17. *Aspects 75: Contemporary Yugoslav Art* was held at Richard Demarco gal-lery from September 27 to October 25, 1975. Catalog designer Boris Bućan made this publication an oversized replica of the red passport of the Socialist Federa-tive Republic of Yugoslavia. Inside pages were also copies of the passport (each page has a "vize-visas" inscription on the top), containing information about artists who participated in the exhibit. Representatives of all six republics and two autonomous regions were presented in alphabetical order, from Marina Abramović to Vilko Žiljak.

18. Tijardović is abbreviating the English translation of Studentski kulturni center—Student Cultural Center, or SCC.

19. "Perspectives of Creativity" was based on his article "Mogućnosti stvaralaštva revolucije" ("Possibilities of Creativity of Revolution") published in the journal *Gledišta* in October 1975.

20. Blažević, Tijardović, Denegri, Vukadinović, Timotijević, Pejić, and Baljković were art historians and critics; Todosijević, Đorđević, Popović, and Gudac were artists; all but Gudac and Baljković lived in Belgrade at the time of publication.

21. It was organized some eighteen months after the publication of the re-marks from the conference of Belgrade artists-members of the Communist League of Yugoslavia, cited earlier in this chapter.

22. *Oktobar '75* was largely ignored by mainstream art criticism. The only follow-up that I know of was published in the literary journal *Književne novine*, which dedicated to this action a thematic block "A propos Oktobar '75" pub-lished few months after the fact. Informal reception of *Oktobar '75* within main-stream art circles can be glimpsed from some of the comments made in short texts published here. For example, the organizer of *Oktobar '75*, Dunja Blažević, writes that "the art public flatly ignored" this art event, and art critic Jasna Tijardović's "objections were made in art couloirs" (1976:n.p.).

23. In *Oktobar '75*, each contribution is paginated separately, so page num-bers in citations don't indicate the article's placement in the brochure.

24. In his comment on *Oktobar '75*, published in the thematic block that *Književne novine* dedicated to this action (see note #22), Denegri illustrates this point by providing the information that, up to that point (basically, a period of eight years) one of state commissions for acquisitions of art works purchased only one work that belonged to the new artistic practice. "Even when one of these commissions decided to make an acquisition from an exhibit of a group of new artists in SKC, this purchase was rescinded by someone higher up on the bureaucratic level, in a way that remains unclear" (Denegri [1976] 2003:117).

25. Denegri's distance from Tapié's pronouncements from the 1950s is strik-

ing. Consider, for example, the latter's statement: "An AUTHRE aesthetic is then the work of interaction between artists and specialists: mathematicians, logicians, psychologists, and art critics. The adventure is perilous, but the situation calls for immediate action. The attempt can only be thereby the more exciting, an alliance of extreme audacity and implacable rigor, a journey into the inspiring real" ([1953] 1956:22).

26. There were very few articles dedicated explicitly to art in all of issues of *Praxis*, and at least two of them dealt with the theater of Bertolt Brecht. Rudi Supek, one the *Praxis* editors, was interested in the sociology of art, and the study he produced together with Maja Minček, *Likovni stvaraoci i likovna sredina (Painters and Cultural Environment)*, is valuable for an understanding of the emergence of new art in Croatia, but it doesn't address this phenomenon in any way.

27. See, for example, Denegri 2007:89.

28. Indeed, Althusser's "Idéologie et appareils idéologiques d'État (Notes pour une recherche)" was published in the June 1970 issue of *La Pensée* (no. 151, pp. 3–38).

29. "Lenjin i filozofija," *Ideje*, nos. 3–4, 1970: 83–228.

30. In the early 1970s, Žižek published almost at the same rate in his native Slovenian and in Serbian and Croatian in scholarly journals in Belgrade and Zagreb (probably self-translated, Žižek's language in these publications is an admixture of Serbian and Croatian, with some elements of Slovene still surviving in it). This activity resulted in the publication of his second book not in Ljubljana and in Slovene but in Belgrade and in Serbo-Croatian. This should not be read as this author's special preference for a certain place or language. In fact, during the 1970s, it was a common practice of artists and theorists to publish and produce their work in other parts of the country, especially if they were prevented from doing so in their republic (this was not the only reason for working outside an author's language and cultural milieu, and there is no evidence I know of that Žižek's work was censored in Slovenia in the early 1970s). In that way the authorities unwittingly contributed to the creation of the alternative cultural space in Yugoslavia.

31. Slavoj Žižek, "Aleš Kermauner—Jaz—vloga" ("Aleš Kermauner—I—Role") and "Aleš Kermauner—zveza artikel—ime" ("Aleš Kermauner—Article Connection—Name").

32. In 1971 four core member of OHO established a commune in the village of Šempas near Kranj in Slovenia, which marked the end of the group's most active period. For an in-depth survey of OHO in English, see Miško Šuvaković's *The Clandestine Histories of OHO Group* (2010).

33. Translated from the Slovene by Maja Lovrenov and Samo Gosarič. In Slovenian, there is a play on words here: entry, stepping in (*vstop*) / approach, stepping up to (*pristop*) / treading, stepping (*stopajoče*) (translators' note).

34. Translated from the Slovene by Samo Gosarič.

35. In order to do that, Žižek explains, the signifiers have to "surpass the logical and rational connections of things and ideas" (27).

36. In "Marxism/Structuralism: An Attempt at Demarcation" Žižek calls for "crossing Marxism and psychoanalysis" with the aim of setting up "*the place of*

the proletariat of signifying practice itself through the critique of the signifying economy, the economy of the Symbolic that through prerepression, the exclusion of the matter/the Real, that is to say through symbolic castration, establishes the 'unitary' 'subject of sense'" (1974:520). Importantly, the goal of this "crossing" is in the "'practice of estrangement' in Brecht's sense of the word, that is, an attempt to break through ideological understanding" of social relations based on commodification of labor (520).

37. I adapted the English translation of the document originally written in Croatian.

38. In the 1950s, Branko Miljković was one of the most prominent poets in Serbia who attempted to get away from socialist-realist clichés by going back to French and Russian symbolist tradition. In a highly unusual move for poets in Yugoslavia of that time, in the fall of 1960 he relocated from Belgrade to Zagreb. In February 1961 he committed suicide by hanging.

39. Critical theory is easily recognizable in the first tendency, and Louis Althusser in the second one.

40. In 1970 (issues nos. 2 and 6) *Ideje* published two articles about the student movement in Italy by Marco Dogo in which he also discussed *operaistas* ("workerists").

41. Vladimir Gligorov is the son of high-ranking Yugoslav politician from Macedonia, Kiro Gligorov. From the 1960s until the disintegration of Yugoslavia, Kiro Gligorov was considered an expert on the economy, and had worked on several major economic reforms. After the breakup, he was the first president of FYR Macedonia. Vladimir Gligorov was a prominent participant in the student uprising in 1968. Throughout 1970s he published articles on philosophical and cultural themes in *Ideje* and other scholarly journals. Gradually, he moved from politics to economy, and is now an expert in that field.

42. Still, this was almost insignificant in comparison to what was to come only a few years later in "rump" Yugoslavia, consisting of Serbia and Montenegro.

43. It is on this point that Boltanski and Chiapello's periodization of capitalism needs adjustment. Focusing on management performance in the industrialized world, particularly France and the United States, they almost completely leave out a complex economic dynamic between industrialized and developing countries. If we take into consideration economic performance on a transnational scale, the era of industrial capitalism, marked by its imperative for efficiency, splits sharply along the lines of expansion and recession. In *The New Spirit of Capitalism*, the focus on organizational patterns marginalizes the importance of a series of profound economic changes in the wake of the global financial crisis of the 1930s: from growth to recession, from openness (fueled by imperialism) to isolationism among national economies, from the pound sterling to the American dollar as the unofficial international currency, from private to public investment, and from a nearly total lack of regulation to its stringent enforcement. Along with other factors, it was this rigorous oversight that drove the extraordinary growth of the first two post-World War II decades in the West, in which, as we have seen, Yugoslavia fully participated and from which it handsomely benefited.

44. According to Griffith-Jones and Sunkel, the crux of the problem lay in the following: "When the governments are not firmly committed to a development policy, the readily available supply of short-term external private financing may take the place of long-term external and internal savings, and is diverted to consumption, instead of helping broaden and diversify productive capacity; and secondly, . . . the market by itself is often not the most appropriate instrument for channeling resources towards the development of a diversified production system, accompanied by social justice, and sustainable over the long term" (1986:66).

45. Griffith-Jones and Sunkel write: "Private banks clearly preferred lending to countries with relatively high per capita income, as well as those whose recent growth record was more impressive" (1986:77). Yugoslavia of the late 1950s and early 1960s met both of these criteria.

46. One of these works is on the cover of this book. In this case, instead of adding zeros, Stilinović erased the value designation from the banknote, thus making it literally into "worthless money."

47. In one of his interviews, Stilinović confessed that part of the thrill in his early work with money was that intentional destruction of banknotes was a criminal offense, as was disrespectful treatment of the national flag. Hence, the first work in which he used money as the medium was *Double Offense* (*Dvostruki prekršaj*, 1980), in which he drew the Yugoslav flag on a ten-dinar banknote.

48. Stilinović's comment is applicable not only to the situation of the arts in Yugoslavia, but also to the broader turn that took place in the late 1970s, the period in which the art market returned with a vengeance. Suzi Gablik captured this (re)turn in her commentary "Art in the Dollar Sign," published in December 1981 issue of *Art in America*: "Postmodernism is a somewhat weasel term now being used to describe the garbled situation of art in the '80s. . . . As the era of modernism comes full circle, our artists are emerging from exile with arms outstretched to greet their old enemy: the market economy, whose only morality is to declare 'useful' anything that makes money" (Gablik 1981:13).

49. The translation of Rossi-Landi's *Il linguaggio come lavoro e come mercato* (1968) was published in Yugoslavia in 1981 by the Belgrade publishing house Rad.

50. The works with Yugoslav money Stilinović produced after 1991 lose their ambiguity and charge. It could have been any money from the historical past: they are banknotes that have outlived their symbolic use, museum pieces, not objects deprived of their value through economic and ideological exploitation.

51. According to Rus and Adam, the main characteristics of the white strike are "intentional lowering of work effort, increase of waste, increased use of crude material and energy, breaking of work discipline and normal forms of behavior in the workplace, literal following of instructions even when they don't apply to the task at hand, severe difficulties in human relations, lowered interest in the functioning of self-managing organs and for formal fulfillment of self-managing responsibilities, alienation from social-political organizations, rise in the number of complaints, etc." (1989:217).

52. Stilinović pointed out in an interview that this was his only work that

was ever censored, when it was removed from the Youth Salon in Zagreb in 1979. "It was exhibited a few months later in Zagreb's Student Center Gallery, with no reaction whatsoever" (2008:42). He concluded his 1993 short tract *Praise of Laziness* with "Marx's" and Martek's slogans. There, he writes: "As an artist, I learned from both East (socialism) and West (capitalism). Of course, now when the borders and political systems have changed, such an experience will no longer be possible. But what I have learned from that dialogue stays with me. My observation and knowledge of Western art has lately led me to a conclusion that art cannot exist anymore in the West. This is not to say that there isn't any. Why cannot art any more exist in the West? The answer is simple. Artists in the West are not lazy. Artists from the East are lazy; whether they will stay lazy now when they are no longer Eastern artists, remains to be seen" (Stilinović and Stipančić 2013:184).

53. This loss was best reflected in medical metaphors of inflation as an incurable epidemic, a force that comes from nowhere and ravages the economic landscape. Žanić reported that the most common metaphor for inflation was cancer, that most deadly of modern illnesses (1986:51); and AIDS, the new plague of the 1980s, entered Yugoslavian public discourse precisely through the language of inflation (54).

54. In her 1983 essay "The Time of Iconodules," art historian Bojana Pejić elaborates on the contrast between art of the 1970s and of the 1980s: whereas the former were the years during which many "lived 'the terrible dream of action,' the years of freedom for, the years of a reduction of, the ego, the years presided over by rationality, epistemology, tautology, and demystification, the years of many media, the years when a nonpictorial internationale was realized . . . , the years when the attitude overpowered the form," the latter were the years in which "all that was left was the 'terrible dream,' the years of the right for, the years of ego-navigation and expansion of the self, . . . the years of one medium, the years of pictorial nationales . . . , the years in which an attitude, if there is one at all, is subservient to the form." Referring to famous schism over the use of religious icons in the eighth-century Byzantine Empire, she described the former as an "exclusively iconoclastic" time and the latter as an "exclusively iconodule" time (1983:104).

55. Newman's essay was published in the spring–summer issue of 1984. A year later, in the summer of 1985, *Salmagundi* published responses from Ihab Hassan, John O'Kane, Charles Molesworth, William O'Rourke, Reed Way Dasenbrock, and Leslie Woolf Hedley, followed by Newman's reply. The same year, Northwestern University Press published Newman's essay as a stand-alone book.

56. This affair was documented in Boro Krivokapić's book *Should Kiš Be Burned? (Treba li spaliti Kiša)*. For a detailed summary in English, see Serge Shishkoff's article "Košava in a Coffee Pot" (1987). More recently, Mark Thompson provides more background information in his *Birth Certificate: The Story of Danilo Kiš* (2013).

57. No less important was Kiš's disclosure about ideology's indiscriminate need for authenticity as the basis for its legitimization. In its voraciousness, it easily substitutes nation for class, thus easily moving between nominally irrec

oncilable political platforms such as those of communism and nationalism. In short, the affair anticipated the fatal outcomes of ideological "deregulation" in Yugoslavia that became apparent in the 1980s and beyond.

58. In his 2003 interview, Đorđević said that in making these copies, his aim was to answer the question, "Is there anything in contemporary art that makes no sense doing? It seemed to me that the copying of *The Harbingers*, that is, of something that is, according to all standards, a completely worthless piece, could hold a possible answer to this question. I kept this painting only because it was my very first work, which in the meantime to me became a kind of a 'benchmark for stupidity'" (2003:165).

59. Đorđević noted that not everyone understood the nature of this project: "The Dutch artist Kristin Koenigs made a twenty-minute film, *Hommage*. In fact, she arranged a dinner in honor of *The Harbingers*, which was projected over the table. If I remember well, the dinner guests were Marina [Abramović] and Ulay" (2003:167). Even though *Hommage* didn't make it into the exhibit of copies, this event is an important link between the 1980s artistic investigations of the copy and Abramović's work on reperformance from the 2000s.

60. It is easy to recognize Žarko Papić, Blažević's partner at the time, in this description. Papić was an up-and-coming politician, one of those who were in the late 1970s and early 1980s converging around the rising star of Serbian Party politics, Ivan Stambolić. He mobilized the young generation of Serbian Communists and helped his protégé Slobodan Milošević climb the Party hierarchy. He returned this favor by ousting Stambolić from power in 1987 and arranging his assassination thirteen years later. Starting in the late 1970s and concluding with Milošević's coup in 1987, Stambolić brought like-minded people into leading positions in all vital sectors, from industry to local government, media, and culture. This broad coalition was distinguished by its members' shared conviction that the internal transformation of institutions was the only valid solution for political and economic problems in Yugoslavia and Serbia. The proponents of this *intrainstitutional critique* tried vigorously to distinguish themselves not only from Party conservatives who prospered from their position within these institutions, but also from leftist intelligentsia so designated by the journal *Praxis*, and from "dissidents," many of whom were nationalists. Radical conceptual artists found intolerable SKC's alliance even with this "soft" wing of the Party.

61. Dimitrijević is borrowing this term from Goran Đorđević, who used it to describe a certain brand of minimal and conceptual art. "There are works of art that are completely minimalist and that in their appearance perfectly comply with high art, but in their makers' relationship with art, in their opportunism, are in fact kitsch. That's how I realized that kitsch is not a certain art form, but first and foremost a relationship, an attitude" (Đorđević 2003:166).

62. In Đorđević's words: "It seems that in the past, probably 'since forever,' there existed a tendency that the political establishment picked and appropriated a group within culture, thus having artists, directors, writers, and critics who 'belonged' to them, or in other words, art that was 'theirs.' An assumption that there is, even as a remote possibility, a notion that this group of 'new' politicians could be brought into relation with 'new' artists, to which I be-

longed, was the crucial moment that led me to distance myself from that work" (2003:163).

63. Blažević claims that her argument to the bosses at TV Belgrade was that "the minority had the right to their television, not only the majority" (2010:160).

64. ICA is the London-based Institute of Contemporary Arts, and CBGB was a legendary club in New York's East Village. As for the change of political attitudes of the SKC's audience in the 1980s, I am always reminded of a graffito made with a marker on a wall close to the box office: "Become workers / a bright future is awaiting you in factories" ("Budite radnici / lepa budućnost vas čeka u fabrici").

65. For more on this period in the history of the journal *Vidici*, see Tomislav Longinović's article "Postmodernity and the Technology of Power: Legacy of the 'Vidici' Group in Serbia" (1994).

66. A number of scholarly articles have been published about them in English over the years. They are the only band from the former Yugoslavia to get an in-depth scholarly work dedicated to their work. See Alexei Monroe's *Interrogation Machine: Laibach and NSK* (2005).

67. The members of Irwin are Dušan Mandić, Miran Mohar, Andrej Savski, Roman Uranjek, and Borut Vogelnik. During first several years of the NSK's existence, the artists associated with this movement adhered to the principle of anonymity. Members of Irwin were the first to break from this principle. For more on the history of Irwin and NSK, see Inke Arns's essay "Irwin Navigator: Retroprincip 1983–2003" (2003).

68. An English translation of "Laibach: 10 Items of the Covenant" has been published in *Neue Slowenische Kunst*, ed. New Collectivism (1991).

69. The most vigorous criticisms of the Youth Day excesses came from youth organizations in Slovenia and Serbia. In 1987, the year of the "poster affair," the Belgrade University weekly *Student* published on its cover page an ironic visual comment on the official poster of the celebration, which was dominated by a green leaf with the contours of the five-pointed star cut into its edge. On the cover of *Student*, the star was replaced with the outline of vampire teeth bite marks, accompanied by the title "Vampire Ball." This affair shook up the Communist organization at Belgrade University, whose conservative wing (supporting Slobodan Milošević) used this case to consolidate its power at the university and in student media. The opposite ways in which Party organizations at universities in Ljubljana and Belgrade reacted to critiques of Youth Day in 1987 indicated the divergent paths these two former Yugoslav republics took in the 1990s.

70. This was the first mention of an NSK member by name came in mass media.

71. See, for example, Kalajić's 1982 "thesis-exhibit" *Post-modernism in Belgrade*, the main criterion of which seems to have been the ethnic identity of artists. In the 1990s, Kalajić became one of the leading ideologues of extreme nationalist and openly fascist politics in Serbia.

72. Pavić created "male" and "female" versions of the book, and this variety certainly had an impact on the sales.

73. The dramaturg for this event was Nenad Prokić, the composer Ksenija

Zečević, and the set designer Marina Čuturilo—all closely associated with the postmodern turn in Yugoslav theater.

74. https://www.youtube.com/watch?v=xPKN-lej8IA, last accessed March 27, 2015. Milko Šparemblek is a Croation choreographer.

75. He provides very close and useful readings of other Laibach "samples," such as their quotations of sleeve-notes from an LP edition of Gustav Holst's *The Planets* (Monroe 2005:62).

76. A short article published in the Belgrade art journal *Moment*, signed with the initials N.M., provides a description of this installation. In one corner of the room, the reproduction of Malevich's paintings were arranged exactly as in the Petrograd exhibit. On the walls facing this corner there were a number of "gypsum reproductions of statues and reliefs from antiquity combined with suprematist signs/symbols (square and cross) painted on these objects and on the walls, as well as a few separate copies of suprematist paintings (black square, cross, circle, etc.) executed on canvas, small wooden plates and in needlepoint" (1986:77). The author goes on to describe a table covered with black velvet on which were displayed gypsum copies of statues with suprematist forms painted on them, and an atmosphere that was created by red lighting and background music that consisted of medieval orthodox chants. The article also mentions that the exhibit elicited great public interest after it was transferred in March 1986 to the Student Cultural Center (ŠKUC) in Ljubljana, Slovenia.

77. Đorđević insists that his participation in these "exhibitions/projects was strictly technical, as someone who helped in the public realization of these exhibits and lectures" (2003:175).

78. The transcript of this lecture has not been published. Slovene art historian and video artist Marina Gržinić cites the author's notes at length in her book *Fiction Reconstructed: Eastern Europe, Post-socialism and the Retro-Avant-Garde*. All ellipses are from this source.

79. The first interview, entitled "Goran Đorđević: The Original of a Copy" ("Goran Đorđević: Original kopija"), conducted by art historian Slobodan Mijušković, was published in the journal *Moment* in 1985, and the second, entitled "Who Is 'Goran Đorđević'?" ("Ko je 'Goran Đorđević'?"), with art historians and theorists Branislav Dimitrijević, Siniša Mitrović, Svebor Midžić, Branimir Stojanović, and Jelena Vesić, was published in the journal *Prelom* in June 2003.

80. For more on this exhibit, see Jamey Gambrell's "Art against Intervention" (1984:9–15). The art historian Branislav Dimitrijević points out that only months later, Levine started making her own copies of Malevich, but restrains from "further comments on this coincidence" (2003:154).

81. For a detailed discussion of Đorđević's work on copies in relation to appropriation art, see Dejan Sretenović's book *The Art of Appropriation* (*Umetnost prisvajanja*) (2014).

82. Marina Gržinić sees this as a legitimate move "within the strategies and tactics of an impoverished and indigent socialism and its artists": "Given the impossibility of paying high art insurance fees, and the fact that at that time there was no art market, the only possible way of exhibiting *Back to the USA* was as a copy, a reconstruction and its symbolic repetition" (Gržinić 2000:72). For a

full list of participants in the show *Back to the USA,* see the exhibition catalog edited by Klaus Honnef (1983).

83. Đorđević made his first painting *The Harbingers of the Apocalypse* in 1969, the same year Michel Foucault published his landmark essay "What Is an Author?," which came in response to Roland Barthes's "The Death of the Author" from the previous year. His turn to copies and exit from the art coincided with the publication of Gilles Deleuze's "The Power of the False" in *Cinema* 2.

AFTERWORD

1. In categorizing the main approaches to workers' participation, Bayat placed Yugoslav self-management at the very center of the category he named "the third way development approach" (30). He offered four categories, the other three being "the corporatist approach," dictated primarily by the International Labour Organization; "the aggressive encroachment approach," advocated by the North American Left; and "the workers' state approach," evidenced in reforms attempted in some Eastern European countries such as Poland and Hungary (1991:27–37).

Bibliography

"A Letter from Kazimir Malevich." 1986. *Art in America* 9.

"A propos Oktobar 75." 1976. *Književne novine*, no. 49.

Agamben, Giorgio. 1999. *Remnants of Auschwitz: The Witness and the Archive*. Translated by Daniel Heller-Roazen. New York: Zone Books.

Alavantić, Rade. 1960. *Prva decenija radničkog samoupravljanja*. Belgrade: Rad.

Albahari, David. 2004. *Götz and Meyer*. Translated by Ellen Elias-Bursać. London: Harvill Press.

Alliez, Eric. 2010. "Capitalism and Schizophrenia and Consensus: Of Relational Aesthetics." In *Deleuze and Contemporary Art*, ed. Stephen Zepke and Simon O'Sullivan, 85–99. Edinburgh: Edinburgh University Press.

Althusser, Louis. 1970. "Lenjin i filozofija." *Ideje* 3–4: 83–228.

Althusser, Louis. 1971. *Lenin and Philosophy and Other Essays*. Translated by Ben Brewster. London: NLB.

Andreev. L. G. 1978. *Istoria zarubezhnoi literaturi posle Oktyabarskoi revolutsii. Chast vtoraia 1945–1970*. Moscow: Moskovskii universitet.

Andrić, Branko. 1969. "Uvod u osnove mini-hepeninga." *Polja* 129–30 (June–July): 5.

Aničić, Mikan, Kosta Bunuševac, Aleksandar Cvetković, Božidar Damjanović, Olja Ivanjicki, et al. 1982. *Post-moderna u Beogradu: izložba teze Dragoša Kalajića: Salon Muzeja savremene umetnosti Beograd, 4–29. jun 1982*. Beograd: Muzej savremene umetnosti.

Archive of Yugoslavia. 1967. Stack I, folder 114.

Archive of Yugoslavia. 1971. Stack II, folder 20.

Archive of Yugoslavia. 1972. Stack II, folder 21.

Arns, Inke. 2003. *Irwin Retroprincip 1983–2003*. Frankfurt: Revolver.

Arsić, Mirko, and Dragan R. Marković. 1984. *'68: Studentski bunt i društvo*. Belgrade: Prosvetni pregled.

Artaud, Antonin. 1974. *Œuvres complètes*. Vol. 13. Paris: Gallimard.

Artaud, Antonin. 1976. *Selected Writings*. Edited by Susan Sontag. Berkeley: University of California Press.

Artaud, Antonin. 1995. *Watchfiends and Rack Screams: Works from the Final Period*. Edited and translated by Clayton Eshleman and Bernard Bador. Boston: Exact Change.

Ast, Slobodanka. 1988. "Dizajniranje Dana mladosti." *NIN* 1951 (May 22): 22–23.

Atlan, Henri. 2011. *Selected Writings: On Self-Organization, Philosophy, Bioethics, and Judaism*. New York: Fordham University Press.

Attali, Jacques. [1977] 1985. *Noise: The Political Economy of Music*. Translated by Brian Massumi. Minneapolis: University of Minnesota Press.

Attali, Jacques. 1978. *La nouvelle économie française*. Paris: Flammarion.

Bair, Deirdre. 1978. *Samuel Beckett: A Biography*. New York: Harcourt Brace Jovanovich.

Bajt, Aleksander. 1988. *Samoupravni oblik društvene svojine*. Zagreb: Globus.

Balibar, Etienne. 1991. "Citizen Subject." In *Who Comes after the Subject*, ed. Jean-Luc Nancy, Peter Connor, and Eduardo Cadava, 33–57. New York: Routledge.

Bataille, Georges. [1967] 1991. *The Accursed Share: An Essay on General Economy*. Translated by Robert Hurley. New York: Zone Books.

Baudson, Michel. 1998. "A Circle of Memory." In *Gina Pane: Opere 1968–1990*, 53–64. Milan: Charta.

Bayat, Assef. 1991. *Work, Politics, and Power: An International Perspective on Workers' Control and Self-Management*. New York: Monthly Review Press.

Becker, Lutz. 2006. "Art for an Avant-Garde Society: Belgrade in the 1970s." In *East Art Map: Contemporary Art and Eastern Europe*, ed. Irwin Art Collective, 390–400. London: Afterall.

Beckett, Samuel. [1952] 1954. *Waiting for Godot*. New York: Grove Press.

Bender, John, and Michael Marrinan. 2010. *The Culture of Diagram*. Stanford, CA: Stanford University Press.

Benjamin, Walter. [1966] 1973. *Understanding Brecht*. Translated by Anna Bostock. London: Verso.

Benjamin, Walter. 1996. *Selected Writings*. Vol. 1: *1913–1926*. Translated by Edmund Jephcott et al. Cambridge: Harvard University Press.

Benjamin, Walter. 1999. *The Arcades Project*. Translated by Howard Eiland and Kevin McLaughlin. Cambridge: Harvard University Press.

Benjamin, Walter. 2002. *Selected Writings*. Vol. 3: *1935–1938*. Translated by Edmund Jephcott et al. Cambridge: Harvard University Press.

Benjamin, Walter. 2003. *Selected Writings*. Vol. 4: *1938–1940*. Translated by Edmund Jephcott et al. Cambridge: Harvard University Press.

Berlin, Isaiah. 1998. *The Proper Study of Mankind*. New York: Farrar, Straus and Giroux.

Bettelheim, Bruno. 1967. *The Empty Fortress: Infantile Autism and the Birth of the Self*. New York: Free Press.

Beuys, Joseph. 1974. "A Score by Joseph Beuys: We Are the Revolution. An Interview with Achille Bonito Oliva." Minneapolis: Dayton's Gallery 12. (Serbian translation published as "Izazov Jozefa Bojsa: Mi smo svi revolucionari." *IIIAprilski susreti, Bilten* 3 (April 18, 1974), n.p.

Biblija, ili Sveto pismo staroga i novog zavjeta. 1981. Translated by Đuro Daničić and Vuk Stefanović Karadžić. Belgrade: Britansko biblijsko društvo.

Bihalji-Merin, Oto. 1949. "Povodom slike Bože Ilića 'Sondiranje terena na Novom Beogradu.'" *Borba* (January 9): 6.

Bilandžić, Dušan, and Stipe Tonković. 1974. *Samoupravljanje 1950–1974*. Zagreb: Globus.

Bilten Aprilskih susreta. 1972. Issue nos. 1, 3, 4, 5.

Bilten Aprilskih susreta. 1974. Issue nos. 2 , 3, 7.

Bishop, Claire. 2004. "Antagonism and Relational Aesthetics." *October* 110 (Autumn): 51–79.

Bishop, Claire. 2012. *Artificial Hells: Participatory Art and the Politics of Spectatorship*. London: Verso.

Blanchot, Maurice. [1983] 1988. *The Unavowable Community*. Translated by Piere Jorris. Barrytown: Station Hill Press.

Blanchot, Maurice. 2010. *Political Writings, 1953–1993*. Translated by Zakir Paul. New York: Fordham University Press.

Blažević, Dunja. 2010. "TV Gallery." In *Political Practice of (post-) Yugoslav Art: Retrospective*, ed. Jelena Vesic and Zorana Dojić, 156–61. Belgrade: Prelom kolektiv.

Blažević, Dunja. 2011. Email correspondence with author, January 20.

Blažević, Marin. 2012. *Izboren poraz: Novo kazalište u hrvatskome glumištu od Gavelle do . . .* Zagreb: Disput.

Blessing, Jennifer. 2002. "Some Notes on Gina Pane's Wounds." In *Gina Pane*, 25–39. Bristol: John Hansard Gallery, University of Southampton, Arnolfini.

Bloch, Ernst. 1962. *Verfremdungen I*. Frankfurt am Main: Suhrkamp Verlag.

Bloch, Ernst. 1969a. "Riječ na otvaranju Korčulanske ljetnje škole." *Praxis* 6.1–2: 3–6.

Bloch, Ernst. 1969b. "Diskusija s Herbertom Marcuseom." *Praxis* 6.3–4: 594–97.

Bloch, Ernst. 1969c. "Diskussion mit Herbert Marcuse." *Praxis: Edition internationalle* 5.1–2: 323–26.

Bloch, Ernst. 1970. "*Entfremdung, Verfremdung*: Alienation, Estrangement." *The Drama Review*: 15.1 (Autumn): 120–25.

Bogdanović, Mira. 2010. "Disidenti druge Jugoslavije." *Status: magazin za političku kulturu i društvena pitanja* 14: 296–314.

Bogišić, Valtazar. 1986. *Izabrana dela i Opšti imovinski zakonik za Crnu Goru*. Belgrade: Službeni list.

Bojović, Boško, ed. 2005. *Ilija B. Bojović. Razgovori na francuskoj levici: Pariz 1967–1968*. Belgrade: Institut za političke studije, Institut za noviju istoriju.

Boltanski, Luc, and Eve Chiapello. [1999] 2005. *The New Spirit of Capitalism*. Translated by Gregory Elliott. London: Verso.

Bondžić, Dragomir. 2008. "Beogradski univerzitet i Osma sednica." In *Slobodan Milošević—Put Ka Vlasti: Osma Sednica CK SkS—uzroci, tok i posledice : Srbija 20 godina kasnije, 1987–2007 : Zbornik radova sa međunarodnog naučnog skupa, održanog u Beogradu 21–22. septembra 2007 = Slobodan Milošević—Road to Power : the Eighth Session of the LCS CC : Serbia 20 Years Later, 1987–2007: Edited Volume From International Conference, Held In Belgrade On 21/22 September 2007*, ed. Momčilo Pavlović, Dejan Jović, and Vladimir Petrović, 149–60. Belgrade: Institut za savremenu istoriju.

Bonito Oliva, Achille. 1976. *Europe/America: The Different Avant-Gardes*. Milan: Deco Press.

Borba. 1949a. "Za 8 časova ozidao 53.84 kubna metra zida." *Borba* 14.210 (September 4): 1.

Borba. 1949b. "U borbi za visoku produktivnost rada." *Borba* 14.212 (September 6): 1.

Bošnjak, Branko. 1964. "Ime i pojam 'praxis.'" *Praxis: filozofski dvomjesečnik* 1.1: 7–20.

Bošnjak, Branko, and Rudi Supek, eds. 1963. *Humanizam i socijalizam: Zbornik radova, prva knjiga*. Zagreb: Naprijed.

Bourdet, Yvon, and Alain Guillerm. 1975. *L'Autogestion*. Paris: Éditions Seghers.

Bourriaud, Nicolas. [1998] 2002. *Relational Aesthetics*. Translated by Simon Pleasance and Fronza Woods. Dijon: Les presses du réel.

Brecht, Bertolt. 2003. *Brecht on Art and Politics*. Edited by Tom Kuhn and Steve Giles. London: Methuen.

Brecht, Bertolt. 2015. *Brecht on Theatre*. Edited by Marc Silberman, Steve Giles, and Tom Kuhn. London: Bloomsbury.

Breton, André. [1930] 1969. *Manifestoes of Surrealism*. Translated by Richard Seaver and Helen R. Lane. Ann Arbor: University of Michigan Press.

Broz, Josip "Tito." 1948. "Politički izvještaj." In *V Kongres Komunističke partije Jugoslavije: izvještaji i referati*, 9–166. Belgrade: Kultura.

Broz, Josip "Tito." 1949. "Ekspoze pretsednika Savezne vlade maršala Jugoslavije Josipa Broza-Tita." In *Borba za Petogodišnji plan u 1949: Govori članova savezne vlade u Budžetskoj debati (26–30 decembra 1948 godine)*, 5–30. Belgrade: Politika.

Brozović, Ante, ed. 1930. *Sveslavensko sokolstvo (svesokolski slet 1930)*. Belgrade: Savez sokola Kraljevine Jugoslavije.

Brozović, Ante. 1934. *Sokolski zbornik*. Belgrade: Savez sokola Kraljevine Jugoslavije.

Bryan-Wilson, Julia. 2009. *Art Workers: Radical Practice in the Vietnam Era*. Berkeley: University of California Press.

Büchner, Georg. 1977. *The Complete Collected Works*. Translated by Henry J. Schmidt. New York: Avon Books.

Burina, Safet. 1949. "Brigade u čeličani." *Književne novine* 2.45 (November 8): 3.

Butenko, A. P, et al. 1960. *Protiv sovremennogo revizionizma v filosofii i sotsiologii*. Moscow: Akademia nauk SSSR.

Butler, Judith. 1990. *Gender Trouble: Feminism and the Subversion of Identity*. New York: Routledge.

Byford, Jovan. 2008. "Remembering and Forgetting the Semlin Judenalger: Memorialisation of the Holocaust in Serbia 1945–2005." Presented at the conference "Holocaust as Local History: Past and Present of a Complex Relation." Thessaloniki, Greece, June 5–8, 2008.

Caillois, Roger. [1935] 1984. "Mimicry and Legendary Psychasthenia." Translated by John Shepley. *October* 31 (Winter): 17–32.

Caillois, Roger. 2003. *The Edge of Surrealism: A Roger Caillois Reader*. Translated by Claudine Frank and Camille Naish. Durham, NC: Duke University Press.

Camhis, Marios. 1979. *Planning Theory and Philosophy*. London: Tavistock Publications.

Canetti, Elias. [1960] 1962. *Crowds and Power*. Translated by Carol Stewart. New York: Viking Press.

Cantz, Hatje. 2001. *Joan Jonas: Performance Video Installation, 1968–2000*. Stuttgart: Galerie der Stadt.

Careri, Giovanni. 2003. *Baroques*. Princeton, NJ: Princeton University Press.

Castoriadis, Cornelius. 1988a. *Political and Social Writings.* Vol. 1, 1946–1955: *From the Critique of Bureaucracy to the Positive Content of Socialism.* Translated by David Ames Curtis. Minneapolis: University of Minnesota Press.

Castoriadis, Cornelius. 1988b. *Political and Social Writings.* Vol. 2, 1955–1960: *From the Workers' Struggle against Bureaucracy to Revolution in the Age of Modern Capitalism.* Translated by David Ames Curtis. Minneapolis: University of Minnesota Press.

Castoriadis, Cornelius. 1993. *Political and Social Writings.* Vol. 3: *Recommencing the Revolution: From Socialism to the Autonomous Society.* Translated by David Ames Curtis. Minneapolis: University of Minnesota Press.

Chto Delat. 2009–13. Text from the installation *Perestroika Timeline.* San Francisco: Yerba Buena Center for the Arts.

Clark, T. J. 1973. *Image of the people: Gustave Courbet and the Second French Republic, 1848–1851.* Greenwich: New York Graphic Society.

Clissold, Stephen. 1983. *Djilas: The Progress of a Revolutionary.* New York: Universe Books.

Constitution of the Socialist Federal Republic of Yugoslavia, The. 1974. Translated by Marko Pavičić. Ljubljana: Dopisna delavska univerza.

Corwin, Sharon. 2003. "Picturing Efficiency: Precisionism, Scientific Management, and the Effacement of Labor." *Representations* 84.1 (November): 139–65.

Ćosić, Bora. 1963. *Sodoma i Gomora: proba jedne uporedne fenomenologije.* Novi Sad: Matica srpska.

Ćosić, Bora. 1970. *Mixed Media.* Belgrade: Nezavisno autorsko izdanje.

Cvejić, Bojana and Ana Vujanović. 2015. *Public Sphere by Performance.* Berlin: b_books.

Cvetković, Dušan. 1998. *Sokoli i sokolski sletovi, 1862–1941.* Belgrade: Knjigprom.

Deleon, Ašer. 1959. "Workers' Self-Management." In *Annals of Collective Economy* 30.2–3: 145–68.

Deleuze, Gilles. [1969] 1990. *The Logic of Sense.* Translated by Mark Lester. New York: Columbia University Press.

Deleuze, Gilles. [1981] 2003. *Francis Bacon: The Logic of Sensation.* Translated by Daniel W. Smith. Minneapolis: University of Minnesota Press.

Deleuze, Gilles. [1985] 1989. *Cinema 2: The Time-Image.* Translated by Hugh Tomlinson and Robert Galeta. Minneapolis: University of Minnesota Press.

Deleuze, Gilles, and Félix Guattari. [1980] 1987. *A Thousand Plateaus: Capitalism and Schizophrenia.* Translated by Brian Massumi. Minneapolis: University of Minnesota Press.

Deleuze, Gilles, and Félix Guattari. [1991] 1994. *What Is Philosophy?* Translated by Hugh Tomlinson and Graham Burchell. New York: Columbia University Press.

Delpeux, Sophie. 2004. "Le 'familier-inconnu' de Gina Pane (à propos d'une image d'archive." *Critique d'art* 23.

Denegri, Ješa. 1980. "Kraj šeste decenije: enformel u Jugoslaviji." In *Jugoslovensko slikarstvo šeste decenije,* ed. Miodrag B. Protić, 125–43. Belgrade: Muzej savremene umetnosti.

Denegri, Ješa. 1983. *Nova umetnost u Srbiji, 1970–1980: Pojedinci, grupe, pojave.* Belgrade: Muzej savremene umetnosti.

Denegri, Ješa. 1993. *Pedesete: Teme srpske umetnosti (1950–1960).* Novi Sad: Svetovi.

Denegri, Ješa. 1995. *Šezdesete: Teme srpske umetnosti (1960–1970).* Novi Sad: Svetovi.

Denegri, Ješa. 1996. *Sedamdesete: Teme srpske umetnosti.* Novi Sad: Svetovi.

Denegri, Ješa. 1997. *Osamdesete: Teme srpske umetnosti.* Novi Sad: Svetovi.

Denegri, Ješa. 2003. *Studentski kulturni centar kao umetnička scena.* Beograd: Studentski kuturni centar.

Denegri, Ješa. 2007. *Razlozi za novu liniju: Za novu umetnost sedamdesetih.* Novi Sad: Muzej savremene umetnosti Vojvodine.

Denegri, Ješa, and Želimir Koščević. 1979. *EXAT 51 (1951–1956).* Zagreb: Centar za kulturnu djelatnost Saveza socijalističke omladine.

Dezès, Marie-Genevière. 2003. "L'Utopie réalisée: les modèles étrangeres mythiques des autogestionnaires français." In *Autogestion: La dernière utopie?*, ed. Frank Georgi. 29–54. Paris: Sorbonne.

Diderot, Denis. 1957. *The Paradox of Acting.* Translated by Walter Herries Pollock. New York: Hill and Wang.

Đilas, Milovan. 1957. *The New Class: An Analysis of the Communist System.* New York: Praeger.

Đilas, Milovan. 1959. *Anatomy of a Moral.* New York: Praeger.

Dimitrijević, Branislav. 2003. "Neke uvodne napomene o radu Gorana Đorđevića u periodu 1974–1985: a posebno u vezi sa njegovim delovanjem u okviru beogradskog Studentskog kulturnog centra." *Prelom: Časopis za savremenu umetnost i teoriju* 3.5 (Spring–Summer): 148–55.

Dimitrijević, Nena. 2002. "Gorgona—umjetnost kao način postojanja." In *Gorgona: Protokol dostavljanja misli*, ed. Marija Gattin, 52–67. Zagreb: Muzej savremene umjetnosti.

Dimitrijević, Vojin. 1994. "The 1974 Constitution as a Factor in the Collapse of Yugoslavia or as a Sign of Decaying Totalitarianism." EUI Working Paper RSC No. 94/9. Florence: European University Institute.

Dobrenko, Evgeny. 2007. *Political Economy of Socialist Realism.* Translated by Jesse M. Savage. New Haven: Yale University Press.

Dobrivojević, Ivana. 2010. "Između ideologije i pop-kulture: Život omladine u FNRJ 1945–1955." *Istorija 20. veka* 1: 119–32.

Doherty, Claire, ed. 2004. *Contemporary Art: From Studio to Situation.* London: Black Dog Publishing.

Đokic, Dejan. 2003. *Yugoslavism: Histories of a Failed Idea, 1918–1992.* London: Hurst and Company.

Đonović, Janko. 1948. "Dvije vene." *Književnost* 3.2 (February): n.p.

Đorđević, Goran. 1975. "Umetnost kao oblik religiozne svesti." *Oktobar* 75: n.p.

Đorđević, Goran. 1976. "On the Class Character of Art." *The Fox* 3: 163–64.

Đorđević, Goran. 1980a. "International Strike of Artists?" *3+4 (b)*: 43–85.

Đorđević, Goran. 1980b. Untitled statement. In *Works and Words: International Art Manifestation*, ed. Josine van Droffelaar and Piotr Olszanski, 89. Amsterdam: Foundation de Appel.

Đorđević, Goran. 1984. "Filozofski traktat o besmislu." *Theoria: Časopis Filozofskog društva Srbije* 3–4: 83–87.

Đorđević, Goran. 1985. "Original i kopija." *Moment* 2: 9–11.

Đorđević, Goran. 2003. "Ko je 'Goran Đorđević': intervju sa Goranom Đorđevićem." *Prelom: Časopis za savremenu umetnost i teoriju* 3.5 (Spring–Summer): 156–80.

Drašković, Dragomir. 1961. "Sociološki aspekt dezalijenacije u uslovima samoupravljanja i raspodele 'prema individualnom kvantumu rada.'" *Pregled: Časopis za društvena pitanja* 13.2 (October): 293–99.

Duda, Igor. 2010. *Pronađeno blagostanje: Svakodnevni život i potrošačka kultura u Hrvatskoj 1970-ih i 1980-ih.* Zagreb: Srednja Europa.

Đukić, Slavoljub. 1990. *Slom srpskih liberala: tehnologija političkih obračuna Josipa Broza Tita.* Beograd: Filip Višnjić.

Duvignaud, Jean. 1965. *Sociologie du théâtre: Essai sur les ombres collectives.* Paris: Presses universitaires de France.

Dyker, David A. 1990. *Yugoslavia: Socialism, Development and Debt.* London: Routledge.

Eichberg, Henning. 1977. "The Nazi *Thingspiel*: Theater for the Masses in Fascism and Proletarian Culture." *New German Critique* 11 (Spring): 133–50.

Enciklopedija samoupravljanja. 1979. Belgrade: Savremena administracija, Komunist.

EXAT 51. 1969. "Manifest." *Polja* 133/134/135: 39.

Ferry, Luc, and Alain Renaut. [1985] 1990. *French Philosophy of the Sixties: An Essay on Antihumanism.* Translated by Mary Schnackenberg-Cattani. Amherst: University of Massachusetts Press.

Filipović, Milenko. 1947. *Naša industrija i petogodišnji plan.* Beograd: Sindikalna biblioteka.

Foucault, Michel. [2004] 2007. *Security, Territory, Population: Lectures at the Collège de France, 1977–78.* Translated by Graham Burchel. New York: Palgrave.

Franičević, Marin. 1947. "Iz zapisa s omladinske pruge." *Republika: mjesečnik za književnost, umjetnost i javna pitanja* 3.9: 574–83.

Freire, Paulo. [1968] 1970. *Pedagogy of the Oppressed.* Translated by Myra Ramos. New York: Herder and Herder.

Fried, Michael. 1990. *Courbet's Realism.* Chicago: University of Chicago Press.

Fromm, Erich, ed. 1965. *Socialist Humanism: An International Symposium.* Garden City: Doubleday.

Fuchs, Elinor. 1996. *The Death of Character: Perspectives on Theater after Modernism.* Bloomington: Indiana University Press.

Gablik, Suzi. 1981. "Art under the Dollar Sign." *Art in America* 69 (December): 13–19.

Galjer, Jasna. 2009. *Expo 58 and the Yugoslav Pavilion by Vjenceslav Richter.* Zagreb: Horetzky.

Gambrell, Jamey. 1984. "Art against Intervention." *Art in America* (May): 9–15.

Gamulin, Grga. 1949. "Zapisi iz 1949." *Republika: mjesečnik za književnost, umjetnost i javna pitanja* 5.10–11: 810–41.

Gattin, Ivo. 1957. "Novi material." *Umjetnost* 4–5 (November–December): 17.

Gattin, Ivo. 1992. [Untitled statement.] In *Ivo Gattin*, ed. Branka Stipančić, 24. Zagreb: Galerije grada Zagreba.

Georgi, Frank, ed. 2003. *Autogestion: La dernière utopie?* Paris: Sorbonne.

Gligorijević, Milo. 1988. *Slučajna istorija.* Belgrade: BIGZ.

Gligorov, Vladimir. 1974. "O stranom." *Ideje* 5.11–12: 111–34.

Golubović, Veselin. 1985. *S Marxom protiv Staljina. Jugoslavenska filozofska kritika staljinizma 1950–1960.* Zagreb: Globus.

Gough, Maria. 2002. "Paris, Capital of the Soviet Avant-Garde." *October* 101: 53–83.

Griffith-Jones, Stephany, and Osvaldo Sunkel. 1986. *Debt and Development Crises in Latin America: The End of an Illusion.* Oxford: Clarendon Press.

Grindon, Gavin. 2013. "Revolutionary Romanticism: Henri Lefebvre's Revolution-as-Festival." *Third Text* 27.2: 208–20.

Gržinić, Marina. 2000. *Fiction Reconstructed: Eastern Europe, Post-Socialism and the Retro-Avantgarde.* Vienna: edition selene.

Guerrilla Art Action Group. 2009. "A Call for the Immediate Resignation of All the Rockefellers from the Board of Trustees of the Museum of Modern Art." In *Institutional Critique: An Anthology of Artists' Writings,* ed. Alexander Alberro and Blake Stimson, 86–87. Cambridge: MIT Press.

Habermas, Jürgen. [1968] 1971. *Knowledge and Human Interests.* Translated by Jeremy. J. Shapiro. Boston: Beacon Press.

Habermas, Jürgen. 1981. "Modernity versus Postmodernity." Translated by Seyla Ben-Habib. *New German Critique* 22 (Winter): 3–14.

Hammond, Fredrick. 1994. *Music and Spectacle in Baroque Rome: Barberini Patronage under Urban VIII.* New Haven: Yale University Press.

Haraszti, Miklós. 1989. *The Velvet Prison: Artists under State Socialism.* Translated by Katalin and Stephen Landesmann. New York: Farrar, Straus and Giroux.

Hardt, Michael, and Antonio Negri. 2000. *Empire.* Cambridge: Harvard University Press.

Hartman, Saidiya. 1997. *Scenes of Subjection: Terror, Slavery, and Self-Making in Nineteenth-Century America.* New York: Oxford University Press.

Heath, Stephen. 1978. "Notes on Suture." *Screen* 18.4 (Winter): 48–76.

Hebdige, Dick. 1979. *Subculture: The Meaning of Style.* New York: Routledge.

Helguera, Pablo. 2011. *Education for Socially Engaged Art: A Materials and Techniques Handbook.* New York: Jorge Pinto Books.

Hirschman, Albert O. 1977. *The Passions and the Interests. Political Arguments for Capitalism before Its Triumph.* Princeton, NJ: Princeton University Press.

Hodžić, Alija, et al., eds. 1971. *Jun-Lipanj 1968: Dokumenti.* Zagreb: Praxis filozofski časopis.

Honnef, Klaus, ed. 1983. *Back to the USA: Amerikanische Kunst der Siebziger und Achtziger: Die Ausstellung steht unter der Schirmherrschaft des Botschafters der Vereinigten Staaten von Amerika in der Bundesrepublik Deutschland S.E. Arthur Burns. Kunstmuseum Luzern, 29. Mai bis 31. Juli 1983.* Cologne: Rheinland-Verlag.

Hudelist, Darko. 1986. "Pokret sa jelenskim rogovima." *Start* (April 19): 49–53, 80–81.

Hughes, Anthony. 1990. "The Cave and the Stithy: Artists' Studios and Intellectual Property in Early Modern Europe." In *Oxford Art Journal,* 13.1:34–48.

Idrizović, Nagorka. 1987. "Zmijsko jaje 'Novog kolektivizma.'" *Oslobođenje* (February 28): 1, 5.

Ignjatović, Petar. 1972. *April Meeting Bulletin 2.*

Irwin. [1984] 2003. "Retro Principle." In *Irwin Retroprincip 1983–2003*, ed. Inke Arns, 150. Frankfurt: Revolver.

Jakovljević, Branislav. 2008. "From Mastermind to Body Artist: Political Performances of Slobodan Milosevic." In *TDR* 52.1 (T197):51–74.

Jakovljević, Branislav. 2009. "Handworks: Yugoslav Gestural Culture and Performance Art." In *1968–1989: Political Upheaval and Artistic Change*, ed. Claire Bishop and Marta Dziewańska, 30–49. Warsaw: Museum of Modern Art.

Jakovljević, Branislav. 2010. "The Theater of the Absurd and the Historization of the Present." In *Theater Historiography: Critical Interventions*, ed. Henry Bial and Scott Magelsson, 61–73. Ann Arbor: University of Michigan Press.

Jameson, Fredric. 1991. *Postmodernism, or, The Cultural Logic of Late Capitalism.* Durham, NC: Duke University Press.

Jokić, Vujadin, and Svetislav Pavićević. 1969. *Društveni položaj slobodnih umetnika.* Belgrade: Zavod za proučavanje kulturnog razvitka.

Jones, Caroline A. 1996. *Machine in the Studio: Constructing the Postwar American Art.* Chicago: The University of Chicago Press.

Jovanov, Neca. 1981. *Teorijska koncepcija samoupravljanja.* Belgrade: Naučna knjiga.

Jovanov, Neca. 1983. *Dijagnoza samoupravljanja 1974–1981.* Zagreb: Sveučilišna naklada Liber.

Jović, Dejan. 2009. *Yugoslavia: A State That Withered Away.* West Lafayette, IN: Purdue University Press.

Kahn, Herman, and Anthony J. Wiener. 1967. "The Next Thirty-Three Years: A Framework for Speculation." *Dædalus: Journal of the American Academy of Arts and Sciences.* "Toward the Year 2000: Work in Progress." 96.3 (Summer): 705–32.

Kaldor, Mary. 2007. *New and Old Wars: Organized Violence in a Global Era.* 2nd ed. Stanford, CA: Stanford University Press.

Kangrga, Milan. 1953. "Problem ideologije." *Pogledi: Časopis za teoriju društvenih i prirodnih nauka* 11: 778–87.

Kangrga, Milan. 1961. "O nekim bitnim pitanjima teorije odraza." In *Neki problemi teorije odraza*, ed. Vuko Pavićević, Bogdan Šešić, and Svetlana Knjazeva, 33–42. Belgrade: Jugoslovensko udruženje za filozofiju.

Kangrga, Milan. 1984. *Praksa vrijeme svijet: Iskušavanje mišljenja revolucije.* Belgrade: Nolit.

Kangrga, Milan. 2001. *Šverceri vlastitog života.* Belgrade: Republika.

Kardelj, Edvard. 1949. "Govor druga Edvarda Kardelja." *Politika* 14 (December): 1–2.

Kardelj, Edvard. 1954. *Problemi naše socijalističke izgradnje.* Beograd: Kultura.

Kardelj, Edvard. 1977. "Sistem socijalističkog samoupravljanja u Jugoslaviji." In *Samoupravljanje u Jugoslaviji 1950–1976: dokumenti razvoja*, 9–39. Belgrade: Privredni pregled.

Kardelj, Edvard. 1979. *Udruženi rad i samoupravno planiranje.* Sarajevo: Svjetlost.

Kastratović-Ristić, Veselinka. 2008. "Proslave u čast Titove štafete—Štafete mladosti / Celebrations in Honour of Tito's Relay Race—Youth Relay Race." In *Titova štafeta—Štafeta mladosti, 1945–1987*, 23–38. Belgrade: Museum of Yugoslav History.

Kātz, Barry. 1982. *Herbert Marcuse and the Art of Liberation: An Intellectual Biography*. London: Verso and NLB.

Kędzierski, Marek. 2009. "Samuel Beckett and Poland." In *The International Reception of Samuel Beckett*, ed. Mark Nixon and Matthew Feldman, 163–87. London: Continuum.

Kemenov, V. S. 1948. "Crte dvaju kultura." *Republika: mjesečnik za književnost, umjetnost i javna pitanja* 4.3: 298–315.

Kesar, Jovan, Djuro Bilbija, and Nenad Stefanović, eds. 1990. *Geneza maspoka u Hrvatskoj*. Belgrade: Književne novine.

Kidrič, Boris. 1949. "Govor pretsednika Privrednog saveta i Savezne planske komisije Borisa Kidriča o izvršenju Plana u 1948 i zadacima u 1949 godini." In *Borba za Petogodišnji plan u 1949. Govori članova savezne vlade u Budžetskoj debate (26–30 decembra 1948 godine)*, 57–82. Belgrade: Politika.

Klajn, Hugo. 1966. "Otuđenje po Marksu i po Brehtu." *Borba* (June 12): n.p.

Kljakić, Ljubomir. 1981. "Studentski kulturni centar: prvih deset godina i posle." In *Prvih deset godina*, ed. Bojana Pejić, 1. Belgrade: SKC.

Kljajić-Imširović, Jelka. 1998. "Disidenti i zatvor." *Republika* 196: n.p.

Koljanin, Milan. 1992. *Nemački logor na beogradskom Sajmištu, 1941–1944*. Belgrade: Institut za savremenu istoriju.

Kontova, Helena. 1979. "The Wound as a Sign: An Encounter with Gina Pane." *Flash Art* 92–93 (October–November): 36–37.

Kracauer, Siegfried. 1995. *The Mass Ornament: Weimar Essays*. Translated by Thomas Y. Levin. Cambridge: Harvard University Press.

Krauss, Rosalind. 1978. "Video: The Aesthetics of Narcissism." In *New Artists Video: A Critical Anthology*, ed. Gregory Battcock, 43–64. New York: E. P. Dutton.

Krauss, Rosalind. 1986. *The Originality of the Avant-Garde and Other Modernist Myths*. Cambridge: MIT Press.

Kristeva, Julia. [1973] 1998. "The Subject in Process." In *Tel Quel Reader*, ed. Patrick French and Roland-François Lack, 133–78. New York: Routledge.

Krivokapić, Boro. 1980. *Treba li spaliti Kiša?* Zagreb: Globus.

Kron, Aleksandar. 1968. "Korčula." *Gledišta* 9.11: 1605–10.

Kukoč, Mislav. 1985a. "Usud otuđenja i upitnost razotuđenja." *Filozofska istraživanja* 5.4: 651–62.

Kukoč, Mislav. 1985b. "Radovi jugoslavenskih autora o problemu otuđenja do 1985. godine." *Filozofska istraživanja* 5.4: 725–60.

Kukoč, Mislav. 1988. "Eshaton razotuđenja." *Sociologija* 30.4: 615–27.

Kukoč, Mislav. 1998. *Kritika eshatologijskog uma: Problem otuđenja i hrvatska filozofija prakse*. Zagreb: Kruzak.

Kuoni, Carin, ed. 1993. *Joseph Beuys in America: Energy Plan for the Western Man: Writings by and Interviews with the Artist*. New York: Four Walls Eight Windows.

Lacan, Jacques. [1966] 2002. *Écrits: A Selection*. Translated by Bruce Fink. New York: Norton.

Lacan, Jacques. [1973] 1978. *The Four Fundamental Concepts of Psychoanalysis*. Translated by Alan Sheridan. New York: Norton.

Lacan, Jacques. [1975] 1988. *The Seminar of Jacques Lacan. Book I: Freud's Papers on*

Technique, 1953–54. Edited by Jacques-Allain Miller. Translated by John For-
rester. Cambridge: Cambridge University Press.

Lazzarato, Maurizio. 2011. "The Misfortunes of the 'Artistic Critique' and of
Cultural Employment." In *Critique of Creativity: Precarity, Subjectivity and
Resistance in the "Creative Industries,"* ed. Gerald Raunig, Gene Ray, and Ulf
Wuggenig, 41–56. London: MayFly Books.

Leary, Timothy. 1968. *The Politics of Ecstasy*. New York: Putnam.

Lefebvre, Henri. 1949. *Diderot*. Paris: Hier et aujourd'hui.

Lefebvre, Henri. [1966] 2009. *State, Space, World: Selected Essays*. Translated by
Gerald Moore, Neil Brenner, and Stuart Elden. Minneapolis: University of
Minnesota Press.

Lefebvre, Henri. [1968] 1969. *The Explosion: Marxism and the French Revolution*.
Translated by Alfred Ehrenfeld. New York: Monthly Review Press.

Lefebvre, Henri. 1971. *Au-delà du structuralisme*. Paris: Editions Anthropos.

Lefebvre, Henri. [1965] 2003. "The Style of the Commune." In *Key Writings*.
Edited by Stuart Elden, Elizabeth Lebas, and Eleonore Kofman. New York:
Continuum.

Lekić, Slaviša, and Zoran Pavić, eds. 2007. *VIII Sednica CK SK Srbije: Nulta tačka
"narodnog pokreta."* Belgrade: Službeni glasnik.

Lenin, Vladimir Ilyich. 1932. *State and Revolution*. New York: International Pub-
lishers.

Lenin, Vladimir Illyich. 1962. "Two Tactics of Social Democracy in the Demo-
cratic Revolution." In *Collected Works*, vol. 7, 15–140. Moscow: Progress.

Leposavić, Radonja. 2005. *VlasTito iskustvo past present*. Belgrade: Samizdat-B92.

Levi, Pavle. 2007. *Disintegration in Frames: Aesthetics and Ideology in the Yugoslav
and Post-Yugoslav Cinema*. Stanford, CA: Stanford University Press.

"Likovni crni talas." 1974. *Mladost* (January 5): 16, 19.

Lippard, Lucy R. 1973. *Six years: the dematerialization of the art object from 1966 to
1972; a cross-reference book of information on some esthetic boundaries*. New
York: Praeger.

Lippard, Lucy, and John Chandler. 1999. "The Dematerialization of Art." In
Conceptual Art: A Critical Anthology, ed. Alexander Alberro and Blake Stim-
son, 46–52. Cambridge: MIT Press.

Longinović, Tomislav. 1994. "Postmodernity and the Technology of Power:
Legacy of the 'Vidici' Group in Serbia." *College Literature* 21.1: 120–30.

Lopušina, Marko. 1989. "Gnev posle TV prenosa." *Intervju* 202 (March 3): 8–10.

Lukács, Georg. [1923] 1971. *History and Class Consciousness: Studies in Marxist
Dialectics*. Translated by Rodney Livingstone. Cambridge: MIT Press.

Lukić, Sveta. 1964. *Umetnost i kriterijumi*. Belgrade: Prosveta.

Lukić, Sveta. [1968] 1972. *Contemporary Yugoslav Literature: A Sociopolitical Ap-
proach*. Translated by Pola Triandis. Urbana: University of Illinois Press.

Lukić, Sveta. 1975. *Umetnost na mostu*. Belgrade: Ideje.

Lukić, Sveta. 1983. *U matici književnog života*. Niš: Gradina.

Lukić, Sveta. 1986. *Stvaraoci i kritičari (Devet portreta)*. Kragujevac: Svetlost.

Lyons, Eugene. 1935. *Modern Moscow*. London: Hurst & Blackett.

Lyotard, Jean-François. [1974] 1993. *Libidinal Economy*. Translated by Iain Ham-
ilton Grant. Bloomington: Indiana University Press.

Lyotard, Jean-François. [1979] 1984. *The Postmodern Condition: A Report on Knowledge*. Translated by Geoff Bennington and Brian Massumi. Minneapolis: University of Minnesota Press.

Lyotard, Jean-François. 1998. "L'aliénation." *Chimères* 34 (Fall 1998): 7–20.

Majdanac, Boro. 1981. *Industrijalizacija i porast radničke klase u Srbiji 1947–1952. godine*. Belgrade: Arhivski pregled.

Maksimović, Desanka. 1947. "Bajka o putu." In *Brčko-Banovići: zbornik leposlovnih in Likovnih del z mladinske proge*, 14–15. Dušan Željeznov, ed. Ljubljana: Mladinska knjiga.

Maletić, S. 1977. "Dan mladosti." In *Enciklopedija fizičke kulture*, 213–14. Zagreb: Jugoslavenski leksikografski zavod.

Malevich, Kazimir. 1968. *Essays on Art, 1915–1928*. Edited by Troels Andersen. Translated by Xenia Glowacki-Prus, Arnold McMillan. Copenhagen: Borgen.

Malevich, Kazimir. 2000. *Poeziya*. Moscow: Epifaniya.

Maliqi, Shkëlzen. 1974. "'Zakon srca' i Jozef Bojs—teze protiv novog utopikona." *III Aprilski susret, Bilten* 6 (April 21): n.p.

Maravall, José Antonio. [1975] 1986. *Culture of the Baroque: Analysis of a Historical Structure*. Translated by Terry Cochran. Minneapolis: University of Minnesota Press.

Marcuse, Herbert. 1955. *Eros and Civilization: A Philosophical Inquiry into Freud*. New York: Vintage Books.

Marcuse, Herbert. 1964. *One-Dimensional Man*. Boston: Beacon Press.

Marcuse, Herbert. 1969a. "The Realm of Freedom and the Realm of Necessity: A Reconsideration." *Praxis: International Edition* 5: 20–25.

Marcuse, Herbert. 1969b. "Revolutionary Subject and Self-Government." *Praxis: International Edition* 5: 326–29.

Marinković, Antonije. 1949. "Pred lepotom naših radilišta." *Književne novine* 2.36 (September 6): 1.

Marković, Dragan, Miloš Mimica, and Ljubiša Ristović. 1964. *Fabrike Radnicima: hronika o radničkom samoupravljanju u Jugoslaviji*. Beograd: Privredni pregled.

Marković, Mihailo. 1982. *Democratic Socialism: Theory and Practice*. New York: St. Martin's Press.

Marković, Mihailo, and Gajo Petrović, eds. 1979. *Praxis: Yugoslav Essays in the Philosophy and Methodology of Social Sciences*. Translated by Joan Coddington et al. Dordrecht, Holland: D. Reidel.

Marković, Predrag J. 1996. *Beograd izmedju istoka i zapada, 1948–1965*. Belgrade: Službeni list.

Marković, Predrag J. 2001. "Istoričari i jugoslovenstvo u socijalističkoj Jugoslaviji." In *Jugoslovenski istorijski časopis*, 34.1–2: 151–64.

Marković, Slobodan. 1949. "*Grad na rukama*" *Književne novine* 2: 43 (October 25): 3.

Martin, Randy. 2007. *An Empire of Indifference: American War and the Financial Logic of Risk Management*. Durham, NC: Duke University Press.

Martek, Vlado. 2011. "Radikalizam i meka misao." In Branka Stipančić, *Mišljenje je forma energije: Eseji i intervjui iz suvremene hrvatske umjetnosti*: 136–43. Zagreb: Arkzin.

Marx, Karl. 1940. *The Civil War in France*. New York: International Publishers.

Marx, Karl. 1971. *A Contribution to the Critique of Political Economy*. Translated by S. W. Ryazanskaya. London: Lawrence and Wishart.

Marx, Karl and Friedrich Engels. 1962. *Manifesto of the Communist Party*. New York: International Publishers.

Marx, Karl, and Friedrich Engels. 1975. *Early Writings*. Translated by Rodney Livingstone and Gregor Benton. London: Penguin.

Matić, Dušan. 1961. *Na tapet dana*. Novi Sad: Matica srpska.

Matičević, Davor. 1980. [Untitled catalog text.] In Mladen Stilinović, *Pjevaj!*, n.p. Zagreb: Galerija suvremene umjetnosti.

Matvejević, Predrag. 1982. *Jugoslavenstvo danas: Pitanja kulture*. Zagreb: Globus.

McKenzie, Jon. 2001. *Perform or Else: From Discipline to Performance*. London: Routledge.

McMillan, Dougald, and Martha Fehsenfeld. 1988. *Beckett in the Theatre: The Author as Practical Playwright and Director*. London: John Calder.

McMillan, Dougald, and James Knowlson, eds. 1993. *The Theatrical Notebooks of Samuel Beckett*. Vol. 1: *Waiting for Godot*. London: Faber and Faber.

Mencinger, Jože. 1987. "Acceleration of Inflation into Hyperinflation: The Yugoslav Experience in the 1980s." *Economic Analysis and Workers' Management* 21.4: 399–418.

Merenik, Lidija. 1995. *Beograd: osamdesete, nove pojave u slikarstvu i skulpturi u Srbiji 1979–1989*. Novi Sad: Prometej.

Mičeta, Luka. 1989. "Miting za Jugoslaviju." *NIN* 1992 (March 5): 7–8.

Michelson, Annette. 1982. "De Stijl, Its Other Face: Abstraction and Cacophony, or What Was the Matter with Hegel?" *October* (21): 5–26.

Mićunović, Dragoljub. 1964. [Untitled comment] In *Prvi naučni skup Marks i savremenost, I deo*, 183–84. Belgrade: Institut za izučavanje radničkog pokreta and Institut društvenih nauka.

Mikecin, Vjekoslav. 1972. *Marksizam i umjetnost*. Belgrade: Izdavački centar Komunist.

Milenkovitch, Deborah D. 1971. *Plan and Market in Yugoslav Economic Thought*. New Haven: Yale University Press.

Milivojević, Slobodan. 2001. "Era." In *Art Sessions*. Belgrade: Geo-Poetika.

Milivojević, Slobodan. 2010. "Era." Telephone interview with the author. December 23.

Miller, Jacques-Alain. [1966] 1978. "Suture (Elements of the Logic of the Signifier)." *Screen* 18.4 (Winter): 24–34.

Mirković, Vlada. 1969. "Granice stvaralačkih sposobnosti čoveka." *Direktor* 5 (May): 60–62.

Mitrović, Momčilo, and Dobrica Vulović, eds. 1989. *Beogaradski univerzitet i '68: zbornik dokumenata o studentskim demonstracijama*. Belgrade: Centar za marksizam Univerziteta.

Moljković, Ilija. 2008. *"Slučaj" Student*. Belgrade: Službeni glasnik.

Molnar, Aleksandar. 1996. "The Collapse of Self-Management and the Rise of Führerprinzip in Serbian Enterprises." *Sociologija: Journal of Sociology. Social Psychology and Social Anthropology* 38 (October–December): 539–59.

Monroe, Alexei. 2005. *Interrogation Machine: Laibach and NSK.* Cambridge: MIT Press.

Monteagudo, Graciela. 2008. "The Clean Walls of a Recovered Factory: New Subjectivities in Argentina's Recovered Factories." *Urban Anthropology and Studies of Cultural Systems and World Economic Development* 37.2: 175–210.

Morin, Edgar. 1975. *L'Esprit du temps: Nécrose.* Paris: Bernard Grasset.

Mosse, George L. 1975. *The Nationalization of the Masses: Political Symbolism and Mass Movements in Germany from the Napoloeanic Wars through the Third Reich.* New York: Howard Fertig.

Mrkalj, Ljubica. 2011. Telephone interview with the author. February 7.

Murría, Alicia, Mariano Navarro, and Juan Antonio Álvarez Reyes. 2013. *Without Reality There Is No Utopia / Sin realidad no hay utopía.* San Francisco: Yerba Buena Center for the Arts.

N. M. 1986. "Poslednja futuristička izložba slika u Beogradu i Ljubljani." *Moment* 5 (April–June): 77–78.

Neal, Fred Warner. 1958. *Titoism in action; the reforms in Yugoslavia after 1948.* Berkeley: University of California Press.

Nejgebauer, Aleksandar. 1969. "Hepening—umetnost projektivne simulacije." *Polja* 127 (April): 5.

New Collectivism, ed. 1991. *Neue Slowenische Kunst.* Zagreb: Grafički zavod Hrvatske; Los Angeles: Amok Books.

Newman, Charles. 1985. *The Post-Modern Aura: The Act of Fiction in an Age of Inflation.* Evanston, IL: Northwestern University Press.

Noir et Rouge. 1972. *Autogestion, Etat, Révolution.* Paris: Editions du Cercle.

Nolte, Claire E. 2002. *The Sokol in the Czech Lands to 1914: Training for the Nation.* London: Palgrave-Macmillan.

"Od mirnih demonstracija do sukoba sa milicijom." 1968. *Borba* (June 4): 6.

O'Dell, Kathy. 1998. *Contract with the Skin: Masochism, Performance Art, and the 1970s.* Minneapolis: University of Minnesota Press.

Oktobar '75. 1975. Belgrade: Studentski kulturni centar.

Orgel, Stephen. 1975. *The Illusion of Power: Political Theater in the English Renaissance.* Berkeley: University of California Press.

Oudart, Jean-Pierre. [1969] 1978. "Cinema and Suture." *Screen* 18.4 (Winter): 35–47.

Ozouf, Mona. [1976] 1988. *Festivals and the French Revolution.* Translated by Alan Sheridan. Cambridge: Harvard University Press.

A Pageant of Youth. 1939. Moscow: State Art Publishers.

Pagès, Claire. 2011. *Lyotard et l'aliénation.* Paris: Presses Universitaires de France.

Pane, Gina. 1973. "Performance of Concern: Gina Pane discusses Her Work with Effie Stephano." *Art and Artists* 8.1 (issue 85, April): 20–26.

Panić, Ana. 2008. "Štafeta—simbol zajedništva." In *Titova štafeta—Štafeta mladosti, 1945–1987,* 12–22. Belgrade: Museum of Yugoslav History.

Papić, Žarko. 1976. *Samoupravljanje i inteligencija.* Belgrade: Mladost.

Pašić, Feliks. 1992. *Kako smo čekali Godoa kad su cvetale tikve.* Belgrade: Bepar Press.

Pavičić, Josip. 1947. "Od jučer do danas: Zapisi sa četiri pruge." In *Na pruzi: zbornik radova književnika iz Hrvatske o pruzi Šamac-Sarajevo,* ed. Marijan Matković. 7–23. Zagreb: Nakladni zavod Hrvatske.

Pavlović, Živojin. 1990. *Ispljuvak pun krvi*. Belgrade: Dereta.

Pejić, Bojana. 1983. "Vreme ikonodula." *Polja: časopis za kulturu, umetnost i društvena pitanja* 289 (March): 103–4.

Pejović, Danilo. 1965. "Jean-Paul Sartre." *Praxis* 1.1: 71–86.

Pešić-Golubović, Zaga. 1966. "What Is the Meaning of Alienation?" *Praxis: Revue philosophique, Edition internationale* 2.3: 353–59.

Petrone, Karen. 2000. *Life Has Become More Joyous, Comrades: Celebrations in the Time of Stalin*. Bloomington: Indiana University Press.

Petrović, Gajo. 1964a. "Čemu Praxis?" *Praxis: filozofski dvomesječnik* 1.1: 3–6.

Petrović, Gajo. 1964b. In *Prvi naučni skup Marks i savremenost, II deo*, 563–69. Belgrade: Institut za izučavanje radničkog pokreta and Institut društvenih nauka.

Petrović, Gajo. [1966] 1969. "'Relevantnost' pojma otuđenje." In *Mogućnost čovjeka*. Zagreb: Studentski centar Sveučilišta.

Petrović, Gajo. 1978. *Mišljenje revolucije: Od "ontologije" do "filozofije politike."* Zagreb: Naprijed; Belgrade: Nolit.

Phelan, Peggy. 1991. "Money Talks, Again." *TDR* 35.3 (T131): 131–41.

Phelan, Peggy. 2004. "Lessons in Blindness from Samuel Beckett." *PMLA* 119.5: 1279–88.

Piotrowski, Piotr. 2009. *In the Shadow of Yalta: Art and the Avant-Garde in Eastern Europe, 1945–1989*. London: Reaktion Books.

Plekhanov, Georgi. 1957. *Unadressed Letters: Art and Social Life*. Translated by A. Fineberg. Moscow: Foreign Languages Publishing House.

Pluchart, François. 1973. "Gina Pane's Performances." *arTitudes International* 3 (February–March): 15.

Pluchart, François. 1984. "Risk as the Practice of Thought." In *The Art of Performance: A Critical Anthology*, ed. Gregory Battcock and Robert Nickas, 125–34. New York: E.P. Dutton.

Popov, Nebojša. 1969. "Štrajkovi u savremenom jugoslovenskom društvu." *Sociologija* 11.4: 605–30.

Popov, Nebojša. 1983. *Društveni sukobi/izazov sociologiji*. Belgrade: Centar za filozofiju i društvenu teoriju.

Popov, Nebojša. 1989. *Contra fatum: Slučaj grupe profesora Filozofskog Fakulteta u Beogradu*. Beograd: Mladost.

Popov, Nebojša, ed. 2003. *Sloboda i nasilje: Razgovor o časopisu Praxis (1964–74) i Korčulanskoj letnjoj školi (1963–74)*. Belgrade: Res publica.

Popović, Jovan. 1949. "Idejnost daje krila talentima." *Umetnost: časopis za likovnu umetnost* 1: 3–9.

Popović, Koča, and Marko Ristić. 1985. *Nacrt za jednu fenomenologiju iracionalnog*. Belgrade: Prosveta.

Popović, Strahinja. 1971. "Samoupravljanje u Pariskoj komuni." *Prilozi za istoriju socijalizma* 8: 301–16.

Popović, Vasilije. 1978. "Sećanje na Godoa." *Teatron* 12: 5–32.

Popović, Zoran. 1983. "Aksiomi." In *Nova umetnost u Srbiji, 1970–1980: Pojedinci, grupe, pojave*, ed. Ješa Denegri. Belgrade: Muzej savremene umetnosti.

Popović, Zoran. 1989. "Strogo kontrolisane predstave." Interview by Ješa Denegri. *Moment* 14 (April–June): 20–32.

Popović, Zoran. 2014. Personal communication.

Praxis. 1969. "Telegram učesnika Korčulanske ljetne škole drugu Titu." *Praxis* 6.1–2: 310.

Protić, Miodrag B. 1970. *Srpsko slikarstvo XX veka: Knjiga druga*. Belgrade: Nolit.

Protić, Miodrag B. 1980. *Jugoslovensko slikarstvo šeste decenije*. Belgrade: Muzej savremene umetnosti.

Pusić, Eugen. 1968. *Samoupravljanje: Prilozi teoriji i praktični problem*. Zagreb: Narodne novine.

Radaković, Žarko. 2010. *Era*. Belgrade: Stubovi kulture.

Radenković, Đorđe. 1958. "Social Management in Yugoslavia." *Yugoslavia* 15: 89–99.

Ragon, Michel. 1971. "Lyrical Abstraction from Explosion to Inflation." In *Abstract Art since 1945*, ed. Jean Leymarie, 72–102. London: Thames and Hudson.

Ralić, Prvoslav. 1975. *Duhovnost i rad: Kritika građanskog koncepta kulture*. Belgrade: Vuk Karadžić.

Rancière, Jacques. [1987] 1991. *The Ignorant Schoolmaster: Five Lessons in Intellectual Emancipation*. Translated by Kristin Ross. Stanford, CA: Stanford University Press.

Reich, Wilhelm. 1970. *The Mass Psychology of Fascism*. St. Louis: Albion Press.

Ressler, Oliver. N.d. "Alternative Economics, Alternative Societies." http://www.ressler.at/alternative_economics/.

Richard Demarco Gallery. 1973. *Eight Yugoslav Artists: Edinburgh arts 73: Marina Abramovic, Radomir Damnjan, Nusa & Sreco Dragan, Nesa Paripovic, Zoran Popovic, Rasa Todosijevic, Gergely Urkom*. Edinburgh: Richard Demarco Gallery.

Robbe-Grillet, Alain. 1965. "Samuel Beckett, or 'Presence' in the Theatre." In *Samuel Beckett: A Collection of Critical Essays*, ed. Martin Esslin, 108–16. Englewood Cliffs, NJ: Prentice-Hall.

Ross, Kristin. 2002. *May '68 and Its Afterlives*. Chicago: University of Chicago Press.

Rossi-Landi, Ferruccio. [1968] 1983. *Language as Work and Trade: A Semiotic Homology for Linguistics and Economics*. Translated by Martha Adams. South Hadley, MA: Bergin & Garvey.

Rus, Veljko. 1969. "Samoupravni egalitarizam i društvena diferencijacija." *Praxis* 6: 5–6.

Rus, Veljko, and Frane Adam. 1989. *Moć i nemoć samoupravljanja*. Zagreb: Globus.

Rus, Veljko, and Vladimir Arzenšek. 1984. *Rad kao sudbina i kao sloboda: Podjela i alijenacija rada*. Zagreb: Sveučilišna naklada Liber.

Rusinow, Dennison I. 1968a. "Anatomy of a Student Revolt, Part I: A Week in June." *American Universities Field Staff Reports*. Southeast Europe Series. Vol. 15, no. 4 (Yugoslavia).

Rusinow, Dennison I. 1968b. "Anatomy of a Student Revolt, Part II: Events of the Later Summer." *American Universities Field Staff Reports*. Southeast Europe Series Vol. 15, no. 5 (Yugoslavia).

Rutland, Peter. 1985. *The Myth of the Plan: Lessons of Soviet Planning Experience*. London: Hutchinson.

Saiu, Octavian. 2009. "Samuel Beckett behind the Iron Curtain: The Reception in Eastern Europe." In *The International Reception of Samuel Beckett*, ed. Mark Nixon and Matthew Feldman, 251–71.

Salecl, Renata. 1994. "The Crisis of Identity and the Struggle for New Hegemony in the Former Yugoslavia." In *The Making of Political Identities*, ed. Ernesto Laclau, 205–32. London: Verso.

Sartorti, Rosalinde. 1990. "Stalinism and Carnival: Organization and Aesthetics of Political Holidays." In *The Culture of the Stalin Period*, ed. Hans Günther, 41–76. London: Macmillan.

Sartre, Jean-Paul. [1943] 1956. *Being and Nothingness: A Phenomenological Essay on Ontology*. Translated by Hazel E. Barnes. New York: Citadel Press.

Saussure, Ferdinand de. [1916] 1959. *Course in General Linguistics*. New York: Philosophical Library.

Saussure, Raymond de, et al. 1954. *L'angoisse du temps présent et les devoirs de l'esprit*. Neuchâtel, Switzerland: Éditions de la baconnière.

Savić, Milisav. 1985. *Topola na terasi*. Beograd: BIGZ.

Schechner, Richard. 1969. *Public Domain: Essays on the Theatre*. Indianapolis: Bobbs-Merrill.

Schechner, Richard. 1976. "From Ritual to Theater and Back." In *Ritual, Play, and Performance: Readings in the Social Sciences / Theatre*, ed. Richard Schechner and Mady Schuman, 196–222. New York: Continuum.

Schechner, Richard. 1985. *Between Theater and Anthropology*. Philadelphia: University of Pennsylvania Press.

Schmidt, Johann-Karl, ed. 2001. *Joan Jonas: Performance Video Installation, 1968–2000*. Ostfildern-Ruit: Hatje Cantz Verlag.

Schnapp, Jeffrey T. 1994. "Border Crossings: Italian/German Peregrinations of the Theater of Totality." *Critical Inquiry* 21 (Autumn): 80–123.

Šejka, Leonid. 1982. *Grad, đubrište, zamak*. Vol. 1. Belgrade: Književne novine.

Selinić, Slobodan. 2007. "Počeci socijalističkog Novog Beograda: Prva faza izgradnje Novog Beograda 1947–1950." *Tokovi istorije* 4: 75–96.

Servan-Schreiber, Jean-Jacques. 1967. *Le Défi américain*. Paris: Denoël.

Shakespeare, William. 1997. *The Norton Shakespeare*. Edited by Stephen Greenblatt. New York: Norton.

Sharp, Willoughby, prod. 1974. *Joseph Beuys' Public Dialogue*. New York: Monday Wednesday Friday Video Club.

Sharp, Willoughby. 2000. "Body Works: A Pre-critical, Non-definitive Survey of Very Recent Works Using the Human Body or Parts Thereof." In *The Artist's Body: Themes and Motives*, ed. Tracey Warr, 231–33. London: Phaidon.

Sher, Gerson S. 1977. *Praxis: Marxist Criticism and Dissent in Socialist Yugoslavia*. Bloomington: Indiana University Press.

Shishkoff, Serge. 1987. "Košava in a Coffeee Pot, or a Dissection of a Literary Cause Célèbre." *Cross Currents* 6: 341–71.

Shklovsky, Viktor. [1917] 1965. "Art as Technique." *Russian Formalist Criticism: Four Essays*. Translated by Lee T. Lemon and Marion J. Reis, 3–24. Lincoln: University of Nebraska Press.

Siegelbaum, Lewis H. 1988. *Stakhanovism and the Politics of Productivity in the USSR, 1935–1941*. Cambridge: Cambridge University Press.

Šimičić, Darko. 1998. "Kronologija i komentari/Chronology, comments." In *Grupa šestorice autora*, ed. Janka Vukmir: 177–311. Zagreb: Soros centar za suvremenu umjetnost.

Sinđić, Miloš M. 1969. "Godine dvehiljadite: efikasnost privređivanja i perspective." *Direktor* 1.1 (January): 18–23.

Sirc, Ljubo. 1966. *Inflacija u SFR Jugoslaviji*. London: Pika Print.

Spasojević, Svetislav. 1984. "Sizokratija: dvojnici države." *NIN: Nedeljne informativne novine* 1733 (March 18): 11–12.

Spehnjak, Katarina, and Tihomir Cipek. 2007. "Disidenti, opozicija i otpor—Hrvatska i Jugoslavija 1945–1990." *Journal of Contemporary History / Časopis za suvremenu povijest* 2: 255–97.

Sretenović, Dejan. 2002. "Umetnost kao društvena praksa / Art as Social Practice." In *Was ist Kunst?* ed. Raša Todosijević, 9–37. Belgrade: Geopoetika.

Sretenović, Dejan. 2014. *Umetnost prisvajanja*. Belgrade: Orion art.

Štajner, Karlo. 1971. *7000 dana u Sibiru*. Zagreb: Globus.

Stanimirović, Ljubica, ed. 1981. *Titova štafeta—Štafeta mladosti*. Belgrade: Muzej "25. maj."

Stepančič, Lilijana. [1994] 2003. "The Poster Scandal: New Collectivism and the 1987 Youth Day." In *Irwin Retroprincip 1983–2003*, ed. Inke Arns, 44–48. Frankfurt: Revolver.

Štih, Bojan. 1949. "Pisci—na poprište tematike." *Književne novine* 2.8 (February 22): 1.

Stilinović, Mladen. 1980. *Pjevaj!*. Zagreb: Galerija suvremene umjetnosti.

Stilinović, Mladen. 2011. "Život znači ne ići na dvor." In Branka Stipančić, *Mišljenje je forma energije: Eseji i intervjui iz suvremene hrvatske umjetnosti*, 164–71. Zagreb: Arkzin.

Stilinović, Mladen, and Branka Stipančić. 2008. *Hoću kući: knjige umjetnika 1972–2006*. Zagreb: Arkzin.

Stilinović, Mladen, and Branka Stipančić. 2013. *Mladen Stilinović: Nula iz vladanja*. Zagreb: Muzej suvremene umjetnosti.

Stirin, Marina. 2012. *Everyday Revolutions: Horizontalism and Autonomy in Argentina*. London: Zed Books.

Stojančić, J. 1987. "Kako je otkrivena obmana?" *Politika* (March 1): 5.

Stojanović, Lazar. 1998. "Ko behu disidenti?" *Republika* 182: n.p.

"Stranac pred Akademijom." 1968. *Večernje novosti* (June 6): 9.

Student. 1968. "Otvoreno pismo Univerzitetskom odboru Saveza studenata BU." *Student* 15 (April 23): 1.

Supek, Rudi. 1950. *Egzistencijalizam i dekadencija: Dva eseja*. Zagreb: Matica Hrvatska.

Supek, Rudi. 1969. "Marx i revolucija." *Praxis* 6.1–2: 6–16.

Supek, Rudi, and Maja Minček. 1970. *Likovni stvaraoci i kulturna sredina*. Zagreb: Institut za društvena istraživanja.

Superflex, Will Bradley, Mika Hannula, and Christina Ricupero, eds. 2006. *Self-Organisation / Counter-economic Strategies*. Berlin: Sternberg Press.

Susovski, Marian, ed. 1978. *Nova umjetnička praksa 1966–1978*. Zagreb: Galerija suvremene umjetnosti.

Susovski, Marian. 1998. "Sedamdesete godine i Grupa šestorice autora." In *Grupa šestorice autora*, ed. Janka Vukmir, 12–23. Zagreb: Soros centar za suvremenu umjetnost.

Sutlić, Vanja. 1967. *Bit i suvremenost: S Marxom na putu k povijesnom mišljenju*. Sarajevo: Veselin Masleša.

Sutlić, Vanja. 1968. "Uvodna riječ za simpozij Birokracija, tehnokracija, i lične slobode" and "Završna riječ na simpoziju." *Praxis* 5.1–2 (January–April): 52–57, 62–66.

Šuvaković, Miško. 1993. "Od socrealizm preko modernizma do neoavangarde." *Tesliana* 1: 150–56.

Šuvaković, Miško. 2010. *The Clandestine Histories of the OHO Group*. Ljubljana: Zavod P.A.R.A.S.I.T.E.

Šuvaković, Miško, and Dubravka Djurić, eds. 2003. *Impossible Histories: Historical Avant-Gardes, Neo-Avant-Gardes, and Post-Avant-Gardes in Yugoslavia, 1918–1991*. Cambridge: MIT Press.

Suvin, Darko. 1969. "Organizational Mediation: The Paris Commune Theatre Law." In *TDR* 13.4: 26–42.

Tapié, Michel. 1956. "The Necessity of an AUTRE Æsthetic." In *Observations of . . . Michel Tapié*, ed. Paul Jenkins and Esther Jenkins, 19–26. New York: George Wittenborn.

Taylor, A. J. P. 1966. *From Sarajevo to Potsdam*. London: Thames and Hudson.

Terzuolo, Eric R. 1982. "Soviet-Yugoslav Conflict and the Origins of Yugoslavia's Self-Management System." In *At the Brink of War and Peace: The Tito-Stalin Split in a Historic Perspective*, ed. Wayne S. Vucinich, 195–218. New York: Brooklyn College Press.

Thirion, André. [1972] 1975. *Revolutionaries without Revolution*. Translated by Joachim Neugroschel. New York: Macmillan.

Thompson, Mark. 2013. *Birth Certificate: The Story of Danilo Kiš*. Ithaca, NY: Cornell University Press.

Tijanić, Aleksandar. 1987. "Kam gremo?" *NIN* 1987 (March 8): 12–14.

Tijardović, Jasna. 1974. "Novo u modernoj umetnosti." *Bilten* 10: n.p.

Tijardović, Jasna. 1976. "The 'Liquidation' of Art: Self-Management or Self-Protection." *The Fox* 3: 97–99.

Tijardović, Jasna. 2006. *Performans/1968–1978/Performance/1968–1978*. Belgrade: Prodajna galerija "Beograd."

Todosijević, Raša. 1975. "Edinburgh Statement: Who Makes a Profit on Art, and Who Gains from It Honestly?" In *Aspects 75: Contemporary Yugoslav Art*. Catalog. Edinburgh: Richard Demarco Gallery.

Todosijević, Raša. 1983. "Performans." *Treći program* 1.53: 57–61.

Todosijević, Raša. 2002. *Hvala Raši Todosijeviću / Thanks Raša Todosijević*. Belgrade: Muzej savremene umetnosti.

Todosijević, Raša. 2010. Personal interview with the author. Belgrade, July 11.

Todosijević, Raša. 2011. Personal interview with the author. Belgrade, September 1.

Tomc, Gregor. 1994. "The Politics of Punk." In *Independent Slovenia: Origins, Movements, Prospects*, ed. Jill Benderly and Evan Kraft, 113–34. New York: St. Martin's Press.

Tomović, M. 1987. "Štafetna palica 'na doradi.'" *Oslobođenje* (February 26): 1.

Tošić, Todor. 1949. "Rad." *Jugoslavija SSSR: časopis Društva za kulturnu saradnju Jugoslavije sa SSSR* 44: 17.

Trifunović, Bogdan. 1976. *Francuska levica i samoupravljanje*. Belgrade: Radnička štampa.

Trifunović, Lazar. 1962. *Enformel: mladi slikari Beograda*. Beograd: Galerija Kulturnog centra.

Trifunović, Lazar. 1990. *Studije, ogledi, kritike*. Belgrade: Muzej savremene umetnosti.

Tripalo, Miko. 1990. *Hrvatsko proljeće*. Zagreb: Globus.

Tronche, Anne. 1997. *Gina Pane: Actions*. Paris: Fall Edition.

Tronche, Anne. 2002. "S'il y a quelqu'un ici, il est lá (If Someone is Here, Then They Are Present)." In *Gina Pane*, trans. Nicola Coleby, 58–71. Bristol: John Hansard Gallery, University of Southampton, Arnolfini.

Tronti, Mario. [1966] 2012. "Struggle against Labor!" In Francesco Matarrese, *Greenberg and Tronti: Being Really Outside?*, 36–38. Kassel: Documenta.

Turner, Victor. 1969. *The Ritual Process: Structure and Anti-structure*. Chicago: Aldine Publishing.

Turner, Victor, ed. 1982. *Celebration: Studies in Festivity and Ritual*. Washington, DC: Smithsonian Institution Press.

Ugrinov, Pavle. 1990. *Tople pedesete*. Belgrade: Nolit.

Ugrinov, Pavle. 1997. "Književnik, akademik Pavle Ugrinov." Unpublished manuscript held at the National Library of Serbia, Belgrade.

Urkom, Gergelj. 2005. *Gera Urkom*. Vienna: Macura; Belgrade: Cicero.

Ustav SFRJ. Ustavi socijalističkih republika i pokrajina. 1974. Belgrade: Prosveta.

Vasetski, G. S., and A. P. Butenko, eds. 1958. *Protiv sovremennogo revizionizma: Sbornik perevodov*. Moscow: Inostrannia literatura.

Vinterhalter, Jadranka. 1983. "Umetničke grupe—Razlozi okupljanja i načini rada." In *Nova umetnost u Srbiji, 1970–1980: Pojedinci, grupe, pojave*, ed. Ješa Denegri, 14–23. Belgrade: Muzej savremene umetnosti.

Vlahović, Veljko. 1964. "Neka zapažanja u tretiranju teorije otuđenja." In *Prvi naučni skup Marks i savremenost, II deo*, 471–79. Belgrade: Institut za izučavanje radničkog pokreta and Institut društvenih nauka.

Vlahović, Veljko. 1973. *Revolucije i stvaralaštvo*. Belgrade: BIGZ.

Volokitina, T. V., et al. 1997. *Vostochnaia Evropa v dokumentakh rossiiskikh arkhivov 1944–1953*, vol. 1: *1944–1948*, documents no. 254 and 267. Moscow: Sibirskii khronograf.

Vranicki, Predrag. 1964. "Socijalizam i alijenacija: Teze." In *Prvi naučni skup Marks i savremenost, II deo*, 480–87. Belgrade: Institut za izučavanje radničkog pokreta and Institut društvenih nauka.

Vranicki, Predrag. 1975. "The Theoretical Foundation for the Idea of Self-Management." In *Self-Governing Socialism: A Reader*, vol. 1: *Historical Development and Political Philosophy*, ed. Branko Horvat, Mihailo Marković and Rudi Supek, 454–66. White Plains, NY: International Arts and Sciences Press.

Vučković, Slavica. 2010. "Bujno i sapeto stvaralaštvo." *Republika* 486–89: n.p.

Wachtel, Andrew. 1997. "Postmodernism as Nightmare: Milorad Pavić's Literary Demolition of Yugoslavia." *Slavic and East European Journal* 41.4 (Winter): 627–44.

Ward, Benjamin. 1958. "The Firm in Illyria: Market Syndicalism." *American Economic Review* 48.4 (September): 566–89.

Waterson, Albert. 1962. *Planning in Yugoslavia: Organization and Implementation.* Baltimore: Johns Hopkins Press.

"Weißer Riese" ("White Giant"). 1984. *Der Spiegel* 21 (May 21): 101.

Westcott, James. 2010. *When Marina Abramović Dies: A Biography.* Cambridge: MIT Press.

Whitehorn, Alan. 1974. "Alienation and Workers' Self-Management." In *Canadian Slavonic Papers / Revue Cannadienne des Slavistes* 16.2 (Summer): 160–86.

Woodward, Susan L. 1995. *Socialist Unemployment: The Political Economy of Yugoslavia, 1945–1990.* Princeton, NJ: Princeton University Press.

Worringer, Wilhelm. [1908] 1997. *Abstraction and Empathy: A Contribution to the Psychology of Style.* Translated by Michael Bullock. Chicago: Ivan R. Dee.

Youngblood, Gene. 1970. *Expanded Cinema.* New York: E.P. Dutton.

Žanić, Ivo. 1987. *Mitologija inflacije: govor kriznog doba.* Zagreb: Globus.

Žanić, Ivo. 1994. "Novinarstvo na tamnoj strani Tennesseeja." *Erasmus: Časopis za Kulturu demokracije / Erasmus: Journal for Culture of Democracy* 9: 65–73.

Zdunić, Dragutin. 1947. *Socijalistički grad. Republika: mjesečnik za književnost, umjetnost i javna pitanja* 3.11: 805–9.

Zečević, Božidar, ed. 1974. Prošireni mediji / Expanded Media. Belgrade: Student Cultural Center.

Zečević, Božidar. 1996. "Talason ili mala istorija zavere." In *Ovo je Studentski kulturni centar / This Is Students Cultural Center: prvih 25 godina 1971–1996,* ed. Slavoljub Veselinovi, 19–32. Belgrade: SKC.

Ziherl, Boris. 1954. *O egzistencijalizmu i drugim savremenim pojavama idejne dekadencije.* Beograd: Kultura.

Žilnik, Želimir. 1969. *Lipanjska gibanja.* Novi Sad, Yugoslavia: Neoplanta Film.

Živanov, Sava. 1999. "Uzroci i posledice sukoba." In *Jugoslovensko-sovjetski sukob 1948. godine,* 21–34. Belgrade: Instiut za savremenu istoriju.

Žižek, Slavoj. 1967a. "Aleš Kermauner—Jaz—vloga." *Tribuna* 16.1: 4–5.

Žižek, Slavoj. 1967b. "Smrdokavra." *Tribuna* 16.6: 11.

Žižek, Slavoj. 1968. "Aleš Kermauner—zveza artikel—ime." *Tribuna* 16.2: 10.

Žižek, Slavoj. 1969."Cartesianische meditations." In *Pericarežeracirep.* Maribor: Založba obzorja.

Žižek, Slavoj. 1972. "Užitak-rad-govor." *Ideje* 3.1–2: 23–42.

Žižek, Slavoj. 1974. "Marksizam/Strukturalizam: pokušaj razgraničenja." In *Marksizam-Strukturalizam: istorija, struktura,* ed. Muharem Pervić, 500–525. Belgrade: Nolit.

Žižek, Slavoj. 1976. *Znak, označitelj, pismo: prilog materijalističkoj teoriji označiteljske prakse.* Belgrade: Mladost.

Žižek, Slavoj. 1989. *The Sublime Object of Ideology.* London: Verso.

Žižek, Slavoj. [1989] 2003. "A Letter from Afar." In *Irwin Retroprincip 1983–2003,* ed. Inke Arns, 64–65. Berlin: Künstlerhaus Bethanien.

Žižek, Slavoj. [1993] 2003. "Why Are Laibach and NSK Not Fascists?" In *Irwin Retroprincip 1983–2003,* ed. Inke Arns, 49–50. Frankfurt: Revolver.

Žižek, Slavoj. 2009. "In 1968, Structures Walked the Street—Will They Do It Again?" In *Power in the academy,* eds. Jerome Satterthwaite, Heather Piper, and Patricia J. Sikes. Stoke-on-Trent: Trentham Books, 15–33.

"Znaci političke krize." 1968. *Student* 19 (May 21): 1.

Zogović, Radovan. 1949. "K licu čovjeka!" *Književne novine* 2.2 (January 11): 3–4.

Županov, Josip. 1985. *Samoupravljanje i društvena moć*. Zagreb: Globus.

Zweig, Stefan. [1942] 1943. *The World of Yesterday*. Translated by Benjamin W. Huebsch and Helmut Ripperger. New York: Viking Press.

Index

Note: Page numbers are given in roman type, illustration numbers in italic type.